INTRODUCTORY READINGS IN AESTHETICS

INTRODUCTORY READINGS IN

AESTHETICS

Edited by

JOHN HOSPERS

DIRECTOR, SCHOOL OF PHILOSOPHY
UNIVERSITY OF SOUTHERN CALIFORNIA

THE FREE PRESS
A Division of Macmillan Publishing Co., Inc.
NEW YORK

Collier Macmillan Publishers
LONDON

The Free Press
A DIVISION OF MACMILLAN PUBLISHING CO., INC.
866 Third Avenue, New York, New York 10022

Collier Macmillan Canada,Ltd.

Library of Congress Catalog Card Number: 69–15921

Printed in the United States of America

printing number
8 9 10

CONTENTS

PREFACE

Here is one more anthology of aesthetics. Since there are already so many, what could possibly justify the existence of yet another?

This one contains, of course, a different set of writings from those already in existence—a selection which may be more to the taste of some readers, and less to that of others. But what underlies the selection? More than anything else, it is the uncomfortable feeling, born of bitter experience in teaching introductory courses in aesthetics, that most anthologies of aesthetic writings do not have the students in mind so much as the instructors.

Most students in introductory aesthetics classes have not had more than a course or two in philosophy; they come to a course in aesthetics without a clear conceptual apparatus; but they want very much to be enlightened on some of the problems that have arisen in their experience and discussion of (and sometimes, creation of) music, painting, sculpture, architecture, poetry, drama, and novels. These students, serious and intense, are put off by discussions of abstract points that are of interest exclusively to philosophers. The issues seem to them remote from their own vital interest in the arts, and the readings to which they are typically subjected are also geared to the tastes and interests of philosophers. Many of these readings are of the highest quality; they come from journals of philosophy, in which professors of aesthetics exchange views with their colleagues. But non-professionals in philosophy simply cannot follow the intricacies of argument in these readings, and their value is lost upon these readers. Had I been assembling an anthology designed for teachers of philosophy, who are already conversant with areas of philosophy other than aesthetics, I would have chosen an entirely different set of readings. But for non-philosophers interested in some of the problems of aesthetics, the readings included here seem appropriate. They are, at any rate, among those that have evoked the most enthusiasm from my own students in introductory courses in aesthetics over a period of some years.

Not all of these readings are easy; they cannot be and still get to the root of the problems being considered. They are of varying difficulty.

The selections by Stevenson and Dickie, for example, are far more difficult than those by Bell and Fry. The more difficult ones are, however, clear in their structure and presentation and are usually understandable to an intelligent student with enough persistence to outline the steps in the argument for himself. None of the selections, given the application of some intellectual elbow grease, should leave the student with the hopeless impression, "I can't figure out what it's all about." But in a subject as complex as aesthetics, perhaps this assumption is over-optimistic.

There are many readings which would have been included but for lack of space. The omission of an entire topic, the aesthetic properties of the individual arts (containing such special topics as the nature of metaphor, poetic use of language, the relations among the visual arts, the use of color and line, and the analysis of musical form), is a matter of particular regret.

The painting by Fra Angelico, *Madonna of Humility*, reproduced at the front of this book (on the front cover of the softbound edition) is described in detail in the selection by Stephen Pepper; thanks are due to the National Gallery in Washington, D. C., for permission to reproduce it for this volume. The other painting, Nicolas Poussin's *Achilles Discovered by Ulysses among the Daughters of Lycomedon* (reproduced on the back cover of the softbound edition), is described in detail in the selection by Roger Fry. The acknowledgments to the various authors and publishers for permission to reprint the selections in this volume are given on the first page of each selection. I am particularly indebted to Miss Sharon Milan for her valuable assistance in the reading of proofs and the preparation of the Index.

JOHN HOSPERS

Los Angeles, California

INTRODUCTORY READINGS IN AESTHETICS

INTRODUCTION

The problems of aesthetics are unusually complex and troublesome. Even in philosophy, which is notorious for difficult and insoluble problems, aesthetics is approached with diffidence. This is not only because of philosophers' ignorance of art, but because, if they have thought about aesthetic problems at all, they are aware of how baffling and intractable they are, how they have a way of branching out into dozens of other problems. Some of these are relatively easily dealt with, requiring only a clarification of the meaning of one or two crucial words. But the problems in aesthetics that are easily solved are not, as a rule, the problems that are of interest to serious students of the arts. The perennially challenging problems of aesthetics are those that resist quick solution. Such an easy-sounding question, for example, as "What makes this melody better than that one?" has resisted the solutions suggested by musicians, critics, and philosophers of art throughout the centuries, and resists it no less strongly today.

Difficult as aesthetic problems are, however, it is typical of students of the arts, particularly if they have no background in philosophy, to have but little patience with these problems or to assume that they are far simpler than they actually are. "I could have said it in a tenth as many words" or "It's so simple that anybody knows it before he's got to first base with art" are typical comments of students first being introduced to Croce's theory of art. For such students, who do not yet see the philosophical implications of questions put to them, a stiff dose of Socratic method is the only recommended treatment. Until it has been applied, treatises in aesthetics are not likely to be of help, or even to be understood.

Frequently students misunderstand at the outset the nature of the subject on which they are about to enter. They think of aesthetics as just another course in art appreciation, wondering perhaps what this subject is doing in the philosophy department. For such students, the following distinctions should be made before the study of aesthetics is begun:

Art appreciation consists largely in looking at (hearing, reading, and so on) works of art, on different occasions and in different moods, so that one may gradually come to enjoy and savor everything in a work of art that is there to be enjoyed and savored. This appreciation may involve lectures, demonstrations, and informal conversations with others; but it may equally well be silent, consisting only of repeated exposure to the works of art.

Art criticism does consist of words, words about works of art and designed to be of help in understanding and appreciating the work (or the style, or the period) under scrutiny. If an essay in art appreciation is successful, it will enable the reader to see in the work of art many features, lines of connection, and subtleties of detail that he did not perceive before. Art criticism is a means to an end. Art criticism is usually best conducted in the college or university department—literature, music, painting, sculpture, architecture, dance—in which the student is exposed to the works of art themselves. The persons best qualified to engage in criticism of works of art in a certain medium are usually those who are most steeped in works of art in that medium.

Aesthetics, by contrast, is a philosophical discipline, and the study of it properly belongs in the department of philosophy. It asks the typical philosophical questions, What do you mean? and How do you know? In aesthetics, we attempt (1) to clarify the basic *concepts* we employ in thinking and talking about the objects of aesthetic experience (which are usually, but not always, works of art—they may also be objects of nature, such as hillsides, trees, sunsets, and human beings). We are interested in words too, not for their own sakes, but only for the sake of clarity in identifying and handling concepts. Among the concepts constantly used in talking about aesthetic matters, the following are typical: the aesthetic; beauty (or aesthetic value); aesthetic meaning; symbolism; representation; expression; truth; art. But in aesthetics we also attempt (2) to answer certain questions in which these concepts are embedded—questions such as: Under what circumstances can a work of art be said to exist? When is an object beautiful? Is there any way of deciding, when there are varying interpretations of a work of art, which one is correct, or is there no such thing as correctness of interpretation? Are there any criteria for distinguishing good works of art from bad ones? Are the criteria of value, if there are any, the same in works of literature as in works of music, for example? If not, how and why do they differ? What is the relation of art to nature? Has art anything to do with truth, or with morality?

Each of the eight Parts of this anthology is devoted to a separate aesthetic concept or problem.

Part I: The Aesthetic Attitude

The question seems simple, but it has puzzled philosophers and psychologists for generations: What is it to perceive something aesthetically? Is there a specific way of looking, hearing, and perhaps also feeling and imagining, which can be called aesthetic? (A much later question is: What is it to *evaluate* something aesthetically? Part I is devoted only to the first of these questions.) According to most writers on the subject, there is indeed an attitude with which we come to those things which we view aesthetically, an attitude that is sufficiently distinct from all others to be called "aesthetic." (Aesthetic experience is then defined as "the experience we have while the aesthetic attitude is sustained"—Stolnitz.) But on the nature of this attitude there is an abundance of diverse though overlapping views:

1. The aesthetic as the *non-practical*. If you perceive something aesthetically, you are perceiving it "for its own sake" and not for the sake of some further end or goal you can achieve by means of it. When you are immersed in the practical affairs of daily life, you do not really *look* at things: you see only as much of them as is required to identify them as belonging to such-and-such a kind or class, and then you pass on. You see enough of the object to recognize that it is a tree, and then you proceed to walk around it. But when you stop to observe it, the sweep of the trunk and the branches, the silhouette of the treetop against the sky, when you *savor* the experience of viewing it, not for any practical purpose but simply for its enjoyment, then you are perceiving it aesthetically.

2. The aesthetic as the *non-cognitive*. When you look at an ancient temple or statue with the sole purpose of identifying its style and period of origin, you are looking at it in order to enhance your knowledge. You may perform a successful exercise in ruin-identification without dwelling on the perceptual experience itself. Only when you dwell on the perceptual details of the object, as opposed to using it in the quest for knowledge (even if that knowledge may be of no practical value to you), are you regarding the object aesthetically.

3. The aesthetic as the *non-personal*. According to this criterion of the aesthetic, viewing things aesthetically excludes viewing them with certain kinds of personal involvement. For example, you are looking at a portrait and are reminded of someone you know and use the por-

trait only as a springboard for your own reminiscences. Or, you are witnessing a play and you cannot concentrate on what is going on in the play because it reminds you of some of your own personal problems, to which your attention is then deflected. Or, you are showing guests your new high-fidelity set, but your pleasure is more pride of possession than enjoyment of the music (you do not enjoy it as much on someone else's set). In all these examples it is your concern with yourself and your own feelings and problems that gets in the way of your enjoyment of the painting, play, or music.

There are other closely related views as well. For example, the author of the first reading, Jerome Stolnitz, defines aesthetic attention as "*disinterested* attention"—attention in which the person is not an "interested party" (just as a good judge in a courtroom is not an interested party in the dispute before him). The author of the second reading, George Dickie, contends that there is no distinctively aesthetic attitude or mode of perceiving at all. There is aesthetic evaluation (one can evaluate something aesthetically rather than morally or socially or economically), but there is no distinctive aesthetic *attitude*. One may attend to the work of art closely or superficially, lazily or with concentration; but this implies no distinctively aesthetic mode of perceiving. There are only varying *motives* with which we come to the objects we perceive; sometimes we wish merely to look at them and enjoy them, and at other times we wish to glean information, or do something useful with them, and so on.

Part II: The Elements of Art

Among the things in the world to which we respond aesthetically, works of art are the most important single class. Unlike sunsets and mountains and oceans, the perception of which we also enjoy, works of art are made by man. One is tempted to say that they are created specifically for the purpose of being enjoyed aesthetically, but this is probably not true in all cases: many of the acknowledged masterpieces of the world's art were created to serve God, or to reform the world, or to express the artist's feelings, or to keep the artist's body and soul together—or at any rate, to do these things *as well as* to stimulate aesthetic contemplation. Regardless of its motivation, however, no work created by man would have come to be considered great unless it had proved, throughout the ages since its creation, to be an enduring source of aesthetic contemplation to many people at many different times and places. (To be a work of art is one thing, and to be a good work of art is another. "Work of art" in no way implies "good work

of art." What makes a work of art a good one is a different topic, discussed in Parts VII and VIII.)

There are various ways of analyzing works of art, and only some of them are suggested in Part II. The concept of "aesthetic *surface*" is discussed at length in the first selection, by the late David W. Prall. Works of art contain certain sensuous elements which are usually the most easily grasped of all their ingredients: the sheen of silk, the pellucid colors of precious stones, the shimmer of violins in a symphonic suite, the hard white marble of a statue—all these are instances of what Prall calls aesthetic surface. It is an instantaneous source of appeal, and one must go beyond it to discover the work's more subtle and enduring qualities; but the pleasure one gets from it is nevertheless considerable.

Far more complex is aesthetic *form*. Form has to do with the way an object is put together—the elements in the medium considered in relation to one another. The central principle of form, hallowed by long tradition, is *unity*. A work of art must hang together; all the parts of it must be mutually coherent. If it comes apart—for example, if a play has two plots that never touch each other—we say that it lacks unity. Unity is fairly easy to achieve if there is no great complexity of detail within the work (a blank wall has unity), but when there is a great variety of elements within the work, it becomes more difficult for the artist to make all the parts hang together. When this is achieved, however, the result is called *unity in variety* (or sometimes, variety in unity), which is the traditional formulation of the supreme principle of form, or design, in a work of art. All the acknowledged masterpieces of the world's art, such as Shakespeare's *King Lear*, Michelangelo's *Last Judgment*, and Bach's *B Minor Mass*, have unity in variety to a very high degree. Other formal features of art, such as theme and variation, balance, and development, are subsidiary to this fundamental principle.

Different aestheticians have suggested different principles of aesthetic form. The selection presented here, by Stephen Pepper, is psychological in its approach. What qualities must perceptual objects have, Pepper asks, if they are not to become monotonous to us with repeated exposure? How can we walk the tightrope between monotony and constant surprise—between the constant reiteration of a central theme, to make the work hang together, and enough variation and diversity so that our attention will not flag? By posing the problem as a psychological one (beginning with his observations about "sensory fatigue" and "attentive fatigue"), which the artist has to solve in order to keep his work from boring repetitiveness on the one hand and constant innovation on the other, Pepper leads us into an interesting and fruitful analysis of the way a work of art is constructed. Other formu-

lations of the concept of form or design in art are listed in the readings
at the end of the Part.

Art can be appreciated in another "dimension" as well. Usually,
though not always, an artist is not simply presenting a series of shapes
and colors to delight the eye or sounds to delight the ear. Important
though these are, most artists also "have something to say about life"—
they try to present some features of the real world (or a more appealing
imaginary world) in an attempt to heighten and enhance our experience
in some way. A study of painting can re-orient our vision of the world
so much that many students of art have said that they did not fully
perceive the world they lived in until they studied painting (or the
other visual arts, such as sculpture and architecture). Works of litera-
ture almost always have "something to say" about life—not an explicit
message, but a portrayal of people and their thoughts and feelings
whereby we can imaginatively identify ourselves with the persons
depicted, thus gaining an insight into their characters, their problems,
their world. (This is discussed in more detail in Part VI.) Even works of
music, though their connection with human life is more controversial,
have qualities that are also qualities of human life: joy and sadness,
serenity and tension, humor and tragedy. The third reading in Part II,
by Theodore M. Greene, discusses some of the ways in which works of
art can be revelatory of aspects of the world and specifically of human
life. The next four Parts of the book also are concerned in various
ways with this same question.

Part III: Art as Form

Parts III, IV, and V each deal with a special theory of the nature
and function of art. Part III deals with the theory, advanced particu-
larly by certain critics of visual art, that art is essentially an exercise in
form. The first reading in this section, by the late British art critic
Clive Bell, presents the thesis that art is "significant form." It is not
significant of anything in life, but is simply a set of colors and shapes
on canvas, enjoyable to contemplate in themselves rather than for
anything that they may represent. Similarly, the art of music consists
of a complex series of sounds, pleasing to the ear, but without reference
to anything in the world outside art—not even to human emotions.

The second reading in this Part, by the late British art critic Roger
Fry, applies this theory in detail to certain paintings, showing us what
to look for in them. He discusses which aspects of these paintings are
(in his opinion) of aesthetic interest and which are irrelevant to
it, interesting though they may be in non-aesthetic ways, such as

portraying the drama of human life and giving us information about the time and place in which the work of art is set.

The third reading in this Part is a criticism of formalism in art. Louis Arnaud Reid does not deny the existence or the importance of formal considerations in art, but he denies their exclusive importance. He attacks the specific points made by Fry in the preceding selection. He shows why he considers the formalist way of looking at art too narrow, why in his opinion art becomes poverty-stricken when it is approached exclusively from the formalist point of view, important though that point of view may be as a corrective to looking at art solely for the things in the world (people, mountains, trees and so on) that it represents.

Part IV: Art as Expression

Another current view of art is that it is first and foremost an expression of human feeling. This is a view held by a large number, perhaps the majority, of living artists in various media (music, poetry, drama, painting, sculpture, architecture, films). But what is it that is expressed? Some say that art is self-expression—"In art, the artist is expressing himself"—which raises the question how his expression is different in art from what it is in laughing or crying, smiling or groaning. Others say that the artist is "expressing something about life" (not necessarily his own feelings) —but is this equivalent to *saying* something about life? And can a composer, for example, truly be said to be saying something in his musical compositions? There are many variations of the idea that art is expression. The first reading in this Part, by the late British aesthetician E. F. Carritt, presents the view (fundamentally that of the Italian aesthetician Benedetto Croce) that the criterion of the value of a work of art is the extent to which we recognize in it the expression of some human feeling.

John Hospers, in the second reading in this Part, criticizes the view that art is expression, by distinguishing several senses of the crucial word "express." Expression in one sense is something a person does, an activity having to do with manifesting his inner feelings in some outward form or behavior. A person may do this when he creates a work of art, just as he may do this in any other activity in which he engages. But does this tell us anything about the nature of the product thereby produced, that it is good or valuable or worth contemplating? Secondly, "express" may also be used equivalently to "evoke": in this sense, to say that the music expresses sadness is to say merely that it evokes a feeling of sadness in me, or makes me feel sad (or some variant

of this). But to say that the music evokes this response in me is not to say what the music itself is like, or indeed that it will affect anyone else in the same way. The only sense in which talk about expression has anything to do with the work of art itself is the sense in which we say, "*The music itself* expresses sadness," meaning thereby that the music *has* the quality of sadness, or, more briefly, that the music *is* sad. (In this sense, we no longer need the word "express": we need only say that the music is sad.) But what is meant by saying that the music is sad? And how can such an assertion be defended against others who might attribute to the same music a different quality? This question is discussed, and a position on it defended, in the last part of the essay.

Part V: Art as Symbol

Still another view of art is that every work of art is a symbol. One very specific and popular form of this theory alleges that a work of art is a symbol of human feeling (not an expression, but a symbol). This view has been set forth in the greatest detail in our own day by Susanne K. Langer in her book *Feeling and Form*, from which the first selection in this Part is taken. She begins with a criticism of Prall's view (Part II of this book), and goes on to present her own theory. Works of art *signify* human feelings—not in the sense in which dark clouds signify rain (that they enable us to predict that rain is coming), but in the sense that there is an *isomorphism* (similarity of structure) between the temporal progression of human feelings and the temporal progression of tones in a work of music, for example. Music "tells us how feelings go"; it is a tonal analogue of man's emotional life. Art in general is defined by Mrs. Langer as "the creation of forms symbolic of human feeling." This view is worked out in considerable detail in the first selection in this Part, and critically evaluated in the second selection, by Charles L. Stevenson.

Part VI: Art and Truth

Virtually no one has declared that the sole function of art is to tell the truth about the world; the sciences have taken over that task with too much success. Nevertheless, one cannot conclude that art and truth have nothing to do with each other. But the ways in which art and truth are related have been the subject of heated controversy ever since Aristotle, who wrote in his *Poetics* that "art gives us universal truth, whereas history gives us particular truth."

Several ways have been suggested in which art gives truth: (1) Works

of literature contain words and sentences, and some of these sentences may well express truths; indeed, they often do. In a novel or drama about Julius Caesar we may learn certain facts about the life and death of Caesar. These truths are *explicitly* stated. (2) Works of literature may also contain implied, or *implicit*, truths. Certain true statements may be the underlying thesis of such a work. For example, a novel by Thomas Hardy does not contain the explicit statement that man is but a pawn on a huge cosmic chessboard, subject to the whims of fate and chance; but if we study Hardy's characters and plots, this is the message that comes through to us. At any rate, there are many *statements* which are implicit in works of literature; not all of them, of course, are true. (3) Novels, dramas, and poems may also be *true to* human nature, in that they describe people as they are, with feelings, thoughts, and motives that people in life outside the novel really have. Nowhere in the novel is it stated that the characters in the novel resemble real people, but this may be so just the same. "Truth to" here means the same as "resemblance to," and such resemblance often exists. Though truth in these senses is most applicable to literature, it could be contended that characters in a movie or even in a painting (such as one of Rembrandt's self-portraits) are true to human nature in that they reveal some of the characteristics of real people.

Morris Weitz, in the first essay in this Part, defends the view that art can sometimes give us truth. In his essay, "Truth in Literature," he contends that many works of art give us truths (usually implicit) which were never before thought of by anyone. For example, Marcel Proust, in his monumental series *Remembrance of Things Past*, gives us a theory of human nature which is different from any that was presented before.

Douglas N. Morgan, in the second selection in this Part, does not deny that works of art can sometimes give us truth, but he denies the importance of truth to literature as art and questions the aesthetic relevance of any of the truths we may glean from art, including truth to human nature. Art may give us many things, but many of them are quite incidental. The ability to give us truth, which art does have, is an ability possessed in greater degree by the sciences and by the vast majority of statements made in daily life. As such, he concludes, it can hardly be a distinctive feature of art.

Part VII: Criteria of Criticism

Much criticism of the arts is purely *descriptive*: it tells us what goes on in the play or the painting, illuminating the work of art to us,

calling our attention to features we could have perceived had we observed carefully but which, without the critic's calling our attention to them, would usually have eluded us. Much criticism is also *interpretative*: it serves to interpret a work of art so that it "makes sense" to us as it did not before. For example, numerous essays about Shakespeare's *Hamlet* try to explain why he delayed in killing his uncle. But there is also much criticism which is *evaluative*: It tells us whether the critic considers this work of art better than another one and gives us his reasons for so thinking.

The question thus arises: What are the criteria by means of which we may evaluate a work of art? Are there any criteria which are applicable to all works of art, in all art media? Monroe Beardsley, in the first selection in this Part, defends the view that there are; he suggests that the three principal criteria of art criticism are unity, complexity, and intensity. In this selection he explains the meaning of these terms and how to apply these criteria. These are the *general* canons of criticism, applicable to all the arts in all media; but there are also *specific* canons of criticism, applicable only to works of art in a certain medium. For example, Shakespeare's poetry is often praised for richness of metaphor; yet richness of metaphor cannot be a source of excellence in all the arts, for metaphor is a feature of verbal expressions only and cannot exist in music or visual art. It is an interesting question whether the specific canons of criticism can all be made to fall under the general canons, or whether, after one has applied the general canons to a given work of art, one is left with a number of specific canons as a residue, not reducible to the general canons.

The second selection in this Part, by the late Arnold Isenberg, denies the existence of any general canons of criticism at all. There is not one general criterion—not even such a popular one as unity—of which one can say, in advance of becoming acquainted with a particular work of art, that if it is present then the work of art will be a better one. All critical reasons, according to this view, are strictly ex post facto; we first decide that a work is good or bad or better than another, and then we find reasons to support the judgment in the specific case. If a work has a high degree of unity, we use this fact in support of our judgment; but if it does not, we may value it none the less and must then cast about for other reasons for judging it favorably. According to this view, there are no general reasons in aesthetics, as there are in ethics (as when we say "If this act causes needless suffering, then it is wrong," using the fact of needless suffering as a general reason for condemning an action). There are reasons, but none is sufficiently general to apply to every work of art in every medium.

Part VIII: Aesthetic Value

The old question, What is beauty? has been recast here to read, What is aesthetic value? The word "beauty" is used too narrowly to cover all the arts; one speaks of a beautiful painting or symphony, but not usually of a beautiful drama or novel. The general question considered in this Part is, What is aesthetic value? Wherein lies the aesthetic value of a work of art—that which makes it a *good* work of art? (We mean good aesthetically, not good morally or socially or in some other way. The word "good" by itself is far too general, and one must make it clear that one is concerned with aesthetic evaluation and not some other kind.)

The *objective* theory of value is exemplified by the first selection in this Part, by T. E. Jessop. According to Jessop, aesthetic value (though he uses the narrower word "beauty") is an objective property of the things that have it, just as much as squareness and circularity, size and shape and weight. If an object has this quality, it has aesthetic value; and it has the value only to the extent that it has this quality. Unfortunately it is a simple quality—simple in the sense that it cannot be further analyzed, any more than the color green can be. One either recognizes its presence or one does not, as in the case of the greenness of the grass But this of course raises a multitude of questions: People don't usually disagree about the color of the grass, but they do disagree about the aesthetic merit of a painting or a symphony; how are such disputes to be settled? Even when people do disagree about the color of an object, tests can be applied to determine which of them is mistaken; are there any such tests in the case of the aesthetic value of a work of art? If someone wanted to learn whether an object had aesthetic value, how would one teach him? What characteristics could one point to? Or would the person have to rely on his intuition? (And how would he defend one intuition against another?) Other versions of objective theory have also been held—for example, that the aesthetic value of something is a complex quality rather than a simple one; that it is a resultant quality, a function of certain other qualities *A*, *B*, and *C* (which *can* be pointed to). Then the questions arise, What are these qualities? Are they perceivable like greenness, or are they abstract qualities like truth? Or are they "semi-perceivable" ones such as gracefulness or delicacy, which one "sees in" the painting, although such seeing seems to involve more than just using one's eyes or ears, as seeing green does.

The *subjective* theory of aesthetic value, exemplified in the second selection in this Part, by Curt J. Ducasse, denies that there is any

objective quality in a work of art in which its aesthetic value consists. Rather, the aesthetic value of an object consists in a *relation* between the object and the observer (not in the observer alone, for it is not the observer that is being said to have aesthetic value). But since one observer may have a certain relation to an object while another observer does not, there may be aesthetic value to one observer and not to another. Being aesthetically valuable is then a "to you," "to me" kind of characteristic, like being to the right or left of something—you may be to the right of an object while I am to the left of it. "Beauty," in the old phrase, "is in the eye of the beholder."

There are many versions of subjectivism, and the selection by Professor Ducasse does not ask us to choose among them. If the relation of the observer to the object is simply that of liking or enjoying, then we can only say that you like it and I do not (so it has aesthetic value to you and not to me, and there is the end of the matter). But there are more sophisticated versions of subjectivism. For example, "*X* has aesthetic value" may be taken to mean not merely that I enjoy *X*, but that most people do, or that most trained critics do, or that most people would if they were sufficiently acquainted with it, or that I would if I were sufficiently acquainted with it, and so on. Any theory of aesthetic value is subjectivistic if the value is dependent on the attitude which an observer (or all observers, or a selected set of observers) have (or would have under specified circumstances) toward the object in question.

An extension of subjectivism, yet quite distinct from it, is the third theory, the *instrumentalist* theory of value, exemplified by the third reading in this Part, by Monroe Beardsley. Stating in clear language what he takes to be the essence of John Dewey's theory of aesthetic value, he takes the aesthetic value of an object to lie in its *capacity* for producing aesthetic experience. The greater the capacity, the greater the aesthetic value. The capacity is in the object, not in the observer. But capacity is unlike other qualities of the object in that it produces a certain kind of effect in an observer who is confronted by the object. The extent of the capacity is determined only over a period of time (a single hearing of the symphony won't do) and only under circumstances in which one is aesthetically receptive (the failure of the music to move one doesn't count against it if the listener is in a state of shock or boredom or grief). But given the right stimulus conditions, the aesthetic value of an object is to be judged by its being an *instrument* for the production of aesthetic experience.

Each of the problems outlined above is far more complex than indicated here, and there are many points and arguments in the readings

that have not been touched upon in this brief introduction; the reader should now immerse himself in the selections themselves. There are also many troublesome problems in aesthetics which have not been included in this volume, such as: Is aesthetic value intrinsic value? Under what conditions may we say that a work of art exists, and when does it cease to exist? How, if at all, are the moral value and the aesthetic value of a work of art connected? Is there any general definition of art applicable to all the arts? The eight problems of aesthetics presented here have been selected because they are all important—to students of art as well as to philosophers—and have long been central in the arena of aesthetic controversy.

I

THE AESTHETIC
ATTITUDE

1. THE AESTHETIC ATTITUDE

JEROME STOLNITZ

How We Perceive the World

Aesthetic perception will be explained in terms of the aesthetic *attitude*.

It is the attitude we take which determines how we perceive the world. An attitude is a way of directing and controlling our perception. We never see or hear everything in our environment indiscriminately. Rather, we "pay attention" to some things, whereas we apprehend others only dimly or hardly at all. Thus attention is *selective*—it concentrates on some features of our surroundings and ignores others. Once we recognize this, we realize the inadequacy of the old notion that human beings are simply passive receptors for any and all external stimuli. Furthermore, what we single out for attention is dictated by the purposes we have at the time. Our actions are generally pointed toward some goal. In order to achieve its goal, the organism watches keenly to learn what in the environment will help and what will be detrimental. Obviously, when individuals have different purposes, they will perceive the world differently, one emphasizing certain things which another will ignore. The Indian scout gives close attention to markings and clues which the person who is simply strolling through the woods will pass over.

Thus an attitude or, as it is sometimes called, a "set" guides our attention in those directions relevant to our purposes. It gives direction to our behavior in still another way. It prepares us to *respond* to what we perceive, to act in a way we think will be most effective for achieving our goals. By the same token, we suppress or inhibit those responses which get in the way of our efforts. A man intent on winning a chess game readies himself to answer his opponent's moves and thinks ahead

FROM *Aesthetics and the Philosophy of Art Criticism* BY JEROME STOLNITZ, PAGES 32–42. COPYRIGHT 1960 BY HOUGHTON MIFFLIN CO. AND REPRINTED BY KIND PERMISSION OF THE PUBLISHER AND THE AUTHOR.

how best to do this. He also keeps his attention from being diverted by distractions.

Finally, to have an attitude is to be favorably or unfavorably oriented. One can welcome and rejoice in what he sees, or he can be hostile and cold toward it. The Anglophobe is a person whose attitude toward all things British is negative, so that when he meets someone with a British accent or hears "Rule Brittania," we expect him to say something disparaging or cynical. When one's attitude toward a thing is positive, he will try to sustain the object's existence and continue to perceive it; when negative, he will try to destroy it or avert his attention from it.

To sum up, an attitude organizes and directs our awareness of the world. Now the aesthetic attitude is not the attitude which people usually adopt. The attitude which we customarily take can be called the attitude of "practical" perception.

We usually see the things in our world in terms of their usefulness for promoting or hindering our purposes. If ever we put into words our ordinary attitude toward an object, it would take the form of the question, "What can I do with it, and what can it do to me?" I see the pen as something I can write with, I see the oncoming automobile as something to avoid; I do not concentrate my attention upon the object itself. Rather, it is of concern to me only so far as it can help me to achieve some future goal. Indeed, from the standpoint of fulfilling one's purposes, it would be stupid and wasteful to become absorbed in the object itself. The workman who never gets beyond looking at his tools, never gets his job done. Similarly, objects which function as "signs," such as the dinner bell or traffic light, are significant only as guides to future behavior. Thus, when our attitude is "practical," we perceive things only as means to some goal which lies beyond the experience of perceiving them.

Therefore our perception of a thing is usually limited and fragmentary. We see only those of its features which are relevant to our purposes, and as long as it is useful we pay little attention to it. Usually perception is merely a rapid and momentary identification of the kind of thing it is and its uses. Whereas the child has to learn laboriously what things are, what they are called, and what they can be used for, the adult does not. His perception has become economized by habit, so that he can recognize the thing and its usefulness almost at once. If I intend to write, I do not hesitate about picking up the pen rather than a paper clip or the cigarette lighter. It is only the pen's usefulness-for-writing-with, not its distinctive color or shape, that I care about. Is this not true of most

of our perception of the "furniture of earth"? "In actual life the normal person really only reads the labels as it were on the objects around him and troubles no further."[1]

If we stop to think about it, it is astonishing how little of the world we really *see*. We "read the labels" on things to know how to act with regard to them, but we hardly see the things themselves. As I have said, it is indispensable to getting on with the "work of the world" that we should do this. However, we should not assume that perception is always habitually "practical," as it probably is in our culture. Other societies differ from our own, in this respect.[2]

But nowhere is perception exclusively "practical." On occasion we pay attention to a thing simply for the sake of enjoying the way it looks or sounds or feels. This is the "aesthetic" attitude of perception. It is found wherever people become interested in a play or a novel or listen closely to a piece of music. It occurs even in the midst of "practical" perception, in "casual truant glances at our surroundings, when the pressing occupations of practical effort either tire us or leave us for a moment to our own devices, as when in the absorbing business of driving at forty or fifty miles an hour along a highway to get to a destination, the tourist on his holiday glances at the trees or the hills or the ocean."[3]

The Aesthetic Attitude

It will forward our discussion of the aesthetic attitude to have a definition of it. But you should remember that a definition, here or in any other study, is only a point of departure for further inquiry. Only the unwary or intellectually lazy student will rest content with the words of the definition alone, without seeing how it helps us to understand our experience and how it can be employed to carry on the study of aesthetics. With this word of caution, I will define "the aesthetic attitude" as "disinterested and sympathetic attention to and contemplation of any object of awareness whatever, for its own sake alone." Let us now take up in turn each of the ideas in this definition and see what they mean precisely. Since this will be a piecemeal analysis, the truth of the account must be found in the total analysis and not in any single part of it.

[1] Roger Fry, *Vision and Design* (New York: Brentano's, n.d.), p. 25. Reprinted by permission of Chatto and Windus Ltd.

[2] Lester D. Longman, "The Concept of Psychical Distance," *Journal of Aesthetics and Art Criticism*, VI (1947), 32.

[3] D. W. Prall, *Aesthetic Judgment* (New York: Crowell, 1929), p. 31.

The first word, "disinterested," is a crucially important one. It means that we do not look at the object out of concern for any ulterior purpose which it may serve. We are not trying to use or manipulate the object. There is no purpose governing the experience other than the purpose of just *having* the experience. Our interest comes to rest upon the object alone, so that it is not taken as a sign of some future event, like the dinner bell, or as a cue to future activity, like the traffic light.

Many sorts of "interest" are excluded from the aesthetic. One of them is the interest in owning a work of art for the sake of pride or prestige. A book collector, upon seeing an old manuscript, is often interested only in its rarity or its purchase price, not its value as a work of literature. (There are some book collectors who have never *read* the books that they own!) Another nonaesthetic interest is the "cognitive," i.e., the interest in gaining knowledge about an object. A meteorologist is concerned, not with the visual appearance of a striking cloud formation, but with the causes which led to it. Similarly, the interest which the sociologist or historian takes in a work of art, referred to in the previous chapter, is cognitive. Further, where the person who perceives the object, the "percipient,"[4] has the purpose of passing judgment upon it, his attitude is not aesthetic. This should be kept in mind, for, as we shall see later, the attitude of the art critic is significantly different from the aesthetic attitude.

We may say of all these nonaesthetic interests, and of "practical" perception generally, that the object is apprehended with an eye to its origins and consequences, its interrelations with other things. By contrast, the aesthetic attitude "isolates" the object and focuses upon it—the "look" of the rocks, the sound of the ocean, the colors in the painting. Hence the object is not seen in a fragmentary or passing manner, as it is in "practical" perception, e.g., in using a pen for writing. Its whole nature and character are dwelt upon. One who buys a painting merely to cover a stain on the wall paper does not see the painting as a delightful pattern of colors and forms.

For the aesthetic attitude, things are not to be classified or studied or judged. They are in themselves pleasant or exciting to look at. It should, then, be clear that being "disinterested" is very far from being "*un*-interested." Rather, as all of us know, we can become intensely absorbed in a book or a moving picture, so that we become much more "interested" than we usually are in the course of our "practical" activity.

[4] This is a clumsy and largely outmoded word, but it is more convenient for our purposes than words of more limited meaning such as "spectator," "observer," "listener," and is accordingly used here and elsewhere in the text.

The word "sympathetic" in the definition of "aesthetic attitude" refers to the way in which we prepare ourselves to respond to the object. When we apprehend an object aesthetically, we do so in order to relish its individual quality, whether the object be charming, stirring, vivid, or all of these. If we are to appreciate it, we must accept the object "on its own terms." We must make ourselves receptive to the object and "set" ourselves to accept whatever it may offer to perception. We must therefore inhibit any responses which are "un-sympathetic" to the object, which alienate us from it or are hostile to it. A devout Mohammedan may not be able to bring himself to look for very long at a painting of the Holy Family, because of his animus against the Christian religion. Closer to home, any of us might reject a novel because it seems to conflict with our moral beliefs or our "way of thinking." When we do so, we should be clear as to what we are doing. We have *not* read the book aesthetically, for we have interposed moral or other responses of our own which are alien to it. This disrupts the aesthetic attitude. We cannot then say that the novel is *aesthetically* bad, for we have not permitted ourselves to consider it aesthetically. To maintain the aesthetic attitude, we must follow the lead of the object and respond in concert with it.

This is not always easy, for all of us have deep-seated values as well as prejudices. They may be ethical or religious, or they may involve some bias against the artist or even against his native country. (During the First World War, many American symphony orchestras refused to play the works of German composers.) The problem is especially acute in the case of contemporary works of art, which may treat of disputes and loyalties in which we are deeply engaged. When they do so, we might remind ourselves that works of art often lose their topical significance with the passing of time and then come to be esteemed as great works of art by later generations. Milton's sonnet "On the Late Massacre in Piedmont" is a ringing protest called forth by an event which occurred shortly before the writing of the poem. But the heated questions of religion and politics which enter into it seem very remote to us now. People sometimes remonstrate with a friend who seems to reject offhand works of art of which they are fond, "You don't even give it a chance." To be "sympathetic" in aesthetic experience means to give the object the "chance" to show how it can be interesting to perception.

We come now to the word "attention" in our definition of "aesthetic attitude." As has been pointed out, any attitude whatever directs attention to certain features of the world. But the element of attention must be especially underscored in speaking of aesthetic perception.

For, as a former teacher of mine used to say, aesthetic perception is frequently thought to be a "blank, cow-like stare." It is easy to fall into this mistake when we find aesthetic perception described as "just looking," without any activity or practical interest. From this it is inferred that we simply expose ourselves to the work of art and permit it to inundate us in waves of sound or color.

But this is surely a distortion of the facts of experience. When we listen to a rhythmically exciting piece of music which absorbs us with its energy and movement, or when we read a novel which creates great suspense, we give our earnest attention to it to the exclusion of almost everything else in our surroundings. To be "sitting on the edge of the chair" is anything but passive. In taking the aesthetic attitude, we want to make the value of the object come fully alive in our experience. Therefore we focus our attention upon the object and "key up" our capacities of imagination and emotion to respond to it. As a psychologist says of the aesthetic experience, "Appreciation . . . is awareness, alertness, animation."[5] Attention is always a matter of *degree*, and in different instances of aesthetic perception, attention is more or less intense. A color, briefly seen, or a little melody, may be apprehended on the "fringe" of consciousness, whereas a drama will absorb us wholly. But to whatever extent it does so, experience is aesthetic only when an object "holds" our attention.

Furthermore, aesthetic attention is accompanied by activity. This is not the activity of practical experience, which seeks an ulterior goal. Rather it is activity which is either evoked by disinterested perception of the object, or else is required for it. The former includes all muscular, nervous, and "motor" responses such as feelings of tension or rhythmic movement. Contrary to what some snobs would have us believe, there is nothing inherently unaesthetic about tapping one's foot in time to the music. The theory of *empathy* points out that we "feel into" the object our muscular and bodily adjustments. We brace ourselves and our muscles become taut in the face of a sculptured figure which is tall, vigorous, and upright.[6] This does not occur in aesthetic experience alone, and it does not occur in all aesthetic experience, but when it does, it exemplifies the kind of activity which may be aroused in aesthetic perception. The direction of attention itself may not improperly be called "activity." But even overt bodily movement and effort may be required for aesthetic perception. We usually have to walk round all

[5] Kate Hevner, "The Aesthetic Experience: A Psychological Description," *Psychological Review*, 44 (1937), 249.

[6] Cf. Herbert S. Langfeld, *The Aesthetic Attitude* (New York: Harcourt, Brace, 1920), chaps. V–VI; Vernon Lee, "Empathy," in Melvin Rader, ed., *A Modern Book of Esthetics*, rev. ed. (New York: Holt, 1952), pp. 460–65.

sides of a sculpture, or through a cathedral, before we can appreciate it. We would often reach out and touch sculptured figures if only museum guards would permit us to do so.

But focusing upon the object and "acting" in regard to it, is not all that is meant by aesthetic "attention." To savor fully the distinctive value of the object, we must be attentive to its frequently complex and subtle details. Acute awareness of these details is *discrimination*. People often miss a good deal in the experience of art, not only because their attention lapses, but because they fail to "see" all that is of significance in the work. Indeed, their attention frequently lapses for just this reason. They miss the individuality of the work, so that one symphony sounds like any other piece of "long-hair" music, and one lyric poem is indistinguishable from another, and all are equally boring. If you have had the good fortune to study literature with an able teacher, you know how a play or novel can become vital and engaging when you learn to look for details to which you were previously insensitive. But awareness of this kind is not always easily come by. It often requires knowledge about allusions or symbols which occur in the work, repeated experience of the work, and even, sometimes, technical training in the art-form.

As we develop discriminating attention, the work comes alive to us. If we can keep in mind the chief themes in the movement of a symphony, see how they are developed and altered in the course of the movement, and appreciate how they are played off against each other, then there is a great gain in our experience. The experience has greater richness and unity. Without such discrimination it is thin, for the listener responds only to scattered passages or to a patch of striking orchestral color. And it is disorganized, for he is not aware of the structure which binds the work together. His experience may be said to be intermittently and to a limited degree aesthetic, but it is not nearly as rewarding as it might be. Everybody knows how easy it is to start thinking of other things while the music is playing, so that we are really aware of it only now and again. All the more reason, then, why we should develop the capacities for appreciating its richness and profundity. Only so can we keep our experience from becoming, in Santayana's famous phrase "a drowsy revery relieved by nervous thrills."[7]

If you now understand how aesthetic attention is alert and vigorous, then it is safe to use a word which has often been applied to aesthetic experience—"contemplation." Otherwise, there is the great danger that this word will suggest an aloof, unexcited gaze which, we have seen, is untrue to the facts of aesthetic experience. Actually, "contemplation" does not so much add something new to our definition as it sums up

[7] George Santayana, *Reason in Art* (New York: Scribner's, 1946), p. 51.

ideas which we have already discussed. It means that perception is directed to the object in its own right and that the spectator is not concerned to analyze it or to ask questions about it. Also, the word connotes thoroughgoing absorption and interest, as when we speak of being "lost in contemplation." Most things are hardly noticed by us, whereas the object of aesthetic perception stands out from its environment and rivets our interest.

The aesthetic attitude can be adopted toward "any object of awareness whatever." This phrase need not, strictly speaking, be included in our definition. We could understand the aesthetic attitude as the kind of perceptual attention we have been talking about, without adding that "any object whatever" may be its object. But definitions are flexible to an extent. We can choose to include in them even what is not strictly necessary to identify the term being defined. The great and even limitless scope of aesthetic experience is one of the most interesting and important things about it.

The definition permits us to say that any object at all can be apprehended aesthetically, i.e., no object is inherently unaesthetic. But it might be thought odd, or even downright wrong, to say this. There are some objects which are conspicuously attractive, so that they "catch our eye" and draw attention to themselves—a bed of bright and many-colored flowers or a marching song, massive cloud formations, or a noble and stately cathedral. Certainly the same is not true of many, indeed most, other things in the world. Are we to say that a dirty, run-down slum section is to be called "aesthetic"? What about dull, unexciting things like supplies stacked row upon row in a warehouse or, if you please, the telephone directory? Indeed, the word "aesthetic" is often used in everyday speech to distinguish these objects which are delightful to look upon or listen to, from those which are not. As was pointed out at the beginning of this chapter, this is also the view of a good deal of traditional aesthetic theory.

This argument—that some objects do not qualify as "aesthetic"—certainly sounds plausible and convincing. I think that the best way to argue against it is to present evidence that human beings have contemplated disinterestedly objects which are enormously diverse. Among such objects are some which we might consider wholly uninviting. As was mentioned earlier, men have found perceptual enjoyment in things which people of earlier times or other cultures judged to be unaesthetic. The whole "history of taste" shows how the boundaries of aesthetic experience have been pushed back and have come to include a tremendous variety of things.

The best evidence of this broadening of vision is to be found in the arts. For here we have permanent records of the objects which have aroused aesthetic interest. It can also be found, however, in the appreciation of nature. The subjects chosen from nature for treatment by artists show the expansion of perceptual interest. "Social historians" can often trace changes in the appreciation of nature in other ways, e.g., memoirs and diaries, sites chosen for resort places, and so on. But let us for the moment speak solely of art. If we confine ourselves to the art of the last 150 years, we find an enormous amount of art devoted to the two sorts of objects which "common sense" considers intrinsically unaesthetic, viz., dull, commonplace objects and ugly or grotesque things and events. The poet Wordsworth, at the beginning of the nineteenth century, devoted much of his poetry to "humble and rustic life." One of van Gogh's paintings of a perfectly prosaic yellow chair . . . , another is of the rude furniture in his bedroom.[8] In our own day, the painter Ben Shahn has chosen as the subject of one of his works city boys playing handball . . . Instances of the depiction of ugly and macabre themes in recent art are even more obvious. The student may be able to think of some himself. I will cite Géricault's "The Raft of the *Medusa*" . . . , the harrowing treatment of a tortured and pathetic figure in Berg's opera *Wozzeck*, and such "realistic" literature as Gorki's *Lower Depths* and Farrell's *Studs Lonigan*.

To be sure, the artist apprehends such subjects with imagination and feeling. And when they emerge in the work of art, he has invested them with vividness and excitement. However, the very fact that his attention has been directed to these subjects shows how far-ranging aesthetic interest can be. Further, his use of them alters and expands the taste of the nonartist. The ordinary man now becomes newly sensitive to the perceptual interest of many different objects and events. Thus appreciation of the grandeur of mountain ranges, which is a relatively recent chapter in the history of taste, was stimulated by such works of art as Haller's poem *Die Alpen*. Less lofty objects and even scenes which are ugly become the objects of aesthetic attention. Here is the testimony of one who is not an artist:

[The] ugliest thing in nature that I can think of at the moment is a certain street of shabby houses where a street-market is held. If one passes through it, as I sometimes do, early on a Sunday morning, one finds it littered with straw, dirty paper and the other refuse of a market. My normal attitude is one of aversion. I wish to hold myself away from the scene. . . . But I sometimes find that . . . the scene suddenly gets jerked away from *me* and

[8] The works here cited to illustrate the argument . . . are readily accessible, and should be consulted by the student or made available to him by the instructor.

on to the aesthetic plane, so that I can survey it quite impersonally. When this happens, it does seem to me that what I am apprehending looks different; it has a form and coherence which it lacked before, and details are more clearly seen. But . . . it does not seem to me to have ceased to be ugly and to have become beautiful. I can see the ugly aesthetically, but I cannot see it as beautiful.[9]

The student can probably think of things in his own experience—a face, a building, a landscape—which, though not conventionally "pretty" or "attractive," arouse aesthetic interest. Evidence of this kind cannot establish that *all* objects can be aesthetic objects. When such evidence is multiplied, however, it makes this assumption a reasonable one at the outset of aesthetic inquiry.

In keeping with this assumption, the word "awareness" is used in our definition of "aesthetic attitude." I have been using the word "perception" to describe aesthetic apprehension, but its meaning is too narrow. It refers to apprehension of sense-data, e.g., colors or sounds, which are interpreted or "judged" to be of a certain kind. Perception differs from sensation as the experience of an adult differs from that of the newborn infant, for whom the world is a succession of mysterious and unrelated sensory "explosions." In adult experience, we rarely apprehend sense-data without knowing something about them and interrelating them, so that they become meaningful. We see more than a color patch; we see a flag or a warning signal. Perception is the most usual sort of "awareness." But if sensation occurs, it too can be aesthetic.[10]

There is another kind of "awareness" that occurs, though relatively infrequently, in adult experience. This is "intellectual," nonsensuous knowledge of "concepts" and "meanings" and their interrelations: such knowing takes place in abstract thinking, such as logic and mathematics. Even if images or "pictures" accompany such thinking, they are only secondary. When the mathematician thinks of the properties of triangles, his thought is not restricted to any particular triangle he may "see in his head" or draw on paper. A man who develops a system of mathematical logic is occupied with logical relationships which are neither sensed nor perceived. Now this kind of apprehension can also be aesthetic. If one's purpose is not, for the moment, problem solving, if he pauses to contemplate disinterestedly the logical structure before him, then his experience is aesthetic. Such experience has been attested to by many mathematicians, and it is evidenced by the use of such words as

[9] E. M. Bartlett, *Types of Aesthetic Judgment* (London: George Allen & Unwin, 1937), pp. 211–12. Italics in original. Reprinted by permission of George Allen & Unwin Ltd.
[10] Cf. below, pp. 61–62.

"elegance" and "grace," borrowed from the realm of the aesthetic, to describe a conceptual system. The poetess Edna St. Vincent Millay says, in a line that has become famous, "Euclid alone has looked on Beauty bare." The great Greek geometrician discerned mathematical properties and relations which had no sensuous "dress" of sound or color.

To take account of such experience as well as sensation, I have used the broad term "awareness" rather than "perception". Anything at all, whether sensed or perceived, whether it is the product of imagination or conceptual thought, can become the object of aesthetic attention.

This completes the analysis of the meaning of "aesthetic attitude," the central concept in our study. "Aesthetic," understood to mean "disinterested and sympathetic attention," marks out the field of our further investigation. All the concepts to be discussed later are defined by reference to this: "aesthetic experience" is the total experience had while this attitude is being taken; "aesthetic object" is the object toward which this attitude is adopted; "aesthetic value" is the value of this experience or of its object. It is therefore imperative that the student understand and think about the meaning of "aesthetic," before going on to further discussions.

2. THE MYTH OF THE
AESTHETIC ATTITUDE

GEORGE DICKIE

Some recent articles[1] have suggested the unsatisfactoriness of the notion of the aesthetic attitude and it is now time for a fresh look at that encrusted article of faith. This conception has been valuable to aesthetics and criticism in helping wean them from a sole concern with beauty and related notions.[2] However, I shall argue that the aesthetic attitude is a myth and while, as G. Ryle has said, "Myths often do a lot of theoretical good while they are still new,"[3] this particular one is no longer useful and in fact misleads aesthetic theory.

There is a range of theories which differ according to how strongly the aesthetic attitude is characterized. This variation is reflected in the language the theories employ. The strongest variety is Edward Bullough's theory of psychical distance, recently defended by Sheila Dawson.[4] The central technical term of this theory is "distance" used as a verb to denote an action which either constitutes or is necessary for the aesthetic attitude. These theorists use such sentences as "He distanced (or failed to distance) the play." The second variety is widely held but has been defended most vigorously in recent years by Jerome Stolnitz and Eliseo Vivas. The *central* technical term of this variety is "disinterested"[5] used either as an adverb or as an adjective. This

[1] See Marshall Cohen, "Appearance and the Aesthetic Attitude," *Journal of Philosophy*, vol. 56 (1959), p. 926; and Joseph Margolis, "Aesthetic Perception," *Journal of Aesthetics and Art Criticism*, vol. 19 (1960), p. 211. Margolis gives an argument, but it is so compact as to be at best only suggestive.

[2] Jerome Stolnitz, "Some Questions Concerning Aesthetic Perception," *Philosophy and Phenomenological Research*, vol. 22 (1961), p. 69.

[3] *The Concept of Mind* (London, 1949), p. 23.

[4] " 'Distancing' as an Aesthetic Principle," *Australasian Journal of Philosophy*, vol. 39 (1961), pp. 155–74.

[5] "Disinterested" is Stolnitz' term. Vivas uses "intransitive."

PUBLISHED AS AN ARTICLE IN THE *American Philosophical Quarterly*, VOL. I NO. I (JANUARY 1964). REPRINTED BY KIND PERMISSION OF THE AUTHOR AND THE EDITOR.

weaker theory speaks not of a special kind of action (distancing) but
of an ordinary kind of action (attending) done in a certain way (dis-
interestedly). These first two versions are perhaps not as different as my
classification suggests. However, the language of the two is different
enough to justify separate discussions. My discussion of this second
variety will for the most part make use of Jerome Stolnitz' book[6] which
is a thorough, consistent, and large-scale version of the attitude theory.
The weakest version of the attitude theory can be found in Vincent
Tomas' statement "If looking at a picture and attending closely to how
it looks is not really to be in the aesthetic attitude, then what on earth
is?"[7] In the following I shall be concerned with the notion of *aesthetic*
attitude and this notion may have little or no connection with the
ordinary notion of an *attitude*.

I

Psychical distance, according to Bullough, is a psychological process
by virtue of which a person *puts* some object (be it a painting, a play, or
a dangerous fog at sea) "out of gear" with the practical interests of the
self. Miss Dawson maintains that it is "the beauty of the phenomenon,
which captures our attention, puts us out of gear with practical life,
and forces us, if we are receptive, to view it on the level of aesthetic
consciousness."[8]

Later she maintains that some persons (critics, actors, members of
an orchestra, and the like) "distance deliberately."[9] Miss Dawson,
following Bullough, discusses cases in which people are unable to bring
off an act of distancing or are incapable of being induced into a state of
being distanced. She uses Bullough's example of the jealous ("under-
distanced") husband at a performance of *Othello* who is unable to keep
his attention on the play because he keeps thinking of his own wife's
suspicious behavior. On the other hand, if "we are mainly concerned
with the technical details of its [the play's] presentation, then we are
said to be over-distanced."[10] There is, then, a species of action—
distancing—which may be deliberately done and which initiates a
state of consciousness—being distanced.

[6] *Aesthetics and Philosophy of Art Criticism* (Boston, 1960), p. 510.

[7] "Aesthetic Vision," *The Philosophical Review*, vol. 68 (1959), p. 63. I shall ignore Tomas'
attempt to distinguish between appearance and reality since it seems to confuse rather than
clarify aesthetic theory. See F. Sibley, "Aesthetics and the Looks of Things," *Journal of
Philosophy*, vol. 56 (1959), pp. 905–15; M. Cohen, op. cit., pp. 915–26; and J. Stolnitz,
"Some Questions Concerning Aesthetic Perception," op. cit., pp. 69–87. Tomas discusses
only visual art and the aesthetic attitude, but his remarks could be generalized into a com-
prehensive theory.

[8] Dawson, op. cit., p. 158. [9] Ibid., pp. 159–60. [10] Ibid, p. 159.

The question is: Are there actions denoted by "to distance" or states of consciousness denoted by "being distanced"? When the curtain goes up, when we walk up to a painting, or when we look at a sunset are we ever induced into a state of being distanced either by being struck by the beauty of the object or by pulling off an act of distancing? I do not recall committing any such special actions or of being induced into any special state, and I have no reason to suspect that I am atypical in this respect. The distance-theorist may perhaps ask, "But are you not usually oblivious to noises and sights other than those of the play or to the marks on the wall around the painting?" The answer is of course—"Yes." But if "to distance" and "being distanced" simply mean that one's attention is focused, what is the point of introducing new technical terms and speaking as if these terms refer to special kinds of acts and states of consciousness? The distance-theorist might argue further, "But surely you put the play (painting, sunset) 'out of gear' with your practical interests?" This question seems to me to be a very odd way of asking (by employing the technical metaphor "out of gear") if I attended to the play rather than thought about my wife or wondered how they managed to move the scenery about. Why not ask me straight out if I paid attention? Thus, when Miss Dawson says that the jealous husband under-distanced *Othello* and that the person with a consuming interest in techniques of stagecraft over-distanced the play, these are just technical and misleading ways of describing two different cases of inattention. In both cases something is being attended to, but in neither case is it the action of the play. To introduce the technical terms "distance," "under-distance," and "over-distance" does nothing but send us chasing after phantom acts and states of consciousness.

Miss Dawson's commitment to the theory of distance (as a kind of mental insulation material necessary for a work of art if it is to be enjoyed aesthetically) leads her to draw a conclusion so curious as to throw suspicion on the theory.

One remembers the horrible loss of distance in *Peter Pan*—the moment when Peter says "Do you believe in fairies? . . . If you believe, clap your hands!" the moment when most children would like to slink out of the theatre and not a few cry—not because Tinkerbell may die, but because the magic is gone. What, after all, should we feel like if Lear were to leave Cordelia, come to the front of the stage and say, "All the grown-ups who think that she loves me, shout 'Yes'."[11]

It is hard to believe that the responses of any children could be as theory-bound as those Miss Dawson describes. In fact, Peter Pan's

[11] Ibid., p. 168.

request for applause is a dramatic high point to which children respond enthusiastically. The playwright gives the children a momentary chance to become actors in the play. The children do not at that moment lose or snap out of a state of being distanced because they never had or were in any such thing to begin with. The comparison of Peter Pan's appeal to the hypothetical one by Lear is pointless. *Peter Pan* is a magical play in which almost anything can happen, but *King Lear* is a play of a different kind. There are, by the way, many plays in which an actor directly addresses the audience (*Our Town*, *The Marriage Broker*, *A Taste of Honey*, for example) without causing the play to be less valuable. Such plays are unusual, but what is unusual is not necessarily bad; there is no point in trying to lay down rules to which every play must conform independently of the kind of play it is.

It is perhaps worth noting that Susanne Langer reports the reaction she had as a child to this scene in *Peter Pan*.[12] As she remembers it, Peter Pan's appeal shattered the illusion and caused her acute misery. However, she reports that all the other children clapped and laughed and enjoyed themselves.

II

The second way of conceiving of the aesthetic attitude—as the ordinary action of attending done in a certain way (disinterestedly)—is illustrated by the work of Jerome Stolnitz and Eliseo Vivas. Stolnitz defines "aesthetic attitude" as "disinterested and sympathetic attention to and contemplation of any object of awareness whatever, for its own sake alone."[13] Stolnitz defines the main terms of his definition: "disinterested" means "no concern for any ulterior purpose";[14] "sympathetic" means "accept the object on its own terms to appreciate it";[15] and "contemplation" means "perception directed toward the object in its own right and the spectator is not concerned to analyze it or ask questions about it."[16]

The notion of disinterestedness, which Stolnitz has elsewhere shown[17] to be seminal for modern aesthetic theory, is the key term here. Thus, it is necessary to be clear about the nature of disinterested attention to the various arts. It can make sense to speak, for example, of listening disinterestedly to music only if it makes sense to speak of listening

[12] *Feeling and Form* (New York, 1953), p. 318.
[13] Aesthetics and Philosophy of Art Criticism, pp. 34-35.
[14] Ibid., p. 35. [15] Ibid., p. 36. [16] Ibid., p. 38.
[17] "On the Origins of 'Aesthetic Disinterestedness'," *The Journal of Aesthetics and Art Criticism*, vol. 20 (1961), pp. 131-143.

interestedly to music. It would make no sense to speak of walking *fast* unless walking could be done *slowly*. Using Stolnitz' definition of "disinterestedness," the two situations would have to be described as "listening with no ulterior purpose" (disinterestedly) and "listening with an ulterior purpose" (interestedly). Note that what initially appears to be a perceptual distinction—listening in a certain way (interestedly or disinterestedly)—turns out to be a motivational or an intentional distinction—listening for or with a certain purpose. Suppose Jones listens to a piece of music for the purpose of being able to analyze and describe it on an examination the next day and Smith listens to the same music with no such ulterior purpose. There is certainly a difference between the motives and intentions of the two men: Jones has an ulterior purpose and Smith does not, but this does not mean Jones's *listening* differs from Smith's. It is possible that both men enjoy the music or that both be bored. The attention of either or both may flag and so on. It is important to note that a person's motive or intention is different from his action (Jones's listening to the music, for example). There is only one way to *listen* to (to attend to) music, although the listening may be more or less attentive and there may be a variety of motives, intentions, and reasons for doing so and a variety of ways of being distracted from the music.

In order to avoid a common mistake of aestheticians—drawing a conclusion about one kind of art and assuming it holds for all the arts— the question of disinterested attention must be considered for arts other than music. How would one look at a painting disinterestedly or interestedly? An example of alleged interested viewing might be the case in which a painting reminds Jones of his grandfather and Jones proceeds to muse about or to regale a companion with tales of his grandfather's pioneer exploits. Such incidents would be characterized by attitude-theorists as examples of using a work of art as a vehicle for associations and so on, i.e., cases of interested attention. But Jones is not looking at (attending to) the painting at all, although he may be facing it with his eyes open. Jones is now musing or attending to the story he is telling, although he had to look at the painting at first to notice that it resembled his grandfather. Jones is not now looking at the painting interestedly, since he is not now looking at (attending to) the painting. Jones's thinking or telling a story about his grandfather is no more a part of the painting than his speculating about the artist's intentions is and, hence, his musing, telling, speculating, and so on cannot properly be described as attending to the painting interestedly. What attitude-aestheticians are calling attention to is the occurrence of irrelevant associations which distract the viewer from the painting or

whatever. But distraction is not a special kind of attention, it is a kind ⟵ of inattention.

Consider now disinterestedness and plays. I shall make use of some interesting examples offered by J. O. Urmson,[18] but I am not claiming that Urmson is an attitude-theorist. Urmson never speaks in his article of aesthetic attitude but rather of aesthetic satisfaction. In addition to aesthetic satisfaction, Urmson mentions economic, moral, personal, and intellectual satisfactions. I think the attitude-theorist would consider these last four kinds of satisfaction as "ulterior purposes" and, hence, cases of interested attention. Urmson considers the case of a man in the audience of a play who is delighted.[19] It is discovered that his delight is *solely* the result of the fact that there is a full house—the man is the impresario of the production. Urmson is right in calling *this* impresario's satisfaction economic rather than aesthetic, although there is a certain oddness about the example as it finds the impresario sitting *in the audience*. However, my concern is not with Urmson's examples as such but with the attitude theory. This impresario is certainly an interested party in the fullest sense of the word, but is his behavior an instance of interested attention as distinct from the supposed disinterested attention of the average citizen who sits beside him? In the situation as described by Urmson it would not make any sense to say that the impresario is attending to the play at all, since his *sole* concern at the moment is the till. If he can be said to be attending to anything (rather than just thinking about it) it is the size of the house. I do not mean to suggest that an impresario could not attend to his play if he found himself taking up a seat in a full house; I am challenging the sense of disinterested attention. As an example of personal satisfaction Urmson mentions the spectator whose daughter is in the play. Intellectual satisfaction involves the solution of technical problems of plays and moral satisfaction the consideration of the effects of the play on the viewer's conduct. All three of these candidates which the attitude-theorist would propose as cases of interested attention turn out to be just different ways of being distracted from the play and, hence, not cases of interested attention to the play. Of course, there is no reason to think that in any of these cases the distraction or inattention must be total, although it could be. In fact, such inattentions often occur but are so fleeting that nothing of the play, music, or whatever is missed or lost.

The example of a playwright watching a rehearsal or an out-of-town

[18] "What Makes a Situation Aesthetic?" in *Philosophy Looks at the Arts*, Joseph Margolis (ed.), (New York, 1962). Reprinted from *Proceedings of the Aristotelian Society, Supplementary Volume* 31 (1957), pp. 75–92. [19] Ibid., p. 15.

performance with a view to rewriting the script has been suggested to me as a case in which a spectator is certainly attending to the play (unlike our impresario) and attending in an interested manner. This case is unlike those just discussed but is similar to the earlier case of Jones (not Smith) listening to a particular piece of music. Our playwright—like Jones, who was to be examined on the music—has ulterior motives. Furthermore, the playwright, unlike an ordinary spectator, can change the script after the performance or during a rehearsal. But how is our playwright's *attention* (as distinguished from his motives and intentions) different from that of an ordinary viewer? The playwright might enjoy or be bored by the performance as any spectator might be. The playwright's attention might even flag. In short, the kinds of things which may happen to the playwright's attention are no different from those that may happen to an ordinary spectator, although the two may have quite different motives and intentions.

For the discussion of disinterested-interested reading of literature it is appropriate to turn to the arguments of Eliseo Vivas whose work is largely concerned with literature. Vivas remarks that "By approaching a poem in a nonaesthetic mode it may function as history, as social criticism, as diagnostic evidence of the author's neuroses, and in an indefinite number of other ways."[20] Vivas further notes that according to Plato "the Greeks used Homer as an authority on war and almost anything under the sun," and that a certain poem "can be read as erotic poetry or as an account of a mystical experience."[21] The difference between reading a poem *as* history or whatever (reading it nonaesthetically) and reading it aesthetically depends on how *we* approach or read it. A poem "does not come self-labelled,"[22] but presumably is a poem only when it is read in a certain way—when it is an object of aesthetic experience. For Vivas, being an aesthetic object means being the object of the aesthetic attitude. He defines the aesthetic experience as "an experience of rapt attention which involves the intransitive apprehension of an object's immanent meanings and values in their full presentational immediacy."[23] Vivas maintains that his definition "helps me understand better what I can and what I cannot do when I read *The Brothers* [*Karamazov*]" and his definition "forces us to acknowledge that *The Brothers Karamazov* can hardly be read as art. . . ."[24] This acknowledgment means that we probably cannot intransitively apprehend *The Brothers* because of its size and complexity.

"Intransitive" is the key term here and Vivas' meaning must be

[20] "Contextualism Reconsidered," *The Journal of Aesthetics and Art Criticism*, vol. 18 (1959), pp. 224–25. [21] Ibid., p. 225. [22] Loc. cit.
[23] Ibid., p. 227. [24] Ibid., p. 237.

made clear. A number of passages reveal his meaning but perhaps the following is the best. "Having once seen a hockey game in slow motion, I am prepared to testify that it was an object of pure intransitive experience [attention]—for I was not *interested* in which team won the game and no external factors mingled with my interest in the beautiful rhythmic flow of the slow-moving men."[25] It appears that Vivas' "intrinsic attention" has the same meaning as Stolnitz' "disinterested attention," namely, "attending with no ulterior purpose."[26] Thus, the question to ask is "How does one attend to (read) a poem or any literary work transitively?" One can certainly attend to (read) a poem for a variety of different purposes and because of a variety of different reasons, but can one attend to a poem transitively? I do not think so, but let us consider the examples Vivas offers. He mentions "a type of reader" who uses a poem or parts of a poem as a spring-board for "loose, uncontrolled, relaxed day-dreaming, wool-gathering rambles, free from the contextual control" of the poem.[27] But surely it would be wrong to say such musing is a case of transitively attending to a poem, since it is clearly a case of not attending to a poem. Another supposed way of attending to a poem transitively is by approaching it "as diagnostic evidence of the author's neuroses." Vivas is right if he means that there is no critical point in doing this since it does not throw light on the poem. But this is a case of *using* information gleaned from a poem to make inferences about its author rather than attending to a poem. If anything can be said to be attended to here it is the author's neuroses (at least they are being thought about). This kind of case is perhaps best thought of as a rather special way of getting distracted from a poem. Of course, such "biographical" distractions might be insignificant and momentary enough so as scarcely to distract attention from the poem (a flash of insight or understanding about the poet). On the other hand, such distractions may turn into dissertations and whole careers. Such an interest may lead a reader to concentrate his attention (when he does read a poem) on certain "informational" aspects of a poem and to ignore the remaining aspects. As deplorable as such a sustained practice may be, it is at best a case of attending to certain features of a poem and ignoring others.

Another way that poetry may allegedly be read transitively is by reading it as history. This case is different from the two preceding ones

[25] Ibid., p. 228. (Italics mine.)

[26] Vivas' remark about the improbability of being able to read *The Brothers Karamazov* as art suggests that "intransitive attention" may sometimes mean for him "that which can be attended to at one time" or "that which can be held before the mind at one time." However, this second possible meaning is not one which is relevant here.

[27] Vivas, op. cit., p. 231.

since poetry often *contains* history (makes historical statements or at least references) but does not (usually) contain statements about the author's neuroses and so on nor does it contain statements about what a reader's free associations are about (otherwise we would not call them "*free associations*"). Reading a poem as history suggests that we are attending to (thinking about) historical events by way of attending to a poem—the poem is a time-telescope. Consider the following two sets of lines:

> In fourteen hundred and ninety-two
> Columbus sailed the ocean blue.

> Or like stout Cortez when with eagle eyes
> He star'd at the Pacific—and all his men
> Look'd at each other with a wild surmise—
> Silent, upon a peak in Darien.

Someone might read both of these raptly and not know that they make historical references (inaccurately in one case)—might this be a case of intransitive attention? How would the above reading differ—so far as attention is concerned—from the case of a reader who recognized the historical content of the poetic lines? The two readings do not differ as far as attention is concerned. History is a part of these sets of poetic lines and the two readings differ in that the first fails to take account of an aspect of the poetic lines (its historical content) and the second does not fail to do so. Perhaps by "reading as history" Vivas means "reading *simply* as history." But even this meaning does not mark out a special kind of attention but rather means that only a single aspect of a poem is being noticed and that its rhyme, meter, and so on are ignored. Reading a poem as social criticism can be analyzed in a fashion similar to reading as history. Some poems simply are or contain social criticism, and a complete reading must not fail to notice this fact.

The above cases of alleged interested attending can be sorted out in the following way. Jones listening to the music and our playwright watching the rehearsal are both attending with ulterior motives to a work of art, but there is no reason to suppose that the attention of either is different in kind from that of an ordinary spectator. The reader who reads a poem as history is simply attending to an aspect of a poem. On the other hand, the remaining cases—Jones beside the painting telling of his grandfather, the gloating impresario, daydreaming while "reading" a poem, and so on—are simply cases of not attending to the work of art.

In general, I conclude that "disinterestedness" or "intransitiveness" cannot properly be used to refer to a special kind of attention. "Disinterestedness" is a term which is used to make clear that an action has

certain kinds of motives. Hence, we speak of disinterested findings (of boards of inquiry), disinterested verdicts (of judges and juries), and so on. Attending to an object, of course, has its motives but the attending itself is not interested or disinterested according to whether its motives are of the kind which motivate interested or disinterested action (as findings and verdicts might), although the attending may be more or less close.

I have argued that the second way of conceiving the aesthetic attitude is also a myth, or at least that its main content—disinterested attention—is; but I must now try to establish that the view misleads aesthetic theory. I shall argue that the attitude-theorist is incorrect about (1) the way in which he wishes to set the limits of aesthetic relevance; (2) the relation of the critic to a work of art; and (3) the relation of morality to aesthetic value.

Since I shall make use of the treatment of aesthetic relevance in Jerome Stolnitz' book, let me make clear that I am not necessarily denying the relevance of the specific items he cites but disagreeing with his criterion of relevance. His criterion of relevance is derived from his definition of "aesthetic attitude" and is set forth at the very beginning of his book. This procedure leads Monroe Beardsley in his review of the book to remark that Stolnitz' discussion is premature.[28] Beardsley suggests "that relevance cannot be satisfactorily discussed until after a careful treatment of the several arts, their dimensions and capacities."[29]

First, what is meant by "aesthetic relevance"? Stolnitz defines the problem by asking the question: "Is it ever 'relevant' to the aesthetic experience to have thoughts or images or bits of knowledge which are not present within the object itself?"[30] Stolnitz begins by summarizing Bullough's experiment and discussion of single colors and associations.[31] Some associations absorb the spectator's attention and distract him from the color and some associations "fuse" with the color. Associations of the latter kind are aesthetic and the former are not. Stolnitz draws the following conclusion about associations:

If the aesthetic experience is as we have described it, then whether an association is aesthetic depends on whether it is compatible with the attitude of "disinterested attention." If the association re-enforces the focusing of attention upon the object, by "fusing" with the object and thereby giving it added "life and significance," it is genuinely aesthetic. If, however, it arrogates attention to itself and away from the object, it undermines the aesthetic attitude.[32]

[28] *The Journal of Philosophy*, vol. 57 (1960), p. 624. [29] Loc. cit.
[30] Op. cit., p. 53. [31] Ibid., p. 54. [32] Ibid., pp. 54–55.

It is not clear how something could *fuse* with a single color, but "fusion" is one of those words in aesthetics which is rarely defined. Stolnitz then makes use of a more fruitful example, one from I. A. Richards' *Practical Criticism*.[33] He cites the responses of students to the poem which begins:

> Between the erect and solemn trees
> I will go down upon my knees;
> I shall not find this day
> So meet a place to pray.

The image of a rugby forward running arose in the mind of one student-reader on reading the third verse of this poem. A cathedral was suggested to a second reader of the poem. The cathedral image "is congruous with both the verbal meaning of the poem and the emotions and mood which it expresses. It does not divert attention away from the poem."[34] The rugby image is presumably incongruous and diverts attention from the poem.

It is a confusion to take compatibility with disinterested attention as a criterion of relevance. If, as I have tried to show, *disinterested attention* is a confused notion, then it will not do as a satisfactory criterion. Also, when Stolnitz comes to show why the cathedral image is, and the rugby image is not relevant, the criterion he actually uses is *congruousness with the meaning of the poem*, which is quite independent of the notion of disinterestedness. The problem is perhaps best described as the problem of relevance to a poem, or more generally, to a work of art, rather than aesthetic relevance.

A second way in which the attitude theory misleads aesthetics is its contention that a critic's relationship to a work of art is different in kind from the relationship of other persons to the work. H. S. Langfeld in an early statement of this view wrote that we may "slip from the attitude of aesthetic enjoyment to the attitude of the critic." He characterizes the critical attitude as "intellectually occupied in coldly estimating . . . merits" and the aesthetic attitude as responding "emotionally to" a work of art.[35] At the beginning of his book in the discussion of the aesthetic attitude, Stolnitz declares that if a percipient of a work of art "has the purpose of passing judgment upon it, his attitude is not aesthetic."[36] He develops this line at a later stage of his book, arguing that appreciation (perceiving with the aesthetic attitude) and criticism (seeking for reasons to support an evaluation of a work) are (1) distinct and (2) "psychologically opposed to each other."[37] The critical attitude is questioning, analytical, probing for strengths and weakness, and so

[33] Ibid., pp. 55–56. [34] Ibid., p. 56.
[35] *The Aesthetic Attitude* (New York, 1920), p. 79. [36] Op. cit., p. 35.
[37] Ibid., p. 377.

on. The aesthetic attitude is just the opposite: "It commits our allegiance to the object freely and unquestioningly"; "the spectator 'surrenders' himself to the work of art."[38] "Just because the two attitudes are inimical, whenever criticism obtrudes, it reduces aesthetic interest."[39] Stolnitz does not, of course, argue that criticism is unimportant for appreciation. He maintains criticism plays an important and necessary role in preparing a person to appreciate the nuances, detail, form, and so on of works of art. We are quite right, he says, thus to read and listen perceptively and acutely, but he questions, "Does this mean that we must analyze, measure in terms of value-criteria, etc., *during* the supposedly aesthetic experience?"[40] His answer is "No" and he maintains that criticism must occur "*prior* to the aesthetic encounter,"[41] or it will interfere with appreciation.

How does Stolnitz know that criticism will always interfere with appreciation? His conclusion sounds like one based upon the observations of actual cases, but I do not think it is. I believe it is a logical consequence of his definition of aesthetic attitude in terms of disinterested attention (no ulterior purpose). According to his view, to appreciate an object aesthetically one has to perceive it with no ulterior purpose. But the critic has an ulterior purpose—to analyze and evaluate the object he perceives—hence, in so far as a person functions as a critic he cannot function as an appreciator. But here, as previously, Stolnitz confuses a perceptual distinction with a motivational one. If it were ← possible to *attend* disinterestedly or interestedly, then perhaps the critic (as percipient) would differ from other percipients. But if my earlier argument about attending is correct, the critic differs from other percipients only in his motives and intentions and not in the way in which he attends to a work of art.

Of course, it might just be a fact that the search for reasons is incompatible with the appreciation of art, but I do not think it is. Several years ago I participated in a series of panel discussions of films. During the showing of each film we were to discuss, I had to take note of various aspects of the film (actor's performance, dramatic development, organization of the screen-plane and screen-space at given moments, and so on) in order later to discuss the films. I believe that this practice not only helped educate me to appreciate subsequent films but that it enhanced the appreciation of the films I was analyzing. I noticed and was able to appreciate things about the films I was watching which ordinarily out of laziness I would not have noticed. I see no reason why the same should not be the case with the professional critic

[38] Ibid., pp. 377–78. [39] Ibid., p. 379. [40] Ibid., p. 380.
[41] Loc. cit.

or any critical percipient. If many professional critics seem to appreciate so few works, it is not because they are critics, but perhaps because the percentage of good works of art is fairly small and they suffer from a kind of combat fatigue.

I am unable to see any significant difference between "perceptively and acutely" attending to a work of art (which Stolnitz holds enhances appreciation) and searching for reasons, so far as the experience of a work of art is concerned. If I attend perceptively and acutely, I will have certain standards and/or paradigms in mind (not necessarily consciously) and will be keenly aware of the elements and relations in the work and will evaluate them to some degree. Stolnitz writes as if criticism takes place and then is over and done with, but the search for and finding of reasons (noticing this fits in with that, and so on) is continuous in practiced appreciators. A practiced viewer does not even have to be looking for a reason, he may just notice a line or an area in a painting, for example, and the line or area becomes a reason why he thinks the painting better or worse. A person may be a critic (not necessarily a good one) without meaning to be or without even realizing it.

There is one final line worth pursuing. Stolnitz' remarks suggest that one reason he thinks criticism and appreciation incompatible is that they compete with one another for time (this would be especially bad in the cases of performed works). But seeking and finding reasons (criticism) does not compete for time with appreciation. First, to seek for a reason means to be ready and able to notice something and to be thus ready and able as one attends does not compete for time with the attending. In fact, I should suppose that seeking for reasons would tend to focus attention more securely on the work of art. Second, finding a reason is an achievement, like winning a race. (It takes time to run a race but not to win it.) Consider the finding of the following reasons. How much time does it take to "see" that a note is off key (or on key)? How long does it take to notice that an actor mispronounces a word (or does it right)? How much time does it take to realize that a character's action does not fit his already established personality? (One is struck by it.) How long does it take to apprehend that a happy ending is out of place? It does not take time to find any of these reasons or reasons in general. Finding a reason is like coming to understand—it is done in a flash. I do not mean to suggest that one cannot be mistaken in finding a reason. What may appear to be a fault or a merit (a found reason) in the middle of a performance (or during one look at a painting and so forth) may turn out to be just the opposite when seen from the perspective of the whole performance (or other looks at the painting).

A third way in which the attitude theory misleads aesthetic theory is its contention that aesthetic value is always independent of morality. This view is perhaps not peculiar to the attitude theory, but it is a logical consequence of the attitude approach. Two quotations from attitude-theorists will establish the drift of their view of morality and aesthetic value.

We are either concerned with the beauty of the object or with some other value of the same. Just as soon, for example, as ethical considerations occur to our mind, our attitude shifts.[42]

Any of us might reject a novel because it seems to conflict with our moral beliefs . . . When we do so . . . We have *not* read the book aesthetically, for we have interposed moral . . . responses of our own which are alien to it. This disrupts the aesthetic attitude. We cannot then say that the novel is *aesthetically* bad, for we have not permitted ourselves to consider it aesthetically. To maintain the aesthetic attitude, we must follow the lead of the object and respond in concert with it.[43]

This conception of the aesthetic attitude functions to hold the moral aspects and the *aesthetic* aspects of the work of art firmly apart. Presumably, although it is difficult to see one's way clearly here, the moral aspects of a work of art cannot be an object of aesthetic attention because aesthetic attention is by definition disinterested and the moral aspects are somehow practical (interested). I suspect that there are a number of confusions involved in the assumption of the incompatibility of aesthetic attention and the moral aspects of art, but I shall not attempt to make these clear, since the root of the assumption—disinterested attention—is a confused notion. Some way other than in terms of the aesthetic attitude, then, is needed to discuss the relation of morality and aesthetic value.

David Pole in a recent article[44] has argued that the moral vision which a work of art may embody is *aesthetically* significant. It should perhaps be remarked at this point that not all works of art embody a moral vision and perhaps some kinds of art (music, for example) cannot embody a moral vision, but certainly some novels, some poems, and some films and plays do. I assume it is unnecessary to show how novels and so on have this moral aspect. Pole notes the curious fact that while so many critics approach works of art in "overtly moralistic terms," it is a "philosophical commonplace . . . that the ethical and the aesthetic modes . . . form different categories."[45] I suspect that many philosophers would simply say that these critics are confused

[42] H. S. Langfeld, op. cit., p. 73. [43] J. Stolnitz, op. cit., p. 36.
[44] "Morality and the Assessment of Literature," *Philosophy*, vol. 37 (1962), pp. 193–207.
[45] Ibid., p. 193.

about their roles. But Pole assumes that philosophical theory "should take notice of practice"[46] and surely he is right. In agreeing with Pole's assumption I should like to reserve the right to argue in specific cases that a critic may be misguided. This right is especially necessary in a field such as aesthetics because the language and practice of critics is so often burdened with ancient theory. Perhaps *all* moralistic criticism is wrong but philosophers should not rule it out of order at the very beginning by use of a definition.

Pole thinks that the moral vision presented by a particular work of art will be either true or false (perhaps a mixture of true and false might occur). If a work has a false moral vision, then something "is lacking within the work itself. But to say that is to say that the [work] is internally incoherent; some particular aspect must jar with what—on the strength of the rest—we claim a right to demand. And here the moral fault that we have found will count as an aesthetic fault too."[47] Pole is trying to show that the assessment of the moral vision of a work of art is just a special case of coherence or incoherence, and since everyone would agree that coherence is an aesthetic category, the assessment of the moral vision is an aesthetic assessment.

I think Pole's conclusion is correct but take exception to some of his arguments. First, I am uncertain whether it is proper to speak of a moral vision being true or false, and would want to make a more modest claim—that a moral vision can be judged to be acceptable or unacceptable. (I am not claiming Pole is wrong and my claim is not inconsistent with his.) Second, I do not see that a false (or unacceptable) moral vision makes a work incoherent. I should suppose that to say a work is coherent or incoherent is to speak about how its parts fit together and this involves no reference to something outside the work as the work's truth or falsity does.

In any event, it seems to me that a faulty moral vision can be shown to be an aesthetic fault independently of Pole's consideration of truth and coherence. As Pole's argument implies, a work's moral vision is a *part* of the work. Thus, any statement—descriptive or evaluative—about the work's moral vision is a statement about the *work*; and any statement about a *work* is a critical statement and, hence, falls within the aesthetic domain. To judge a moral vision to be morally unacceptable is to judge it defective and this amounts to saying that the work of art has a defective part. (Of course, a judgment of the acceptability of a moral vision may be wrong, as a judgment of an action sometimes is, but this fallibility does not make any difference.) Thus, a work's moral vision may be an aesthetic merit or defect just as a work's degree of unity

[46] Loc. cit. [47] Ibid., p. 206.

is a merit or defect. But what justifies saying that a moral vision is a part of a work of art? Perhaps "part" is not quite the right word but it serves to make the point clear enough. A novel's moral vision is an essential part of the novel and if it were removed (I am not sure how such surgery could be carried out) the novel would be greatly changed. Anyway, a novel's moral vision is not like its covers or binding. However, someone might still argue that even though a work's moral vision is defective and the moral vision is part of the work, that this defect is not an *aesthetic* defect. How is "aesthetic" being used here? It is being used to segregate certain aspects or parts of works of art such as formal and stylistic aspects from such aspects as a work's moral vision. But it seems to me that the separation is only nominal. "Aesthetic" has been selected as a name for a certain sub-set of characteristics of works of art. I certainly cannot object to such a stipulation, since an underlying aim of this essay is to suggest the vacuousness of the term "aesthetic." My concern at this point is simply to insist that a work's moral vision is a part of the work and that, therefore, a critic can legitimately describe and evaluate it. I would *call* any defect or merit which a critic can legitimately point out an aesthetic defect or merit, but what we call it does not matter.

It would, of course, be a mistake to judge a work solely on the basis of its moral vision (it is only one part). The fact that some critics have judged works of art in this way is perhaps as much responsible as the theory of aesthetic attitude for the attempts to separate morality from the aesthetic. In fact, such criticism is no doubt at least partly responsible for the rise of the notion of the aesthetic attitude.

If the foregoing arguments are correct, the second way of conceiving the aesthetic attitude misleads aesthetic theory in at least three ways.

III

In answer to a hypothetical question about what is seen in viewing a portrait with the aesthetic attitude, Tomas in part responds "If looking at a picture and attending closely to how it looks is not really to be in the aesthetic attitude, then what on earth is?"[48] I shall take this sentence as formulating the weakest version of the aesthetic attitude. (I am ignoring Tomas' distinction between appearance and reality. See footnote 7. My remarks, thus, are not a critique of Tomas' argument; I am simply using one of his sentences.) First, this sentence speaks only of "looking at a picture," but "listening to a piece of music," "watching and listening to a play," and so on could be added easily

[48] Tomas, op. cit., p. 63.

enough. After thus expanding the sentence, it can be contracted into the general form: "Being in the aesthetic attitude is attending closely to a work of art (or a natural object)."

But the aesthetic attitude ("the hallmark of modern aesthetics") in this formulation is a great letdown—it no longer seems to say anything significant. Nevertheless, this does seem to be all that is left after the aesthetic attitude has been purged of *distancing* and *disinterestedness*. The only thing which prevents the aesthetic attitude from collapsing into simple attention is the qualification *closely*. One may, I suppose, attend to a work of art more or less closely, but this fact does not seem to signify anything very important. When "being in the aesthetic attitude" is equated with "attending (closely)," the equation neither involves any mythical element nor could it possibly mislead aesthetic theory. But if the definition has no vices, it seems to have no virtues either. When the aesthetic attitude finally turns out to be simply attending (closely), the final version should perhaps not be called "the weakest" but rather "the vacuous version" of the aesthetic attitude.

Stolnitz is no doubt historically correct that the notion of the aesthetic attitude has played an important role in the freeing of aesthetic theory from an overweening concern with beauty. It is easy to see how the slogan, "Anything can become an object of the aesthetic attitude," could help accomplish this liberation. It is worth noting, however, that the same goal could have been (and perhaps to some extent was) realized by simply noting that works of art are often ugly or contain ugliness, or have features which are difficult to include within beauty. No doubt, in more recent times people have been encouraged *to take an aesthetic attitude toward a painting* as a way of lowering their prejudices, say, against abstract and non-objective art. So if the notion of aesthetic attitude has turned out to have no theoretical value for aesthetics, it has had practical value for the appreciation of art in a way similar to that of Clive Bell's suspect notion of significant form.

Selected Readings on Part I: The Aesthetic Attitude

Aldrich, Virgil C. "Back to Aesthetic Experience." *Journal of Aesthetics and Art Criticism*, XXIV (Spring 1966), 365–72.

———. *The Philosophy of Art*. Englewood Cliffs: Prentice-Hall, 1963. Chapter 1.

Buermeyer, Laurence. *The Aesthetic Experience*. Merion, Pa.: Barnes Foundation Press, 1924.

Bullough, Edward. "Psychical Distance as a Factor in Art and an Aesthetic Principle." *British Journal of Psychology*, V (1912–13), 87–118. Reprinted in *Aesthetics: Lectures and Essays* by Edward Bullough. London: Bowes & Bowes, 1957.

Dewey, John. *Art as Experience*. New York: Minton, Balch, 1934; Putnam (Capricorn), 1958. Especially Chapter 3.

Ducasse, Curt J. *The Philosophy of Art*. New York: Dial, 1929. Chapters 9–12.

Kant, Immanuel. *Critique of Judgment*. Translated by J. H. Bernard. London: Macmillan, 2nd edition, 1914, pp. 45–100.

Langfeld, Herbert S. *The Aesthetic Attitude*. New York: Harcourt, 1920.

Margolis, Joseph. *The Language of Art and Art Criticism*. Detroit: Wayne, 1965. Part One.

Mauron, Charles. *Aesthetics and Psychology*. London: Hogarth Press, 1935.

Mead, Hunter. *Aesthetics*. New York: Ronald, 1952. Chapters 2, 3, and 4.

Nahm, Milton. *Aesthetic Experience and Its Presuppositions*. New York: Harper, 1946.

Pepper, Stephen C. *Aesthetic Quality*. New York: Scribner, 1937.

Reid, Louis Arnaud. *A Study in Aesthetics*. London: Macmillan, 1931. Chapter 1.

Tomas, Vincent. "Aesthetic Vision." *Philosophical Review*, 68 (1959).

Vivas, Eliseo. "A Definition of the Aesthetic Experience." *Journal of Philosophy*, XXXIV (1937), 628–34.

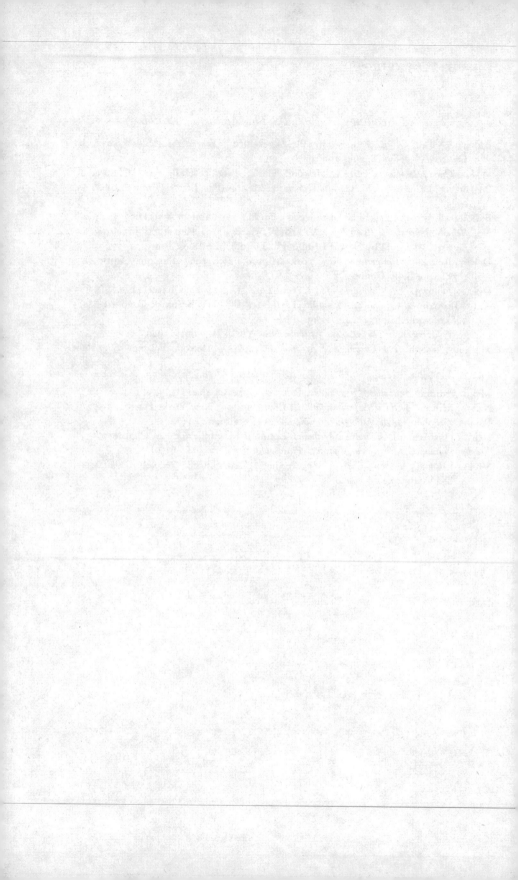

II

THE ELEMENTS
OF ART

3. AESTHETIC SURFACE

DAVID W. PRALL

I

Discriminating perception focused upon an object as it appears directly to sense, without ulterior interest to direct that perception inward to an understanding of the actual forces or underlying structure giving rise to this appearance, or forward to the purposes to which the object may be turned or the events its presence and movement may presage, or outward to its relations in the general structure and the moving flux—such free attentive activity may fairly be said to mark the situation in which beauty is felt. It is the occurrence of such activity that makes possible the records put down in what we have called aesthetic judgments. Only the red that has really caught our attention fully, and upon which the attention has actually rested, is more than merely red—bright or glaring or hard or stirring, or lovely and rich and glowing, or fresh and clear and happy, or harsh or muddy or dull or distressing, ugly or beautiful in any one of a thousand determinate and specific meanings of those words.

But though these variations are indefinitely great in number, they are after all limited, as appearing upon the aesthetic surface of our world, by the limitations of the variations in that surface itself. There is a limited range of hues to see, a limited range of sounds to hear, and even a limit to the dimensions of shapes perceived or imagined. Not that the number of possible variations in color, for example, is the number of the possible beauties of color, for the beauty of color is not simply its specific hue or shade or tint or intensity or saturation, but that specific color as upon an object, and not merely as distinguished there by vision, or noted in passing or for further reference as the color it appears to be, but also as appreciated, as felt to be delightful or the reverse to the perceiving subject. And this is plainly indicated, this relational char-

CHAPTER 5 OF *Aesthetic Judgment* BY D. W. PRALL (PP. 57–75). COPYRIGHT 1929 BY THOMAS Y. CROWELL CO. AND REPRINTED WITH THEIR KIND PERMISSION.

acter of the situation in which the beauty of sense elements is present, a relation involving feeling, in the long list of typical words used in describing such elements.

As we pass from the perceptually discriminated quality, taken as sensed, to the intuited beauty immediately felt, we pass from terms like bright and clear and red, to warmly red, pleasantly bright, charmingly clear, or to attractive or lovely or fascinating. As the aesthetic nature of the judgment is more and more unambiguously expressive of beauty as against ugliness, the terms used to describe it more and more definitely assert the relation to the perceiving subject which is attracted or interested or fascinated by it, or who finds it lovely as he loves it. Not that all qualities are not found in a relation to a subject who finds them, but that strictly aesthetic qualities involve not merely this finding, but such quality as is found, such quality as is perhaps only constituted at all, when the feelings of the subject are involved in its relation to the object. But the range of possibilities for delightful or ugly color, for example, bears some relation to the range of possible variations intrinsic to color as perceived; and if we are to know what we mean when we assert that colors are beautiful or ugly, we should know first a little about color itself.

So of the other elements of sensuous content; so of all the materials of aesthetic experience, sounds and shapes, textures and lines, and as it would also seem, so of tastes and smells and various recognizable kinds of bodily feelings which have distinctive character of their own. But if aesthetic character is properly limited to the object of attention, which takes on as directly apparent to sense its own specific beauty, felt in intuition but felt as a quality of itself, it is clear enough that fully appreciable beauty must be that of objects upon which this beauty actually shines as their own nature when we perceive them. Now we do perceive fruits, for example, as clearly upon the palate as upon the retina, although as the rationalists would say, not so distinctly; clearly, in that the taste is present as what it seems to be, indistinctly, in that what it seems to be, what it appears as, is not in its own essential nature rationally transparent, self-explanatory, native to mind as understandable by intellect. We are using the distinction within a field where historical rationalism did not make it, but the distinction itself, as we do make it, is exactly parallel, and worth putting into these old terms to show how troublesome, though in the end fruitless, this kind of distinction has been for all thinking. In our example, the exquisite aroma and taste of rich, ripe strawberries, marked by the palate and the organs of smell, are qualities exactly parallel in perception to their visual qualities, their specific form and color and texture as discrimin-

ated by the eye. And there is no doubt either that strawberries or foaming milk, or cabbages, for that matter, have clearly characteristic savour. But these sense qualities, subtle and specific and characteristic and objective as they are, seem to lack just the possibility of giving such fully satisfying aesthetic experience as is given by colors and shapes and sounds.

It is not that they are unworthy because they are so close to our bodies. The palate is no more internal than the ear, and the taste of strawberries is no more a function of the human body than their color or their shape. It would be a very determined esoteric theorist indeed who should deny that the fragrance of roses or gardens or orchards or perfumes was not merely no part of their visual beauty but no part of their beauty at all, even as its richness. And it is not their intimate connection with our vital bodily processes and motions that makes tastes less characteristically aesthetic than sounds or colors or shapes. Part of the appreciation of form itself, as in jars or vases, is without question incipient motions or motor tendencies in our own bodies, and the beauty of the morning is in part the freshness of our vital functioning as well as of our perceptive faculties. We cannot rule out the specific character of tastes and of bodily feelings and of smells from the materials of genuine aesthetic experience on any clear ground. Certainly the fact that we usually consume what we taste but not what we see or hear does not furnish such a ground; for we do not need to consume and absorb it in order to taste it, though, as with tobacco or incense, we sometimes appreciate its savour best by passing the smoke of its destruction intimately over the organs by which we apprehend it. Such distillations of beauty are common enough even with roses or lavender, with the resin of pines or the oil of bays. It is only accident, then, that bodily consumption is the means to the full aesthetic flavor of objects, and this without any relation, either, to biological needs or interests. Appetite is not hunger, of course, and even appetite need not precede enjoyment except as a tendency or possibility or natural disposition of the human body and its organs, scarcely different on principle from the disposition of the eyes to see or the ears to hear. Moreover, we could be nourished by our food perfectly well, though our senses were anaesthetized. And in any case the perception of tastes or odors is never as such the devouring of them. We devour the substance not the quality. And the smell of boiled cabbage, as of blooming roses, is a distinctly discriminated and easily remembered quality, eternally a quality to delight in or be offended by, were all the cabbages in the world consumed, and all the roses dead forever.

Nor does the transitoriness of smells and tastes in their occurrence

rule them out as materials of aesthetic pleasure. Nothing is more transitory than sound. And what is more transitory than beautiful expressions upon human faces, or than beautiful young human bodies themselves?

But the fact remains that we do not say of the taste of even the most subtly blended salad or the most delicately flavored ice that it is beautiful. Hence it is clear that smells and tastes and vital feelings are not the materials of beauty in the sense that colors are, or sounds or forms, or even textures, for they are obviously not the contents of typical aesthetic judgments. If they are not to be ruled out on grounds of their nearness to the body, or their destruction by consumption, which is contemporaneous with and sometimes necessary to the very act of perception, or because of their transitoriness of occurrence, or because they are associated in our minds with fulfilling biological needs, or because of any lack of objectivity or specificity of quality, we must find some other ground for the obvious fact that though they occur in delighted perception, though attention may be focused on them, as specific qualities directly apprehended in sense experience, they are not usually pronounced beautiful, do not become the content of aesthetic judgments, and thus apparently are not the characteristic materials of the aesthetic experience that such judgments record.

Now this ground is not far to seek, and when we stop to notice just what it is, it will offer us three points of clarification for general aesthetic theory. In the first place, smells and odors are unquestionably and emphatically sensuously delightful, and so far are elements of aesthetic experience, however elementary. In the second place much of the beauty of nature is made up of just such elementary sensuous materials, which also enter into complex natural beauties just as truly as other elementary materials, more commonly called beautiful. But in the third place, smells and odors do not in themselves fall into any known or felt natural order or arrangement, nor are their variations defined in and by such an intrinsic natural structure, as the variations in color and sound and shape give rise to in our minds. Hence our grasp of them, while it is aesthetic very clearly, since they may be felt as delightful, is the grasp in each case upon just the specific presented non-structural quality, which is as absolutely different, unique, simple, and unrelatable to further elements intrinsically through its own being, as anything could be. One smell does not suggest another related smell close to it in some objective and necessary order of quality or occurrence or procedure, nor does one taste so follow another. There are apparently more or less compatible and incompatible smells and tastes, but there is no clearly defined order of smells and tastes, or any structure of smells and

tastes in which each has its place fixed by its own qualitative being. Our experience of these elements is always of elements properly so-called, but also aesthetically elementary, of course.

Tastes may be subtly blended, and so may odors. Cooks and perfumers are in their way refined and sensitive artists, as tea-tasters and wine-tasters are expert critical judges. But such art and such criticism have no intelligible, or at least so far discovered, structural or critical principles, simply because the elements they work with have neither intelligible structure nor apparently any discoverable order in variation. It is this lack that rules them out of the characteristically aesthetic realm, not any lack of spatial distance from the body, nor of objectivity in themselves as specific characterized elements; nor is it their admitted occurrence in the consumption of the objects of which they are qualities. Their extremely transitory occurrence only marks them as not suitable elements for aesthetic structures that are to remain long before us. They do have a degree of distance after all, as great, if measured from our minds, as the distance of any sense quality; and is it the mind or the mind-body, not the body as such to which they are present at all. They have complete and well-defined objective native character, clearly discriminable specific natures, often even very subtle and refined and exciting. If they are more fleeting in their occurrence than some other beauties, they are no more fleeting than the colors of sunset, nor than many beautiful forms, and they are just as readily reproducible or more so. No beauty is more than a little lasting, for whatever occurs at all, to present us with any quality, also by its very nature passes away.

But relations objectively clear in given orders and a defining structure of variation, tastes and odors and bodily feelings do not have, and it is for this reason that we call them not merely the bare materials of beauty —colors and sounds and shapes are also only materials of beauty— but elementary aesthetic materials. For they remain merely elements, refusing to become for us, in any kind of intelligible human arts, within relational structures or movements or processes, that is, such composed and complex and elaborated beauties as we build up out of shapes and colors and lines and sounds.

Before we turn to these latter it is important to repeat with emphasis the fact that, while taste and smell are not the aesthetic senses *par excellence*, they are capable of aesthetic experience merely by virtue of being senses at all. For like all sense presentations, smells and tastes can be pleasant to perception, can be dwelt on in contemplation, have specific and interesting character, recognizable and rememberable and objective. They offer an object, that is, for sustained discriminating attention, and in general they fulfill the conditions necessary for

aesthetic experience recorded in aesthetic judgments. While they remain only elements in such experience, like bodily feelings, and offer no intrinsic structure or formal relations in variation or combination by which they might become the materials of conscious arts of smell and taste, they are still beauties, the elementary materials of certain limited aesthetic experiences.

They do also enter into higher, that is, less elementary, aesthetic experiences, if not of all the arts at least of some representative art, and without forcing themselves upon attention they help compose beauties definitely expressive, the recognized elements of which are forms and colors and sounds. Organ tones depend without question, for even their strictly aesthetic effect, at least in part on the feelings not due to hearing and ears, but stirred by quite other bodily processes. The beauty of flowers is enriched by fragrance, the beauty of Catholic ceremonials by the odor of incense. Thus while they are only elementary aesthetic qualities, they are in exactly the same sense as sound and shapes the materials of beauty and even of complex structural beauty. While they themselves are but elements, they are materials of more than elementary beauties. So far science and art have discovered in them no order or structural principles by which to compose with them, so that they remain either separately appreciated bare elements, or, if they go to make up beauties apprehended in the main by other senses, they enter as hidden or unconsciously employed constituents, with no apparently necessary relations to or in the structures of such non-elementary, that is composed or complex beauty.

Since tastes and smells and vital feelings reveal no principles of ordered variation, it is obvious that the compositions, into which they do as a matter of fact enter are cases of natural or representative beauty; for the beauties of art as such, being forms created by man on some principle or other, however vaguely known or crudely followed, require such objectively established relations. Human composing is doing something with elementary materials that are capable of being composed, and elements cannot be put together at all unless in themselves and by their very nature they are capable of sustaining structural relations to one another, relations of contrast, balance, rhythmic sequence, form in general. These relations must be at least dimly discerned by any artist if he is to use the materials of beauty at all. But there is no such system of smells and tastes, and what relations and contrasts we do notice in such matters seem fairly arbitrary and accidental: apples with pork perhaps, and perhaps not sour wine with sweets; certain blendings of tea and of spices, certain combinations toned into each other with sugar, or toned in general with garlic; but

no structure, or any very clear general principles, though the whole matter is in all probability not so formless and accidental as it may seem, as current psychology is beginning to discover. One is indeed tempted to look for articulate principles here as elsewhere, if only to dignify to obstinately verbal minds whole realms of expert activity which seem to them too natural and domestic to be important and interesting, and too illiterate, it may be thought, to have any full moral status in the society of the arts.

What we are to point out here is that natural beauty in general is so largely of just this unprincipled sort, whether in its rank, unchaste profusion, or in its natural but unintelligible selection and composition. Nature at some places, at least, and at various times, without men's efforts, assumes lovely aspects, unintelligibly composed and unreasonably fine. In fact much of what men, artists particularly, know of color combination has been learned out not of any knowledge or perception of the orders and structures that color and line and shapes inherently possess by being color and line and shape, but from the purely accidental and familiar success of such combinations as nature has exhibited to them, in rocks under sunlight, birds and flowers against trees and sky, hills beyond running streams, metals or jewels against human flesh, and the thousand other happy accidents of natural beauty. If we do not know enough of perfumes or colors or sounds to compose with all of them at once, this is not to say that all these may not in nature go to make up rare beauty, not that nature may not with impunity paint the lily with its own fragrance and add as integral elements in natural beauties the aesthetic materials of the despised senses of smell and taste.

If there is a beauty of August nights, or beauty in the rareness of a June day, or the fresh loveliness after rain, if there is ripe and languorous beauty in the mist and mellow fruitfulness of autumn, or a hard, cold beauty of glittering winter frosts, such beauty is not all for the eye and ear, and if we do not ourselves know how to blend smells and tastes with sound and form and color to compose such beauties, we need not foist our limitations upon nature. The saltiness of the breeze is as integral to the beauty of the sea as the flashing of the fish or the sweep of the gulls or the thunder of the surf or the boiling of the foam. If we know no modes of arranging smells or tastes or vital feelings or even noises in works of art, nature does not hesitate to combine the soughing of pines, the fragrance of mountain air, and the taste of mountain water or its coolness on the skin, with dazzling mountain sunlight and the forms and colors of rocks and forests, to make a beauty intense and thrilling in an unexpected purity and elevation, almost ascetic in its very complexity and richness. The greatest beauties of nature are con-

crete and full. Nature appears to have no aesthetic prejudices against any sort of elementary aesthetic materials, nor to lack insight into the principles of their combination in the greatest variety. Only human limitations may miss some of these elements and human insight fail to recognize any principles of structure or form to hold them so firmly together and make them often so transcendently beautiful.

But what happens in nature is not, of course, art, and an artist must work with materials that have relations, degrees of qualitative difference, established orders of variation, structural principles of combination. While we must be careful to include in the materials of beauty sense elements of all sorts, since all the senses, by virtue of being senses, may take such pleasure in their specific objects as is in all rigor to be called aesthetic pleasure, we must admit that these elements of smell and taste remain mere elements, except where natural occurrences happen to combine them, and through familiarity sometimes to sanctify the combination to men and to art, on no principles intelligible or available to human beings, but as some of the richest of natural or of representative beauties. As aesthetic materials they remain for us elementary in the simple sense of being elements, specifically aesthetic in quality, but still merely elements, not amenable to composition through intrinsically established orders.

2

For less elementary aesthetic experience the materials are sound and shapes and color and lines. The simple distinction that marks these materials is that they present objective structural orders intrinsic to their qualitative variation, through which we have control over them to build them into the complex formal beauties characteristic of the human arts and no longer the beauties of elements alone or of merely accidental natural combinations. If nature loves tastes and smells and vital feelings as well as she does colors and sounds and shapes, we may be ready enough to appreciate the beauty both of her materials and of her compositions; but in our own human compositions we are limited to such materials as order and arrange themselves by their own intrinsic nature. And to know even a little of humanly made beauties or even of natural ones involving these intrinsically ordered elements, we must know their order and their formal variation, and learn from this the possibilities they furnish, not for mere fortuitous, if often felicitous, combinations, but for composition in which the principles of such order and form have been consciously employed or at least intuitively discerned.

The essential nature of these orders or structural principles, which are

intrinsic to the materials as such, which lie embedded in the very nature of color or sound or shape and line, varies of course with the varying materials, since it is just the defining nature of the material that is its falling into that sort of order that it has, that unique kind of relation that establishes the place of any one given determinate color or sound or shape in the range of colors or sounds, or the structural possibilities of lines and shapes and masses. It is clear that what is peculiar to color, for example, is not any quality that sounds can have; what is peculiar to sound is impossible to color; and spatial form as such is simply spatial, not colored or resonant. Thus no intrinsic order or structure of colors can be the order intrinsic to sounds or shapes, much less to smells or tastes or muscular imagery.

There are also, of course, orders common to several materials. Clearly enough, sounds occur and in occurring involve temporal sequence; and if they occur in throats, they involve the feelings of muscular coordinations and activities besides. Clearly enough, also, colors are found in shapes, along lines, and in general in spatial order. What we must look for here is that peculiar order in color which is not temporal, and for that order in shapes that is uniquely spatial. Time orders we shall find common to the occurrence of any color, any sound, any shape, and so, available for composing with them and making structures out of them, but not intrinsic to them and their nature in the sense in which the order of hue is intrinsic to color, the order of pitch intrinsic to sound, and geometrical structure intrinsic to line and shape.

While all this directs us to these intrinsic orders as fundamental, it indicates clearly enough that still more fundamental factor in all aesthetic experience, a factor in all occurrence and therefore in all experience of form or color or sound, in all the experience to be had in an existing—that is, temporally occurring—world. This most funda-mental fact of order and arrangement is of course rhythm, and rhythm, as we shall see, is applicable to composition with *any* materials what-ever. But that which rhythmically occurs is in itself aesthetic material, and, though sound embodies it more obviously than line or shape—for even space is temporal in all motion—shapes, too, may be rhythmical, though not unless their spatial nature defines them as what moves rhythmically or progresses in a pattern. Rhythm is all-pervasive in its application, since all there is in the world moves to its own peculiar measure, rocks and trees as well as waves of sand or of ocean, of drum-beats or dances or songs, or laboring bodies or machines themselves. But only perceptible rhythm is aesthetic, and for perception motion on too great or too small a scale is rest.

To complicate matters even here, however, perception and feeling, occurring as they do in time, have their own rates, and these may intro-

duce rhythm into movements or spatial structure where it would not otherwise be felt. But it will be easier to grasp both the nature and the significance of this possibly all-pervasive and absolutely—even meta-physically, perhaps—fundamental character of aesthetic experience and of all objects of such experience, all manifestations in beauty, after we have surveyed those intrinsically present orders of the very materials of beauty that manifest rhythms so variously, faintly or clearly, directly or indirectly, making rhythm sometimes a primary, and sometimes scarcely even a secondary, consideration.

3

Before we pass to a detailed account of these intrinsic and unique orders in the very materials of beauty, we may here mention them briefly and then leave this general account to turn to more specific description of the separate kinds of aesthetic material in their peculiarities, their possibilities of variation on the one hand and of combination and composition on the other. It is clear at once that in color the intrinsic variation, peculiar and unique, is what we call difference in hue, so that absence of color in the rich, lively meaning of the word means absence of hue. We contrast colored surface, colored walls, colored toys, colored glasses, colored light, with white or black or gray pri-marily, not with absence of all visual sensation. The colors of the rain-bow are what we mean by colors, the breaking of the white radiance into the discriminably different hues from red to violet. Colors vary in other ways; of course, but it is variation in hue, and combinations and contrasts of hue, that are intrinsic to color and nowhere else to be found.

This is what is sometimes called the specificity of sensation. It is the fact that color, being color, being the specific hue that it is in any case, is just uniquely its own quality for vision; and if we apply loosely the term color to musical sounds, or mental states of depression or the reverse, or if we speak of the colors of tones or the toning of color, we go beyond what we mean by color itself, to apply terms not in their specific literal senses, but either by analogy, and often vaguely and with resulting confusion as well as the suggestiveness intended, or else by letting these terms color and tone carry as their meaning the principles of order and variation common to both but not uniquely present in either. For color or sound may vary also not in specific hue or pitch but in intensity, for example, although even here the specific intensity is in the one case brightness or darkness, in the other, loudness or softness, and these are not directly but only indirectly or even only analogously comparable.

In sound it is clear enough that pitch, differences in pitch or com-

binations of pitch, is the uniquely ordering quality. Sounds may vary
in intensity too, as we just noted, as colors also may; but as color has
no pitch, so sound has no hue, and nowhere but in the aesthetic materials
called sounds do we find an intrinsic order of pitch established. We may
use abstract terms such as value in its technical meaning for painters,
and say that as color-value is higher or lower, so pitches are higher and
lower; but here the confusion of the parallel is obvious and the work
mostly of words. What we mean by high in pitch depends entirely on
the meaning of pitch itself, which simply is this specific way in which
sounds differ from each other more or less, and in which colors do not,
the way in which a high note is above a lower note, not the way in
which a high color value is above a lower one of the same or another
hue. For this last is a difference in what is usually, but after all am-
biguously, called saturation, a way of differing peculiar to color not to
pitch; so that while there is an analogy between higher and lower color
value and louder and softer sounds, there is an equally good analogy,
perhaps a better one, between higher and lower color-value and dif-
ferences in timbre, the difference, for example, between brass and
strings, and only a rather faint analogy between pitch differences and
differences in color-values. Even these analogies find little but abstract
words to base themselves upon, words which refer to abstracted aspects
of what in reality are full concrete qualities, the abstraction being
sometimes useful enough to make a comparison, and forceful and
enlightening enough as indicating in both fields genuine structural
possibilities, but as applied to the materials themselves and their
specific intrinsic orders established by their unique qualitative specificity
with which we are all so familiar, only analogies, which, since there is
no common principle involved, no identity of these two structural
modes of variation, but only the fact that in both cases the variations
are ordered, lead almost inevitably to confusion and often to actual
error.

When we come to lines and space-forms, the intrinsically ordering
feature is harder to name, but is after all clear enough except that it is
two-fold. We have two principles, which we may call that of simple
extension or extendedness itself—shape perhaps is the best term—
that of geometrical order, which permits what we call different per-
spectives of the same spatial configuration, such different perspectives
being often not merely geometrically correlated but apparent to vision
as the same. While the geometrical identity may remain, however, a
change in perspective may result in such great changes in the spatial
appearance that for vision there is no identity recognizable, but only
a difference. It will be necessary to explain the two principles and
differentiate them not only from each other but from other meanings

suggested by the terms we seem forced to employ. But mathematics is, in its strictly geometrical, non-analytical methods, at least in part visually intuitive, and we have therefore to seek the intrinsic orders of the aesthetic materials of spatial form not only in obvious appearances but in the mathematical nature of spatial order. So far as we can give any clear account of all this, it is to be deferred to a later chapter. For the present we may be content with illustrations that suggest the difficulties.

A shift in perspective makes the circular elliptical, the vertical horizontal, and so on. But also the eye sometimes sees the elliptical as circular, sometimes not. Thus the character of shapes and lines may or may not vary while the strictly geometrical order remains the same, as a mathematically defined conic section may in limiting cases be a line or a point, and still possess all its geometrical order and the corresponding properties. So too lines or surfaces or solids lose none of their mathematically ordered properties by being revolved through angles or referred to a new system of coördinates or moved to greater distances or projected upon planes or solids at various angles. But for aesthetic perception such shifts are often all-important. A circle is one shape, an ellipse another. A group of horizontal parallels is one appearance, a group of vertical parallels another. Shapes and directions and sizes are absolute for our sight and not to be confounded with one another simply because geometrically they may be mere transformations in reference not affecting intrinsic mathematical order or structure.

In fact spatial form itself is one of the striking illustrations that any beauty is absolutely its unique self only in relation to the perceiving subject, his spatial orientation and habits in general, and his space location in particular. But for such a subject, so constituted and placed, the spatial characters of objects and their visible beauty are what they are uniquely and absolutely. Objects are of one specific size and shape and proportion, they lie in one direction, and the lines themselves have the direction they have and no other. Obviously the unique and intrinsic ordering quality and structural principles of spatial form are a complex and difficult matter, but we have at least seen that they are present, and their uniqueness is plain. Colors have as hues neither shape nor direction but only hue, sounds may move in space and time, but only sounds have pitch, and pitch itself has neither dimensions nor shape nor is even duration of sound its actual intrinsic quality. Thus we have marked and distinguished from one another these three orders of variations, each intrinsic to its own realm. We may now go on to treat these three different kinds of differently ordered aesthetic materials separately and in greater detail.

4. AESTHETIC DESIGN

STEPHEN C. PEPPER

Sensory Fatigue

With most of our senses, the first stimulations are the most vivid—the first taste of a pear or of maple syrup, the first odor of the sea, or of a flower, the first touch of a texture or pressure on the skin. After a period of continuous or closely repeated stimulation, the senses do not respond as strongly as they did at first, and the result is sensory fatigue. Put on a pair of blue glasses. At first everything is very blue, but in a few minutes this color change is less noticeable. The world is still blue but not nearly so intensely blue as at first. The cones of the eye, which are the organs that respond to hues, have lost some of their energy of response through continuous stimulation.

The general form of this mutation, as the example just given indicates, is exactly like that of the habit mutation described on page 23. The same diagram can symbolize it, namely:

PLEASURE	NEUTRALITY	PAIN
+	0	−

After a little continuous stimulation a pleasant odor becomes less and less vivid and generally in consequence less and less pleasant. Similarly, an unpleasant odor becomes less and less unpleasant. After working with an unpleasant fertilizer for a few minutes one scarcely smells it. And so it is with the other senses susceptible to sensory fatigue. The color effect of a stage set is strongest when the lights first come on.

The similarity of form between the fatigue mutation and mechanized habit frequently leads to the mistaken idea that they are the same thing. But their aesthetic effects are completely different. For the fatigue

mutation requires only a few moments to develop and, equally, only a short time for recovery with a complete readiness for fresh stimulation. It is, as we said, a short-term mutation, and therefore can be utilized over and over again in a single work of art. But mechanized habit is a long-term mutation and once developed sticks and takes a very long time to undo. For instance, a musical theme can be repeated a few times till you begin to tire of it, and then after an interval be repeated again and heard with relish in the same piece of music. But when a popular tune has been heard so much that it is "stale", and has become a mechanized auditory habit, it takes a very long time for it to become fresh again.

The reverse of the fatigue mutation, or the return to full capacity of vivid sensation in a sense organ, has the same form as that of forgetting in conditioning, namely:

But, of course, it is not a case of forgetting, which is a long-term affair requiring days, months, or years. The reverse fatigue mutation is simply a case of resting. Give the overstimulated sense organs a rest (that is, absence of stimulation), and they recover their energy in a few moments, and are ready to give vivid sensations with the corresponding intensity of pleasure or pain that goes with the intensity of the sensation. You soon get dull to the odor of acacia or almond, but leave for a few minutes and return to the trees and the odor is strong again.

There is, however, another way of producing the counterfatigue mutation, which is probably more rapid than mere absence of stimulation. There is no adequate experimental evidence on the matter, but there is plenty of evidence in the practice of artists indicating that the stimulation of the sensation opposite or contrasting to the one fatigued produces a quicker recovery than simple rest. Moreover, the fatiguing of one sensation apparently increases the capacity of vividness for its opposite. This effect is called *sensory contrast.*

Most sensations have physiological opposites. This is notably the case with colors, and can be physiologically demonstrated. If the eye is stimulated for a while with a strong blue area, and then shifted to a white wall, a patch called an "after image" will appear on the wall just the shape of the blue area, but yellow. This is known as *successive contrast,* and shows that yellow is the physiological opposite of blue. Similarly, stimulation of yellow gives an after image of blue. Such colors are known as *complementary colors.* Red and a bluish green are such

another pair of colors, and so are black and white. Every color has its complement.

This physiological contrast effect appears even while one is looking at a color. If you look at a strong blue patch on a gray ground and turn your attention to the gray area around the blue, you will find it is tinged yellow, and, similarly, the area around a strong yellow patch will be tinged blue. This is known as *simultaneous contrast*. It follows that if a yellow patch is placed upon a blue ground the yellow will be increased in intensity (or, to use the more technical term, in "saturation"). This occurs because the color of the yellow patch is rendered more intense by the yellow sensation resulting from the simultaneous contrast of yellow and blue. In the Fra Angelico Madonna . . . [see front cover], notice the yellow in the lower folds of the Madonna's gown. See how intense it is compared with the same yellow about the face of the Madonna. In the original picture the difference of intensity is so great that at first one doubts if the two sets of folds are painted with the same pigments. Fra Angelico unquestionably intended these differences of contrast. The strong yellow and blue on the gown about the Madonna's feet enrich the texture of the gown framing the divinity of the Mother of God. But so intense a contrast about the Madonna's head would detract from the beauty of her face. Notice also that the blue about her face is lightened almost to white to hold down the contrast. At the same time, of course, this whiteness suggests a light shining on her head from the halo behind, so that the artist is producing several effects at once by the handling of his colors—as great artists always do.

Returning to the effects of simultaneous contrast, we may now notice that the whole blue gown enveloping the Madonna is laid upon a gold ground, which is a species of intense yellow. The consequence is that by simultaneous contrast the whole gown is intensified by the gold, and the gold by the gown. The total picture is thus endowed with an effect of supernatural brilliance, as if a light radiated from the colors themselves. The reproduction, of course, only partially carries over the brilliance of the original picture. The gold in the original is real gold leaf.

This illustration gives some idea of the aesthetic force of sensory contrast. It develops out of sensory fatigue and would not be felt but for the aesthetic fatigue mutation and its countermutation.

Sensory contrast is most vividly experienced with complementary sensations. But other sensations can also give a strong contrast effect provided they are distantly related to each other in the "natural order" (as some writers call it) of sensations. By the "natural order" of sense qualities is meant the array the qualities make when they are spread

out in series of imperceptible gradations. Thus blues grade into greens, which grade into yellows, which grade into reds, thence into purples and violets, and finally back to blues again. This circle of hues grading into each other is their natural order, or, as I shall henceforth call it, their *sensory scheme*.

There are sensory schemes for all sensations. We shall develop those for color, line, mass, and volume when we come to these topics later. It is the position of sense qualities in such schemes that determines whether they are closely or distantly related to each other. The further apart two qualities are from each other in a scheme (that is, the larger the number of barely perceptible steps of gradation from one quality to the other) the greater the contrast. There is not much contrast between red and orange, because they so quickly grade into each other. But between red and yellow there develops a moderate contrast, and between red and green a very strong contrast. Complementary sense qualities are always far apart in a sensory scheme. Where they exist, they are properly placed at opposite poles of a scheme, if it is constructed to represent the maximum contrast as it is actually felt and physiologically reported. Consequently a sensory scheme of color hues which follows the natural order of contrasting colors will place the physiological complementaries opposite each other—a bluish-green opposite red, and yellow opposite blue. For these are the hues which the physiological effects of simultaneous and successive contrast indicate are the most vividly contrasting ones. However, as we have said, any hues with a wide gap between them in a sensory scheme will have a strong contrast effect.

One further point in this connection. Aesthetic contrasts hold only for qualities contained within a sensory scheme. Blue and yellow are strong contrasts since they are opposites in the scheme of colors. And rough and smooth are strong aesthetic contrasts, both being within the scheme of sensations of texture. But smooth does not contrast with blue. These sense qualities are simply different. Aesthetic contrast thus signifies a definite relation of qualities holding within a qualitative scheme such as the sensory scheme of colors. The qualities of one sensory scheme are not in a contrast relation with those of another sensory scheme. A color may contrast with another color, but not with a line, or a shape, or a texture, or a sound, or an odor. The relief of contrast can be obtained only from qualities within the sensory scheme in which lies the sense quality suffering from the fatigue mutation. The stimulus of a new color will relieve the sensory fatigue to a color too long before the eye, but the fresh stimulus of a shape or a texture has no effect upon a color at all.

This is not to say that there are not subtle aesthetic relationships between certain colors and other sense qualities. We speak of delicate lines and delicate colors, strong lines and strong colors. A pattern of delicate lines might conceivably be contrasted with some strong colors. But here it is not the lines and colors that are in contrast but the mood of delicacy and strength which certain lines and colors are able to stimulate. For there is a natural order or scheme for moods. The scheme defines a gradation of moods from strength to delicacy and shows a strong contrast between the extremes. Apparent exceptions, therefore, simply prove further our principle that aesthetic contrasts hold only within qualitative schemes, and that a quality of one scheme cannot be contrasted with a quality of a different scheme.

We have been speaking so far only of sensory fatigue. Not all are susceptible to sensory fatigue. Smell, taste, touch, and color are highly susceptible to it, but there are two types of sensations that are conspicuously free from it, namely, sound and kinesthetic (or muscle-joint) sensation. Consequently these are the sensations particularly useful for studying the effects of attentive fatigue, since whatever changes of liking or disliking appear with these sense qualities must be due to something different from a tiring of the sense organs.

Attentive Fatigue

If you enter a room where a clock is ticking loudly, you are at first extremely conscious of the sound. But in a short time you find that you do not notice it any more. Yet if later somebody calls your attention to it, you hear it again as loud as ever. Notice that this sort of thing cannot happen with the blue from blue glasses. If you have been wearing blue glasses a while and have ceased to notice them, and then somebody reminds you of the glasses, you cannot recover, try as you will, the intense sensation of the blueness of things you felt when you first put the glasses on. Yet this is just the sort of thing you can always do with sensations of sound (unless the sound is deafening like a boiler factory or an artillery bombardment where actual injury is being done to the ears).

The gradual unconsciousness of sound that comes from repeated stimulation like the ticking of a clock is not the result of a dulling of the sense organs, but of a loss of attention. The aesthetic result is about the same as that from sensory fatigue, but more complete. In sensory fatigue complete loss of sensation does not occur though the intensity of it is greatly reduced. But in attentive fatigue the stimulus is ultimately completely blotted out of consciousness. Thus attentive fatigue

may work on top of sensory fatigue. In fact we just now had an instance of this fact in the reference to the blue glasses. When a person finds not only that the world is less blue than when he first put on the glasses, but that he has ceased to notice that it is blue at all, then attentive fatigue has worked on top of sensory fatigue.

But even though the mutation is more complete with attentive than with sensory fatigue, the aesthetic effect is more serious in sensory fatigue. For it takes more time for a sense organ to recover than it does to rearouse the attention. This is one reason, I believe, why the major arts, as they are called, favor the sense qualities that are not susceptible to sensory fatigue. There are no arts of taste, smell, and touch that have the degree of development found in music, literature, and the visual arts. It is noticeable that sound is free from sensory fatigue, and likewise the symbols of literature, and likewise all the qualities of the visual arts dependent on line (for line is not color sensation but probably a movement sensation). I venture to say that if the art of painting depended solely on color and lacked linear form, it would never have developed further than the art of perfumery. But fortunately color could fuse with linear shapes and volumes and so greatly enhance the beauty of visual objects.

The general form of the fatigue mutation for attentive fatigue is the same as that for sensory fatigue. Accordingly the earlier diagrams apply equally to both forms of fatigue.

As with sensory fatigue, absence of stimulation automatically restores the capacity of awareness to the attention. It does so very quickly. Sometimes, as when a clock stops, the absence of the ticking is noticed even though the ticking just before was not. And as with sensory fatigue, a contrasting stimulus is the most effective way of restoring the original sensitivity. With attention, however, the effective contrast is not so much that of an opposition of sense qualities like yellow and blue, as that of quantity of stimulation. Contrasts of intensities like loud and soft, dark and light, or of extensities like large and small, long and short, wide and narrow, or of rhythms like quick and slow are the characteristic contrasts for rearousing attention. In short, qualitative contrasts are associated with sensory fatigue and quantitative contrasts with attentive fatigue.

An example of quantitative contrast may be seen in the rhythm developed by the folds of the mat beneath Fra Angelico's Madonna . . . [see either insert or front cover]. Each fold makes a group of *short* lines followed by a *long* line between the folds. This rhythm is then repeated with a variation in the folds of the Madonna's blue gown. There is also a quantitative contrast between the *large* blue area of the Madonna

and the *small* blue areas of the two little angels above. And similarly between the *large* red area at the Virgin's breast and the *smaller* red areas scattered about below.

Sometimes it is hard to decide whether to consider a contrast as quantitative or qualitative. Two sensations differ quantitatively if one is discriminated as more or less of the other in any way whatever. There is no question about the quantitative nature of the contrasts pointed out in the previous paragraph. A long line has more line than a short one, a large area more area than a small one. Also there is no question about the qualitative contrasts we pointed out in the previous section. There is no way in which blue can be considered more or less of yellow. These hues simply differ completely in their sensory qualities. Similarly with the contrast of red with blue or yellow. But suppose we think of black and gray, or of black, gray, and white. Black is definitely a darker gray, a *more* intensely dark gray. And white is a *more* intensely light gray. If a difference of intensity is felt in the contrasts of such colors, then the contrast must be considered quantitative, otherwise it should be considered qualitative. An artist can often make it clear which way such sensations should be interpreted, so that a spectator would not even think of taking them but one way. Notice the contrasting red and black squares on the mat under the Madonna. These will unquestionably be accepted as a qualitative contrast just like red and blue. Yet actually black can be regarded as the limit of a series of darker and darker reds. If some of the intermediate gradations of red to black were present in the design, this very combination of black and red might appear quantitatively opposed and contrasting. But Fra Angelico does not give us the least sign of a quantitative relation between red and black, and we accept them unquestioningly as a qualitative contrast.

The distinction between quantitative and qualitative relations among sensations is not particularly important in matters of aesthetic fatigue. But the distinction has important consequences in the development of certain kinds of patterns . . . Note, however, the recovery from aesthetic fatigue (the counterfatigue mutation) may be induced by either qualitative or quantitative contrast, and that sensory fatigue tends to be associated with the former and attentive fatigue with the latter. Both kinds of contrast have about the same effect.

Monotony

Now it must have become abundantly clear from our examples that the fatigue mutation is subversive to art and something to be

avoided for aesthetic appreciation, since it dulls sensation or puts it out of consciousness. When its effect becomes noticeable it is called *monotony*, and monotony is one of the cardinal sins of art. Aesthetic fatigue cannot, of course, be entirely stopped. The mutation begins to work as soon as a stimulus is given. What an artist tries to do is to keep the mutation from going very far. He certainly wants to keep it well away from neutrality or unconsciousness.

The experience of generations has taught artists a number of methods for keeping the fatigue mutation at bay. These methods are aesthetically of very great importance, and no work of art is without them. They are known as the *principles of design* and will be the subject of the next chapter.

In this chapter we have studied the main principles relevant to the development of our immediate likes and dislikes. By way of summary, let us see how these fit together. Rather obviously, our basic dispositions to like and dislike are instinctive. These are probably much the same in all men, just as all men are much the same anatomically. On top of these instinctive dispositions ride the long-term mutations of conditioning and habituation. And on top of the latter ride the short-term mutations of fatigue.

Habituation seems to be a maturing process of our instinctive likings. Through experience a rather small original repertory of immediate sensory likings becomes enlarged so that nearly all sense qualities become enjoyable.

Conditioning is a process by which instinctive likes and dislikes become attached to objects which were originally of no interest, so that the range of objects immediately liked and disliked becomes greatly extended. In so far as the field of immediate likes is increased, this is to our aesthetic advantage.

The observed variations of taste among individuals are due largely to differences in the degree of habituation and to differences of conditioning. Since both of these are controllable, or, at least, understandable, there does not seem to be much justification for any very extreme skepticism about describing conditions of human appreciation. If a man does not appreciate a potentially beautiful object from lack of habituation, he can generally, if he desires, remedy this lack. Or if his lack of appreciation is a failure in acquiring some form of cultural conditioning, such as an understanding of the stylistic peculiarities of another period, these may be learned. In short, there is nothing about variations of taste to shut any man off from the appreciation of most objects of great beauty.

As to the short-term variations of likings due to fatigue, these are

controlled by the artist himself through the principles of design which
we are about to study.

. . .

Contrast

Of these principles of design *contrast* is the simplest. It consists in
holding off the fatigue mutation by throwing in those qualitative or
quantitative contrasts of which we were speaking in the previous
chapter. If an area of color begins to be monotonous, break it up into
a number of contrasting areas of color. If a repetition of short vertical
lines begins to get tiresome, put in some long lines, or a horizontal.
Contrast is the most striking of the principles of design, and gives the
quickest shock to the tendency for monotony. For it consists simply in
the elementary principle of relieving sensory or attentive fatigue in the
most immediately effective way.

The weakness of the method, however, is that it cannot be applied
often by itself without leading to confusion. A succession of contrasting
areas, or lines, or shapes without any unifying principle to give them
order becomes a jumble, and we lose interest in them because a jumble
is irritating. Four or five disconnected objects of contrast are the most
that we would stand for.

An artist is thus caught between two aesthetically undesirable results
—monotony and confusion. There is a certain amount of leeway
between the two within which he can develop his object of beauty, but
if he falls off on either side he drops into dullness or ugliness. The
avoidance of monotony is often called variety, and the avoidance of
confusion is often called unity. From this arises that age-old principle
of unity in variety, which every work of art or thing of beauty must
possess. But the idea of unity in variety is vague and not very rewarding
until we can discover just what constitutes unity and what variety.

Aesthetic unity consists in fact in the avoidance of confusion, or,
what amounts to the same thing, in the attainment of order, in what
we shall soon study under the head of "pattern" . . . Variety consists in
the avoidance of monotony, that is, in keeping aesthetic fatigue at bay;
and the means of doing this we are calling "design." What the ancient
principle of "unity in variety" means, then, is that since variety carried
to excess results in confusion, and unity carried to excess results in
monotony, it is essential that design and pattern co-operate with one
another if a work of art is to be successful and hold our interest steadily.

Now, there is no more direct way of stopping fatigue and monotony

than by bringing in a contrasting quality, but after this has been done four or five times confusion threatens, the unity of the composition breaks down, and the spectator turns away in annoyance. For this reason artists have sought out other principles of design that have an element of order within themselves. Such are the principles of gradation and theme-and-variation, to which we turn in the next sections. These principles of design do not have as much force as contrast in breaking up monotony. They are not so much of a shock to aesthetic fatigue, but their lack of force is compensated by their much greater versatility and capacity to hold the spectator's interest for much larger masses of aesthetic material.

Gradation

We mentioned earlier the fact that sensory qualities can be organized in schemes. These schemes show which qualities are opposed to each other in strong contrast, and which ones are nearly related and close together. Now a gradation consists in following a sequence of nearly related qualities along a line in such a scheme.

Thus a sequence of grays from black to white would be a gradation, or a sequence of hues from red through orange to yellow. In fact, draw any line from one point to another in the color scheme, and you will have a sequence of color gradations. The same, of course, is possible with lengths and widths and degrees of curvature of lines, with sizes of areas and volumes, with shapes such as gradations from circles into narrower and narrower ellipses, or from squares into narrower and narrower rectangles. In sound there is a gradation of pitches from low to high, and of intensities from soft to loud. And so with all sense qualities.

The presentation of gradation sequences in a work of art is an excellent way of avoiding monotony. Any number of different sense qualities can be put together so long as they can be felt as following a line in a sensory scheme. The limitation of the principle of contrast to four or five elements only is thus overcome in the principle of gradation.

We tend to think of gradations as imperceptible transitions of qualities as in a rainbow or in the blue of the sky on a clear day which shades from light blue near the horizon to a deep ultramarine overhead. But a gradation can be felt also with wide gaps between the colors provided they are at regular intervals along a single line. Black, dark gray, light gray, and white will be felt as a gradation even though the gaps between the colors are very wide. And so it is with all sensations. A glissando on a violin where the finger slips up the string as the bow

is drawn across it is a continuous gradation of rising pitch. But a rising pitch gradation is also felt in playing up a scale on the piano or running up a succession of octaves, where the gradation is discontinuous with large gaps between the pitches. So long as the line of gradation is clear in the sensory scheme, the feeling of gradation will be there and monotony will be avoided no matter how many different sense qualities are used, and no confusion will be felt either.

Moreover, some gradations have an added property—climax— that not only keeps monotony away but progressively increases interest. We shall call this *gradational climax* to distinguish it from another sort of climax, which comes out in the design principle of restraint. If, for any reason, one end of a sensory gradation is more interesting to us than the other, then the gradation from the less to the more interesting end is a gradational climax. In general loud sounds are more arresting than soft ones, so that a transition from soft to loud is a typical gradational climax. Similarly long lines and large shapes tend to draw the attention more than short lines and small shapes, so that gradational climaxes naturally generate in transitions from small to large. Expressions or suggestions of movement are usually more striking than those of rest and quiet. Bright colors and black and white are generally more attractive to the attention than grays, so that gradation climaxes are often developed from less intense grayish colors to the intense saturated hues or to black or white. Also light is generally more attractive than darkness.

Several such gradation climaxes may be seen in the Fra Angelico Madonna. There is a suggestion of increased agitation as the eye (or, better, the visual attention) passes from the lap of the Madonna down toward the folds at her feet. It is a transition from large shapes with long lines to small shapes with short lines. Incidentally, notice that the movement of these forms is totally independent of any suggested movement by the Madonna herself, who is represented as momentarily motionless.

There is also a color gradation from dark to light with a gradational climax towards the light as the eye moves from the dark blues of her gown up to the light blue of her hood surrounding the light of her face. Here the interest in the light end of this gradation is augmented by the central interest in the Madonna's face. Even if light were not intrinsically more interesting than dark, this gradation of color would have been interpreted as a climax toward the light because of the interest set upon the light end of the gradation by the Madonna's face culminating at that end. A progressive gradation may thus be given a climax by placing something of great interest at one end of it.

Thus the design principle of gradation has unifying capacities lacked by contrast. It can bring together without confusion any number of qualities so long as they follow a simple gradational line. Its limitation is that these variations of quality must follow such a line.

It is superior to contrast. In fact we did not fully take in the limitations of contrast in the last section, because we overlooked the action of gradation in the Fra Angelico. But now imagine the Madonna's gown a flat blue without the gradations just noticed. How monotonous it would be! We shall see in the next section that theme-and-variation is as superior to gradation in holding off monotony without yielding to confusion as the latter is to contrast.

Theme-and-Variation

Theme-and-variation consists in the selection of some easily recognizable pattern, such as a group of lines or a shape, which is then varied in any manner that the imagination suggests. A pattern so used is called a "theme" or "motive." The only requirement is that the theme should be recognizable through all its variations. For if the recognition fails, the connection among the varied forms is lost, and so the order or sense of unity is lost, and confusion ensues. Strangely enough, the recognition does not always have to be fully conscious or explicit, so long as it is felt. Probably all richly developed designs contain many such subtle variations. The artist himself may not have been aware he was making them, but the composition seemed to him to call for a certain arrangement of lines in certain areas and this arrangement on analysis turns out be be a variation of one of the themes in the composition. All parts of the composition are thus pulled together by a sense of familiarity and family relationship.

In Fra Angelico's Madonna there is a pair of such themes that interweave and reappear all over the composition. We may pick them up from the curtain which the angels are holding up behind the Madonna. The pattern of this curtain consists of a row of circles alternated with a row of forms consisting of two pairs of straight lines set crosswise like a little grill. Take the circle and the grill as the two themes (noticing incidentally the strong linear contrast between them), and observe how they are echoed in variations all through the picture. The circle reappears varied in size in the halos, in the neck-lines, wristbands, and girdles of the angels and the Madonna, in the shapes of their heads. Arcs and elongations of the circles are taken up in the folds and edges of the Madonna's gown and the curtain and the mat,

and in the ends of the cushion on which she is sitting. Circles will even be found in the centers of the contrasting grill theme.

Now follow the grill. It reappears on the mat in the form of alternate red and black squares. The alternation of red and black squares on the mat, incidentally, is a variation of the alternation of *red* circles and *black* grills on the curtain. The theme reappears in the half square formed by the angels' arms at right angles to each other, holding up the curtain. It comes out in a central position in the crossed arms of the Madonna. The child's arms form right angles, so does the Madonna's knee and some of the folds in her gown and in the drapery about her.

Are these analogies of forms far-fetched? Did Fra Angelico intend them? In the sense of deliberate, preconsidered intent, he probably did not. But in the sense of feeling his way through the creation of these forms toward a richly ordered composition, we may be quite sure he intended every one of them. He knew through his imagination how wrong any forms would be that did not interrelate with one another. In avoiding the jarring and confusion of unrelated forms, he inevitably created related forms that were variations of one another. Just imagine the squares of the mat turned into fleur-de-lys or violets, and you will see why Fra Angelico made them squares. Go over the picture form by form and imagine some unrelated form in its place, and you will see why the artist was drawn to variation of a theme. He was avoiding confusion. And he was not making exact repetitions of his theme, because he was avoiding monotony. Imagine the grills of the curtain repeated in the mat, or imagine little circles there. These would be passable but not nearly as interesting as the squares. Fra Angelico knew his squares felt right, whether he consciously knew they were variations of the grill pattern or not.

Why did I select the grill as the theme rather than the square? It makes no difference. Each is a variation of the other. As a matter of conjecture, I should venture that the crossed arms of the Madonna was the original source of the theme. This attitude has deep symbolic meaning partly instinctive, partly cultural. And perhaps the halo was the original source of the circle theme. The variation of these themes thus subtly carries the emotional tone of these symbols through the whole picture and helps to produce something of the mystical quality it has.

The power of theme-and-variation to keep away monotony is well illustrated in this example. There are practically no limits to the amounts of material that can be kept interesting by this principle. The only limit lies in the selection of a theme which must be simple enough to be taken in quickly and recognized in its variations. But its

variations may become as intricate as desired so long as a relationship to the theme is still felt. In fact, there is a very intricate development of the circular theme in the conventionalized plant form developed within the circles on the drapery behind the Madonna.

The versatility and flexibility of the principle of theme-and-variation in comparison with the principles of contrast and gradation comes out quite clearly in these examples.

Restraint

We come now to the last of the four principles of design, that of restraint. This principle is on a different level from the others. It recognizes that interest itself grows tired. The other three principles assume that there is plenty of interest available in the spectator and that the only problem is how to keep that interest directed upon the aesthetic materials. But what if the store of interest is used up too quickly, and gives out, so that no more interest is available? The principle of restraint is the recognition of a need for economizing the expenditure of interest so that it will be adequately distributed over the whole duration and the whole extent of a work of art.

The principle is most clearly seen in a temporal work of art like a piece of music, a play, or a novel. One might naively think that in a play a dramatist would raise the interest to a maximum and hold it there or as nearly there as possible from the beginning to the end. But think of any actual play, and it is obvious that a playwright does not do that, and that if he did the effect would be satiating, strained, and unendurable for the two hours or so that a play is intended to last. The play opens with some scene of considerable interest to take hold of the attention. Then ordinarily the intensity of interest relaxes to give the spectator a view of the situation and the dramatic background out of which the plot will evolve. There is then a gathering intensification of interest to what might be called the first incident. After this comes another relaxation which rises to another climax of interest, and so on, incident by incident, with alternations of tension and relaxation. In a well-formed play, the maximum of tension is usually held for an incident near the end of the play which is the climax of the performance, and then ordinarily there is a final relaxation of interest at the very end to relieve the spectator of extreme tension and release him from the play with a sense that there was still a great store of interest that might have been drawn upon. The spectator leaves the theater not totally drained, but still interested and perhaps wishing there were more of the play, or reflecting upon it and reliving it in

imagination. This way of handling the spectator's store of interest, playing it out so that there is always more left, is what is meant by the principle of restraint.

Notice that it involves a new sense of climax. We shall call it "interest climax" to distinguish it from the "gradational climax" pointed out in an earlier section. Interest climax refers to a gathering increase of interest *developed through any sort of materials* selected by the artist, and leading up to a point of maximum interest in a work of art. Interest climax naturally utilizes gradational climaxes among other means of gathering interest. But a gradational climax is always restricted to a line of gradations within a sensory scheme. Interest climax has no such restriction.

The tensions and relaxations of interest, the alternating climaxes and recessions in the composition of a temporal work of art like a play can be imaginatively plotted as a succession of curves or waves, with the waves rising on the whole higher and higher, as the play progresses, up to the highest wave of all which is the climax of the entire play.

Now, the same sort of thing happens in a spatial work of art like a picture, or a statue, or a building. These also have their points of highest interest or interest climaxes and intervening areas of lesser interest. A picture equally interesting all over is likely to be disturbing, and to contain less total interest than one that makes more use of the principle of restraint. A picture very rich in aesthetic material would be unendurable without areas of relaxation.

Let us turn again to Fra Angelico's Madonna. The area of maximum interest, the climax of the whole picture, is obviously that enfolding the Madonna's face and the child, and the Madonna's face itself is the point of maximum interest in that area. The face acquires this interest not only from its emotional significance and from its being a deeply sympathetic representation of a type of human beauty, but from what are often called the formal aspects of painting. The face is the largest area of very light color in the picture. The hands of the Madonna and the child are painted in a darker slightly reddish tone which in this picture lowers the interest in these areas in comparison with the Madonna's brighter face. A gradational climax of dark to light (already alluded to) leads up to the head. The head is framed in a large halo. It is at the apex of a triangle formed by her blue robe and seated posture and accented by converging lines in the folds of her garments, in the rug beneath her, and even in the drapery behind. Eliminate all emotional, symbolic, and representational elements and think of the picture as mere line, color, and shape, still the head of the Madonna would be the area of maximum interest, the climax of the picture.

But the child is a close rival of interest, a secondary climax, and after the child follow in interest the crossed hands of the Madonna, the two angels in the upper corners, the yellow folds at the hem of the Madonna's robe, and the folds at her feet. Interest gravitates to these areas from all other parts of the picture.

Between these areas of climax are, however, areas of rest. Consider the long blue surface between the child's head and the folds at the Madonna's feet, and all the other large areas of blue. The mat and even the rich drapery behind with the repetitive and so relatively monotonous patterns are relatively restful and relaxing in contrast to the attention due to the Madonna and child.

The picture thus develops an interest structure in space just as a play does in time. This too could be imaginatively plotted by thinking of the intensely interesting areas as heavily shaded, and the less interesting areas as more lightly shaded in proportion to the degree of interest present. This picture would then be very heavily shaded in the center and quite heavily shaded at the upper corners and around the hem of the Madonna's robe. The rest of the picture would be more lightly shaded. The quantity of lightly shaded areas is the sign of Fra Angelico's restraint.

Imagine an attempt to raise every surface of the picture to the intense interest of the Madonna's head. There would be too much competing interest and every area would lose in interest by the rivalry of all the other areas, and by the restlessness of it all. The net result would be a total picture of much less interest than this one—if, indeed, it did not become a total confusion and an object of aversion.

There is a maxim among some abstract painters of the present time that every area of a picture should hold up equally in interest with every other. Actually, in practice this ideal is never achieved. But there are approximations to it, especially among the less skillful abstractionists. Strictly adhered to, this practice would eliminate all climaxes within a picture as well as rest areas. The element of truth in the maxim is that every area of a picture should be interesting, but it by no means follows that every area should be *equally* interesting.

As may already have been noticed, there is a pattern of interest in any work of art well designed according to the principle of restraint. In the Fra Angelico the pattern is almost symmetrical—a large spot of major interest in the center, two spots above on either side, and a semicircle of stressed interest around the base.

Thus, the principle of restraint not only acts negatively as a means of avoiding monotony, but also becomes a source of positive delight in the climactic suspense and balance of its pattern.

Design Principles May Combine

Contrast, gradation, theme-and-variation, and restraint are, then, the four principles of design. As our exemplification of all of them in the Fra Angelico shows, they are not mutually exclusive. On the contrary they are mutually co-operative, and any considerable work of art employs all of them together.

5. ART AS AN EXPRESSIVE VEHICLE

THEODORE M. GREENE

The central thesis which I shall try to defend is that, in a work of art, (a) *reality* is (b) *interpreted,* and (c) *expressed in a distinctive way.*

(a) The true artist, I shall argue, has never conceived of art as an escape from reality into an ivory tower. He has attempted to come to grips with reality in his own way, and the more serious the art, the more resolute has been this attempt. Only the "aesthete" has subscribed to the thesis of "art for art's sake"; the motto of the conscientious artist has been "art for life's sake." In attempting to apprehend reality in his own way the artist resembles the scientist and the philosopher, the moralist and the theologian. Art is one among other significant human enterprises, and, like them, derives its significance[1] from the artist's preoccupation with what man accepts as real. To ignore this basic characteristic of art is to do violence to its historical character and to rob it of much of its human import.

(b) But the true artist has never striven merely to duplicate reality or to copy it with slavish fidelity. He has recognized the need for interpretation. From primitive times to the present creative artists have offered us in their art a series of interpretations of human life and of man's physical and spiritual environment, and the critics in the main critical traditions have emphasized the importance of this interpretative factor.

(c) Art differs from science, morality, and religion in its generic approach to, and interpretation of, reality. Its subject-matter, broadly

[1] The term "significance" has a dual meaning, i.e., (i) importance or value, and (ii) reference or signification. My thesis is that the significance (importance) of art is essentially conditioned by its signification of (or reference to) something other than itself, though such reference does not of itself suffice to endow the work of art with value.

REPRINTED BY PERMISSION OF PRINCETON UNIVERSITY PRESS FROM *The Arts and the Art of Criticism,* BY THEODORE M. GREENE, PP. 229–35. COPYRIGHT 1940 BY PRINCETON UNIVERSITY PRESS. REPRINTED ALSO BY KIND PERMISSION OF THE AUTHOR.

considered, embraces every *kind* of reality known to man. But only certain *aspects* of reality interest the artist; his approach to it, like that of other specialists, is selective. Unlike the scientist, he apprehends reality in terms of individuality and value, not in terms of abstract generality, and his goal is not the mere conceptual apprehension of truth for its own sake but rather the comprehension of reality in its relation to man as a normative and purposive agent. On the other hand, art resembles science and differs from morality and religion in being essentially contemplative. It is not the primary function of art as such to initiate action or to induce spiritual commitment. Hence, though art does, like science, concern itself primarily with universals rather than mere particulars, it does so in its own peculiar way, and though it makes an essential contribution to moral and religious insight, it refrains, at its best, from every form of propaganda. Furthermore, the artist "expresses" his distinctive insights in a distinctive way which differs in essential respects from the way in which nature "manifests" her character to us and also from the way in which the scientist "formulates" his apprehensions of natural order.

A work of art may accordingly be re-defined as a distinctive expression, in a distinctive medium, and by means of a distinctive type of formal organization, of a distinctive type of interpretation of man's experience and of the real world to which this experience is oriented.

Since the artist's attitude and objective, his mode of expression, and the content of his art are all intimately related as functions of a single organic process, their analysis and exposition raises all the difficulties incidental to the analysis of any organic situation. Any order of exposition is in a sense arbitrary, since no one aspect of the total situation can be fully understood prior to an understanding of other functionally related aspects. I have chosen, on purely pragmatic grounds, to examine first the *differentiae* of the artist's generic approach to reality. . . . , next, the distinguishing characteristics of artistic expression. . . . and, finally, various generic types of artistic content as exemplified in the six major arts . . . Since this investigation will presuppose the expressiveness of art, a word of explanation should be offered in support of this presupposition.

. . .

If the true artist seeks to express in his art an interpretation of some aspect of the real world of human experience, every genuine work of art, however slight and in whatever medium, must have *some* subject-matter. It is not *merely* an aesthetically satisfying organization of sen-

suous particulars. The entire history of the fine arts and literature, from the earliest times on record down to the present, offers overwhelming evidence that art in the various media has arisen from the artist's desire to express and communicate to his fellows some pervasive human emotion, some insight felt by him to have a wider relevancy, some interpretation of a reality other than the work of art itself in all its specificity.

The history of ornament may be taken as a test case, since ornament is frequently non-representational and since it appears in every society and culture. To the untutored eye, an ornament is nothing but a more or less agreeable pattern which reveals nothing and signifies nothing beyond itself. Yet a study of the types of ornament characteristic of any specific culture and period tells a different story.[2] An ornament which is indigenous to a culture, or which, though borrowed, has been assimilated by a culture, is as highly stylized as any self-contained work of art in any of the major artistic media. Now style can, as we shall see,[3] be defined only by reference to the point of view adopted by the artist towards his subject-matter. Style is a function of artistic expression; a wholly inexpressive object is devoid of style. To admit the stylistic character of artistic ornament, accordingly, is to admit its expressive character, hence its artistic content, and so the fact that even an ornament is, in its own limited way, a revealing cultural document. The reader is referred, for empirical evidence of the way in which ornament can express the spirit and temper of a culture, to illustrations of ornamental designs characteristic of different cultures . . .

But, granting that all art is in essence expressive, it might be argued that what it expresses is not an interpretation of objective reality but merely the unique personality and point of view of the individual artist, or even, as it has sometimes been urged, merely the artist's passing mood or fancy. Is this interpretation of art tenable?

To limit the subject-matter of art to the artist's fugitive mental states divorced from his more enduring personality and outlook is to revert to a type of atomistic psychology now happily outmoded. It is recognized today that human consciousness is not a mere aggregate of unrelated mental states, but that, save in extreme pathological cases, consciousness is at each instant a function of a more enduring self, however personal identity be defined. Selfhood transcends psychological atomicity and implies a vital continuity of experience, i.e., the influence of an experienced past and an anticipated future upon each present moment of awareness. Consciousness is a function of a "self"

[2] Cf. A. Riegl, *Stilfragen* (Berlin: Georg Siemens, 1893).
[3] *Aristotle on the Art of Poetry*, tr. with commentary I. Bywater (Oxford: The Clarendon Press, 1909), p. 27. The reference is to the *Poetics*, IX, 1451 b, 5–6.

persisting in time as a relatively enduring pattern of memories, habits, impulsions, etc. Every mental state must therefore be regarded as pertaining to, and in its own way reflecting, the character of a self which maintains its identity amid the flux of inner and outer change. "Self-expression" in art is therefore, even in its most restricted forms, the expression of more than a passing mood, idea, or impulse. It must to some extent express the artist's enduring personality.

But every human being, and therefore every individual artist, resembles other human beings and reflects in his own way his physical and cultural environment. As Leibniz would express it, man mirrors the world of which he is a part. Like other finite creatures (but more completely, because of his complex nature) man transcends himself in being what he is, and the richer his personality, the more richly does he reflect his total environment. When, therefore, an artist expresses *himself* in his art, he simultaneously and necessarily expresses certain aspects of the *environment* that has formed him, and the more spiritually significant his personality and outlook, the more does his art reveal the forces which have made him what he is. Thus even the doctrine of art as self-expression implies that the subject-matter of art is, in any concrete instance, not merely the enduring self of the creative artist but as much of the objective world as the artist has assimilated in the development of his own personality.

Finally, to assert that artists throughout the ages have been concerned merely to express what uniquely characterized their individual personalities is grossly to misread the historical record and the empirical evidence at our disposal. The more petty the artist and the more egoistic, the more anxious has he been, no doubt, to exhibit himself to the world as a unique individual. Instances are on record of artists so absorbed in their own inner states that their chief desire was to indulge in autobiographical self-revelation. But the more significant the artist, the stronger has been his conscious or unconscious preoccupation with some aspect of universal human experience and the more compelling has been his desire to employ artistic form as a vehicle not for mere self-expression but for what he has felt to be a true and revealing interpretation of some aspect of his environment.

The critical tradition in western Europe, to say nothing of similar traditions in other cultures such as the Chinese, supports this interpretation of the artist's motives and achievements. From Greek and Roman times, through the Middle Ages and the Renaissance, and down to the modern period most of the critics who have achieved distinction and whose names have endured have been those who were not content to bask in the pleasing "aesthetic surface" of art, but who sought rather to delve beneath this surface to the interpretations of

human life and objective reality which, they believed, specific works of art expressed. It is only in periods of cultural and spiritual decadence, periods characterized by a loss of inner assurance in spiritual values, that the "aesthete" (in the narrow and derogatory sense) has made his appearance and proclaimed that art is *reducible* to aesthetically agreeable patterns of sound and color and is therefore in essence an escape from reality, mere play, an object of aesthetic delight and nothing more.

It is of course essential that the aesthetic surface of a work of art should satisfy the strictly aesthetic criterion. It is also true that beauty, and beauty alone, is the proper object of "pure" aesthetic taste, and that "pure" taste, as Kant so cogently argued, is man's aesthetic response to this quality and to nothing else. What must be combated in an age of cultural instability such as ours is the attempt to *reduce* art to mere formal beauty and to consider the production and enjoyment of such beauty not only as an end in itself (which it certainly is) but as the only end, or even the chief end, of art. Just as the true scientist, however great his enthusiasm for logical consistency, is never content merely to play with concepts and propositions according to the rules of logic, but seeks to use his reason and his logic for the attainment of scientific truth, so the true artist, though enchanted with the beauty which he and others can occasion, is never willing to be a mere creator of beauty but always strives to express, in terms of beauty, his interpretation of a wider reality and a richer experience. And just as scientific truth involves not merely logical consistency but also correspondence to the real world of spatio-temporal events, so too does artistic truth demand not only the presence of formal beauty but the expression of a true understanding of certain aspects of human experience and reality. The doctrine of "art for art's sake" has at times, as at the end of the nineteenth century, been of great value as a reminder that art is not a mere reproduction of reality, that subject-matter and artistic content are not identical, and that aesthetic objects in general, and works of art in particular, are distinguished from other objects of awareness by their aesthetic surface. But this has never been regarded by the main critical traditions as an adequate formulation of the nature of art at its best.

Philosophers of art have, as a rule, agreed with the critics in this respect. Plato never succeeded in formulating a clear and adequate account of art as an expressive vehicle. But his moralistic strictures in the *Republic* demonstrate his belief that both music and literature affect man more profoundly than they could if they were mere exemplifications of beauty, in the *Phaedrus* and the *Symposium* he explicitly recognizes art's expressive power. Aristotle, standing on his master's shoulders, recorded his interpretation of the drama in the famous dictum that "poetry is something more philosophic and of graver

import than history"—a dictum which, applicable as it is to all art, raises art far above the category of the merely aesthetically agreeable. Kant isolated pure taste and pure beauty in order to determine their *differentiae*, and it is noteworthy that his best examples of "free" (as opposed to "adherent") beauty are flowers and sea-shells, which are not works of art at all, and wall-papers and arabesques, which, in comparison with other forms of art, are limited in expressed content. It is also noteworthy that Kant held no very high regard for mere formal beauty as such. He valued natural beauty chiefly as "the symbol of the morally good,"[4] and denied spiritual significance to art which merely satisfies formal aesthetic criteria.[5] Hegel, unlike Kant, was from the first primarily concerned with art rather than with beauty in and for itself, and was anxious that his analysis of art should do justice to the great masterpieces of Oriental and Western culture. He was accordingly led to define art in all the several media as being in essence expressive of the artist's interpretation of reality itself in one or other of its manifestations.

More recently, we are indebted to Croce for a renewed insistence on the expressiveness of art. His formula, "art = intuition = expression," is at once too simple and too comprehensive to be wholly acceptable. But it clearly indicates his recognition of the fact that art has a subject-matter which the artist seeks to interpret. The expressiveness of art has been recognized by other contemporary philosophers of art with varying degrees of emphasis—by Bergson and Alexander, Dewey and Parker, and even by Santayana, especially in his critical essays on literature. Despite several dissenting voices, the general verdict of philosophers through the centuries may thus be said to have sustained the judgment of the critics and the conviction and practice of the creative artists themselves, namely, that art has been and should be essentially expressive of the artist's interpretation of reality and human life.

As we have seen, the several arts differ in their characteristic subject-matter, and these differences are dictated by their respective primary media. But despite these differences, the arts are alike in their generic approach to their subject-matter. The generic subject-matter of art, in turn, is not distinctive at all; it is identical with that of ethics and theology, science and philosophy. The artist is preoccupied with the same world of objective existence and the same human experiences which concern the other cognitive disciplines. He merely approaches this world and these experiences in a distinctive manner and with a distinctive goal in view.

[4] *Kant's Critique of Judgement*, tr. J. H. Bernard (London: Macmillan, 1914), p. 250.

[5] Ibid., p. 214. "If the beautiful arts are not brought into more or less close combination with moral Ideas, ... they then serve only as a distraction. ..."

Selected Readings on Part II: The Elements of Art

Aldrich, Virgil C. *The Philosophy of Art.* Englewood Cliffs, N.J.: Prentice-Hall, 1963. Chapters 1 and 2.

Barnes, Albert C. *The Art in Painting,* New York: Harcourt, 1925.

Beardsley, Monroe C. *Aesthetics.* New York: Harcourt, 1958. Chapters 1–3.

——. *Aesthetics from Classical Greece to the Present.* New York: Macmillan, 1966.

Dewey, John. *Art as Experience.* New York: Minton, Balch, 1934; Putnam (Capricorn), 1958.

Gombrich, Ernst H. *Art and Illusion.* 2nd ed. Princeton: Princeton, 1961.

Greene, Theodore M. *The Arts and the Art of Criticism.* Princeton: Princeton, 1941.

Gurney, Edmund. *The Power of Sound.* London: Smith, Elder & Co., 1880.

Hartshorne, Charles. *The Philosophy and Psychology of Sensation.* Chicago: U. of Chicago, 1934.

Hospers, John. *Meaning and Truth in the Arts.* Chapel Hill: U. of N. C., 1946. Chapter 4.

Isenberg, Arnold. "Perception, Meaning, and the Subject-Matter of Art." *Journal of Philosophy,* XLI (1944), 561–75.

Margolis, Joseph. *The Language of Art and Art Criticism.* Detroit: Wayne, 1965. Part Two.

Munro, Thomas. *The Arts and Their Interrelations.* New York: Liberal Arts Press, 1949.

Parker, DeWitt. *The Principles of Aesthetics.* New York: Silver Burdett, 1920.

——. *The Analysis of Art.* New Haven: Yale, 1926.

Pepper, Stephen C. *The Work of Art.* Bloomington, Ind.: Indiana, 1955.

——. *Principles of Art Appreciation.* New York: Harcourt, 1949.

Portnoy, Julius. *Music in the Life of Man.* New York: Holt, 1963.

Prall, David W. *Aesthetic Analysis.* New York: Crowell, 1929.

——. *Aesthetic Judgment.* New York: Crowell, 1927.

Toch, Ernst. *The Shaping Forces in Music.* New York: Criterion Music, 1958.

Wollheim, Richard. *Art and Its Objects.* New York: Harper, 1968.

Classified Advertisements

Employment Opportunities

AGENTS WANTED. Licensed agents and PPGAs life, health. Highest commissions paid. A+ companies. Write Director, M.M.S., Box 8406, Jacksonville, Fla. 32239.

Literary

PUBLISH YOUR BOOK! Join our successful authors. Publicity, advertising, beautiful books. All subjects invited. Send for fact-filled booklet and free manuscript report. Carlton Press, Dept. NRM, 84 Fifth Avenue, New York, N.Y. 10011.

CONSERVATIVE CATHOLICS should read "The Roman Catholic," a 32-page monthly dedicated to combatting modernism in faith, morality, and worship. $16.00 per annum. P.O. Box 217, Oyster Bay, N.Y. 11771.

MEN IN OUR TIME by Katherine Young. 17 memorable portrait photographs of controversial men such as Adenauer, Truman, Nixon, Franco, Nehru. Send $16.50 to Katherine Young, 140 East 40th Street, New York, N.Y. 10016.

OUT-OF-PRINT BOOKS. Box 86NR, Cutten, Calif. 95534. Send wants.

IS CHRISTIANITY CREDIBLE? Little book brilliantly exposes fatal flaw in today's humanist reasoning. Christian, fear this question no longer; rather welcome it. Honest skeptic, a satisfying yet challenging answer. Confirmed atheist, know the enemy's thinking. Send $2.00. WSL Enterprises, Box 9135-NR1, Pembroke Pines, Fla. 33024.

ATTENTION: NEWSLETTER WRITERS, writers, researchers, politicians: Send for free information regarding unique research clipping service. Davis Research, P.O. Box 1536, Sun City, Ariz. 85372.

1,100-TITLE CATALOGUE of Catholic books. All categories, many scarce, out-of-print, 25¢. Catholic Catalogue, Box 433, East Elmhurst, N.Y. 11369.

THE UNFINDABLE FOUND. For our free and indefatigable search service, just send us your "hard-to-find" book wants. No obligation. Dept. NR, Bookfinders General, Inc., 145 East 27th Street, New York, N.Y. 10016.

BOOKS LOCATED. Send wants. No obligation. Baza Books, Box 496, Chico, Calif. 95927.

THE INDEPENDENT JOURNAL OF PHILOSOPHY provides an international forum for the exploration of responsible, articulate alternatives to the positivist/ analytical, Marxist, and narrowly academicist trends of contemporary philosophy. Subscription—$12.00 (Students $8.50); 38 rue St.-Louis-en-l'Ile, F-75004-NR, Paris, France.

FREE SEARCH for out-of-print books. Write, visit, call 201-221-9024, Bookstock, 7N Church Street, Bernardsville, N.J. 07924.

BILL RICKENBACKER's funny, warm accounts of life on his Yankee farm: subscribe to "The Berry Patch Letters." Twelve issues, $8 a year. Box 158, West Boxford, Mass. 01885.

PUBLISHER'S OVERSTOCKS, BARGAIN BOOKS. 2,000 titles, all subjects! Free catalogue: Hamilton, 98-73 Clapboard, Danbury, Conn. 06810.

CHILTON WILLIAMSON JR.

the West has unnecessarily forfeited governments, influence, and international prestige to guerrilla armies and their distant masters.

Shackley finished his book before the 1980 election, but even from that uncertain perspective he saw the glimmering of hope. The country, he thinks, has entered the post-Vietnam era: Iranian students bearing THE U.S. CANNOT DO ANYTHING placards have had their effect. What the United States must do, says Shackley, is replace the mangled CIA with an entirely new agency, train and equip more counterinsurgency specialists and get back to work fight

III
ART AS FORM

6. SIGNIFICANT FORM

CLIVE BELL

The Aesthetic Hypothesis

... The starting-point for all systems of aesthetics must be the personal ←
experience of a peculiar emotion. The objects that provoke this emotion
we call works of art. All sensitive people agree that there is a peculiar
emotion provoked by works of art. I do not mean, of course, that all
works provoke the same emotion. On the contrary, every work produces
a different emotion. But all these emotions are recognizably the same
in kind—so far, at any rate, the best opinion is on my side. That there
is a particular kind of emotion provoked by works of visual art, and that
this emotion is provoked by every kind of visual art, by pictures,
sculptures, buildings, pots, carvings, textiles, etc., is not disputed, I
think, by any one capable of feeling it. This emotion is called the
AESTHETIC emotion; and if we can discover some quality common and ←
peculiar to all the objects that provoke it, we shall have solved what I
take to be the central problem of aesthetics. We shall have discovered
the essential quality in a work of art, the quality that distinguishes works
of art from all other classes of objects.

For either all works of visual art have some common quality, or
when we speak of "works of art" we gibber. Every one speaks of "art,"
making a mental classification by which he distinguishes the class
"works of art" from all other classes. What is the justification of this
classification? What is the quality common and peculiar to all members
of this class? Whatever it be, no doubt it is often found in company
with other qualities; but they are adventitious—it is essential. There
must be some one quality without which a work of art cannot exist;
possessing which, in the least degree, no work is altogether worthless.
What is this quality? What quality is shared by all objects that provoke

FROM CHAPTERS 1 AND 3 OF *Art*, BY CLIVE BELL. COPYRIGHT 1913 BY CHATTO & WINDUS
LTD., LONDON, AND REPRINTED BY KIND PERMISSION OF CHATTO & WINDUS LTD. AND
MR. QUENTIN BELL AND OF G. P. PUTMAM'S SONS.

our aesthetic emotions? What quality is common to Sta. Sophia and
the windows at Chartres, Mexican sculpture, a Persian bowl, Chinese
carpets, Giotto's frescoes at Padua, and the masterpieces of Poussin,
Piero della Francesca, and Cezanne? Only one answer seems possible—
significant form. In each, lines and colors combined in a particular way,
certain forms and relations of forms, stir our aesthetic emotions. These
relations and combinations of lines and colors, these aesthetically
moving forms, I call "Significant Form" and "Significant Form" is
the one quality common to all works of visual art.

At this point it may be objected that I am making aesthetics a
purely subjective business, since my only data are personal experiences
of a particular emotion. It will be said that the objects that provoke this
emotion vary with each individual, and that therefore a system of
aesthetics can have no objective validity. It must be replied that any
system of aesthetics which pretends to be based on some objective
truth is so palpably ridiculous as not to be worth discussing. We have
no other means of recognizing a work of art than our feeling for it.
The objects that provoke aesthetic emotion vary with each individual.
Aesthetic judgments are, as the saying goes, matters of taste; and about
tastes, as every one is proud to admit, there is no disputing. A good
critic may be able to make me see in a picture that had left me cold
things that I had overlooked, till at last, receiving the aesthetic emotion,
I recognize it as a work of art. To be continually pointing out those
parts, the sum or rather the combination, of which unite to produce
significant form is the function of criticism. But it is useless for a critic
to tell me that something is a work of art; he must make me feel it for
myself. This he can do only by making me see; he must get at my emo-
tions through my eyes. Unless he can make me see something that
moves me, he cannot force my emotions. I have no right to consider
anything a work of art to which I cannot react emotionally; and I have
no right to look for the essential quality in anything that I have not
felt to be a work of art. The critic can affect my aesthetic theories only
by affecting my aesthetic experience. All systems of aesthetics must be
based on personal experience—that is to say, they must be subjective.

Yet, although all aesthetic theories must be based on aesthetic
judgments, and ultimately all aesthetic judgments must be matters of
personal taste, it would be rash to assert that no theory of aesthetics
can have general validity. For, though A, B, C, D are the works that
move me, and A, D, E, F the works that move you, it may well be that
x is the only quality believed by either of us to be common to all the
works in his list. We may all agree about aesthetics, and yet differ about
particular works of art. We may differ as to the presence or absence of
the quality x. My immediate object will be to show that significant

form is the only quality common and peculiar to all the works of visual art that move me; and I will ask those whose aesthetic experience does not tally with mine to see whether this quality is not also, in their judgment, common to all works that move them, and whether they can discover any other quality of which the same can be said. . . .

"Are you forgetting about color?" someone inquires. Certainly not; my term "significant form" included combinations of lines and of colors. The distinction between form and color is an unreal one; you cannot conceive a colorless line or a colorless space; neither can you conceive a formless relation of colors. In a black and white drawing the spaces are all white and all are bounded by black lines; in most oil paintings the spaces are multi-colored and so are the boundaries; you cannot imagine a boundary line without any content, or a content without a boundary line. Therefore, when I speak of significant form, I mean a combination of lines and colors (counting white and black as colors) that moves me aesthetically.

Some people may be surprised at my not having called this "beauty." Of course to those who define beauty as "combinations of lines and colors that provoke aesthetic emotion," I willingly concede the right of substituting their word for mine. But most of us, however strict we may be, are apt to apply the epithet "beautiful" to objects that do not provoke that peculiar emotion produced by works of art. Everyone, I suspect, has called a butterfly or a flower beautiful. Does anyone feel the same kind of emotion for a butterfly or a flower that he feels for a cathedral or a picture? Surely, it is not what I call an aesthetic emotion that most of us feel, generally, for natural beauty. I shall suggest, later, that some people may, occasionally, see in nature what we see in art, and feel for her an aesthetic emotion; but I am satisfied that, as a rule, most people feel a very different kind of emotion for birds and flowers and the wings of butterflies from that which they feel for pictures, pots, temples, and statues. Why these beautiful things do not move us as works of art move us is another, and not an aesthetic, question. For our immediate purposes we have to discover only what quality is common to objects that do move us as works of art. In the last part of this chapter, when I try to answer the question "Why are we so profoundly moved by some combinations of lines and colors?" I shall hope to offer an acceptable explanation of why we are less profoundly moved by others.

Since we call a quality that does not raise the characteristic aesthetic emotion "beauty," it would be misleading to call by the same name the quality that does. To make "beauty" the object of the aesthetic emotion, we must give to the word an overstrict and unfamiliar definition. Every one sometimes uses "beauty" in an unaesthetic sense;

most people habitually do so. To everyone, except perhaps here and
there an occasional aesthete, the commonest sense of the word is
unaesthetic. Of its grosser abuse, patent in our chatter about "beautiful
huntin' " and "beautiful shootin' ", I need not take account; it would
be open to the precious to reply that they never do so abuse it. Besides,
here there is no danger of confusion between the aesthetic and the non-
aesthetic use; but when we speak of a beautiful woman there is. When
an ordinary man speaks of a beautiful woman he certainly does not
mean only that she moves him aesthetically; but when an artist calls
a withered old hag beautiful he may sometimes mean what he means
when he calls a battered torso beautiful. The ordinary man, if he be
also a man of taste, will call the battered torso beautiful, but he will
not call a withered hag beautiful because, in the matter of women, it
is not to the aesthetic quality that the hag may possess, but to some other
quality that he assigns the epithet. Indeed, most of us never dream of
going for aesthetic emotions to human beings, from whom we ask
something very different. This "something," when we find it in a young
woman, we are apt to call "beauty." We live in a nice age. With the
man-in-the-street "beautiful" is more often than not synonymous with
"desirable"; the word does not necessarily connote any aesthetic
reaction whatever, and I am tempted to believe that in the minds of
many the sexual flavor of the word is stronger than the aesthetic. I
have noticed a consistency in those to whom the most beautiful thing
in the world is a beautiful woman, and the next most beautiful thing
a picture of one. The confusion between aesthetic and sensual beauty is
not in their case so great as might be supposed. Perhaps there is none;
for perhaps they have never had an aesthetic emotion to confuse with
their other emotions. The art that they call "beautiful" is generally
closely related to the women. A beautiful picture is a photograph of a
pretty girl; beautiful music, the music that provides emotions similar
to those provoked by young ladies in musical farces; and beautiful
poetry, the poetry that recalls the same emotions felt, twenty years
earlier, for the rector's daughter. Clearly the word "beauty" is used to
connote the objects of quite distinguishable emotions, and that is a reason
for not employing a term which would land me inevitably in confusions
and misunderstandings with my readers.

On the other hand, with those who judge it more exact to call these
combinations and arrangements of form that provoke our aesthetic
emotions, not "significant form," but "significant relations of form,"
and then try to make the best of two worlds, the aesthetic and the
metaphysical, by calling these relations "rhythm," I have no quarrel
whatever. Having made it clear that by "significant form" I mean

arrangements and combinations that move us in a particular way, I
willingly join hands with those who prefer to give a different name to
the same thing.

The hypothesis that significant form is the essential quality in a
work of art has at least one merit denied to many more famous and
more striking—it does help to explain things. We are all familiar with
pictures that interest us and excite our admiration, but do not move
us as works of art. To this class belongs what I call "Descriptive
Painting"—that is, painting in which forms are used not as objects
of emotion, but as means of suggesting emotion or conveying infor-
mation. Portraits of psychological and historical value, topographical
works, pictures that tell stories and suggest situations, illustrations of all
sorts, belong to this class. That we all recognize the distinction is clear,
for who has not said that such and such a drawing was excellent as
illustration, but as a work of art worthless? Of course many descriptive
pictures possess, amongst other qualities, formal significance, and are
therefore works of art: but many more do not. They interest us; they
may move us in a hundred different ways, but they do not move us
aesthetically. According to my hypothesis they are not works of art.
They leave untouched our aesthetic emotions because it is not their
forms but the ideas or information suggested or conveyed by their forms
that affect us. . . .

Let no one imagine that representation is bad in itself. A realistic
form may be as significant, in its place as a part of the design, as an
abstract. But if a representative form has value, it is as form, not as
representation. The representative elements in a work of art may or
may not be harmful; always it is irrelevant. For, to appreciate a work
of art we need bring with us nothing from life, no knowledge of its
ideas and affairs, no familiarity with its emotions. Art transports us
from the world of man's activity to a world of aesthetic exaltation. For a
moment we are shut off from human interests; our anticipations and
memories are arrested; we are lifted above the stream of life. The pure
mathematician rapt in his studies knows a state of mind which I take to
be similar, if not identical. He feels an emotion for his speculations
which arises from no perceived relation between them and the lives of
men, but springs, inhuman or superhuman, from the heart of an
abstract science. I wonder, sometimes, whether the appreciators of art
and of mathematical solutions are not even more closely allied. Before
we feel an aesthetic emotion for a combination of forms, do we not
perceive intellectually the rightness and necessity of the combination?
If we do, it would explain the fact that passing rapidly through a room
we recognize a picture to be good, although we cannot say that it has

provoked much emotion. We seem to have recognized intellectually the rightness of its forms without staying to fix our attention, and collect, as it were, their emotional significance. If this were so, it would be permissible to inquire whether it was the forms themselves or our perception of their rightness and necessity that caused aesthetic emotion. But I do not think I need linger to discuss the subject here. I have been inquiring why certain combinations of forms move us; I should not have traveled by other roads had I enquired, instead, why certain combinations are perceived to be right and necessary, and why our perception of their rightness and necessity is moving. What I have to say is this: the rapt philosopher, and he who contemplates a work of art, inhabit a world with an intense and peculiar significance of its own; that significance is unrelated to the significance of life. In this world the emotions of life find no place. It is a world with emotions of its own.

To appreciate a work of art we need bring with us nothing but a sense of form and color and a knowledge of three-dimensional space. That bit of knowledge, I admit, is essential to the appreciation of many great works, since many of the most moving forms ever created are in three dimensions. To see a cube or a rhomboid as a flat pattern is to lower its significance, and a sense of three-dimensional space is essential to the full appreciation of most architectural forms. Pictures which would be insignificant if we saw them as flat patterns are profoundly moving because, in fact, we see them as related planes. If the representation of three-dimensional space is to be called "representation," then I agree that there is one kind of representation which is not irrelevant. Also, I agree that along with our feeling for line and color we must bring with us our knowledge of space if we are to make the most of every kind of form. Nevertheless, there are magnificent designs to an appreciation of which this knowledge is not necessary: so, though it is not irrelevant to the appreciation of some works of art it is not essential to the appreciation of all. What we must say is that the representation of three-dimensional space is neither irrelevant nor essential to all art, and that every other sort of representation is irrelevant.

That there is an irrelevant representative or descriptive element in many great works of art is not in the least surprising. Why it is not surprising I shall try to show elsewhere. Representation is not of necessity baneful, and highly realistic forms may be extremely significant. Very often, however, representation is a sign of weakness in an artist. A painter too feeble to create forms that provide more than a little aesthetic emotion will try to eke that little out by suggesting the emotions of life. To evoke the emotions of life he must use representation. Thus a

man will paint an execution, and, fearing to miss with his first barrel of significant form, will try to hit with his second by raising an emotion of fear or pity. But if in the artist an inclination to play upon the emotions of life is often the sign of a flickering inspiration, in the spectator a tendency to seek, behind form, the emotions of life is a sign of defective sensibility always. It means that his aesthetic emotions are weak or, at any rate, imperfect. Before a work of art people who feel little or no emotion for pure form find themselves at a loss. They are deaf men at a concert. They know that they are in the presence of something great, but they lack the power of apprehending it. They know that they ought to feel for it a tremendous emotion, but it happens that the particular kind of emotion it can raise is one that they can feel hardly or not at all. And so they read into the forms of the work those facts and ideas for which they are capable of feeling emotion, and feel for them the emotions that they can feel—the ordinary emotions of life. When confronted by a picture, instinctively they refer back its forms to the world from which they came. They treat created form as though it were imitated form, a picture as though it were a photograph. Instead of going out on the stream of art into a new world of aesthetic experience, they turn a sharp corner and come straight home to the world of human interests. For them the significance of a work of art depends on what they bring to it; no new thing is added to their lives, only the old material is stirred. A good work of visual art carries a person who is capable of appreciating it out of life into ecstasy; to use art as a means to the emotions of life is to use a telescope for reading the news. You will notice that people who cannot feel pure aesthetic emotions remember pictures by their subjects; whereas people who can, as often as not, have no idea what the subject of a picture is. They have never noticed the representative element, and so when they discuss pictures they talk about the shapes of forms and the relations and quantities of colors. Often they can tell by the quality of a single line whether or no a man is a good artist. They are concerned only with lines and colors, their relations and quantities and qualities, but from these they win an emotion more profound and far more sublime than any that can be given by the description of facts and ideas.

This last sentence has a very confident ring—over-confident, some may think. Perhaps I shall be able to justify it, and make my meaning clearer too, if I give an account of my own feelings about music. I am not really musical. I do not understand music well. I find musical form exceedingly difficult to apprehend, and I am sure that the profounder subtleties of harmony and rhythm more often than not escape me. The form of a musical composition must be simple indeed if I am

to grasp it honestly. My opinion about music is not worth having. Yet, sometimes, at a concert, though my appreciation of the music is limited and humble, it is pure. Sometimes, though I have a poor understanding, I have a clean palate. Consequently, when I am feeling bright and clear and intent, at the beginning of a concert for instance, when something that I can grasp is being played, I get from music that pure aesthetic emotion that I get from visual art. It is less intense, and the rapture is evanescent; I understand music too ill for music to transport me far into the world of pure aesthetic ecstasy. But at moments I do appreciate music as pure musical form, as sounds combined according to the laws of a <u>mysterious necessity</u>, as pure art with a tremendous significance of its own and no relation whatever to the significance of life; and in those moments I lost myself in that infinitely sublime state of mind to which pure visual form transports me. How inferior is my normal state of mind at a concert. Tired or perplexed, I let slip my sense of form, my aesthetic emotion collapses, and I begin weaving into the harmonies, that I cannot grasp, the ideas of life. Incapable of feeling the austere emotions of art, I begin to read into the musical forms human emotions of terror and mystery, love and hate, and spend the minutes, pleasantly enough, in a world of turbid and inferior feeling. At such times, were the grossest pieces of onomatopoetic representation—the song of a bird, the galloping of horses, the cries of children, or the laughing of demons—to be introduced into the symphony, I should not be offended. Very likely I should be pleased; they would afford new points of departure for new trains of romantic feeling or heroic thought. I know very well what has happened. I have been using art as a means to the emotions of life and reading into it the ideas of life. I have been cutting blocks with a razor. I have tumbled from the superb peaks of aesthetic exaltation to the snug foothills of warm humanity. It is a jolly country. No one need be ashamed of enjoying himself there. Only no one who has ever been on the heights can help feeling a little crestfallen in the cozy valleys. And let no one imagine, because he has made merry in the warm tilth and quaint nooks of romance, that he can even guess at the austere and thrilling raptures of those who have climbed the cold, white peaks of art.

About music most people are as willing to be humble as I am. If they cannot grasp musical form and win from it a pure aesthetic emotion they confess that they understand music imperfectly or not at all. They recognize quite clearly that there is a difference between the feeling of the musician for pure music and that of the cheerful concert-goer for what music suggests. The latter enjoys his own emotions, as he has every right to do, and recognizes their inferiority. Unfor-

tunately, people are apt to be less modest about their powers of appreciating visual art. Everyone is inclined to believe that out of pictures at any rate, he can get all that there is to be got; everyone is ready to cry "humbug" and "impostor" at those who say that more can be had. The good faith of people who feel pure aesthetic emotions is called in question by those who have never felt anything of the sort. It is the prevalence of the representative element, I suppose, that makes the man in the street so sure that he knows a good picture when he sees one. For I have noticed that in matters of architecture, pottery, textiles, etc., ignorance and ineptitude are more willing to defer to the opinions of those who have been blest with peculiar sensibility. It is a pity that cultivated and intelligent men and women cannot be induced to believe that a great gift of aesthetic appreciation is at least as rare in visual as in musical art. A comparison of my own experience in both has enabled to discriminate very clearly between pure and impure appreciation. Is it too much to ask that others should be as honest about their feelings for pictures as I have been about mine for music? For I am certain that most of those who visit galleries do feel very much what I feel at concerts. They have their moments of pure ecstasy; but the moments are short and unsure. Soon they fall back into the world of human interests and feel emotions, good no doubt, but inferior. I do not dream of saying that what they get from art is bad or nugatory; I say that they do not get the best that art can give. I do not say that they cannot understand art; rather I say that they cannot understand the state of mind of those who understand it best. I do not say that art means nothing or little to them; I say they miss its full significance. I do not suggest for one moment that their appreciation of art is a thing to be ashamed of; the majority of the charming and intelligent people with whom I am acquainted appreciate visual art impurely; and, by the way, the appreciation of almost all great writers has been impure. But provided that there be some fraction of pure aesthetic emotion, even a mixed and minor appreciation of art is, I am sure, one of the most valuable things in the world—so valuable, indeed, that in my giddier moments I have been tempted to believe that art might prove the world's salvation.

Yet, though the echoes and shadows of art enrich the life of the plains, her spirit dwells on the mountains. To him who woos, but woos impurely, she returns enriched what is brought. Like the sun, she warms the good seed in good soil and causes it to bring forth good fruit. But only to the perfect lover does she give a new strange gift—a gift beyond all price. Imperfect lovers bring to art and take away the ideas and emotions of their own age and civilization. In twelfth-century Europe a man might have been greatly moved by a Romanesque church

and found nothing in a T'ang picture. To a man of a later age, Greek
sculpture meant much and Mexican nothing, for only to the former
could he bring a crowd of associated ideas to be the objects of familiar
emotions. But the perfect lover, he who can feel the profound signi-
ficance of form, is raised above the accidents of time and place. To him
the problems of archaeology, history, and hagiography are impertinent.
If the forms of a work are significant its provenance is irrelevant. Before
the grandeur of those Sumerian figures in the Louvre he is carried on the
same flood of emotion to the same aesthetic ecstasy as, more than four
thousand years ago, the Chaldean lover was carried. It is the mark of
great art that its appeal is universal and eternal. Significant form stands
charged with the power to provoke aesthetic emotion in anyone capable
of feeling it. The ideas of men go buzz and die like gnats; men change
their institutions and their customs as they change their coats; the
intellectual triumphs of one age are the follies of another; only great
art remains stable and unobscure. Great art remains stable and un-
obscure because the feelings that it awakens are independent of time
and place, because its kingdom is not of this world. To those who have
and hold a sense of the significance of form what does it matter whether
the forms that move them were created in Paris the day before yesterday
or in Babylon fifty centuries ago? The forms of art are inexhaustible;
but all lead by the same road of aesthetic emotion to the same world of
aesthetic ecstasy.

(Mr. Roger Fry permits me to make use of an interesting story that
will illustrate my view. When Mr. Okakura, the Government editor of
The Temple Treasures of Japan, first came to Europe, he found no
difficulty in appreciating the pictures of those who from want of will
or want of skill did not create illusions but concentrated their
energies on the creation of form. He understood immediately the
Byzantine masters and the French and Italian primitives. In the
Renaissance painters, on the other hand, with their descriptive pre-
occupations, their literary and anecdotic interests, he could see nothing
but vulgarity and muddle. The universal and essential quality of art,
significant form, was missing, or rather had dwindled to a shallow
stream, overlaid and hidden beneath weeds, so the universal response,
aesthetic emotion, was not evoked. It was not till he came on to Henri
Matisse that he again found himself in the familiar world of pure art.
Similarly, sensitive Europeans who respond immediately to the signi-
ficant forms of great Oriental art, are left cold by the trivial pieces of
anecdote and social criticism so lovingly cherished by Chinese dilettanti.
It would be easy to multiply instances did not decency forbid the
laboring of so obvious a truth.)

The Metaphysical Hypothesis

... It seems to me possible, though by no means certain, that created form moves us so profoundly because it expresses the emotion of its creator. ... If this be so, it will explain that curious but undeniable fact, to which I have already referred, that what I call material beauty (e.g. the wing of a butterfly) does not move most of us in at all the same way as a work of art moves us. It is beautiful form, but it is not significant form. It moves us, but it does not move us aesthetically. It is tempting to explain the difference between "significant form" and "beauty"—that is to say, the difference between form that provokes our aesthetic emotions and form that does not—by saying that significant form conveys to us an emotion felt by its creator and that beauty conveys nothing.

For what, then, does the artist feel the emotion that he is supposed to express? Sometimes it certainly comes to him through material beauty. The contemplation of natural objects is often the immediate cause of the artist's emotion. Are we to suppose, then, that the artist feels, or sometimes feels, for material beauty what we feel for a work of art? Can it be that sometimes for the artist material beauty is somehow significant—that is, capable of provoking aesthetic emotion? And if the form that provokes aesthetic emotion be form that expresses something, can it be that material beauty is to him expressive? Does he feel something behind it as we imagine that we feel something behind the forms of a work of art?. . . .

The emotion that the artist felt in his moment of inspiration he did not feel for objects seen as means, but for objects seen as pure forms—that is, as ends in themselves. He did not feel emotion for a chair as a means to physical well-being, nor as an object associated with the intimate life of a family, nor as the place where someone sat saying things unforgettable, nor yet as a thing bound to the lives of hundreds of men and women, dead or alive, by a hundred subtle ties; doubtless an artist does often feel emotions such as these for the things that he sees, but in the moment of aesthetic vision he sees objects, not as means shrouded in associations, but as pure forms. It is for, or at any rate through, pure form that he feels his inspired emotion.

Now to see objects as pure forms is to see them as ends in themselves. For though, of course, forms are related to each other as parts of a whole, they are related on terms of equality; they are not a means to anything except emotion. But for objects seen as ends in themselves, do we not feel a profounder and a more thrilling emotion than ever we

felt for them as means? All of us, I imagine, do, from time to time, get
a vision of material objects as pure forms. We see things as ends in
themselves, that is to say; and at such moments it seems possible, and
even probable, that we see them with the eye of an artist. Who has not,
once at least in his life, had a sudden vision of landscape as pure form?
For once, instead of seeing it as fields and cottages, he has felt it as
lines and colors. In that moment has he not won from material beauty
a thrill indistinguishable from that which art gives? And, if this be so,
is it not clear that he has won from material beauty the thrill that,
generally, art alone can give, because he has contrived to see it as a pure
formal combination of lines and colors? May we go on to say that,
having seen it as pure form, having freed it from all casual and adventi-
tious interest, from all that it may have acquired from its commerce
with human beings, from all its significance as a means, he has felt its
significance as an end in itself?. . . .

But if an object considered as an end in itself moves us more pro-
foundly (i.e. has greater significance) than the same object considered
as a means to practical ends or as a thing related to human interests—
and this undoubtedly is the case—we can only suppose that when we
consider anything as an end in itself we become aware of that in it
which is of greater moment than any qualities it may have acquired
from keeping company with human beings. Instead of recognizing its
accidental and conditioned importance, we become aware of its
essential reality, of the God in everything, of the universal in the par-
ticular, of the all-pervading rhythm. Call it by what name you will,
the thing that I am talking about is that which lies behind the appear-
ance of all things—that which gives to all things their individual
significance. . . . And if a more or less unconscious apprehension of this
latent reality of material things be, indeed, the cause of that strange
emotion, a passion to express which is the inspiration of many artists,
it seems reasonable to suppose that those who, unaided by material
objects, experience the same emotion have come by another road to the
same country.

That is the metaphysical hypothesis. Are we to swallow it whole,
accept a part of it, or reject it altogether? Each must decide for himself.
I insist only on the rightness of my aesthetic hypothesis. And of one
other thing I am sure. Be they artists or lovers of art, mystics or mathe-
maticians, those who achieve ecstasy are those who have freed them-
selves from the arrogance of humanity. He who would feel the signi-
ficance of art must make himself humble before it. Those who find the
chief importance of art or of philosophy in its relation to conduct or its

practical utility—those who cannot value things as ends in themselves or, at any rate, as direct means to emotion—will never get from anything the best that it can give. Whatever the world of aesthetic contemplation may be, it is not the world of human business and passion; in it the chatter and tumult of material existence is unheard, or heard only as the echo of some more ultimate harmony.

7. ART AS FORM

ROGER FRY

. . . In nearly all works of art agreeable sensations form the very texture
of the work. In music pleasurable quality of sound is the object of
deliberate research, but it is by no means evident that this is essential.
Some effects of modern music suggest that relations of more noises
not in themselves agreeable can arouse aesthetic pleasure, and many
great composers have worked in sound textures which were generally
proclaimed harsh and disagreeable. If it be said that though disagree-
able to the audiences they had been found agreeable by the composer,
we are none the less faced with the fact that his contemporaries did,
after all, accept his work for its aesthetic quality even whilst the sound-
texture appeared unpleasing; although under stress of that aesthetic
satisfaction the unpleasure gradually changed to pleasure.

For vision, as for hearing, there are simple pleasant sensations and
simple indifferent or even unpleasant sensations, notably with regard
to colour. Pure, brightly luminous colours have a strong physiological
effect of a pleasing kind. This is especially marked in children, but long
after we have ceased to stop in front of the chemist's windows to gaze
at light seen through blue and red solutions we are still aware of the
attraction. But when we come to arrangements of colour in a work of
art all these sensational effects may be overridden by our emotions
about colour relations. Some works of the greatest colourists are built
up of elements each of which is devoid of any specially pleasurable
quality, and they may even be, to particular observers, positively
unpleasant, although that displeasure is immediately swamped by the
pleasure which results from their interrelation.

In literature there is no immediate sensual pleasure whatever,
though it may be a favourable predisposing condition for poetry to be
spoken by a beautiful voice. There is, of course, the pleasure of rhythmic

FROM CHAPTER I OF *Transformations* BY ROGER FRY, PP. 4–7, 9–10, 15–27. COPY-
RIGHT 1926 BY CHATTO & WINDUS LTD., LONDON, AND REPRINTED BY KIND PER-
MISSION OF THE PUBLISHER AND MRS. PAMELA DIAMAND.

utterance, but this is already concerned with relations, and even this is, I believe, accessory to the emotion aroused by rhythmic changes of states of mind due to the meanings of the words.

In architecture materials are often chosen for the comparatively simple sensual pleasure which their surfaces arouse. But we distinguish at once between this pleasure and those emotions which are generated by our apprehension of architectural plasticity. Before too many buildings on which polished marble and gilt bronze are lavished our pleasure in these appearances is more than counterbalanced by the painful absence of aesthetic purpose. The ensuing reflections on the waste of so much precious material cause them to become actually a source of mental pain.

The aesthetic emotion, then, is not an emotion about sensations, however necessary a responsive sensualism may be for our apprehension of aesthetic wholes. Nor it it an emotion about objects or persons or events. Here we touch the crux of the aesthetic experience for the greater number of people who are accustomed to rely almost exclusively on their interest in, or emotion about, the persons or events called to mind by the imagery of the fine arts. Landscape, for such, is just reminiscence or revelation of pleasant natural scenes; portraiture interests by the beautiful or fascinating ladies and the celebrated gentlemen it presents; figure painting avails by its attractive or provocative nudes; literature by its exciting events or its imagined wish fulfilments. In fact, the vast mass of so-called works of art are designed primarily to arouse these interests and emotions even though in doing this some aesthetic appeals may supply an accompaniment.

These observations appear to me to have made out a very fair *a priori* case for the existence in all aesthetic experiences of a special orientation of the consciousness, and, above all, a special focussing of the attention, since the act of aesthetic apprehension implies an attentive passivity to the effects of sensations apprehended in their relations. We have no need for our purposes to create the hypothesis of any mysterious or specific faculty.

There is no need to imagine that the state of mind here indicated is unanalysable, probably it may be resolved into different factors, none of which is peculiar to this state. The same mental faculties and aptitudes as enter into play in aesthetic apprehension no doubt are employed elsewhere. What matters for us is that there should be a constant and recognisable pattern of the mental disposition in such situations. I believe that this is so, and that the pattern is distinct enough for us to say, in contradiction to Mr. Richards, that when we are in the picture gallery we are employing our faculties in a manner so distinct from that

in which we employed them on the way there, that it is no exaggeration to say we are doing a quite different thing. On the way there our conscious attention must frequently have been directed to spotting and catching the right 'bus, or detecting the upright flag of a distant taxicab, or, at least, avoiding collisions on the pavement or recognising our friends. I exclude the case of those who being artists themselves may, in the course of their walk, have been preoccupied with distilling from their diverse visual sensations some vague sketches and adumbrations of possible harmonic combinations. Such, and such alone, might, I think, be said to have been similarly occupied on their way to and within the gallery.

If I am right, then it is not impossible to draw a fairly sharp dividing line between our mental disposition in the case of aesthetic responses and that of the responses of ordinary life. A far more difficult question arises if we try to distinguish it from the responses made by us to certain abstract mental constructions such as those of pure mathematics. Here I conceive the emotional states due to the apprehension of relations may be extremely similar to those aroused by the aesthetic apprehension. Perhaps the distinction lies in this, that in the case of works of art the whole end and purpose is found in the exact quality of the emotional state, whereas in the case of mathematics the purpose is the constatation of the universal validity of the relations without regard to the quality of the emotion accompanying apprehension. Still, it would be impossible to deny the close similarity of the orientation of faculties and attention in the two cases.

The special cases of literature and representative painting still call for further elucidation.

With regard to literature, much misunderstanding is likely to arise owing to the absence of any proper classification and nomenclature of the very various purposes which are covered by the term. We have no words to distinguish between writing used for exposition, speculation, criticism or exhortation, and writing used for the creation of a work of art. Moreover, the medium allows of sudden and often concealed shifts from its uses for one purpose to those for another. It is a medium which admits the mixture of aesthetic and non-aesthetic treatment to an almost unlimited extent. Even in the novel, which as a rule has pretensions to being a work of art, the structure may be so loose, the aesthetic effects may be produced by so vast an accumulation of items that the temptation for the artist to turn aside from his purpose and interpolate criticisms of life, of manners or morals, is very strong. Comparatively few novelists have ever conceived of the novel as a single perfectly organic aesthetic whole. An instance of the confusion to which

this loose nomenclature may give rise, occurs in Mr. Richards' book, where, in order to prove that literature may have ulterior ends which ← envisage morals, religions, etc., he says, "There seem to be kinds of poetry in which its value as poetry definitely and distinctly depends upon the ulterior ends involved. Consider the Psalms, Isaiah, the New Testament, Dante, the 'Pilgrim's Progress,' Rabelais, any really universal satire, Swift, Voltaire, Byron." Now only a few of the works alluded to here are works of art in any proper sense. In most, no doubt, some aesthetic qualities are introduced. In the case of the "Pilgrim's Progress," for instance, the appearance of an aesthetic structure is deliberately chosen as a bait to lure the reader for an ulterior non-aesthetic end, but it is surely a common experience that a reader can fully relish the bait without so much as a scratch from Bunyan's hook. The fact that ulterior ends are pursued in many of these books does not show that those parts of them which appeal to the aesthetic sensibility cannot be fully apprehended by those who reject the ends. It would need detailed investigation of the passages at issue to prove that these ulterior ends in any way contributed to the poetic effect, however much they may have been the pretext of the predisposing condition of their creation.

. . .

 I believe that the cinema has provided us with a new angle of perspective which helps us to a clearer idea of what our experience really is before at least one type of literary structure, the tragic drama. I must cite in this context what was for me a crucial experiment and one which every one is sure to have opportunities to repeat. I was present at a film which recorded the work of rescue from a ship wrecked off the coast of Portugal. One saw at a considerable distance the hull of the vessel stranded on a flat shore and in between crest after crest of huge waves. In the foreground men were working desperately pulling at a rope which ever so slowly drew away from the distant ship a small black object which swayed and swung from the guide rope. Again and again the waves washed over it in its slow progress shorewards. It was not till it was near shore that one realised that this was a basket with a human being in it. When it was finally landed the men rushed to it and took out—a man or a corpse, according to the luck of the passage or the resistance of the individual. The fact that one was watching a film cut off all those activities which, in the real situation, might have been a vent and mitigation of one's emotions. One was a

pure, helplessly detached spectator, and yet a spectator of a real event with the real, not merely the simulated, issue of life and death.

For this reason no situation on the stage could be half so poignant, could grip the emotions of pity and terror half so tensely. If to do this were the end and purpose of drama, according to Aristotle's purgation theory, and not a means to some other and different end, then the cinema had surpassed the greatest tragedians. But, in point of fact, the experience, though it was far more acute and poignant, was recognisably distinct and was judged at once as of far less value and significance than the experience of a great tragic drama. And it became evident to me that the essential of great tragedy was not the emotional intensity of the events portrayed, but the vivid sense of the inevitability of their unfolding, the significance of the curve of crescendo and diminuendo which their sequence describes, together with all the myriad subsidiary evocations which, at each point, poetic language can bring in to give fullness and density to the whole organic unity.

. . .

Let us take . . . a picture in which the representational element is obviously of great importance, for instance, Pieter Brueghel's "Carrying of the Cross" in the museum at Vienna . . . Here we look out upon a large stretch of country filled with crowds of figures which are inevitably so small in scale that they can hardly be related plastically with the picture space. Nor is any attempt made to do this. Rather we are invited by the whole method of treatment to come close and peer at each figure in turn, and read from it those details which express its particular state of mind so that we may gradually, almost as we might in a novel, bring them together to build up a highly complex psychological structure. We are able thus to distinguish the figure of Christ bearing the Cross, and, with the knowledge of the Gospel story which is presupposed, we get the central motive of the dramatic theme which is pursued throughout the picture with that leisurely accumulation of separate psychological elements which is characteristic of some dramatic literature. In the distance we recognise the hill of Calvary and on it what looks like a black ring, too small indeed to have any significance in a plastic sense, but when we look close and realise that it represents the crowds who have long been struggling for a favourable point of view for the forthcoming spectacle of the Crucifixion, we get a peculiar thrill of dramatic terror and pity. We recognise at once that this is a great psychological invention, setting up profound vibrations of feeling within us by its poignant condensation of expression. It is such an

invention as Shakespeare will at times throw in a couple of lines of description. But it is, I repeat, purely literary, and throughout this picture it is clear that Brueghel has subordinated plastic to psychological considerations. It is indeed to my mind entirely trivial and inexpressive when judged as a plastic and spatial creation. In short, it is almost pure illustration, for we may as well use that as a convenient term for the visual arts employed on psychological material. And we must regard illustration as more closely akin in its essence to literature than it is to plastic art, although in its merely external and material aspect it belongs to the latter. It is indeed this, from a fundamental point of view, accidental association which has been the source of so much difficulty and confusion about the nature and purpose of pictorial and glyptic art.

The next case I propose to examine is Daumier's "Gare St. Lazare" ... Speaking for myself, the first impression derived from this is of the imposing effect of the square supports of the arcade, the striking and complicated silhouette of the man to the right, the salience of the centre figure so firmly planted on his feet, and the contrast of all this with the gloomy space which retires to the left, and finally the suggestion of wide aerial spaces given by the houses glimpsed to the right. The first effect, then, is mainly of feelings aroused by plastic relations. But I am almost immediately seized by curiosity about the striking silhouette to the right. Not only the strong contrast of light and shade, but the intricate and accented contours and the agitated movement help to attract attention. The interpretation of these forms as representing an extremely fussy, egoistic, well-to-do, middle-aged, professional gentleman of the '50's sets my imagination going down quite other paths, and so vivid is the notation and appropriateness of every detail that vague adumbrations of his whole domestic life with his pretty, timid, conventional wife, flit across the consciousness. In a similar but less acute way we almost instantly "place" the stout, self-possessed, retired colonel or country gentleman with the muffler. In between these we note the two poor people waiting patiently and uncomplainingly against the column, and share for an instant Daumier's slightly sentimental attitude about the poor which helps to excite, by its adroit contrast, our critical feelings towards the professional gentleman, and we come back to note the avaricious grasp with which he clutches his umbrella.

Then the incident of the sportsman turning round to whistle his dog gives another suggestion of human life and a hint at quite another type of character. We note the extreme aptness to the type of the florid features and the alert gesture, not without a thrill of admiration at the economy with which all this is given, since the imagination is always

most satisfied when it is forced into activity by having to complete the suggestions given to it. Then we turn to the groups to the left—less emphatic because enveloped in the penumbra of the arcade—to the soldier and the priest who merely contribute vague suggestions of the variety of human types without adding anything very pointed; and then to the rather too noble old man invoking the protection of heaven on his daughter leaving him for service in a distant place, and here, speaking personally, I feel that for the first time in this picture a slightly false note is struck, a note that mars though ever so slightly the perfection of the psychological structure.

So all this time we have been entirely forgetting plastic and spatial values we have, through vision, plunged into that spaceless, moral world which belongs characteristically to the novel, and we can hardly help noting, by the way, how distinct this state of mind is from that with which we began. If, however, having for the moment exhausted the rich illustrational matter we return to the contemplation of plastic relations we shall find, I think, that it is not possible to push them much further. We find, no doubt, a generally coherent and intelligible disposition of the volumes in the space. The ample block made by the colonel's figure creates the chief salience and divides the space left to right satisfactorily—or nearly so, for I find myself always wondering whether it should not be a little further to the left for perfect balance; nor is it after all quite big enough as volume to fulfil the function it has to perform. For this it should be fused more closely with some other mass to the left instead of being, as it is, rather sharply cut off from the light on the pious father, whose forms, thus cut into, are rather meagre and insignificant. And this failure in plastic completeness seems actually due to Daumier's desire to bring out more clearly this particular dramatic incident. Nor can we be much interested in the solid rectangle of figures to the left from which four, too equally spaced, upright volumes detach themselves; no interesting plastic sequences here invite us to further contemplation. We see at once that one of the hardest plastic problems of such a scene is due to the fact that human beings are all of about the same height and that a crowd produces a rectangular mass which it is very difficult to relate significantly with the architectural setting. Daumier was clearly conscious of this, for it would be absurd to suppose that his illustrational preoccupations blinded him to plastic considerations, and the seated peasants are an excellent device to break this monotony, as is also the space left between them and the colonel which invites the eye to break into the too monotonous mass by a diagonal receding movement. This may have suggested the excellent pose of the sportsman which is all-effective in enforcing this movement,

though its value is somewhat lessened by an uncertainty as to his position in the space. If we regard his head and shoulders he appears to be, like the child beside him, some way back; the light appears to fall on him through the second opening in the arcade; but when we see, none too clearly, his feet, we find that he is far nearer to us and is in fact, lit by the first arcade. In addition to this the dog is so placed that, although his pose is rightly conceived for assisting the diagonal movement, he blocks the space and hinders the spatial organisation. Had the man been definitely situated in the second opening and the dog had been moving towards him through the shadow we should have been more able to articulate this part of the composition intelligibly. The group to the right is the most plastically satisfactory of all, and the device of the box being lowered from the cab roof and carrying on the diagonal of the man's top-hat breaks for the first time the monotony of the horizontal line of heads.

We have to admit, then, that impressive as the general setting is, the design is not so organised plastically as to unfold to our contemplative gaze new interrelations and correspondences. Nor do I think we have ever been able, except perhaps in the case of the sportsman, definitely to relate plastic with psychological considerations, or find any marked co-operation between the two experiences.

A third case shall be Poussin's "Ulysses discovering Achilles among the daughters of Lycomedon," in the Louvre . . . [see either insert or back cover]. I do not consider this as by any means one of Poussin's masterpieces. I have chosen it because it bears a sufficient likeness to the Daumier, so far as the problem of a group of people related to architecture is concerned. Proceeding in the same manner as before, let us note our impressions as nearly as possible in the order in which they arise. First the curious impression of the receding rectangular hollow of the hall seen in perspective and the lateral spread, in contrast to that, of the chamber in which the scene takes place. This we see to be almost continuously occupied by the volumes of the figures disposed around the circular table, and these volumes are all ample and clearly distinguished but bound together by contrasted movements of the whole body and also by the flowing rhythm set up by the arms, a rhythm which, as it were, plays over and across the main volumes. Next, I find, the four dark rectangular openings at the end of the hall impose themselves and are instantly and agreeably related to the two dark masses of the chamber wall to right and left, as well as to various darker masses in the dresses. We note, too, almost at once, that the excessive symmetry of these four openings is broken by the figure of one of the girls, and that this also somehow fits in with the slight asymmetry of the dark masses of the

chamber walls. So far all our interests have been purely plastic. What the picture is about has not even suggested itself. Perhaps in taking my own experience I am not quite typical: others may at an earlier stage have felt the need of inquiring a little more curiously into this. But at whatever stage we do turn to this we are not likely to get much for our pains. The delight of the daughters in the trinkets which they are examining is expressed in gestures of such dull conventional elegance that they remind me of the desolating effect of some early Victorian children's stories, nor is Ulysses a more convincing psychological entity, and the eager pose of his assistant is too palpably made up because the artist wanted to break the rectangle and introduce a diagonal leading away from the upright of Ulysses. Finally, Achilles acts very ill the part of a man suddenly betrayed by an overwhelming instinct into an unintentional gesture. Decidedly the psychological complex is of the meagrest, least satisfactory, kind, and the imagination turns from it, if not with disgust, at least with relief at having done with so boring a performance. We return to the contemplation of the plasticity with the conviction that our temporary excursion into the realm of psychology had led us nowhere. But on the other hand our contemplation of plastic and spatial relations is continually rewarded. We can dwell with delight on every interval, we accept the exact situation of every single thing with a thrilling sense of surprise that it should so exactly satisfy the demands which the rest of the composition sets up. How unexpectedly, how deliciously right! is our inner ejaculation as we turn from one detail to another or as we contemplate the mutual relations of the main volumes to the whole space. And this contemplation arouses in us a very definite mood, a mood which, if I speak for myself, has nothing whatever to do with psychological entities, which is as remote from any emotions suggested by the subject, as it would be if I listened to one of Bach's fugues. Nor does the story of Ulysses enter into this mood any more than it would into the music if I were told that Bach had composed the fugue after reading that story. As far as I can discover, whatever Poussin may have thought of the matter—and I suspect he would have been speechless with indignation at my analysis—the story of Achilles was merely a pretext for a purely plastic construction. Nor can I, in this case at least, discover any trace of co-operation between the psychological and the plastic experiences which we derive from this work of art, though we have seen, in the pose of Ulysses' attendant, at least one instance of plastic needs making the psychological complex even more insignificant than it would have been otherwise.

Are we not almost forced by these considerations to conclude that

our experiments fail to confirm those theoretical and *a priori* conclusions laid down by Mr. Richards? I think in these matters it is safer to base ourselves on exact observation of our own reactions than on results predicted from a theoretical consideration of how our sensibilities ought to function. There are, indeed, in the long sequence of European art a good many cases which must make us pause before accepting as a fact the co-operation between the illustrational and plastic elements in a picture so confidently predicted by Mr. Richards. We may omit the innumerable cases where, as in Poussin, the illustrational element may be entirely neglected and look at one or two where it is undoubtedly effective. In the case of Raphael, we find a psychological realization which, whatever we may think of it ourselves, has proved its crudely popular but effective appeal on each succeeding generation for centuries; and, in astonishing divergence from that, a plastic realization of so rare and subtle a perfection that those who are capable of responding to its appeal can generally disregard, more or less completely, the distracting impertinences of Raphael's psychology.

El Greco affords another interesting case. I suspect that for his own generation his psychological appeal was strong. His contemporaries knew intimately, or at least admired profoundly, those moods of extravagant pietistic ecstasy which he depicts. Those abandoned poses, those upturned eyes brimming with penitential tears, were the familiar indications of such states of mind. To us they seem strangely forced and hint a suspicion of insincerity which forbids our acquiescence, and we almost instinctively turn aside to invitations to a quite different mood which his intense and peculiar plasticity holds out. No less does the colour, with its entrancing sublimation of Venetian opulence, draw us in a direction which, to us at all events, is utterly distinct from that given by his illustration which, to tell the truth, clamc rs for a quite other method, for something more akin to the penitential gloom of Ribera.

Co-operation, then, between the two experiences derived from the psychological and plastic aspects of a picture does not appear to be inevitable. I have not sought to prove that it is impossible or that it never occurs.

Indeed, one case at once suggests itself of possibly finding that fortunate correspondence, namely Rembrandt. Rembrandt is certainly rare, if not unique, among artists in having possessed two separate gifts in the highest degree. His psychological imagination was so sublime that, had he expressed himself in words, he would, one cannot help believing, have been one of the greatest dramatists or novelists that has ever been, whilst his plastic constructions are equally supreme.

To what extent he could control these two methods of expression, when using illustration instead of words for his psychological constructions, so that they should always reinforce one another would require a detailed examination of his whole work. I suspect that there was often a tension between the two. In the early work illustration tends to predominate, often to the evident diminution of plastic completeness. Of this one may take the "Philosopher" in the National Gallery, and the "Last Supper" of the Jacquemart-André collection as examples. Throughout his life there was a gradual shift of emphasis from psychological to plastic expression, as though, after all, the medium of paint was more nicely suited to that than to the other. In short, I do not know whether the world would not have gained had Rembrandt frankly divided his immoderate genius into a writer's and a painter's portion and kept them separate.

I find it hard in looking through his work to find examples where either one or the other element does not clearly predominate or where the mutual accommodation of the two does not entail some sacrifice. Perhaps one of the best examples will be that of the "Christ before Pilate," in the National Gallery. . . . This is surely a masterpiece of illustration. As Rembrandt has seen it, Christ Himself falls into the background. This in itself is a striking indication of how fresh and original Rembrandt's dramatic imagination was. As he reconstructed from the Gospel text the whole scene before his inner vision he saw that such a moment as he has chosen must have arisen. It is the moment of greatest dramatic tension, where the protagonists are no longer Pilate and Christ, but Pilate and the Rabbis. And he has given this moment with astonishing perception of exactly the kind of characters involved and the inevitable effect of their clash. Pilate is an elderly, cultured civil servant, a diplomat who has always moved in polite society and has found how to shelter his essentially feeble character behind an entrenchment of decorum and precedent. The shock to his feelings produced by this sudden onrush of elderly churchmen maddened with theological prejudice and hatred is admirably given in the fussy indignation of his gesture. No less perfect are the various types of the Rabbis, one, hardly moved from his self-satisfied, self-important grossness, one so abandoned to the passion of hate that he shakes the prætorial wand of office in his frenzy, one screaming out his vindictive fury, one turning back to restrain for a moment the crowd that they have hypnotised into madness. Behind, and hardly more than indicated, since at this moment it falls dramatically into the second place, the group of soldiers who out of sheer indifference and habit continue to buffet and maltreat the tortured figure of Christ, which too is given

with that unmitigated psychological truth that Rembrandt was bound to follow. Certainly as drama this seems to me a supreme example of what the art of illustration can accomplish. And as a plastic construction it is also full of interest and strange unexpected inventions. The main group piles up into a richly varied but closely knit plastic whole which leads on by the long upward curve of Pilate's robe and turban to the less clearly modelled volume of the soldiers around Christ. Around these Rembrandt has created first of all the concavity of shade beneath the overhanging baldachin of the judge's seat, and this opens out into the vaster concavity of the public place through which a diagonal movement, hinted at by the inpouring crowds, leads us away under the arched entrance.

Personally I feel that the great, uprising pillar surmounted by the bust of Cæsar, admirable as it is in its dramatic suggestiveness, is a little detrimental to the spatial harmony. Still, one cannot deny the plastic beauty of the whole conception, although it is somewhat too crowded and overlaid with detail to be considered one of Rembrandt's great discoveries. This may, perhaps, be placed to the psychological account, since the general agitation and bustle of every detail increases the idea of the whole mad turbulence of the scene.

Here, then, is perhaps as good an instance as one can get of that co-operation of the dramatic and plastic experiences in a single picture. But I think that we cannot help noticing that even here we are compelled to focus the two elements separately. Indeed, I cannot see how one is to avoid this. How can we keep the attention equally fixed on the spaceless world of psychological entities and relations and upon the apprehension of spatial relations? What, in fact, happens is that we constantly shift our attention backwards and forwards from one to the other. Does the exaltation which gratification in one domain gives increase our vigilance and receptiveness when we turn to the other, as would be implied by true co-operation? In this case I incline to think it does, although I doubt whether this more than compensates for a certain discomfort which the perpetual shifting of focus inevitably involves.

We may get a little further light on our question by examining another example of Rembrandt's art, and this time we will take one of those innumerable drawings in which the point of departure was a dramatic event or situation.

In the "Parable of the Hidden Talent" . . . the psychological complex formed by the clash of these two characters seems to me to be vividly realised. The types which give this its significance are chosen with Rembrandt's unfailing psychological insight. The dignified, grave and austere man of business one guesses to be a man of conscious

rectitude, just but inflexible, and the other exactly such a type of slovenly incapacity as would not be able to restrain his ready, pothouse eloquence even at the risk of still further outraging his master by his self-justification. It will be noticed that the full value of the representational element almost always depends on a reference to something outside the actual work of art, to what is brought in by the title and such knowledge as the title implies to the spectator, whereas plastic values inhere in the work itself.

Now in this drawing the plastic and spatial elements are also such as to give us a keen satisfaction. The volumes of the two figures are vivid to the imagination by the amazing evocative power of Rembrandt's few hasty indications; we accept with delight the interplay of their movements. No less clear and significant is the relation of these volumes to the enclosing space, though this too is given rather by a few vivid suggestions than with any full realisation. So that there, far more definitely, I think, than in any picture, that co-operation which we have been seeking for seems realised. This may, perhaps, give us a hint as to the nature of such combinations of two arts, namely, that co-operation is most possible where neither of them is pushed to the fullest possibilities of expression, where in both a certain freedom is left to the imagination, where we are moved rather by suggestion than statement.

It may be interesting to examine in the light of these considerations some cases of contemporary artists. There can be no doubt that the tendency of European art, as centred in Paris, has for a long time been towards a more deliberate and conscious concentration on plastic expression than heretofore, but there are, perhaps, more exceptions to this than appear at first sight. The case of Rouault at once rises to the mind as that of an artist who is clearly inspired in the main by conceptions of a moral order. It is quite evident, for instance, that his distortions of actual appearances arise from a different feeling and envisage a different end from those of his fellow-pupil Matisse. It is clear that his imagination is haunted by strange psychological beings to which he gives visible embodiment. It is true that in doing this he can rely also on a powerful and original plastic feeling. It may be noticed from the example here given ... that his method comes curiously near at times to that of Rouveyre. But whereas in Rouveyre's case the plastic complex is only indicated, Rouault realises it more fully, it appears of sufficient richness and plenitude to interest us in and for itself. But we cannot ever quite forget the psychological evocations which accompany it and often emanate from it. The psychological material is of the strangest, most disquieting kind, as of the projection of the psychological beings of real life on to an imaginary plane where

their qualities and characteristics become portentous and menacing. Here he is to some extent the follower of Odilon Redon, though not in his method of expression. With Rouault, then, both the plastic and psychological material has great imaginative intensity, and yet it is hard to say upon which of the two our focus is most fixed. Does he, then, provide us with the case of perfect fusion into a single expression of the double experience? Or is there not, after all, a certain tension set up? Different people will answer this in different ways, according to their ruling preoccupation. Perhaps, as in the case of El Greco, in process of time the psychological elements will, as it were, fade into the second place, and his plastic quality will appear almost alone. I do not profess to give an answer. I may note, however, in passing this phenomenon of evaporation. I believe that in nearly every one, wherever a psychological appeal is possible this is more immediately effective, more poignant than the plastic, but that with prolonged familiarity it tends to evaporate and leave plasticity as a more permanent, less rapidly exhausted, motive force. So that where pictures survive for a long period their plastic appeal tends to count more and more on each succeeding generation.

Bonnard is another case of an artist who admits some illustrational element. But his case and that of Picasso are further discussed in the article on Modern Drawings. With regard to the latter, however, we note that his cubist art is essentially plastic in purpose; but it is noteworthy that the cubist idea has been seized on elsewhere and turned to illustrational purposes. Futurism is essentially a literary and psychological adaptation of this new plastic conception, and in England Mr. Nevinson at one time made use of it for frankly illustrational and dramatic appeal. It is probable that new means of expression are always discovered by the plastic researchers, but that they are subsequently pressed into the service of illustration. Thus Marie Laurencin has used the general formula of modern plastic designers like Matisse, but used it almost entirely for decorative-psychological fantasies.

This brings us to yet another question, namely, the relation of the decorative treatment of the picture surface to illustration. This again is a question of the co-operation of two arts. It is doubtful whether a purely flat surface, without suggestions of significant volume, can arouse any profound emotion, so that we should expect that it would easily co-operate with some illustrational matter, and here Raoul Dufy supplies an interesting confirmation. It is obvious that if the decorative accompaniment is to be properly felt the psychological appeal must also be slight. It would be a hopeless task to use Daumier's bitter satires or even Rouveyre's profound interpretations of character as elements in a decorative design. Dufy shows perfect tact in this

respect. In some of his brocades he includes witty and charming allusions to contemporary life, to Longchamps, to tennis, or any of the amusements of fashionable society, and these allusions, which only brush the surface of life, avoiding any serious appeal, perceptibly heighten the pleasant effect of his harmonious decorative dispositions. On this plane of playful and amused responses co-operation seems to be entirely successful . . .

A curious incidental confirmation of the view here put forward is afforded by the history of painting in England. It is notorious that as a nation our aptitudes for literature are developed out of all proportion to our aptitude for the other arts. And so we find that the English have cultivated almost exclusively the illustrational aspects of painting in defiance of the great plastic tradition of European art. In this branch we might have attained to pre-eminence had we not been always so anxious to arrive at dramatic effect that our draughtsmen could not wait to master the medium of draughtsmanship adequately for its expression in pictorial form. As it is, Hogarth is but a sorry champion to pit against a Daumier.

In view of this characteristic of so large a proportion of English painting it is possible that I may sometimes have criticised some of our more celebrated popular painters from a wrong standpoint. It is, perhaps, unfair to ask the painters of the Royal Academy to give us significant plastic expression, since they have all the time been envisaging only psychological entities. But I fear the change of terrain will not make much difference, since nothing could well be more cheaply sentimental or vulgarly trivial than most of the psychological constructions which annually obtain their ephemeral success. Even if we abandon all questions of plasticity and confine ourselves to psychology, Luke Fildes's "The Doctor," to take a typical and celebrated instance, is on the level of only our fifth-rate writers. Why is it that our *litterateurs* of the brush are so palpably inferior to their *confrères* of the pen? I may cite as an exception the case of Mr. Stanley Spencer, who is also a pure illustrator, indifferent to plastic significance, but whose psychological creations are at least original, curious and vividly apprehended. They at least never sink to the deplorable level of stereotyped sentimentality which rules in the Royal Academy.

Our experiments and inquiries have then, I hope, given us one result on which we may rely with some confidence: the notion that pictures in which representation subserves poetical or dramatic ends are not simple works of art, but are in fact cases of the mixture of two distinct and separate arts; that such pictures imply the mixture of the art of illustration and the art of plastic volumes—the art of Art, our horribly incorrect vocabulary almost forces us to say.

8. A CRITICISM OF ART AS FORM

LOUIS ARNAUD REID

Because, in these matters, concreteness is important, because it is specially necessary to have examples before our mind, I propose in what follows to refer a great deal to Mr. Roger Fry's *Transformations*, particularly to his first chapter, "Some Questions in Aesthetics". Mr. Fry, as everyone knows, is a distinguished critic and artist whose opinions are always worth the most serious consideration. And Mr. Fry not only discusses at great length this general question of what I have called "competition", including the cases of opera and song, but he gives us many actual illustrations from the sphere of visual art, to which, as they are accessible in one volume, it will be convenient and profitable to refer. I shall frequently have to criticise Mr. Fry's conclusions, but this in no way conflicts with a deep sense of indebtedness to him.

Mr. Fry, after a preliminary discussion, begins by making a distinction between what he calls "pure" and "impure" arts. He says that "it nowise invalidates this conception if such a thing as an absolutely pure work of art has never been created: the contention is that some works approximate much more nearly than others to this ideal construction". I am not absolutely clear what Mr. Fry means by "pure" and "impure", for he does not define them specifically. Sometimes it looks as though by "pure" he means "without competition of interests" (as in pure music, or pure visual plasticity, versus song or opera or representative painting). At other times it looks as though in using the terms "pure" and "impure" he were referring to the perfection, or the failure of perfection, of the aesthetic *unification* or fusion of various competing interests in some (perhaps all) works of art. I am inclined to

FROM *A Study in Aesthetics* BY LOUIS ARNAUD REID, PP. 312–25. COPYRIGHT 1931 BY GEORGE ALLEN & UNWIN LTD., AND REPRINTED BY KIND PERMISSION OF THE AUTHOR AND THE PUBLISHER.

think that the context shows that this latter sense is the sense of which he is really thinking, though on Mr. Fry's view (he is very emphatic about the difficulty of complete aesthetic fusion in complex arts) the purest arts in the second sense *tend* in fact to approximate to "pure" art in the first sense. But the second sense is certainly the more important and its problems occupy the whole of Mr. Fry's first chapter. It is the sense which I wish to discuss.

For convenience' sake we may range the arts roughly in a kind of scale, starting with arts like music and architecture at one end of the scale, and finishing with opera at the other end. The scale will represent a transition from relatively "unmixed" arts to very "mixed" ones, and the mixture will be mainly[1] of two kinds, (*a*) a mixture of the appeals of different sense elements (e.g. of the visual with the auditory in musical dancing), and (*b*) a mixture of the appeals of "body" and of subject-matter. It is impossible to make any neat classification on one basis or the other; there is bound to be frequent overlapping. But on the basis of both taken together, we might get first—after pure music and architecture (and perhaps dancing without music)—such arts as drawing, painting, sculpture, acting without words, etc. Here the appeal is mainly through one sense, but the element of representation enters in. (I say "mainly through one sense" because of course in all the cases mentioned imagery of other sensations is involved, and, perhaps, other actual sensations. But in painting, for example, the main focus of attention is upon the visual, and this is what we are at the moment concerned with.) In this class also might be placed poetry read aloud to oneself (as opposed to poetry spoken before us by another, where the visual apprehension of attitude and gesture would enter in along with the auditory appeal of words). Here too might come privately read drama, the read novel, etc. In the next division of the scale we might place arts appealing to more senses than one, but which are not essentially representative, for example, some musical dancing (visual and auditory). Here also would come representative arts which appeal to more than one sense, e.g. recited poetry or acted drama (representation and visual and auditory appeal). Lastly might come arts which are mixed almost in the sense of being compound. Compound, that is, of separate arts. Song and opera would be examples. Thus, song, it might be said, is a compound of poetry and music, and opera a compound of many arts. Here again (though it has already been included) might come musical dancing, a combination of music and dancing. I do not think,

[1] There may be finer gradations of mixture of appeals, as in the competition in painting between the appeal of plasticity and that of colour or of line. . . . But we are concerned at the moment with broad divisions.

as I shall show, that to regard one art as a real compound of others which can themselves be pursued as arts, is in the end satisfactory, but it is at any rate a point of view, and is good enough for classification purposes. The present attempt to make out a "scale" has no motive but the desire to see broadly the extent of a rather far-reaching problem. I have no intention here of trying to deal with the problem as it arises in all the arts mentioned. I shall merely select some instances, and in preference, those which have been discussed by Mr. Fry. Let us begin with our familiar friends, subject-matter and body.

The "Dramatic" Versus the "Plastic"

Mr. Fry discusses at length in *Transformations* the tension in visual art between psychological or "dramatic" interest on the one hand, and "plastic" interest on the other hand. In a somewhat earlier work, *Vision and Design*, containing reprinted essays, he has a footnote to a paper on Giotto, in which he criticises a former assumption of his own, that not only did dramatic ideas inspire Giotto to the creation of his form, but that the value of the form for us is bound up with recognition of the dramatic idea. He adds:[2] "It now seems to me possible by a more searching analysis of our experience in front of a work of art to disentangle our reaction to pure form from our reaction to implied associated ideas." This "more searching analysis" he makes, with great care, in the first essay in *Transformations*. In this essay he takes a large number of examples, Pieter Brueghel the elder, Daumier, Poussin, Rembrandt, and many others, which he examines in a certain order, putting those in which psychological interest predominates (e.g. Pieter Brueghel's *Christ carrying the Cross*) at one end. As we proceed, the plastic interest increases, till we arrive, in the case of Rembrandt's "Christ before Pilate", at "perhaps as good an instance as one can get of . . . co-operation of the dramatic and plastic experiences in a single picture". Mr. Fry's thesis is that this blend of experiences is rare, and that in most cases there occurs not fusion, but <u>tension</u> of interest between the psychological and the plastic. He says, even of Rembrandt's work, that we are compelled to focus the two elements <u>separately</u>. "Indeed, I cannot see how one is to avoid this. How can we keep the attention equally fixed on the spaceless world of psychological entities and relations and upon the apprehension of spatial relations? What, in fact, happens is that we constantly shift our attention backwards and forwards from one to the other. Does the exaltation which gratification in one domain gives increase our vigilance and receptive-

[2] *Vision and Design* [London: Chatto & Windus, 1920], p. 131 (footnote).

ness when we turn to the other, as would be implied by true co-opera-
tion? In this case I incline to think it does, although I doubt whether
this more than compensates for a certain discomfort which the perpetual
shifting of focus inevitably involves."[3]

In the case of Rembrandt's picture there is a minimum of this
(alleged) discomfort. There are examples of well-known pictures in
which it is very considerable. Mr. Fry cites, in *Vision and Design*, the
instance of Raphael's *Transfiguration*. The whole of the essay on this
subject makes fascinating reading, and cannot be properly reproduced,
except as a whole. But the main points of interest for us now are as
follows. There is (1) the appeal of the subject-matter. "To those who
are familiar with the Gospel story of Christ it brings together in a single
composition two different events which occurred simultaneously at
different places, the Transfiguration of Christ and the unsuccessful
attempt of the Disciples during His absence to heal the lunatic boy.
This at once arouses a number of complex ideas about which the in-
tellect and feelings may occupy themselves."[4] But in the subject-
matter regarded as representation there are suggested things which
are by no means wholly pleasing. If "our Christian spectator has also
a knowledge of human nature he will be struck by the fact that these
figures, especially in the lower group, are all extremely incongruous
with any idea he is likely to have formed of the people who surrounded
Christ in the Gospel narrative. And according to his prepossessions
he is likely to be shocked or pleased to find", instead of the poor and
unsophisticated peasants who followed Christ, "a number of noble,
dignified, and academic gentlemen in improbable garments and purely
theatrical poses. Again the representation merely as representation,
will set up a number of feelings and perhaps of critical thoughts de-
pendent upon innumerable associated ideas in the spectator's mind."[5]

In these things our pleasure and displeasure is, of course, affected
by our extra-aesthetic knowledge, as well as by our general background
of taste, training, and tradition. The pagan spectator will have a
different view from the Christian.

(2) There is, secondly, the entirely distinct appeal of form, for those
who are sensible to its meanings. "Let us now take for our spectator a
person highly endowed with the special sensibility to form", who feels
intensely the intervals and relations of forms; let us suppose him either
completely ignorant of, or indifferent to, the Gospel story. Such a
spectator will be likely to be immensely excited by the extra-ordinary
"co-ordination of many complex masses in a single inevitable whole,

[3] *Transformations* [London: Chatto & Windus, 1924], p. 23. [4] *Vision and Design*, p. 296.
[5] Ibid., p. 297.

by the delicate equilibrium of many directions of line. He will at once feel that the apparent division into two parts is only apparent, that they are co-ordinated by a quite peculiar power of grasping the possible correlations. He will almost certainly be immensely excited and moved, but his emotion will have nothing to do with the emotions which we have discussed hitherto, since in this case we have supposed our spectator to have no clue to them."[6]

Is Fusion Possible? Criticisms of Mr. Fry

These are examples. And the problem is, in Mr. Fry's words, "Do these form chemical compounds, as it were, in the case of the normal aesthetically gifted spectator, or are they merely mixtures due to our confused recognition of what goes on in the complex of our emotions?"[7] Mr. Fry inclines to think that fusion "of two states of emotion [is] due to my imperfect analysis of my own mental state".[8] Again, in *Transformations*,[9] he concludes: "Our experiments and inquiries have then, I hope, given us one result on which we may rely with some confidence: the notion that pictures in which representation subserves poetical or dramatic ends are not simple works of art, but are in fact cases of the mixture of two distinct and separate arts; that such pictures imply the mixture of the art of illustration and the art of plastic volumes—the art of Art, our horribly incorrect vocabulary almost forces us to say". But he is very tentative, and is careful not to say that co-operation between the psychological and the plastic aspects is impossible or that it never occurs.[10] And he is ready to admit (in *Vision and Design*) that perhaps the question is one for the experimental psychologist.

This, then, is our first problem. Is there really true fusion of experiences, or is there only, at the very best, an unfused "co-operation" of experiences?

In asking whether fusion is possible, we must go back to our early distinction between "psychological" fusion and "aesthetic" fusion, or aesthetic relevance. Clearly what is meant in this context is chiefly *aesthetic* fusion. Psychological fusion in various degrees may or may not occur; we may, that is to say, be less, or more, explicitly conscious of the many elements which go to enrich the total significance of an aesthetic complex. But what matters, and what Mr. Fry is I think chiefly interested in, is whether in certain cases a single harmonious (or aesthetically fused) aesthetic experience is possible. I believe, indeed, that Mr. Fry often wrongly identifies the two in his mind, and thinks that because

[6] *Vision and Design*, p. 298. [7] Ibid., p. 300. [8] Ibid., p. 301.
[9] *Transformations*, p. 27. [10] Ibid., p. 21.

psychological fusion does not, in particular cases occur, that because we have a number of different objects of interest more or less explicitly before our mind at once, *therefore* aesthetic fusion is impossible. But aesthetic fusion is his, and our, main problem, and, unless specified otherwise, the term "fusion" will here be taken to mean aesthetic fusion.

In this matter it is only fair to seek out the best examples. It may be that in very many instances of our experience of works of art there is some failure of fusion, some disorganised shifting about of attention from one element to another. Mr. Fry concentrates a great deal of attention on such instances (though he does not deny outright the possibility of fusion). But there is a danger in so doing. We may get the problem out of proportion. Because failure often occurs in the instances we select, we must not conclude that it always does, or even tends to, for our instances may be too specialised; a single instance to the contrary is sufficient to disprove any generalisation. I shall try to show later that it is probable that there are many instances of fusion. But, in order to find them, we must select; and this is a perfectly fair procedure.

No doubt it is possible to disentangle and analyse elements in our aesthetic experience, and this could be done, even in the hypothetical cases where fusion occurs. Mr. Fry's later point of view when he distinguishes between dramatic and formal appeal[11] is an advance on his earlier. But would it not be possible for him to go back to the earlier position, only at a higher level of synthesis? It there not a danger of taking the products of our legitimate analysis as separate "parts" which can only co-operate, but can never fuse? In analysis always there does lurk this danger, and in the analysis of aesthetic experience, where unity is so vitally essential, and at the same time so delicately fabricated, it is an especial danger. Aesthetic experience may contain many different elements, and I have argued that it is a synthesis containing many meanings. But is it not also its essence that the elements and meanings should be made one and inseparable from the aesthetic whole? And do not the "parts" thus resolve themselves either into abstractions from the given existing aesthetic whole, or into the elements entering into its history or genesis?

Mr. Fry does appear to be taking the products of his analysis of aesthetic experiences as if they were separate parts of a composite whole. He does seem to be reinforcing this error by emphasis upon special examples in which there is at least a great danger of the breakdown of the unity of aesthetic experience. And he does speak constantly as if neutral, or primary, subject-matter could be an object of interest

[11] See above, [p. 117].

in an aesthetic experience. This can be illustrated in two sentences taken from his first essay in *Transformations*. One sentence occurs where he is speaking of the difference between interest in psychological, and interest in plastic, factors.[12] He says: "These two kinds of representation are, likely enough, governed by different principles, and imply certain differences of emphasis which explains in part the great difficulty of conciliating them. For instance, where drama is in question minute changes of tone in the face will be likely to have a far greater significance than they would have on plastic grounds, and it is almost inevitable that the dramatic painter should give them ultra-plastic values." The other quotation which I will select is a passage where, speaking of a drawing of Rouault in which there is both plastic and psychological interest, he asks:[13] "Does he, then, provide us with the case of perfect fusion into a single expression of the double experience? Or is there not, after all, a certain tension set up? Different people will answer this question in different ways, according to their ruling preoccupation. Perhaps, as in the case of El Greco, in process of time the psychological elements will, as it were, fade into the second place, and his plastic quality will appear almost alone. I do not profess to give an answer. I may note, however, in passing this phenomenon of evaporation. I believe that in nearly every one, wherever a psychological appeal is possible this is more immediately effective, more poignant than the plastic, but that with prolonged familiarity it tends to evaporate and leave plasticity as a more permanent, less rapidly exhausted, motive force. So that where pictures survive for a long period their plastic appeal tends to count more and more on each succeeding generation."

In both the above quotations it is implied that part of the work of the artists mentioned has been representation, reproduction of extra-aesthetic values. Mr. Fry would be quit of it if he could. He writes: "It is a great simplification to . . . look upon both illustration and plastic as having each their proper form, the one psychological, the other spatial."[14] This desire is natural, for it is the outcome of the supposition that the two factors are really at war. But is not the cure worse than the disease? Does it not lead to an artificial idea of art and does it not impoverish art of much of its meaning? Life may be difficult to transform aesthetically, but is it impossible? Must we simply abandon the attempt, choosing art *or* life, but not both?

As regards the first of the above quotations, if the artist is interested *merely* in the "pure" formal relations of the human face, if he is interested, that is, simply in the general emotional values of plastic forms and their relations, he is not painting a *human* face at all. His subject-

[12] *Transformations*, p. 34. [13] *Transformations*, p. 25. [14] Ibid., p. 27.

matter is merely a general arrangement of plastic forms, which, as it
happens, bears some resemblance to a human face. It is not a matter
of the psychological factor being "emphasised" less; it is a case of the
psychological factor not existing at all for the artist. But it is a strained
and unnatural attitude. Of course the painter is interested in the
expressiveness of visual *forms*. But he is interested in their *expressiveness*.
The forms are "significant". And what does a human face express more
definitely than human character? Surely the artist has more before
him than "lines, planes, and volumes". Surely, if he is not ridden by
theories, he is interested in character. Not the disembodied, purely
mental character which is the object of the psychologist, but, once
again, character plastically expressed in a face which interests him. If
this interest can in some sense be called dramatic, it will not be true to
say that the "dramatic" painter will give emphasis to ultraplastic
values, in the sense of values outside and independent of the plasticity.
Rather, psychological values will become apprehended plastically.
This continually happens. We do not see a face, *and* its character. We
see character *in* the face. There is not a better—or commoner—example
of aesthetic expressiveness anywhere than this.

The character transforms the aesthetic expressiveness of the plasti-
city. It is not that we are interested in two things, side by side. Intro-
spection of art experience makes this fairly clear. When I look
aesthetically at Verocchio's *Colleoni* I am not in the least interested in
the character which the gentleman on the horse originally possessed.
Yet I cannot but feel braced up and inspired by the intense vigour of
character which is embodied in every inch of horse and man. Or when
I see the fresco (in the Arena Chapel at Padua) of *Joachim Retiring to the
Sheep-fold*, it may be that my first interest is psychological, or it may be
that it is plastic (in my own case it was the latter). But in a full apprecia-
tion I cannot possibly cut out one or other element. In the whole, each
becomes transformed. There is not, to repeat, when the experience is
complete and mature, psychological interest *and* plastic interest. There
is just the plastic-psychological expressiveness of the forms of the
dignified old man with head bent, enwrapt in his mantle, in contrast
to the different plastic-psychological expressiveness of the naïve-looking
shepherds who come to meet him. Our object is plastic psychology,
plastic drama. One does not need to know the original story in order
to appreciate the delightful expressiveness of the forms, though doubt-
less knowledge of the story assimilated into the aesthetic experience
would enrich it. Aesthetic assimilation is essential, not only here, but
always. *All* representative pictures require external knowledge. Some
of it is common to everyone, some of it has to be specially acquired. Who

could fully appreciate Leonardo's *Last Supper* without external know-
ledge? But the knowledge must have become familiar, assimilated.
The danger is, always, of its remaining external; for aesthetic assimila-
tion is not easy.

Exactly parallel reasonings hold good of the second quotation. It is
only if the psychological interest in paintings is an extrinsic interest,
an interest in primary subject-matter, it is only where there are elements
of external allusion and mere illustration, that psychological elements
will tend to "evaporate". If the artist has imagined his way through to
the end, the psychological interest will not evaporate because it will
be intrinsic to the painting: the psychology is plastic psychology.

Introspection of actual aesthetic experience certainly does appear
to show that there can be aesthetic fusion. And this seems to be possible,
not only in the relatively simple cases taken, but in more complex ones.
Speaking for myself, I do not experience the continual "shifting of
attention" of which Mr. Fry speaks, in appreciation of works of art of
the type of Rembrandt's *Christ before Pilate*, or still more of his drawing
of *The Hidden Talent*.[15] There is, of course, always a stage when we are
coming to comprehend the picture, in which we have to attend to this,
and then that, and then something else. And it is not suggested that it is
easy to attain perfection of apprehension, or that an alternation of
attention can always be overcome. But perfection can, it is probable,
be attained, and it is *always* the ideal of aesthetic experience. To fall
short of it is to fail.

Fusion in Simpler and More Complex Cases

Mr. Fry, I think, must assume that fusion occurs in the case of
"pure" form, for he approves, I take it, of Mr. Bell's phrase "significant
form". But whether Mr. Fry does or does not admit fusion in the case of
"pure" form, we have at least seen for ourselves[16] that fusion does exist
here. There is, strictly speaking, no such thing, aesthetically, as "pure"
form. In terms of Bell's phrase, form, even in the most "abstract" of
art, is always, for aesthetic experience, *significant*, whether of organic or
ideal values, whether of values directly or indirectly apprehended.
These values are aesthetically fused with the form as we apprehend
them aesthetically, or aesthetic experience does not exist at all.

If fusion of meaning is possible in the case of "pure" form, why not
in the case of mixed, e.g. "representative", arts? Introspection, we
have seen, suggests that fusion in such cases is possible, though it may
be difficult. The aesthetic theory we have been defending—and, I

[15] *Transformations*, (facing) 24.　　[16] Chapter IV [*A Study in Aesthetics*], p. 101 sq.

should imagine, any aesthetic theory—takes it as absolutely essential that fusion should occur, if they are to be aesthetic experiences at all. Is there any possible theoretical objection to the possibility of its existence in these cases, beyond the admitted fact that it is difficult to achieve?

I cannot see that there is. We must not, of course, allow metaphors to run away with us, and think of aesthetic fusion as if meanings melted together in our minds like bits of lead in a ladle. Neither must we think of aesthetic, as if it were psychological, fusion. Mr. Fry, I think, is sometimes guilty of seeking after a too great simplicity of aesthetic experience. The aesthetic experience is (even when "pure") a complex experience and, even when much psychological fusion occurs, a complexity of meaning remains. This complexity must be fused and unified aesthetically, but aesthetic fusion does not mean the disappearance of the parts. The aesthetic fusion, or assimilation or unification of parts, must simply be accepted as a fact which is irreducible.

To say all this is not to deny that the emphasis in different works may be on different things, or that in the same work the focus of our interest may shift about. Indubitably the focus does shift. This does not mean the same thing as that of which Mr. Fry is speaking when he speaks of the "shifting of attention". In poetry the images and ideas may be an accompaniment of the delightful words: or the ideas and images may be the focus, and the sound of the word their accompaniment. In representative painting we may now be interested in the character-aspect of the content, and now in the formal aspect of the body-side. But the "shifting" is not from *mere* "dramatic", *mere* "psychological" interest, to *mere* formal interest. It is only, if the experience be an aesthetic one, an emphasis on aspects of a whole, in which one aspect modifies and colours the others. In other words, and to repeat, emphasis upon and attention to this or that, is not incompatible with this aesthetic fusion. But enough.

The Importance, for Fusion, of the Artist's Interests

From the point of view of the artist's creation, it is of course necessary, if fusion is to occur, that all the items of his interest should be imagined in terms of his material. If the artist's choice of subject is a spontaneous one, if, in his restless searching after expression, he comes to a subject naturally, and comes to it aesthetically, seeing (if he is a painter or sculptor) the characters of his subject in plastic terms, then there is for him of course no conscious problem of assimilation, no conscious conflict, between character or dramatic subject, and form.

We feel, for example, of Rembrandt's *Hidden Talent*[17] that the subject-interest and the plastic interest must be for the artist one throughout. Indeed, where fusion has finally been successfully accomplished, it is difficult to feel that there ever has been conflict. We feel this spontaneous fusion of interest in many of the paleolithic cave-drawings of animals, in many catacomb paintings, in Giotto, in much Dutch domestic painting—in all subject-work, in fact, which is genuinely good.

In work like Raphael's *Transfiguration*, on the other hand, already discussed, we do not feel nearly so certain. It is good in this or in that aspect, but not as a whole. We feel that the subject or character-side has never interested the painter, and so why should he have painted it? Because of tradition, convention, commissions? Much of the religious painting of the Renaissance must have been carried out without great spontaneous interest in the subject-matter. Similarly, painting of portraits of uninteresting subjects for commissions is often a compromise. Ideally speaking, the subject should choose the artist. If it does, he may be relied on to reveal it plastically. If it does not, and he is compelled, for non-artistic reasons, to paint it, we shall get compromise—for better or for worse.

[17] *Transformations*, plate vi.

Selected Readings on Part III: Art as Form

Abell, Walter. *Representation and Form*. New York: Scribner, 1936.

Barnes, Albert C. *The Art in Painting*. New York: Harcourt, 1937.

Beardsley, Monroe C. *Aesthetics*. New York: Harcourt, 1958. Chapters 4 and 5.

Bell, Clive. *Art*. London: Chatto & Windus, 1914.

———. *Since Cézanne*. London: Chatto & Windus, 1922.

Bowers, David. "The Role of Subject-Matter in Art." *Journal of Philosophy*, XXVI (1939), 617–30.

Fry, Roger. *Transformations*. London: Chatto & Windus, 1926.

———. *Vision and Design*. London: Chatto & Windus, 1920.

Greenough, Horatio. *Form and Function*. Ed. H. A. Small. Berkeley: U. of Calif., 1947.

Hanslick, Eduard. *The Beautiful in Music*. Ed. Morris Weitz. New York: Liberal Arts Press, 1957.

Osborne, Harold. *Aesthetics and Criticism*. London: Routledge & Kegan Paul, 1955.

Weitz, Morris. *Philosophy of the Arts*. Cambridge, Mass.: Harvard, 1950. Especially Chapters 1–3.

Y Gasset, Ortega. *The Dehumanization of Art*. Princeton: Princeton, 1948.

IV

ART AS EXPRESSION

9. BEAUTY AS EXPRESSION

E. F. CARRITT

I have not tried to conceal that the conclusion I am myself inclined to, as the result of the various views I have mentioned and shortly discussed, is that beauty is found in what is expressive of feeling. I shall presently try to show that this is no new view, and indeed that one reason which commends it to me is the great mass of evidence in its favour given by artists and thinkers before it had been distinctly formulated. I mean that though they had not the insight or courage to reject the cruder orthodox theories of their time, such as that beauty was truth or goodness or pleasure, yet, when they were not thinking about those theories, their spontaneous confessions by the way so often point forward to this view. It was left for the contemporary Italian philosopher, Croce, explicitly to formulate the theory. This he did first in his *Estetica* (1900) which can be read in the second edition of the translation by Douglas Ainslie (1922), but there is a shorter and simpler version in his *Breviario di Estetica* (1912), translated by Douglas Ainslie (1921) under the title of *Essentials of Aesthetic*, and also in the last edition of the *Encyclopaedia Britannica* under the title of *Aesthetics*.[1]

As I say, then, the first reason that commends this theory to me is the convergence, which I seem to trace, of all previous theories towards it. A second is that, better than any other, it seems, as I will try to show, to solve some of the ancient and perpetually recurring difficulties of discussions about beauty, such as the opposition of formal and expressive beauty, of romantic and classical beauty, of beauty and sublimity, and the relation of beauty to truth and to morality.

My third and chief reason, which I suppose is really a way of stating the other two, is that when I first read Croce (having already

[1] I have tried to expound fully my reasons for preferring this theory to any other in my book *The Theory of Beauty* (Methuen), and anybody who wants to follow out the past theories on the subject and see how they support this most recent one can do so in my *Philosophies of Beauty from Socrates to Robert Bridges* (Oxford Press).

CHAPTER 6 OF *What Is Beauty?* BY E. F. CARRITT, PP. 87–111. COPYRIGHT 1932 BY THE CLARENDON PRESS, OXFORD, AND REPRINTED BY THEIR KIND PERMISSION.

tried to adopt in turn several of the older views and even contrived a modification of my own) I seemed to find something which I had always been looking for and getting near but never able quite to hit off. I do not of course mean that I understand or agree with him in every detail, but that I think he is nearer the root of the matter than any previous philosopher. I can only here set out the merest outline of the view, and I am well enough aware that it is full of difficulties, so that the last thing I should wish would be to put it dogmatically. If we find ourselves unable to accept it, I think we should have either to say that the explanation of beauty is still undiscovered or to accept the alternative which I mentioned in my first chapter and admit that there *is* no explanation—that beautiful things have no other common and peculiar quality which makes them beautiful, but that beauty is a simple ultimate fact behind which we cannot go.

In briefest outline, then, Croce's doctrine is that our desires and repulsions, or, in a word, our passions, are in themselves blind. We may be said to feel them, but that only means we are shaken and moved by them, and, if that were all, we should perhaps be something like the lower animals which strive after food and drink and sexual satisfaction, but presumably never consider what they are doing. But we, being intellectual as well as practical creatures, have also the gift of knowing ourselves and what we are. And the only way in which we know our feelings is by imaging them or embodying them or expressing them in words or something else sensuously apprehensible. It is a commonplace that we can only *think* in *words*. And yet we speak of finding words for our thoughts. The truth of these apparently contradictory statements is that until we can put our thought into words it is only an embryo thought. But words, besides being used to express thought, as in science, can be used to express feeling, and something of the same kind is true there. Until we have found words or some other expression of our feeling we have only a dim vague awareness of what it is; it is in fact only a dim, vague, though perhaps very powerful feeling. Croce points out that all art is a kind of language; it expresses and so fixes and makes recognizable what before was vague, fleeting, and merely felt. The aesthetic activity, then, of recognizing one's own states embodied in sensuous objects, whether real or imaginary (for at this stage we do not care to question which they are), is the first stage of intellect or knowledge, as distinct from mere feeling. To begin with, perhaps we ought to distinguish this "expression" from other things with which it is commonly confused. First, it is not symptom.

There may be many signs or consequences of feeling, perhaps peculiar to an individual, or perhaps recognizable by doctors or other

beholders, which are not expressions. A scream or cry need not by itself be expressive of pain, though it is usually a sign of it. It might enter into a dramatic expression of pain. Neither is sweating or change of the pulse expression. An expression is a sensuous or imagined object in which we *perceive* (not infer) feeling.

Secondly, expression is not communication. Expression may be confined to ourselves. A poem or tune we make in our heads and keep there may be completely beautiful; then, it would have expressed our feeling to ourselves. And I suppose a mere symptom, such as a scream, might communicate our terror to others, either in the sense of blindly infecting them with it or of letting them know we had it; yet it need not be expressive.

Lastly, expression is not symbol in the proper sense of that word, though many people talk of the symbolism of art who really mean its expressiveness, as, for instance, Mr. W. B. Yeats in *Ideas of Good and Evil*. A symbol, as I explained in an earlier chapter, is an *artificial* sign, of which the meaning is something agreed upon and is a meaning which we should not know unless we knew it had been agreed upon. Of course there is, or has been, an element of conventional symbolism in language. But we have forgotten learning the meaning of most words, and these now seem to us to have a natural meaning; as the countryman who was asked why potatoes were called spuds replied, "Well, what else could you call them?" It is perhaps partly for this reason that it seems less poetical to call snap-dragons antirrhinums than by their proper name —we remember being *told* they were *called* antirrhinums, but we always *knew* they *were* snapdragons. And so with feelings. The language in which a doctor might *describe* melancholia would be symbolic, the language in which a poet would express it would not.

The cause of my anger might be a liver out of order; its object might be a talkative fellow-traveller; its symptoms might be silence or stiffness or scowls. Its artistic expression would probably be some such thing as a painting of a face or a dramatic speech or a figurative description, in any of which I might—though probably not till my anger was tranquillized—recognize a feeling I was familiar with even if I had forgotten the occasion of its occurrence. There are plainly two questions which we have to answer. The first is, are all expressions, in the sense of the word defined, beautiful? The second is, are all beautiful things expressions in this sense? In asking the first question: Are all expressions beautiful? we must remember a point made in an earlier chapter, that by beautiful we do not mean pretty or attractive. We mean beautiful in the sense in which that word can be applied to a grim tragedy like *Othello* or *King Lear*, and to a portrait of decrepit age as

well as to a spring landscape or a love-poem. In this sense of the word I am myself inclined to answer that, whenever we recognize a feeling as expressed, this can only be because we are for the moment in imagination re-experiencing it, and so for the moment sympathizing with it. It is for the moment in a sense *our* feeling, and the expression of that is beautiful. If we do not attain this sympathetic mood, then, whether the fault be ours or an artist's, the object is not recognized by us as expressive.

Clearly there is difficulty here. And many people have felt it so strongly that they have rejected the identification of beauty with expression and gone back to the earlier pre-Croce, Tolstoyan point of view which identified expression with *art* and held that art strictly does not aim at beauty at all, beauty being only that which is agreeable or attractive in contemplation. Professor Ducasse, for instance, in his recent book *The Philosophy of Art* holds that the aim of the artist is simply to satisfy an instinctive passion for self-expression. When he has expressed a feeling he and others can look at the expression and, if they find the feeling expressed pleasant to contemplate, they call it beautiful. This view differs from Croce's, who would hold that all who get the peculiar satisfaction of recognizing a feeling as expressed call the expression beautiful, whether apart from this expression of it they approve and welcome or on the other hand condemn and dread the feeling. Of course we only get this satisfaction when the artist persuades us to "sympathize" with the feeling, for the moment to "enter into it" or "entertain it". There is, however, a good deal in the view of these critics which is plausible. We are often apt to say "Just because the man has so clearly expressed his state of mind in that poem or picture I dislike it intensely". Take for instance the well-known hymn "Rock of Ages", or Guido Reni's picture of Christ crowned with thorns, or a certain one of El Greco's religious pictures. Very likely the fault is mine, but I do not like any of them. Yet, whatever we may think about Guido, I quite believe that Toplady and El Greco were sincere. But either they were in these two particular works altogether unsuccessful or I am so unsympathetic that they are not successful with me. The experience of beauty does not arise; I do not find a genuine expression of something I recognize; at certain points of the hymn or picture I feel as if I were just going to, but then comes either something which I do not recognize at all as anything I have ever felt but only as something I have been told I ought to feel or even possibly wished I could, or else something which I guess is an arbitrary and conventional symbol of a real feeling but does not express it. If these works of art were successful with me, however much I disapproved the feeling, the genius of the

artist would for the moment make me imaginatively enter into it. I should feel, as Macaulay did for the dying Jacobite, that here was one who spoke my own language and belonged to the same country, however much we differed. I cannot distinguish beauty from success in art. I am myself sure that I have always meant the same by a successful work of art and a beautiful one, and by an ugly work of art and a failure. So if the artist's aim is admitted to be self-expression, then all expression is beautiful, at least in my experience and in my use of words.

If all expression be beautiful, the second question is whether all beauty is expressive. We have already discussed to some extent the question of what is called formal beauty. We saw that those who would admit poetry and possibly painting and sculpture to be expressive found a difficulty about pure arabesque, music, architecture, and nature. And we saw then that the most natural sorts of epithet to apply to beautiful music, architecture, flowers, sky, sea, and landscape were gay, solemn, dignified, sad, pure, dreary, angry; which are all properly the names of states of mind.

How and why mere shapes and lines or patterns of colour and sound have become expressive to us is a complicated question which we cannot expect to answer very readily. Probably there are many ways. Psychologists seem pretty well agreed that one way among others is what is called Empathy, a word coined on the analogy of Sympathy, to mean "feeling ourselves into things". In quite general terms this theory seems to be that we only come to know other people are alive and acting, as distinct from mere moving things, by imagining ourselves executing the movements which we actually see their bodies execute. Thus we read into their movements feelings of our own, feelings we do have in imagining the execution of these movements, and like those we should have in actually executing them. We only understand that things are alive by imagining ourselves as doing what we see them doing. So the most direct empathy is in watching a drama or dance, but it also occurs in looking at a statue or picture where action is suggested, or in reading novels or poems where it is described. But mere lines also suggest movements in various ways, either the movements we should have to make to draw them or the movements we have to make to follow them with our eyes. And these movements, real or imaginary, of ours may account for the language we use when we speak of heavy or soaring or lifting or peaceful lines in pictures or mountains or architecture. Thus Swinburne not only addresses the sea-gull,

> When I had wings my brother
> Such wings were mine as thine

but also says of the wave

> When loud with life that quakes,
> The wave's wing spreads and flutters,
> The wave's heart swells and breaks.

and Shelley longs to pant beneath the Cloud's power and to share the impulse of its strength. It is perhaps Wordsworth who has laid most stress on this kind of expressiveness. He seems, much more consciously and explicitly than most of us, to have felt a life like his own going on in nature, not only in trees and flowers, but in storms and mountains and waterfalls. In the poem called *Nutting* he describes how, as a boy, he beat down and trampled a thicket of hazels which "patiently gave up their quiet being", and how the "mutilated bower", "deformed and sullied", gave him "a sense of pain": therefore, he concludes,

> move among these shades
> In gentleness of heart; with gentle hand
> Touch—for there is a spirit in the woods.

And in his *Preface to Lyrical Ballads* he describes the poet as "a man pleased with his own passions and volitions, and who rejoices more than other men in the spirit of life that is in him; delighting to contemplate similar volitions and passions as manifested in the goings-on of the Universe, and habitually impelled to create them where he does not find them". Again in *The Prelude* he says that the poet in looking at natural objects must

> see them feel
> *or* link them to some feeling.

For there seems to be another way in which things become expressive besides this "empathy" we have been describing. Not only can we imaginatively read our feelings into things and so treat them as it were *intrinsically*, but we can call up the feelings we might in practical life have towards these same things and so treat them *extrinsically*. Not only may we see a wave as alive, panting, dying, but as a delicious thing to bathe in or sail upon. Trees not only grow and dream and weep, but shelter us from sun and storm. Skies are rainy as well as smiling and frowning. We may either look into Macbeth's heart, share his temptation and shrinkings and slip with him into crime and remorse, or we may share rather in the rage and indignation of his subjects who look upon him as a mere senseless criminal. In almost all drama and fiction some characters are treated intrinsically or from inside; the author has felt himself as living in them. If the author is a man he generally treats,

at least, his hero thus; if a woman she so treats her heroine. But some characters are treated extrinsically; we only see them, as it were, through the eyes of the other characters, and that really means through the eyes of the author; we do not feel their feelings through his heart. Most authors, except very great ones, treat their villains, if they have any, thus; even Shakespeare sometimes does so. Most authors, except great ones, treat the other sex thus.

There are the same two ways of treating nature in poetry. Wordsworth, as we have seen, treats it, in the main, intrinsically; Milton, in his early poems at least, mainly extrinsically, as a nice quiet thing to be with.

In both these ways, then, things become expressive of our feelings. Either we imagine them as living lives like ours, by what Ruskin called the Pathetic Fallacy,[2] or we imagine ourselves having some kind of intercourse or traffic with them. There may be other ways in which things become expressive. There certainly are these two. Music and the pure lyric seem to be more direct utterances of the soul. I think, then, that all beauty is expressive. The artist, when he is creating, generally starts with a feeling which he needs to express, and looks for a shape to express it. *He* therefore talks rather about expression than about beauty. The recipient of his art or the man looking at nature starts with a perceived object and, if he is to appreciate its beauty, he has to find its meaning, to decipher and imaginatively to realize a feeling which it expresses. He therefore talks rather about beauty than about expression. Spectators who talk about expression are generally critics or resting artists who take the artist's point of view. Artists who talk about beauty are sometimes less artists than lovers and imitators of natural objects or works of art already existing. It might seem, then, that the artist when creating starts from his feeling and looks about for a sensuous image to express it, whereas admirers of art or nature have to start from the imagery and find in themselves a feeling it will express. But the contrast is not always so clear. Perhaps the beauty we see in strange nature or art depends on what is predominant in our mind when the object is presented to us. The same child or tune might seem joyously beautiful or tragically beautiful to different people. And on the other hand the artist sometimes starts by noticing a colour or sound pattern, natural or mechanically produced by himself, which reminds him of a mood that it can be made perfectly to express. A good instance of this[3] appears to be in Blake's poem finally completed thus:

[2] *Modern Painters*, iv, xii.
[3] Pointed out to me by Professor J. A. Smith; see *Blake's Poetical Works*, ed. J. Sampson, p. 126.

> The modest Rose puts forth a thorn,
> The humble sheep a threat'ning horn;
> While the Lilly white shall in Love delight,
> Nor a thorn nor a threat stain her beauty bright.

He first wrote "The rose puts envious . . ." then substituted for the last three words "hurtful rose" and added:

> puts forth a thorn
> The coward sheep a threat'ning horn;
> While the lilly white shall in love delight,
> And the lion increase freedom and peace.

Subsequently he deleted the last line and substituted:

> The priest loves war and the soldier peace.

but finally replaced this by the present last line, changing "hurtful" to "modest" and "coward" to "humble".

Here, no doubt, the first version of the quatrain attracted the author as a picture-cadence of some beauty, having a certain emotional tone, or he would have abandoned it. Probably its expressions seemed to him vague or indistinct and he kept it by him till it suggested a mood, or a mood arose, which the picture-cadence, with a little alteration, would express, perhaps perfectly express. The modification is, I suppose, always of the two sides reciprocally, both of the mood and of the pattern, no matter which we are supposed to start from, till the two will fuse. The artist, in creating, actually alters the words or notes or colours; the admirer can only modify his selective attention to them or his interpretation of them, or the associations he attends to. The mood is bound to be modified in the way of increased definition by expression, and may be modified in other ways too.

What a beautiful thing expresses we cannot of course say; the beautiful thing expresses it and nothing else exactly can. The poetical import, even of a poem, could not, if it were a perfect poem, be fully and precisely expressed in any words except those of the poem. Still less can the pictorial import of a picture be expressed fully and precisely in any words, and only approximately by a similar picture. I do not even think we can say that the most successful work of art precisely expresses the feeling which the artist had before he began to express it. For since he cannot know but only feel his feeling before it is expressed, during the very act of expression it becomes more clear and definite, which was indeed his aim. So perhaps the artist always feels, even in his greatest triumph, a certain sense of failure. He set out to express a dim feeling, and he makes it a clear one by expressing it; yet he recognizes

it as a development of the old. "Heard melodies are sweet, but those unheard are sweeter." So a work of art, even for its maker, is something like a natural thing or a work of art made by another man. The maker has to look at it and *find out* what it expresses. He does not know first. But he has a clue. It may seem paradoxical to say that in trying to express our feelings we do not know what they are till they are expressed and yet then do know that we have expressed them. But in fact we know for certain that something of this kind does occur in other spheres. When we are looking for the answer to a problem we certainly do not know what the answer is, yet when we have found it we know it is the right answer, the one we were looking for. When we try to remember the name of an acquaintance or a telephone number we certainly are not yet able to say what it is, but we can often reject wrong suggestions; and when, with or without help, we do remember it, may be certain it is the right one. So a man trying to write a melody does not know what it is going to be, yet of various things that come into his head he knows some are wrong.

Croce has been criticized with much acerbity by his compatriot Gentile.[4] Most of the criticisms are concerned with alleged contradictions by Croce of his avowed idealist metaphysics, and these cannot be discussed here.

Whereas Croce had defined beauty as *the expression of* feeling, and held that this always occurred in the intuition of an individual image, Gentile asserts that beauty *is* the feeling which accompanies every act of thought, whether that be perception or doubt or judgment. "Everything", he says, "is beautiful—just as far as it is beautiful." "Beauty is the amount of self or feeling a man puts into his thought." It is the subjective side of all acts of consciousness, of which the thing or truth apprehended is the objective side. Neither of the two sides can exist alone; we only distinguish them by a subsequent act of analysis or abstraction. When the artist is creating or his public is appreciating him they both take his message for truth, just as we take our dreams for truth while we are dreaming. It is only the critic who distinguishes the feeling or beauty from the fact—scientific, religious, political—with which the work was concerned, just as it is the waking man who talks about dreams. Anything of which we are aware, then, is beautiful, but it is also much else; for instance, good and true.

It is true that artists are often not deliberately aiming at beauty but at the propagation of some theory or policy. But when this is so, the beauty they incidentally produce is rather natural than artistic, like the movements of a child. And the receptive, sympathetic attitude to art

[4] *La Filosofia dell'Arte*, 1931. I have translated this book for Mr. Titus of Paris.

is not conviction but an enthusiastic suspension of unbelief. It seems hard to say that more feeling (apart from the feeling aroused by their beauty) was involved in the mere perception of the natural objects we call beautiful than of others. It is more convincing to say that they appear beautiful when they are not desired or hated or considered for their scientific interest but contemplated as expressing feeling. I do not see how Gentile could avoid concluding that a man who acts or schemes whole-heartedly under the sway of lust or passion is experiencing beauty as fully as one who watches a tragedy; a savage in battle as much as one enjoying the dance; the desperately struggling sailor as much as one who sees the sublimity of the storm; the jealous lover as much as the reader of *Othello*. Beauty would be not "emotion recollected in tranquillity" but emotion. And it hardly improves matters to be told that we only *distinguish* the beauty when we have ceased to experience it, when we have woken up from the dream. It looks as if we should have to say that when, and only when, we see an experience to have been false or wrong, to have been lacking in objectivity or truth, do we fix our attention on the subjective side of feeling, which alone is left, and call it beautiful.

I think, then, that beauty is better described as the contemplation of feeling expressed in an individual image than as the feeling which accompanies all mental activity.

Some who cannot accept the doctrine that all experience of beauty is the expression of feeling are driven to the view that it is the discovery of what they call individual quality; not of course the physical qualities or relations of things investigated by science, but such qualities or essences (which they take to be real apart from our consciousness) as gloom, grandeur, freshness, majesty. To this I should reply that in seeing certain sizes and shapes as grand or majestic, certain arrangements of colour as gloomy or fresh, we have already interpreted their actual physical appearance in terms of feeling.

I said that I was strengthened in my inclination to accept this definition of beauty as the expression of feeling by the way in which it seems to solve some of the constantly recurring problems about differences of taste.

Take first the old quarrel between upholders of what are called the classical and the romantic tastes. So far as any clear meaning can be given to the antithesis it seems to be one between the perfection of the sensible image and the moving import it conveys. Our definition would enable us to point out that these are not two kinds of beauty, but two elements in all beauty, which in perfect beauty would be perfectly balanced but in actual imperfect beauties are apt one to outweigh the

other. Crude, youthful, barbaric taste is often satisfied with emotional excitement for which no adequate expression has been found. Sophisticated natures, with less ardent passions, care more for the perfection and accomplishment of the expression and overlook its emptiness. If, as Wordsworth said, poetry is Emotion recollected in Tranquillity, some care for the emotion more and some for the tranquillity.

Some ages and races find beauty for the most part in a life and energy which seems to mirror their own self-confident activities. Others seek it rather in the rigid order of geometrical forms which seem to express their longings for peace and escape from the turbulent and baffling restlessness of life.[5] But both elements, that of passion and that of order, must always be present, more or less balanced, in everything that is beautiful.

Again the so-called *truth* of beauty, which we saw could not be philosophical, scientific, or historical truth, would on this view be truth of expression, the correspondence of the image to the feeling.

And the difficulty that we do think there is good and bad taste, but cannot understand in what way the bad is wrong, might be lessened if we held that different shapes are differently expressive to different people, but that some people do not really care for their expressiveness but only for their stimulating qualities.

Lastly, the relation of beauty to conduct would be that some of our deepest and most permanent feelings are bound up with our verdicts on right and wrong, justice and cruelty, and that the expression of these must make a large part of beauty. If asked what makes things ugly, I should reply: the failure to be expressive in a thing which claims or is expected to be so. Hardly anything in nature is ugly, because we do not necessarily expect it to be expressive. And hardly any plain, unpretending useful thing is. Perhaps the shape and size which fit a thing exactly to serve our purpose usually become expressive of the desire which the thing helps us to satisfy and of that satisfaction. But when men make fine houses or clothes, which should express feeling, and especially when they make pictures and poems, which are useless and whose only reason for existence is expression, then if they fail and are merely pretentious, affected, didactic, or sensual we feel cheated.

I also said that I would illustrate by some of the more striking sayings from different periods the gradual convergence of theories towards this point of view. Plato, the very first theorizer on the subject, said that music and shapeliness "imitated" states of mind. He was simply at a loss for a word. Sounds and shapes can only "imitate" moods by expressing them. Aristotle said that drama purges us from

[5] Cf. Hulme, *Speculations*.

emotions of pity and fear, and music from excitement perhaps of a religious kind. I can only understand this by supposing that in expressing such passions these arts for the time relieve us from our blind bondage to them. The author known as Longinus, perhaps in the first century A.D., said that greatness in nature and art pleases us because it echoes a greatness in our own souls. Plotinus, the neo-Platonist, says that a man who admires beauty is like one who not recognizing his own face in a mirror should fall in love with it.

Pope said of True Wit (and by Wit he meant almost what we should mean by poetry)

> True Wit is Nature to advantage dress'd;
> What oft was thought, but ne'er so well express'd;
> Something, whose truth, convinc'd at sight we find,
> That gives us back the image of our mind.[6]

And his contemporary and opponent Dennis: "Most of our thoughts are attended with some sort and some degree of Passion. And 'tis the expression of this Passion which gives so much pleasure both in Conversation and in Human Authors."[7] J. S. Mill says: "Poetry and eloquence are both the expression of feeling, . . . eloquence is *heard*, poetry is *over*heard. . . . Poetry is feeling, confessing itself to itself in moments of solitude, and embodying itself in symbols, which are the nearest possible representation of the feeling in the exact shape in which it exists in the poet's mind." (*Discussion II.*) Emerson says: "Every appearance in nature corresponds to some state of mind, and that state of the mind can only be described by presenting that natural appearance as in a picture." (*Infinite Beauty.*) To quote modern philosophers, or more of Wordsworth, would take far too long. So I will conclude with Coleridge, who said: "In looking at Objects of Nature I seem rather to be seeking a symbolical language for something within me than observing anything new." (*Anima Poetae.*) And in the great *Ode to Dejection* he speaks of

> the spirit and the power
> Which, wedding Nature to us, gives in dower
> A new Earth and new Heaven.

For

> We receive but what we give,
> And in our life alone does Nature live:
> Ours is her wedding-garment, ours her shroud!
> And would we aught behold of higher worth,
> Than that inanimate, cold world allowed

[6] *Essay in Criticism.* [7] *Advancement and Reform of Modern Poetry.*

> To the poor loveless, ever-anxious crowd,
> Ah! from the soul itself must issue forth
> A light, a glory, a fair luminous cloud
> Enveloping the Earth,—
> And from the soul itself must there be sent
> A sweet and potent voice, of its own birth,
> Of all sweet sounds the life and element.

This says in poetry what he had also said in prose: "Imagination acts by impressing the stamp of humanity, and of human feelings, on inanimate or mere natural objects."[8] We all do this when we find beauty in nature. Artists and poets do it more readily, and then they use the nature they have so seen in their own works. At other times they create works that seem to have little relation to nature. But whenever we look at artists' works, whether resembling nature or not, and find them beautiful, we have discovered in them the stamp of humanity and of human feelings. And to do this we must use imagination just as they did in creation.

[8] *Lectures*, Bohn, p. 221.

10. THE CONCEPT OF ARTISTIC EXPRESSION

JOHN HOSPERS

The expression theory of art, in one form or another, has dominated the aesthetic scene for the past two centuries as much, perhaps, as the imitation theory had done previously. It is often assumed without question that the distinctive function of the artist is to express emotions; that if the artist does not express in his work, what he does is to that extent less entitled to be called art; and that all art must be expressive of something or other, so much so that a non-expressive work of art is a contradiction in terms. Nor has the predominance of expression been limited to art; it has been extended to all objects of beauty. It is said that all truly beautiful objects are expressive, and some have even asserted their identity: beauty *is* expression.

In all this the terms "express," "expressive," and "expression" are, of course, all-important. It is of the utmost consequence, then, that we know what these terms are being used to mean. What is artistic expression? What does an artist do when he expresses? What is it for a work of art to be expressive? In this paper I shall try to do no more than give a brief critical examination of the principal senses which can be given to the notion of expression as it occurs in the literature of aesthetics.

I. Expression as a Process

What, then, is expression? One answer seems obvious, though we shall see that it is not the only possible one: expression is an activity of the artist in the process of artistic creation; expressing is something that the artist *does*. What precisely is it that the artist does when he expresses? On this point accounts differ from one another considerably,

FROM VOL. 55 (1954–55) OF *Proceedings of the Aristotelian Society*, PP. 313–44. REPRINTED BY KIND PERMISSION OF THE EDITOR OF THE ARISTOTELIAN SOCIETY.

and I can do no more than mention a few main points to indicate briefly the area in which aesthetic philosophers are working when they discuss expression.

Most accounts of the expressive process emphasize the confusion and chaos with which the process begins in the artist's mind, gradually replaced by clarity and order as it approaches completion. Collingwood, for example, says:

When a man is said to express emotion, what is being said about him comes to this. At first, he is conscious of having an emotion, but not conscious of what that emotion is. All he is conscious of is a perturbation or excitement, which he feels going on within him, but of whose nature he is ignorant. While in this state, all he can say about his emotion is: "I feel . . . I don't know what I feel." From this helpless and oppressed condition he extricates himself by doing something which we call expressing himself.[1]

At this point, he writes, he paints, or he carves in stone, and from doing this his emotions become channeled in the exercise of a medium, and his oppressed state is relieved, his inner turbulence ceases, and what was inchoate becomes clear and articulate.

Although Collingwood does not make clear what sense of the phrase "what it is" he is employing when he says that the artist does not know what his emotion is, let us assume that the process he is describing is in general clear enough and turn to his account of the expressive process.

A man's conscious wit and will are aiming at something only dimly and inaccurately imagined. Yet all the while the forces of organic ripening within him are going on to their own prefigured result, and his conscious strainings are letting loose subconscious allies behind the scenes which in their way work toward rearrangement, and the rearrangement toward which all these deeper forces tend is pretty surely definite, and definitely different from what he consciously conceives and determines. It may consequently be actually interfered with (jammed as it were) by his voluntary efforts slanting toward the true direction. When the new center of energy has been subconsciously incubated so long as to be just ready to burst into flower, "hands off" is the only word for us; it must burst forth unaided.

In all this, the expression of feeling or emotion is to be distinguished sharply from the deliberate *arousing* of it; accounts are fairly unanimous on this point. A writer of fiction, for example, may deliberately attempt to arouse feelings in his readers, which he does not experience himself. In this case he is expressing nothing, but cold-bloodedly adopting what devices he can to arouse feelings in others, remaining himself unmoved. Because the artist, while expressing his feeling, is clarifying it to him-

[1] R. G. Collingwood, *The Principles of Art* (Oxford: The Clarendon Press), 1938, p. 109.

self, he cannot before expressing it know or state what he is going to express; therefore he cannot *calculate* in advance what effects he wants to produce and then proceed to produce them. If he could, he would have no need to express, since the emotion would already be clear to him. "Until a man has expressed his emotion," says Collingwood (p. 111), "he does not yet know what emotion it is. The act of expressing it is therefore an exploration of his own emotions. He is trying to find out what these emotions are." The novelist who tries deliberately and consciously to arouse a certain emotion in his audience cannot, on the expression theory, be an artist; expression is the activity of an artist, while arousal is the activity of a clever craftsman or a trained technician.

In the foregoing characterization of the expressive process, attention has been given primarily to what is going on in the artist; and this, indeed, is the center of emphasis in the Croce-Collingwood school of aesthetics. Though they do talk about the artistic medium, and insist that what the artist expresses must be conceived in the medium the artist is going to use—be it words or paints or musical tones—they tend to view the artist's actual manipulation of a physical medium outside himself as an accident or an afterthought. That such a bias, though perhaps affecting most accounts of expression, is no essential part of the expression theory is brought out most clearly by John Dewey in his account of expression in *Art as Experience*. Dewey conceives expression, as (one is tempted to add) he conceives of everything else, as an inter- action between the organism and its environment: more specifically, in the case of art, as the recalcitrance of the medium and the artist's attempt to bend the medium to his will. To talk about expression in terms of the artist alone is to omit half the story; no amount of talk about the artist's inner experiences is enough.

There is no expression without excitement, without turmoil. Yet an inner agitation that is discharged at once in a laugh or a cry, passes away with its utterance. To discharge is to get rid of, to dismiss; to express is to stay by, to carry forward in development, to work out to completion. A gush of tears may bring relief, a spasm of destruction may give outlet to inward rage. But where there is no administration of objective conditions, no shaping of materials in the interest of embodying the excitement, there is no ex- pression. What is sometimes called an act of self-expression might better be termed one of self-exposure; it discloses character—or lack of character— to others. In itself, it is only a spewing forth.[2]

We have already distinguished expressing from arousing; Dewey asks us now to make another distinction, from the opposite direction, between expressing and discharging, getting rid of, or as Dewey puts

[2] John Dewey, *Art as Experience* (New York; Minton, Balch & Co., 1934), pp. 61–62.

it, "spewing forth." Aesthetic theory, says Dewey, has made the mistake
of supposing that the mere giving way to an impulsion, native or habitual,
constitutes expression. Such an act is expressive not in itself but only in
reflective interpretation on the part of some observer—as the nurse may
interpret a sneeze as the sign of an impending cold. As far as the act itself
is concerned, it is, if purely impulsive, just a boiling over. While there is no
expression, unless there is urge from within outwards, the welling up must
be clarified and ordered by taking into itself the values of prior experiences
before it can be an act of expression. And these values are not called into
play save through objects of the environment that offer resistance to the
direct discharge of emotion and impulse. Emotional discharge is a necessary
but not a sufficient condition of expression.[3]

There are many questions which one might ask of the above
accounts as descriptions of what goes on when artists create. But as a
psychological account I shall leave it largely unquestioned. It becomes
of interest for the philosopher when it is presented, as it often is, as a
theory of art. And as such there are a few questions which should be
put to it:

1. Expression theories usually speak of *emotions* as what is being
expressed, although sometimes the phrase "expression of *feelings*" is
used; but the meaning of these two terms, and their relation to one
another, is not usually made clear. But let that pass: cannot other
things be expressed as well, such as ideas? One wants to know more
about *what* it is that the artist *qua* artist is expressing, and, if some
things are appropriate for artistic expression and not others, why.

2. But no matter what the artist is said to be expressing, why should
one assume that the artist in his distinctively artistic activity is always
expressing? Why not say that he is sometimes representing, for example,
or just playing around with tones or colors? Many composers do not
begin with emotions or feelings at all, but with fragments of melody
which they then develop. For them feelings do not particularly enter
the picture at all, except possibly feeling of frustration at delays and
jubilation at having finished the job. Artists have been creating great
works of art for many centuries, yet only in the last two centuries or
less would it have been customary, or even seemed natural, to say that
the distinctive activity of the artist was that of expression.

Indeed, if we accept as being artists those men who have created
unquestionably great works of art—Bach, Shakespeare, Cezanne, and
so on—it is by no means clear that the creative processes through which
they passed can be adequately labeled under the heading of "ex-
pression." In the first place, in the case of most artists we have very little

[3] Ibid., p. 61.

idea of what their creative processes were like, since we have no record of them. And in the second place, even when we have such records, whether by the artist himself or his biographers, they do not always point to the kind of thing set forth by the expression theory. For example what was Shakespeare doing—was he, necessarily and always, expressing? There are doubtless creative experiences in the life of every artist which could be described by talking about an inner turbulence gradually becoming clarified and ordered, and emotions being released through the manipulation of an artistic medium; but I suspect that, as a general description of artistic activity, this is far too narrow, and is a bit too reminiscent of the mystical concept of genius fostered by the Romantic era. I doubt whether Shakespeare was always expressing feelings; sometimes he probably wrote, although he did not feel like it, to meet a deadline, or to have money coming in for the next month, or because the plot he had borrowed from somewhere else intrigued him and he wondered how he could incorporate it into a five-act drama. The motivation, the ends and aims, as well as the inner springs of artistic activity are, I am sure, a very mixed lot; and to assume that the artist *qua* artist is always expressing seems just as one-sided as the earlier assumption that he is always imitating nature or human action.

The written records left by artists, when we have them, sometimes seem flatly to contradict the expression theory—even though artists as a whole probably tend to glamorize themselves and like to leave the impression that they are solitary geniuses engaged in mysterious acts of self-expression. Thus, Poe gives us an account of cold-blooded calculation in the composition of his poem "The Raven," which is such a far cry from the description of the artistic process given us by the expression theory that it would be difficult to make it fit in at any point. And T. S. Eliot said in *The Sacred Wood* that "poetry is not a turning loose of emotion but an escape from emotion." One may, of course, say that if these men did not go through the process described by the theory, they were therefore not true artists; but this is surely to allow an *a priori* dogma to take precedence over cold facts. It is, I think, more certain that these men were artists than that any single theory of art, such as the expression theory, is true. And if the theory is presented, not as an *a priori* pronouncement but as an actual account of the creative process in artists, it will have to stand the empirical test, namely: in all cases of admitted works of art, was the process of its creation such as the expression theory describes? And I do not see any evidence that it holds true in all cases.

3. If it is true that not all great art was created in the way the theory describes, it is, I think, even more plainly true that not every-

thing created in the way the theory describes is great art. Let us assume that Shakespeare, Virgil, Mozart, Rembrandt, and Hokusai all went through the throes of creations as described by the expression theory; the same can be said of any number of would-be poets, painters, and composers whom one has never heard of for the very good reason that they have never produced anything worth looking at twice. I do not mean, now, the deliberate hacks and quacks, the detective-story writers who spin out half a dozen books a year with an eye on next season's market—these could be accused of trying to arouse emotions in others instead of expressing emotions of their own; I mean the host of deeply earnest would-be artists with delusions of grandeur, so dedicated to Art that they would starve if need be to give proper expression to their genius—but who have neither genius nor, sometimes, even talent. The same turmoil and excitement, the same unpredictability of outcome, the feelings of compulsion and dedication, the surcease from emotion from working in a medium, are experienced not alone by the great creators of art but by their hosts of adoring imitators and camp-followers as well as the supreme individualists who sigh and die alone, ignored and unrecognized but devoted still. This is indeed the most disconcerting fact about the expression theory as a criterion of art: that

all the characteristic phenomena of inspiration are described in undistinguishable terms by good and bad artists alike. Nor has the most penetrating psychological investigation succeeded in detecting any general differences between the mental processes which accompany the creation of a masterpiece and the inspirations of a third-rate botcher.[4]

4. In any case, can anything at all relating to the artistic process be validly used as a criterion for evaluating the artistic product? Even if all artists did in fact go through the process described by the expression theory, and even if nobody but artists did this, would it be true to say that the work of art was a good one *because* the artist, in creating it, went through this or that series of experiences in plying his medium? Once the issue is put thus baldly, I cannot believe that anyone could easily reply in the affirmative; it seems much too plain that the merits of a work of art must be judged by what we can find in the work of art, quite regardless of the conditions under which the work of art came into being. Its genesis is strictly irrelevant; what we must judge is the work before us, not the process of the artist who created it. And yet much critical writing seems to be beset by the delusion that the artist's creative processes are relevant to judging his product— that a bad work is excused or a great work enhanced by considerations

[4] Harold Osborne, *Aesthetics and Criticism* (London: Routledge & Kegan Paul, 1955), p. 161.

of how hard he tried or whether the conditions of work were unfavorable or whether he was inspired or in a mystical trance, and so on. And, perhaps, such considerations do excuse the *artist*, but they do not change the value of the work of art. It is a moral condemnation of Fitzgerald that he was lazy and indolent, and could have composed many poems like the *Rubaiyat* but failed to do so; but this is no criticism of the *Rubaiyat* itself; and it may be praise of Mozart's genius that every note in a concerto of his popped into his head in one afternoon, but not praise of his work—the concerto would be just as great if it had taken him ten years to complete. Even Collingwood, when he is distinguishing false art from art proper, does so on the basis of the artistic process: the artist is one who, during creation, expresses emotions formerly unclear to himself, while the false artist is the one who tries to evoke in others emotions which he does not feel. And I cannot emphasize too strongly that, however much this may be a criterion for judging the artist as a man (and I am not saying that it is a good one), it is not a criterion for judging his work. To judge the distinction between these two is to fall victim to the process-product ambiguity with a vengeance: the word "art" is normally used to name both a process and the product of that process, and because of this fact formulas like "art is expression" can be made to sound true and reasonable; the misfortune here is that this ambiguity, so obvious once it is pointed out, may help to make people think that any considerations about the artistic process can be relevant to judging the merits of the artistic product.

Our conclusion is, then, that when we make a judgment of aesthetic value upon a work of art, we are in no way judging the process, including any expressive process, which led to its completion, and therefore the act of expression does not enter into a critical judgment. If we do not know what the process was like, we need not on that account hold our judgment of the work in abeyance; and if we do happen to know what it was like, we should not let this sway our judgment of the work of art. But there *are* times when we *seem* to invoke the process as a criterion of judgment, and these we should now briefly examine. Here is an example from Dewey:

If one examines into the reason why certain works of art offend us, one is likely to find that the cause is that there is no personally felt emotion guiding the selecting and assembling of the materials presented. We derive the impression that the artist . . . is trying to regulate by conscious intent the nature of the emotion aroused.[5]

[5] *Art as Experience*, p. 68.

One example of this occurs, I suppose, when we feel that a novel is "plot-ridden"—for example, that the novelist has forced his characters into conformity with the demands of a plot which he had outlined in full before giving much thought to his characters. This feeling, I take it, is familiar enough. But is our criticism here really of the author's creative processes? Are we blaming the novel because he outlined the plot first and then manufactured the characters to fit the plot? I do not think so: we criticize the work because the actions that these characters are made to perform are not such as characters of this kind would do; in other words, they oversimplify and falsify human nature, and it is because of this that we are offended. If the characters strike us as real human beings, we do not care what process the artist went through in creating them: whether he thought of the plot first and the characters afterward, or whatever it may have been.

The same considerations apply in other cases where we seem to make use of the process in criticizing the product. For example, we say, "One must feel that the work of art came out of the artist's own experience, that he himself lived through the things he was describing," or we say, "I don't like this work because I don't feel that the artist was being *sincere* when he wrote it." Now, living through something and being sincere about something are things we say about people; are we not therefore using the process in evaluating the product? Again, I think not. Perhaps we do require that the characters in the drama behave *as if* the dramatist had personally experienced all their emotions and shared all their fates; but as long as we feel this, must we reverse our judgment if we should subsequently discover that the dramatist had felt none of these things at all, or only a small part of them? Shakespeare could hardly have gone through the experiences of Hamlet, Macbeth, Iago, Cleopatra, Lear, Goneril, Prospero and Coriolanus in one lifetime, but what difference does this make as long as he could present us with a series of vivid, powerful, convincing characterizations? Or suppose we praise a work, say *Uncle Tom's Cabin*, for its sincerity. Does it really change our critical judgment when we know that Mrs. Stowe was weeping tears during many of the hours in which she wrote it, and if we should discover that it was written by a wealthy Southern slaveowner on a wager to prove how well he could present the feelings of "the other side," would it alter our critical judgment of his work? It would alter our judgment about the author, surely; it would change our judgment about the author's sincerity, and it would probably make us attribute to the author much more ingenuity than we now attribute to Mrs. Stowe. But our judgment of the work would not be changed; or, at any rate, I submit, it *should* not

—for the novel, after we have made this discovery, would be just the same as before; not a jot or a tittle of it would be changed by our discovery. And as long as it is the *work* which we are judging, surely our judgment should remain unchanged as long as the work is unchanged.

What difference does it make *what* emotions the artist felt, so long as the work of art is a good one? If the artist was clever enough to compose a work of art without expressing emotion in anything like the manner described by the expression theory, or even if he felt nothing at all, this is of no importance so long as we find the work an enduring source of aesthetic satisfaction. It may be true as an empirical fact about artists, that *unless* they really feel something, unless they are or have been on fire with emotion, or unless they have deep perturbations which demand resolution, they are not able to create great works of art. This may sometimes be true, though I doubt whether it is true in all cases. But even if it were true in all cases, we need still have no interest in the artist's creative processes as such; knowing facts about the artist's processes would at best be a good indicator of his having created great works of art, which we might then go on to examine, and test the correlation between process and product. To know (supposing it to be true) that a work of art could be produced only when the artist went through this or that kind of creative process would be to know an interesting correlation, but it would not be a means of judging the work of art itself. Even if Bach's Preludes and Fugues had been produced by machinery, would they not be as great as before?—and this in spite of the fact that there were no artist's emotions to be expressed because there was no artist. For appreciating the work of art, the artist's biography is not essential: "by their works shall ye know them."

II. Expression as Evocation

Thus far we have been discussing the sense of "express" in which expressing is something the artist does. Let us now turn to another sense, that in which we say that a work of art expresses something, or is expressive. Here we need not bring in the artist's creative process, which we found to be so damaging to the expression theory of Section I.

1. There is, I think, a sense in which we can bring in the artist even here. We may say, "The music expresses sadness," meaning thereby the sadness which the artist felt; this sense means approximately the same as "reveal." In this sense there *is* a biographical commitment, for if it should turn out that the artist did not feel any sadness, this would falsify our statement that the music expressed the sadness that he felt.

This sense of "express" is easily confused with something we distinguished from expression in Section I, namely giving vent to or releasing emotion as opposed to expressing it. The two are easily confused because they may both be asserted of one and the same person in one and the same situation; they differ only in *from whose point of view* the expressing is done. We may say of the person who is raging that he is expressing rage. In Dewey's sense (considered in Section I) this is false, since he is merely giving vent to rage, not expressing it; but *to us as observers* his actions may be expressive of rage in the sense we are now considering, namely that they *reveal* it. Another example:

> ... the cry or smile of an infant may be expressive to mother or nurse and yet not be an act of expression of the baby. To the onlooker it is an expression because it tells (reveals) something about the state of the child. But the child is only engaged in doing something directly, no more expressive from his standpoint than is breathing or sneezing—activities that are also expressive to the observer of the infant's condition.[6]

Whether this "reveal" sense of "express" is much used of art is doubtful. At any rate it is primarily used in speaking of a person's state-of-mind as being expressed (revealed) by his facial expression or gestures. If Jones was not feeling joyful, we would probably retract our statement that his face expressed his joy; but if Mozart was not feeling joy, we would probably not retract our statement that Mozart's rondo expresses joy. This shows that when we make the expression-claim of music we are not involving ourselves in any biographical commitment, anything that could be falsified by knowing more about the composer's biography. We would insist that the music was expressive of joy even if we learned that Mozart hadn't had a joyful moment in his life. Since in this case we do not test our statement by facts about Mozart's life, what *do* we mean when we say that the music expresses, or is expressive of, the emotion?

2. One obvious answer is that to say that the music expresses joy is to say that it *evokes* joy in the listener. (Expression is in this sense a "to me" characteristic: it may express to you and not to me because it evokes sadness in you but not in me.)

But this analysis is at once seen to be too crude to do the job. Music which I say expresses joy may not make me joyful at all, especially if I am in a sour mood today or am tired or have already heard the same composition twenty times this week.

3. Perhaps then we should say, not that it actually *does* make me

[6] *Art as Experience*, p. 61.

feel so-and-so, but that when I hear it I have a *disposition* to feel so-and-so, the fulfillment of this disposition depending on the non-occurrence of certain inhibiting factors such as fatigue, boredom, worry, and sleep. In short, in normal circumstances (and we can specify what these are) the music will make me feel so-and-so, but it will not always do so, just as normally light-waves of a certain character impinging on my retina will make me see red but will not do so if I am drugged, asleep, or color-blind.

4. But this, though an improvement, will not do either. To respond to works of art with emotions, some will say, is not yet to have developed the aesthetic attitude towards art-objects. Those who respond to a drama or a novel with tears have not developed aesthetic distance; they are responding to the work of art as they would respond to a situation in real life; they are still in the position of the yokel in the gallery who shoots the villain on the stage as he is about to capture the heroine. We should not respond to art with the emotions of life.

One might object also: if "The music expresses sadness" means "I am disposed to feel sad when I hear it," why should I ever wish to hear it? Sad experiences, such as suffering personal bereavement or keen disappointment, are not the kind of thing we wish to repeat or prolong. Yet sad music does not affect us in this way; it may bring relief, pleasure, even happiness. Strange kind of sadness that brings pleasure!

One may, of course, reply to this as follows: Sadness expressed in music is a very different thing from sadness in life; it is only by a kind of analogy that we use the same word for both. Sadness in music is depersonalized; it is taken out of, or abstracted from the particular personal situation in which we ordinarily feel it, such as the death of a loved one or the shattering of one's hopes. In music we get what is sometimes called the "essence" of sadness without all the accompanying accidents, or causal conditions which usually bring it into being. In view of this, it is said, we can continue to say that music expresses sadness, but we should distinguish the music-sadness, which is a happy experience, from life-sadness, which is not.

Now, this view is not beyond criticism. Why, one might ask, should the experience of sadness come into being when it is cut off from its usual causal conditions? And if it is replied that the experience is after all very different, why call it sadness? is not sadness the kind of experience that accompanies events like bereavement and disappointment? and would it be sadness without these things?

There is both a psychological and a linguistic point involved here. I shall not attempt to discuss the psychological issue: *why* it is that

music is able to evoke in us experiences which we describe as sad is a psychological-physiological question of great complexity; it is the kind of question to which the answer lies, as I. A. Richards once said, still hidden in the jungles of neurology. The linguistic point is that however unlike music-sadness and life-sadness may be, and although music-sadness may not deserve the name "emotion" at all, the experiences are sufficiently similar to have received the same name—and not through accidental ambiguity, like the river bank and the Bank of England, but quite spontaneously, so that a person who has experienced sadness in life does not need to learn the application of the same word to music-experiences. And this is enough for our purposes. Let us grant, then, that music-sadness is different from life-sadness, and that whatever the psychological causes of the felt similarity may be, it is the music-sadness and not the life-sadness that the music evokes.

Here, then, is a possible meaning for "The music expresses sadness": "I am disposed, in response to hearing the music, to feel music-sadness." But there are other possible meanings as well:

5. It may be that when we hear the music we do not ourselves *have* or *experience* the sadness, we *imagine it.* Quite surely this often happens; we imagine what we do not feel.

6. Or again, we may not imagine it, but *think* of it. On hearing the music we may feel nothing at all, but say to ourselves, "Oh yes, sadness." I am sure that this often happens, but I am inclined to think that this is a derivative sense: when I say "Oh yes, sadness" I recognize it as the kind of music which under *other* conditions would make me feel or imagine the music-sadness. Unless I had at least once experienced the feeling, I would be unable so to recognize it.

7. I may even say that the music expresses sadness without having ever felt anything in response to it at all; perhaps I am tone-deaf; but I have heard others say that it expressed sadness and I may recognize this composition as similar to other compositions of which I have heard people say this, and therefore say that this one too expresses sadness. Again this is clearly derivative: if I have not experienced the music-sadness, someone else must have. This is strictly a trying-to-keep up-with-the-Joneses sense: not having a musical sense myself, I disguise the fact by aping the locutions of others.

8. All these are rough characterizations of states of mind evoked in us by the music which may be the criterion for our calling them expressive. But there are other, more demanding and complicated, criteria, which there is no time to discuss in detail. I shall select only one, perhaps the best known, that of Santayana, who says in *The Sense of Beauty* that A (an element in a work of art) does not express B

(an emotion) to me unless A and B are confounded with one another in my mind; or, as he says in another passage, A and B are so indissolubly fused together in my mind that I do not think of them as separate entities. The music does not express joy to me unless the joy is felt as being "in the very notes I hear"; if I merely associated joy with the notes, then the one would merely remind me of the other and the two would not have fused in my mind, and without this fusion there is no expression.

It is not easy to know what to make of this way of putting the matter. (a) If in taking A to express B I am *confounding* A with B then our entire talk about expression depends on a delusion: a false identification between the A and B which are clearly not identical things. It is difficult to believe that when I take A to express B I am confusing two things which in my soberer moments I know very well should not be confused—a case of mistaken identity. (b) But if, in taking A to express B, I am said to be *fusing* A with B, I am not clear about what I am supposed to be doing. I know what it is like for two metals to be fused together in intense heat, but talking about two such different kinds of thing as notes and emotions as being fused together seems just as mysterious as talking about two railway cars as being connected, not by a coupling, but by the *thought* of a coupling. It may be, of course, that this kind of language is not meant to be taken literally; perhaps it refers merely to the kind of experience which would lead us to say such curious things. But this, of course, leaves the rest of us, who are not moved to say these things, in the dark about what this experience is like.

The words "express" and "expressive," however, can be variously used, as we have already seen; and if anyone finds in his experience anything which leads him to use the combination of words which Santayana employs, and wants to use the word "express" to refer to it, he is welcome to do so. Since the word "express" in the content of evocation has numerous related meanings, I suppose it will not be fatal to add still another to the list.

In this section we have been speaking of A expressing B, or A being expressive of B, if A evokes or tends to evoke in us a feeling of kind B— with the variations and complications we have now reviewed. Let us now pause for a moment to examine the question, How does the expression theory of art stand up when we use *this* kind of meaning for the term "expression"?

Personally, I am not inclined to say either that a work is better art, or that it is more beautiful, when I say that it is expressive of something.[7]

(1) When I hear several compositions and say what they express to me,

[7] Some of the following arguments are drawn from Edmund Gurney, *The Power of Sound*.

and then hear some entirely different, non-descriptive compositions (a Mozart quintet, a Bach fugue) and cannot say what they seem to me expressive of, in fact I cannot honestly say I find them expressive of anything at all, I do not value them any the less as music on this account. My judgment of their merit as music remains unchanged by whether I do or do not attribute to them any expressive character. I can say that some passages of *Tristan und Isolde* express longing but I cannot say that the *Prelude and Fugue in G Minor* is expressive of anything, but I still prefer the *Prelude and Fugue* for all that. (2) When I say that a composition expresses this or that, I do not think that its beauty or its merit as music depends on this. I may find many mediocre compositions also expressive of the same emotion. Expressiveness is one thing and beauty is another; as Gurney said, why should expressiveness be any more an indicator of beauty in a tune than in a face? Just as there may be faces which are expressive but not beautiful, so also with works of art. (3) On those occasions when I hold the same composition to be both beautiful and expressive, I do not mean to imply that it is beautiful *because* it is expressive. Its beauty seems to depend on an extremely complex, subtle, and delicate combination of tones; and while I cannot say why I find this melody beautiful and another one, almost exactly like it, repulsive, I find the recourse to expressiveness quite unhelpful in explaining the difference. Indeed, when I say that it expresses so-and-so, the expressiveness seems to be as far from constituting its beauty, or even being an explanation of its beauty, as a heap of scattered clothes on the floor constitutes or explains the living beauty of face and form. (4) The expressive quality attributed to a composition by a person or a generation of people may alter, while leaving the attribution of beauty and musical merit unchanged. When Mozart's compositions first appeared, they struck the public as being full of storm and stress as opposed to the serenity and peace characterizing the works of Haydn. When Beethoven appeared on the scene, the compositions of Mozart joined those of Haydn in the Olympian realm of calm. And when Beethoven was followed by Brahms, Wagner, and Mahler, the expressive qualities attributed to the works of music again shifted. In all this the attribution of musical merit remained fairly stable; the beauty of Mozart's compositions, for example, was nowhere questioned. Again: Hanslick reports that he found the opening passage of the great E flat trio by Schubert "the *ne plus ultra* of energy and passion," while Schumann called that same passage "tender, girlish, and confiding." Yet these two sensitive listeners did not disagree in their judgments about its beauty; if they had been called upon to make a list of all Schubert's works in order of merit, they might well have constructed

identical lists. I am not trying to show here that our verdict of expressiveness has nothing to do with our verdict of beauty, but that it is far from being the only thing. At the very least it should lead us to reject the notion that beauty *is* expressiveness. Even if we held that all beautiful works were *also* expressive (or vice versa), the material equivalence would still not constitute an identity.

Expressiveness, then, as constituting, or even being a reliable indicator of, beauty in a work of art, is a view I would reject. Of course one may simply stipulate the alleged identity in a definition, saying "Beauty = expressiveness." But I see no reason to adopt such a use of terms, and would no more equate them than I would be inclined to say "Blue = solid." If, on the other hand, we tone down the assertion to read, "Whenever you say that something is beautiful, then you will also find that you will want to call that object expressive," then I think we shall find that in many cases this correlation does not hold. In this area, of course, since we are talking about evocation, each person can speak only in terms of what is evoked in him; if anyone honestly says that all those things he finds beautiful he also finds expressive, and vice versa, then I cannot deny what he says, but would still remind him that what he is uttering, at most, is a correlation which he has found to hold thus far in his experience between two different things—a correlation which could conceivably be upset by the next instance that appeared. This indeed is the possible fate of any contingent connection.

III. Expression as Communication

But we may long since have become impatient with the line of reasoning pursued in Section II. What we have been talking about all through it (it will be said) is evocation—trying to analyze expression in terms of certain effects, of whatever kind, evoked in the listener or reader or observer. And whatever expression is, it is not evocation; no theory of expression is merely a theory about evocation. So we shall have to look elsewhere if we want a sensible meaning for the term "expression," when used to characterize not artistic processes but works of art.

Why is this evocation-talk inadequate, one might ask, to deal with expression? One could imagine the following reply: To say that a work of art expresses something is not to say that the artist underwent certain creative processes, such as described in Section I, nor to say that the listener had certain experiences, such as described in Section II. Rather, it is to say that the artist has communicated something *to* the listener by means of his work. Expression is not just something evoked

in us, it is something which the artist *did* which he then *communicated* to us. Thus far we have dealt with the two aspects—artist and audience—in isolation from each other; but we should have considered them both together; this has been our error. Let us pursue this line of thought a little.

The typical kind of view here is one hallowed by tradition; we might describe it roughly as follows: The artist feels a powerful emotion which he expresses by creating a work of art, in such a way that we, the audience, on reading or seeing or hearing the work of art, feel that same emotion ourselves. Whether the artist did this by intent—i.e. whether in creating he wanted us to feel this emotion, which is what Collingwood denies that a true artist will do—or whether he was working something out within himself without thinking of an audience, does not matter at this point; the important thing is that, whether by intent or not, whether he created with an audience in mind or only to express what he felt, the artist put something into his work which we, the audience, can get out of it; and what we get out is the same thing that he puts in. In this way whatever it is that he put in is communicated to us who get it out. Expression is thus a "two-way deal" involving both the artist and his audience.

The language used just now in characterizing the view is deliberately crude, for I do not know how else to describe it with any accuracy. Indeed, this is the very feature of it which makes it, on reflection, extremely difficult to defend. Nor is it easy to remedy it by employing a more sophisticated language in formulating it, for the sophisticated terms usually turn out to be metaphorical. Yet these metaphors seem to be basic to the theory.

For example, it is said that the artist, by means of his work, *transmits* his emotion to us. But what is meant by "transmit" here? When water is transmitted through a pipe, the same water that comes into the pipe at one end comes out at the other; this is perhaps a paradigm case of transmission. When we speak of electricity as being transmitted through a wire, there is not in the same sense something that comes in at one end and out at the other, but at any rate there is a continuous flow of electricity; or if the word "flow" is itself metaphorical, it is perhaps enough to remark that at any point between its two ends the wire will affect instruments and produce shocks. When we transfer this talk about transmission from these contexts to works of art, we may tend to imagine a kind of wire connecting the work of art with the artist at one end and with the audience at the other; or, if we do not actually have such an image, at any rate the term "transmit" takes its meaning from situations such as we have just described; and the question arises, what does

it mean in the very different context of art? If it is not like these ortho-
dox cases of transmission, what makes it transmission? what is one
committing himself to when he says that in art emotion is transmitted?

A metaphor that may seem to do better justice to the theory is that
of deposition. The artist has, as it were, *deposited* his emotion in the work
of art, where we can withdraw it at any time we choose. It is somewhat
like the dog burying a bone, which another dog may dig up at his own
pleasure. But of course, the artist has not literally buried or deposited
emotion in his work; he has, rather, with or without the divine agonies
of inspiration, painted in oils or written a complicated set of notes on
paper. It is true that on seeing the one or hearing the other performed
we may have certain feelings; but in no literal sense has the artist *put*
them there in the way that we put money into the bank to withdraw
at a later time. Moreover, the bone that is dug up is one and the same
bone that was previously buried; whereas the emotion which we feel
(I shall not say "extract") when we hear or see the work of art cannot
be one and the same numerical emotion as the one which the artist felt
(I shall not say "put in").

Let us then substitute the metaphor of *conveying*. Whatever it is that
the artist is said to be conveying to his audience, of what does such
conveyance consist? One person conveys the ball to another by throw-
ing it; the postman conveys letters from the postoffice to one's door. Is
a material continuum necessary for conveyance—the postman between
the postoffice and the house, the moving conveyor-belt for trays and
machinery? If something mysteriously disappeared at one place and
reappeared at another, would it be said to be conveyed? If the emotion
ceases in the artist and turns up in the audience when they examine his
work, has the artist's emotion been conveyed? Again it is not clear
exactly what is involved in the talk about conveying. And even if the
emotion ceased in the artist and thereupon occurred in the audience
would it be the same emotion that occurred in the two? In all the
cases of conveyance—the ball, the letter, the water through the pipe—
it is one and the same thing that is conveyed from the one person or
place to the other. This condition is not fulfilled in the case of emotion.
One and the same emotion could no more occur in both artist and
observer than the same pain can be passed along from one person to
another by each person in a row successively pricking his finger with
the same pin.

Though the language of the expression theory leaves the impression
that it is one and the same emotion which occurs in both artist and
observer, on the analogy with the other examples, this is surely not
essential to the theory; perhaps it is enough that they be two emotions

of the same kind or class. It may be enough that the artist in composing may feel an emotion of kind X, and the observer on seeing it may feel another emotion of kind X. This probably occurs often enough. But suppose it does; is *this* sufficient for saying that X is conveyed from the one to the other? Is this watered-down formulation really what the theory means when it says that art expresses emotion?

Let us, then, speak simply of "communication." The word "communicate" is somewhat more elastic than the previous ones—people can communicate in person, by wireless, even telepathically—but it is also more vague and difficult to pin down. We could spend many hours discussing criteria for communication. Since we cannot do this here, let us take an example in which we would probably agree that communication had occurred. A student summarizes the contents of a difficult essay, and the author looks at the summary and says, "That's it exactly!" Similarly, one might say that an emotion had been communicated if the listener to a symphony described a movement as "haunting, tinged with gentle melancholy, becoming by degrees hopeful ending on a note of triumph" and the composer said, "Exactly so! that's just what I meant to communicate."

I have some doubts about whether even this last example would satisfy us as being a "communication of emotion." At any rate, what the listener did here was intellectual, not emotional—he *recognized* the emotions rather than experiencing them himself; and perhaps this suffices for communication, but it is worth pointing out that in the traditional expression theory the listener does not merely recognize the feeling, he himself *has* the feeling. But, so as not to spend more time tinkering with the highly vulnerable terminology of the expression theory (in the form we are considering in this section), let me state some objections that could be raised to any formulation of it known to me.

1. There are many experiences which the artist undergoes in the process of creation—the divine agonies of inception, the slow working through of ideas to fruition, and the technical details of execution—which the audience need not and probably should not share. This part of the artist's creative activity need in no sense be communicated. For example, much of the creative process may be agonizing or even boring, but the audience on viewing or hearing the work of art should not feel either agonized or bored. At most, then, it is only a selection of the artist's experiences in creation that should be communicated. One should not speak as if somehow the artist's whole experience in creation were somehow transferred bodily to the observer or listener.

2. Even for the part that the artist wants to communicate to his

audience, it is not necessary that he be feeling this at the time of creation, as the theory so often seems to imply. When the artist is under the sway or spell of an emotion, he is all too inclined to be victim and not master of it, and therefore not to be in a good position to create a work of art, which demands a certain detachment and distance as well as considerable lucidity and studied self-discipline. Wordsworth himself said that the emotion should be recollected in tranquillity; and others, such as Eliot, have gone further and expunged emotion from the account altogether. Perhaps, then, it might be held essential only that the artist *have had* the emotion at some time or other. But if all that is required is that the artist have some emotion or other of type X, then, since most people of any sensitivity have experienced a considerable part of the gamut of human emotions, including some from type X or any other one chooses to mention, this feature is no way distinguishes the artist from other people, and the theory loses all its punch; it becomes innocuous and, like all highly diluted solutions, uninteresting and indistinctive.

3. To say that the audience should feel the same kind of emotion as the artist seems often to be simply not true. Perhaps, in lyric poems and some works of music, the listener may feel an emotion of the same kind as the artist once felt; but in many cases this is not so at all. Even when we do feel emotions in response to works of art (and most of the time what we experience should not, I think, be called "emotions" at all, at least if our attitude is aesthetic), they are often of a quite different sort: if the author has expressed anger, we feel not anger but (perhaps) horror or repulsion; if he has expressed anguish, we may feel not anguish but pity.

Often it seems quite clear that the audience emotion should be quite different from anything that was or sometimes even could have been in the mind of the artist. We may experience fascination, horror, or sympathy when seeing *Hamlet* because of what we feel is the oedipal conflict unconsciously motivating his inaction; but this response, a result of Freudian psychology, could hardly have been in the mind of Shakespeare. And why indeed should it have been? It is enough that his drama can be consistently interpreted in this way, perhaps even giving it an added coherence; it is enough that he wrote a drama capable of arousing such feelings; it is not necessary that he have experienced them himself.

4. Epistemologically the most ticklish point for the expression theory is simply this: how can we ever know for sure that the feeling in the mind of the artist was anything like the feeling aroused in a listener or observer? Our judgments on this point, in cases where we do have

evidence, have notoriously often been mistaken. We might feel absolutely certain that Mozart felt joy when he composed the Haffner Symphony, and be amazed to discover that during this whole period of his life he was quite miserable, full of domestic dissension, poverty, and disease. A happy composition does not imply a happy composer. Strictly speaking the only way we can know how a composer felt is to ask him, and then only if he is not lying. If he is dead, we have to consult his autobiography, if any, or other written records, if any, and hope that they do not misrepresent the facts and that they do not tell us what the composer or biographer wanted us to think rather than what really was the case. And of course they often do this: "Artists who are dead have rarely left satisfactory psychological records, and the difficulties of appealing to living artists, whose motives and intentions are often mixed and their powers of introspective analysis small, are over-whelming."[8]

This consequence is fatal if the expression theory is made a criterion of good art. For it would follow that if we do not know whether the emotion experienced by a listener is of the same kind as that ex-perienced by the artist, we do not know whether or not this is a good work of art. Therefore in those cases where we have no records or they are of dubious value, we must hold our judgment of the work of art in abeyance. And such a consequence, it would seem, makes the theory in this form pass the bounds of the ridiculous.

"But," it may be said, "we don't have to find out from the artist himself or from written records what emotion the artist felt—we can tell this from seeing or hearing the work of art." But this is precisely what we cannot do. Though in this area conviction is strong and subjective feelings of certainty run high, our inferences from works of art to artists are as likely as not to be mistaken. We cannot tell from just listening to the symphony how Mozart felt; the work simply provides no safe clue to this. The best we can do is guess, after hearing the composition, what he was feeling; and then, if the available evidence should point to the conclusion that he actually was feeling so at the time, our inference would have been correct for at least this instance. But once we do this, we are already checking our inference (made from hearing the work) against the empirical evidence, and it is the evidence that is decisive.

We might, in the light of these objections, wish to revise the theory so as not to require that the audience should feel what the artist felt, but only what the artist wanted or *intended* the audience to feel. But when this is done, difficulties again confront us: (1) The same diffi-

[8] Harold Osborne, *Aesthetics and Criticism*, p. 153.

culties that attend our knowing how the artist felt are also present, though sometimes in lesser degree, in knowing what he intended. (2) The artist's whole intention may have misfired; he may have intended us to feel one thing, but if even the most careful and sensitive listeners for generations fail to feel anything like when they hear his composition, shall we still say that we should feel what the artist intended us to feel? (3) The moment we abandon the stipulation that the audience should feel, not as the artist felt but as the artist intended the audience to feel, we seem to abandon anything that could be called the expression theory. For it is characteristic of the expression theory that the artist must have felt something which he "conveys" through his work and which we on observing the work also feel; if he did not feel it, but only tried to make us feel it or intended us to feel it, this is no longer an expression of feeling on his part but a deliberate attempt to evoke it in others—in other words, not expressing but arousing.

It may seem that in the last few pages we have been flogging a dead horse; yet if one examines much critical writing he must be aware how far from dead this horse is. Critics and laymen alike are dominated, quite unconsciously, by the metaphors of transmission, conveyance, and the like, the emotion in the analogy being usually a kind of liquid that is transmitted bodily from artist to audience. Although when made explicit this kind of formulation would doubtless be rejected, it is precisely these metaphors which are at the very roots (to use another metaphor) of the expression theory in the form we have been considering in this section. And the very strong objections to the theory seem seldom to be realized.

But then, one might say, why should the expression theory be held in any such form as this? What we have been discussing in this section concerns communication between artist and audience; and a theory of communication, one might say, is no more a theory of expression than a theory of evocation is. For an artist to *express* something, however irrelevant this may be to a judgment of its value, is one thing; for him to *communicate* it to an audience is another. For a work to be expressive is one thing; for an audience to feel so-and-so is another. If this is so— if reference to an audience has no place in a theory of expression—it immediately rules out both the evocation forms of the theory which we discussed in Section II, and the communication forms which we have been discussing in Section III.

IV. Expression as a Property of the Work of Art

Is there yet another possibility? We have now discussed expression as an activity of the artist, expression as evocation in an audience, and

expression as communication between artist and audience. But we may be dissatisfied with all of these. "To say," we might object, "that the artist went through a certain series of experiences, or (if you prefer) interactions with his artistic medium, is indeed to talk about expression, in the sense of the expressive *process*; but this is chiefly of importance if we are interested in the psychology of artistic creation; it says nothing about the expressive *product*. The attempt to talk about the expressive product in terms of what feelings it evokes in an audience is, I suspect, a mistake; and so is the attempt to talk about it as a transaction between the artist and the audience. It is neither the artist nor the audience that matters here; it is the work of art itself. It is *the music* that is expressive; and the music may be expressive even if the artist had no emotions when he wrote it, and even if the audience is composed of such dull insensitive clods that they feel nothing when they hear it. Surely we do not want expression to depend in its very definition on the reliability or unreliability of audience response. The expressiveness of the music is dependent on neither the experiences of the artist nor the experiences of the audience."

This way of looking at the matter probably strikes a responsive chord in most of us. If somebody said to us that the last movement of Beethoven's Ninth Symphony, which we take to be expressive of joy or exultation, was mournful, dour, and depressing, we would probably dismiss his claim as absurd and assert with complete confidence that he had not even begun to listen to the music. We are inclined to feel that the music *does* express so-and-so just as objectively as it contains so-and-so many measures; and that if the audience is so stupid as not to respond appropriately to it, so much the worse for the audience.

Yet how are we in the final analysis to defend such a claim? If our opponent in the controversy has just as long an experience of music as we have, and is just as learned, sincere, and intelligent, and after repeated hearings he retains his conviction, what now can we do? Shall we simply say, "Now ends the argument and begins the fight?" Or is there some way in which we can defend the view that the music *really does* express what we say it does?

Let us try. We may take pains to define the music's expressive character in terms of certain configurations of tones or rhythmic patterns in the music. We may say, for example, that music is expressive of sadness if it falls within a certain range of (rather slow) tempo, is in the minor key, has more than a certain proportion of descending notes, a certain proportion of sixths or diminished thirds among its intervals, etc. The formula will have to be extremely complex, for the characteristics of music which make us say that a composition expresses sadness are extremely numerous. Moreover, it may be that no single

one of them is necessary; for example, sad music does not *have* to be in the minor key; it is only necessary that some of the characteristics be present. We shall doubtless end up with something of this sort: "Music expressive of sadness has features ABCD or ABDE or BEFG or . . ." etc. But it is at least conceivable that we might, with some patience, be able to track down all of what I shall call the sad-making features of the music and formulate them in a precise way, entirely in terms of what is to be found on the musical score. (And similarly for the other arts.) If this happened, we could say to our opponent, "Music that has features ABCD expresses sadness; this music has those features, as I can prove to you by showing you the score; therefore this music *is* expressive of sadness, and you are wrong when you say it isn't." We could then do the same with as many emotions or states of feeling as we wished: "Musical pattern of type 3856; this means emotion #3856, gentle melancholy tinged with doubt"—and so on.

The reason why this suggestion may not be helpful is, of course, that our opponents may reject these patterns of notes as expressive of sadness. He will perhaps present a counter-list of sad-making features. The difficulty is that which features of the music we are willing to include on our list of sad-making features is dependent on which features of the music make us feel the music-sadness, or at any rate make us inclined to say that the music is sad. And those features in virtue of which you call the music sad *may* be different from those in virtue of which I call it sad. And when this happens, what are we to do?

But now, it will be said, the case is not quite so hopeless as this. For there *are* times when we can say that, quite objectively, this expresses that. We can do it with regard to human facial expressions and gestures; this one expresses grief, another expresses perturbation, another jubilation, and so on. We know that this facial configuration expresses grief because when we feel grief we behave so-and-so and have such-and-such facial features. When we feel joy or disturbance we have other facial features. And this is quite objective: everyone recognizes in general what facial features are expressive of what inner states. Tears go with sadness and smiles with gladness, and this is just an objective fact. Anyone who said that furrowed brows and menacing gestures were expressive of joy or relaxation would be wrong. Now, if publicly observable facial features and gestures can be expressive, why cannot publicly observable patterns of sounds or colors also be so?

But let us examine this comparison for a moment. My facial features and general demeanor express my disturbed state of mind; that is to say, they reveal it to others; they express in the sense of "reveal." What then do these musical tones reveal? That the composer was in a

certain state of mind? But we have already sought to attack this notion; first, because the pattern of notes does not enable us to know this, or even infer it with great probability; and second, because even if it did, it would not be particularly relevant anyway, unless we are psychologists trying to get at the composer's state of mind. Surely this is not what we want. Yet the analogy of music with facial features here permits no more than this; if a person's facial features express his feeling in the sense of revealing it, then the musical tones, even if the argument from analogy is here accepted, do no more than express in the same sense.

Perhaps another consideration may help the situation: The person *need* not feel the emotion his face expresses. Ordinarily he does, else we would never have arrived at the connection between the facial features and what they express; but in some cases it may not—if the man is an actor his face may express grief, but on the stage he does not feel the grief which his face expresses. And so too the composer may not feel the grief which his composition expresses. It may express grief regardless of what he really feels, if indeed he feels anything.

Very well; but having reached this point, how far does it take us? Pursuing still the analogy of the musical notes with the facial features, we are only permitted to say that whereas usually when a person shows facial features X he also feels X', this is sometimes not so, and that similarly when music expresses X the composer usually felt X', though sometimes not. The link with the composer is still a usual one though not an exceptionless one; and we want it to be not usual but nonexistent: we want music to be expressive of X' even if the composer felt not X' but Y' or even nothing at all.

And how are we to do this? If we can do it at all, it is surely on the basis of some *similarity* between what exists in the musical tones and what exists in a person's facial features and behavior. Thus, as Professor Bouwsma says, "sad music has some of the characteristics of people who are sad. It will be slow, not tripping; it will be low, not tinkling. People who are sad move more slowly, and when they speak, they speak softly and low."[9]

Now, I venture to suggest that any theory of musical expression must be based on some such resemblance as this. But it is not so easy as it sounds.

1. The properties by virtue of which we call musical patterns sad or tense or exultant or profound are often, it would seem, not the properties by virtue of which we call people these things. For example, if there are any passages in music which I would call tense, it would be

<hr>

[9] "The Expression Theory of Art," in W. Elton, *Aesthetics and Language*, Oxford, 1952, p. 99.

such passages as occur in Strauss' *Salome* and *Elektra* in which, for instance, after a sudden silence followed by a soft intermittent and irregular drumbeat, there is a quick piercing shriek from the piccolo, silence, then a wail from the bassoon, playing alone, coupled a moment later with small fragments of tonality from the tuba (and with a large range of octaves between). And yet these "tense-making" properties of the music cannot be attributed to a person when he is tense in daily life; one cannot truly say of Jones when he feels tense after a quarrel with his wife that there is a large tonal interval between his upper and lower registers.

(2) When we ask ourselves, quite literally, what features are possessed in common by the music and the person? there turns out, I think, to be much less than we might at first have thought. And let us remember that we cannot take the easy way and say that just as a person is excited or melancholy, so music may be excited or melancholy; for this would be to read into the music the very expressive character we were setting out to analyze. What we want to know is what features there are in the tones and tone-relationships themselves which are quite literally like features we attribute to human beings when we say that they are excited or melancholy. Thus, to return to Professor Bouwsma's example, sad music really *is* slow and sad people really do tend to move slowly—here is a real and objective similarity; but when he goes on to say that sad music is low, we cannot apply this adjective to human beings in the same sense, for the word "low" in music refers to pitch, and if we say that sad people are low this probably means something like "feeling low," which is a very different (and meta-phorical) sense of the word.

(3) In any case, there will again be difficulty in defending our judgment of expressiveness against others. Let us assume that we agree pretty well about the claim that a given work of music is sad. But what about more complex claims, especially when disagreement continues? How would we defend against attack our judgment that this is after all not joyful, as we had always thought, but a bit frenzied, and that its rapidity is that of tension rather than of exuberance? or that a composition which we had always thought to be highly dramatic in character is not really so but pompous, ostentatious, and posed? It may be that these examples too could be handled along the same general lines as the sadness example; but in the field of aesthetics, where there are probably more promises and fewer fulfillments than anywhere else in philosophy, I am impelled to be suspicious of the promissory note, especially when the date due is repeatedly postponed, and to be content only with the cold hard cash of fulfillment.

Selected Readings on Part IV: Art as Expression

Arnheim, Rudolf. *Art and Visual Perception*. Berkeley: U. of Calif., 1957. Chapter 10.

Beardsley, Monroe. *Aesthetics*. New York: Harcourt, 1958. Chapter 7.

Collingwood, Robin G. *The Principles of Art*. Oxford: The Clarendon Press, 1938. Especially Chapter 5.

Croce, Benedetto. *Aesthetic*. London: Macmillan, 2nd edition, 1922.

Dewey, John. *Art as Experience*. New York: Minton, Balch, 1934; Putnam (Capricorn), 1958. Chapters 4 and 5.

Ducasse, Curt J. *The Philosophy of Art*. New York: Dial, 1929. Chapters 2, 3, 4, and 8.

Goodman, Nelson. *Languages of Art*. Indianapolis: Bobbs, 1968. Chapter 2.

Hospers, John. "The Croce-Collingwood Theory of Art." *Philosophy*, 1956, 291–308.

Osborne, Harold. *Aesthetics and Criticism*. London: Routledge & Kegan Paul, 1955. Chapter 7.

Meyer, Leonard B. *Emotion and Meaning in Music*. Chicago: U. of Chicago, 1956.

Reid, Louis Arnaud. *A Study in Aesthetics*. London: Macmillan, 1931. Chapters 2–4.

Santayana, George. *The Sense of Beauty*. New York: Scribner, 1896. Part Four.

Tolstoy, Leo. *What Is Art?* Translation by Aylmer Maude. London: Oxford U.P., 1896.

Tomas, Vincent, and Douglas Morgan. "The Concept of Expression in Art." *Proceedings of the American Philosophical Association, Eastern Division*, Vol. 1, 1952, 127–65.

V

ART AS SYMBOL

11. THE WORK OF ART AS A SYMBOL

SUSANNE K. LANGER

Prall's treatment is particularly interesting because it springs from the most serious and systematic analysis that has been made, so far as I know, of the sensuous element in the arts, which he calls the "aesthetic surface." Each art, according to Prall, has a limited sensory realm defined by the selectiveness of a specialized sense, within which its whole existence lies. That is its "aesthetic surface," which can never be broken without breaking the work itself to which it relates, because it is the universe within which artistic form is articulated. The whole gamut of colors constitutes one such realm, and that of tones makes up another. In every case the "aesthetic surface" is something given by nature; so are the basic rules of structure, which spring from the nature of the material, as the diatonic scale, for instance, stems from the partial tones that lie in any fundamental of definite pitch. The several arts, therefore, are governed by the natural departments of sense, each giving the artist a particular order of elements out of which he may make combinations and designs to the limit of his inventive powers. Prall's philosophical approach to art is boldly technical, and guided by sound artistic sense in several departments. He treats every work of art as a structure, the purpose of which is to let us apprehend sensuous forms in a logical way. "The difference between perceiving clearly and understanding distinctly," he says, "is not the great difference we are sometimes led to think it,"[1] And further:

Any conscious content is taken to be intelligible just so far as it is grasped as form or structure. This means, of course, as made up of elements in relations by virtue of which they actually come together. . . . For elements not natively ordered by a relation of some sort will not make structures for us

[1] *Aesthetic Analysis* [NEW YORK: THOMAS Y. CROWELL CO., 1929], p. 39.

at all, nor will intrinsically related elements make structures for us unless we have become aware of the kinds of relation involved. You cannot make a spatial whole except with elements the very nature and being of which is spatial extension. You cannot make melodic structures except out of elements which are natively ordered by an intrinsic relation in pitch from which they cannot be removed. . . . The elements must lie in an order native to their very being, an order grasped by us as constituted by a relation. We call structures intelligible . . . in so far as we find them capable of analysis into such elements so related.[2]

In other words, structures, or *forms* in the broad sense, must lie in some intellectual dimension in order to be perceived. Works of art are made of sensuous elements, but not all sensuous materials will do; for only those data are *composable* which hold stations in an ideal continuum —e.g. colors in a scale of hues, where every interval between two given colors can be filled in with further elements given by implication, or tones in a continuous scale of pitches that has no "holes" for which a pitch is not determinable.

Prall's method seems to me impeccable: to study the work of art itself instead of our reactions and feelings toward it, and find some principle of its organization that explains its characteristic functions, its physical requirements, and its claims on our esteem. If, then, I start from a different premise, it is not because I disapprove Prall's statements —they are almost all acceptable—but because certain limitations of his theory seem to me to lie in the basic conception itself, and to disappear upon a somewhat different assumption. One of these limitations meets us in the analysis of poetry, where only one ingredient—the temporal pattern of sound, or "measure"—offers anything like a true "aesthetic surface" with commensurable elements to be deployed in formal relations, and this ingredient, though it is important, is not pre-eminent. In prose it is too free for scansion. Yet one feels that the true formal principle, whereby literature is constructed, must be just as evident and dominant in one gender as in another, and such characteristics as the pattern of poetic measure are merely specialized means for achieving it; and every distinct literary form must have some such means of its own, but not a new principle, to make it literature.

Another difficulty arises if we turn our attention to the art of dancing. Prall has not subjected this art to analysis, but indicated by cursory mention that he would treat it as a spatio-temporal form, and of course its constituent elements—motions—are mensurable and commensurable under both space and time. But such a conception of its basic forms brings it entirely and perfectly into the same category as

[2] Ibid., pp. 41–42.

mobile sculpture; even though one could adduce some characteristics that distinguished those two spatio-temporal arts, they would remain intimately related. Actually, however, they are very remotely related; mobile sculpture has no more connection with dance than stationary sculpture. It is *entirely sculpture,* and dance is entirely something else.

The art of acting becomes even more difficult to analyze than dancing, since the sensuous continuum of space and time, color and rhythm, is further complicated by sound elements, namely words. The fact is that Prall's theory is clearly applicable only to purely visual or purely auditory arts—painting and music—and its extension to other domains, even poetry, is a project rather than a natural consequence.

In short, the limitation inherent in Prall's theory is its bondage to those very "basic orders" to which it applies so excellently that practically everything he says about their artistic functions is true. The principle of the "aesthetic surface," consistently followed, actually leads to that purist criticism which has to condemn opera as a hybrid art, can tolerate drama only by assimilating it to literature, and tends to treat religious or historical themes in painting as embarrassing accidents to a pure design. It leads to no insight into the distinctions and connections of the arts, for the basic distinctions it makes between sensory orders are obvious. Consequently the connections it allows—e.g. between music and poetry, or music and dance, by virtue of their temporal ingredients —are obvious too; obvious, yet sometimes deceptive.

Limitation is not itself a reason for rejecting a theory. Prall knew the limitations of his inquiry and did not tackle the problems that lay beyond its reach. The only excuse for discarding a fundamental principle is that one has a more powerful notion, which will take the constructive work of the previous one in its stride, and then do something more. The weakness of Prall's aesthetics lies, I think, in a misconception of the dimensions underlying the various arts, and therefore of the fundamental principles of organization. The new idea of artistic structures, which seems to me more radical and yet more elastic than Prall's assumption of scales and spatio-temporal orders, causes a certain shift of focus in the philosophy of art; instead of seeking for elements of feeling among the sensuous contents, or qualia, literally contained in the art object, we are led straight to the problem of created form (which is not always sensuous) and its significance, the phenomenology of feeling. The problem of creativity, which Prall never had occasion to mention, is central here; for the elements themselves, and the wholes within which they have their distinct elementary existence, are created, not adopted.[3]

[3] Not the scales and geometries, for these are logical; but the exemplified continua of existence, the spaces and durations and fields of force.

A work of art differs from all other beautiful things in that it is "a glass and a transparency"—not, in any relevant way, a *thing* at all, but a symbol. Every good philosopher or critic of art realizes, of course, that *feeling* is somehow expressed in art; but as long as a work of art is viewed primarily as an "arrangement" of sensuous elements for the sake of some inexplicable aesthetic satisfaction, the problem of expressiveness is really an alien issue. Prall wrestles with it throughout a carefully reasoned psychological chapter, and although his psychology is clear and excellent, it leaves one with a sense of paradox; for the emotive element in art seems somehow more essential than the strictly "aesthetic" experience itself, and seems to be given in a different way, yet the work of art is aloof from real emotion, and can only suffer harm from any traffic with sentimental associations. In some sense, then, feeling must be *in* the work; just as a good work of art clarifies and exhibits the forms and colors which the painter has seen, distinguished, and appreciated better than his fellowmen could do without aid, so it clarifies and presents the feelings proper to those forms and colors. Feeling "expressed" in art is "feeling or emotion presented as the qualitative character of imaginal content."[4]

· · ·

"If it is asked how qualitative imaginal content can present feeling," says Prall, "how it can be actual feeling that art expresses, we arrive at the supposed miracle that art is so often said to be, the embodiment of spirit in matter. But thinking can have no intercourse with miracles. And since the simplest thinking finds that works of art do express feeling, we are forced by the obvious character of our data to look for feeling *within* the presented content, as an aspect of it, that is, integral to its actually present character, or as its unitary qualitative nature as a whole.[5]

The solution of the difficulty lies, I think, in the recognition that what art expresses is *not* actual feeling, but ideas of feeling; as language does not express actual things and events but ideas of them. Art is expressive through and through—every line, every sound, every gesture; and therefore it is a hundred per cent symbolic. It is not sensuously pleasing and *also* symbolic; the sensuous quality is in the service of its vital import. A work of art is far more symbolic than a word, which can be learned and even employed without any knowledge of its meaning; for a purely and wholly articulated symbol *presents* its import directly

[4] Ibid., p. 145. [5] Loc. cit., *infra.*

to any beholder who is sensitive at all to articulated forms in the given medium.[6]

An articulate form, however, must be clearly given and understood before it can convey any import, especially where there is no conventional reference whereby the import is assigned to it as its unequivocal meaning, but the congruence of the symbolic form and the form of some vital experience must be directly perceived by the force of *Gestalt* alone. Hence the paramount importance of *abstracting the form*, banning all irrelevancies that might obscure its logic, and especially divesting it of all its usual meanings so it may be open to new ones. The first thing is to estrange it from actuality, to give it "otherness," "self-sufficiency"; this is done by creating a realm of illusion, in which it functions as *Schein*, mere semblance, free from worldly offices. The second thing is to make it plastic, so it may be manipulated in the interests of expression instead of practical signification. This is achieved by the same means—uncoupling it from practical life, abstracting it as a free conceptual figment. Only such forms can be plastic, subject to deliberate torsion, modification, and composition for the sake of expressiveness. And finally, it must become "transparent"—which it does when insight into the reality to be expressed, the *Gestalt* of living experience, guides its author in creating it.

Whenever craftsmanship is art, these principles—abstraction, plastic freedom, expressiveness—are wholly exemplified, even in its lowliest works. Some theorists assign different values to the various manifestations of art (e.g. pure design, illustration, easel painting), ranking them as "lower" and "higher" types, of which only the "higher" are expressive, the "lower" merely decorative, giving sensuous pleasure without any further import.[7] But such a distinction throws any theory of art into confusion. If "art" means anything, its application must rest on one essential criterion, not several unrelated ones—expressiveness, pleasantness, usefulness, sentimental value, and so forth. If art is "the

[6] Prall came so close to this realization that his avoidance of the term "symbol" for a work of art appears to be studied. Evidently he preferred the specious theory that assumes feelings to be contained in sensory qualities, to a semantic theory of art that would have laid him open to the charge of intellectualism or iconism. So he maintains that a feeling is *in* a picture, and that we "have" it when we look at the work. Compare, for instance the following passage with what has just been said about a perfected presentational symbol: "The point of the picture, its effective being, is just this embodied feeling that we have, if with open sensitive eyes we look at it and let its character become the content of our own affective conscious life at the moment." (Ibid., p. 163.)

[7] Eugène Véron is the best known exponent of this view (see his *Aesthetics*, especially chap. vii). But compare also the much more recent judgment of Henry Varnum Poor, that "decoration pursued as decoration is apt to be so shallow and limited" that it requires some combination with "realistic painting" to stir the imagination. (*Magazine of Art*, August, 1940.)

creation of forms expressive of human feeling," then gratification of the senses must either serve that purpose or be irrelevant.

. . .

The tonal structures we call "music" bear a close logical similarity to the forms of human feeling—forms of growth and of attenuation, flowing and stowing, conflict and resolution, speed, arrest, terrific excitement, calm or subtle activation and dreamy lapses—not joy and sorrow perhaps, but the poignancy of either and both—the greatness and brevity and eternal passing of everything vitally felt. Such is the pattern, or logical form, of sentience; and the pattern of music is that same form worked out in pure, measured sound and silence. Music is a tonal analogue of emotive life.

Such formal analogy, or congruence of logical structures, is the prime requisite for the relation between a symbol and whatever it is to mean. The symbol and the object symbolized must have some common logical form.

But purely on the basis of formal analogy, there would be no telling which of two congruent structures was the symbol and which the meaning, since the relation of congruence, or formal likeness, is symmetrical, i.e. it works both ways. (If John looks so much like James that you can't tell him from James, then you can't tell James from John, either.) There must be a motive for choosing as between two entities or two systems, one to be the symbol of the other. Usually the decisive reason is that one is easier to perceive and handle than the other. Now sounds are much easier to produce, combine, perceive, and identify, than feelings. Forms of sentience occur only in the course of nature, but musical forms may be invented and intoned at will. Their general pattern may be reincarnated again and again by repeated performance. The effect is actually never quite the same even though the physical repetition may be exact, as in recorded music, because the exact degree of one's familiarity with a passage affects the experience of it, and this factor can never be made permanent. Yet within a fairly wide range such variations are, happily, unimportant. To some musical forms even much less subtle changes are not really disturbing, for instance certain differences of instrumentation and even, within limits, of pitch or tempo. To others, they are fatal. But in the main, sound is a negotiable medium, capable of voluntary composition and repetition, whereas feeling is not; this trait recommends tonal structures for symbolic purposes.

Furthermore, a symbol is used to articulate ideas of something we

wish to think about, and until we have a fairly adequate symbolism we cannot think about it. So *interest* always plays a major part in making one thing, or realm of things, the meaning of something else, the symbol or system of symbols.

Sound, as a sheer sensory factor in experience, may be soothing or exciting, pleasing or torturing; but so are the factors of taste, smell, and touch. Selecting and exploiting such somatic influences is self-indulgence, a very different thing from art. An enlightened society usually has some means, public or private, to support its artists, because their work is regarded as a spiritual triumph and a claim to greatness for the whole tribe. But mere epicures would hardly achieve such fame. Even chefs, perfumers, and upholsterers, who produce the means of sensory pleasure for others, are not rated as the torchbearers of culture and inspired creators. Only their own advertisements bestow such titles on them. If music, patterned sound, had no other office than to stimulate and soothe our nerves, pleasing our ears as well-combined foods please our palates, it might be highly popular, but never culturally important. Its historic development would be too trivial a subject to engage many people in its lifelong study, though a few desperate Ph.D. theses might be wrung from its anecdotal past under the rubric of "social history." And music conservatories would be properly rated exactly like cooking schools.

Our interest in music arises from its intimate relation to the all-important life of feeling, whatever that relation may be. After much debate on current theories, the conclusion reached in *Philosophy in a New Key* is that the function of music is not stimulation of feeling, but expression of it; and furthermore, not the symptomatic expression of feelings that beset the composer but a symbolic expression of the forms of sentience as he understands them. It bespeaks his imagination of feelings rather than his own emotional state, and expresses what he *knows about* the so-called "inner life"; and this may exceed his personal case, because music is a symbolic form to him through which he may learn as well as utter ideas of human sensibility.

There are many difficulties involved in the assumption that music is a symbol, because we are so deeply impressed with the paragon of symbolic form, namely language, that we naturally carry its characteristics over into our conceptions and expectations of any other mode. Yet music is not a kind of language. Its significance is really something different from what is traditionally and properly called "meaning." Perhaps the logicians and positivistic philosophers who have objected to the term "implicit meaning," on the ground that "meaning" properly so-called is always explicable, definable, and translatable, are

prompted by a perfectly rational desire to keep so difficult a term free from any further entanglements and sources of confusion; and if this can be done without barring the concept itself which I have designated as "implicit meaning," it certainly seems the part of wisdom to accept their strictures.

Probably the readiest way to understand the precise nature of musical symbolization is to consider the characteristics of language and then, by comparison and contrast, note the different structure of music, and the consequent differences and similarities between the respective functions of those two logical forms. Because the prime purpose of language is discourse, the conceptual framework that has developed under its influence is known as "discursive reason." Usually, when one speaks of "reason" at all, one tacitly assumes its discursive pattern. But in a broader sense any appreciation of form, any awareness of patterns in experience, is "reason"; and discourse with all its refinements (e.g. mathematical symbolism, which is an extension of language) is only one possible pattern. For practical communication, scientific knowledge, and philosophical thought it is the only instrument we have. But on just that account there are whole domains of experience that philosophers deem "ineffable." If those domains appear to anyone the most important, that person is naturally inclined to condemn philosophy and science as barren and false. To such an evaluation one is entitled; not, however, to the claim of a better way to philosophical truth through instinct, intuition, feeling, or what have you. Intuition is the basic process of all understanding, just as operative in discursive thought as in clear sense perception and immediate judgment; there will be more to say about that presently. But it is no substitute for discursive logic in the making of any theory, contingent or transcendental.

The difference between discursive and non-discursive logical forms, their respective advantages and limitations, and their consequent symbolic uses have already been discussed in the previous book, but because the theory, there developed, of music as a symbolic form is our starting point here for a whole philosophy of art, the underlying semantic principles should perhaps be explicitly recalled first.

In language, which is the most amazing symbolic system humanity has invented, separate words are assigned to separately conceived items in experience on a basis of simple, one-to-one correlation. A word that is not composite (made of two or more independently meaningful vocables, such as "omni-potent," "com-posite") may be assigned to mean any object *taken as one*. We may even, by fiat, take a word like "omnipotent," and regarding it as one, assign it a connotation that is not composite, for instance by naming a race horse "Omnipotent."

Thus Praisegod Barbon ("Barebones") was an indivisible being although his name is a composite word. He had a brother called "If-Christ-had-not-come-into-the-world-thou-wouldst-have-been-damned." The simple correlation between a name and its bearer held here between a whole sentence taken as one word and an object to which it was arbitrarily assigned. Any symbol that names something is "taken as one"; so is the object. A "crowd" is a lot of people, but *taken as a lot*, i.e. as one crowd.

So long as we correlate symbols and concepts in this simple fashion we are free to pair them as we like. A word or mark used arbitrarily to denote or connote something may be called an associative symbol, for its meaning depends entirely on association. As soon, however, as words taken to denote different things are used in combination, something is expressed by the way they are combined. The whole complex is a symbol, because the combination of words brings their connotations irresistibly together in a complex, too, and this complex of ideas is analogous to the word-complex. To anyone who knows the meanings of all the constituent words in the name of Praisegod's brother, the name is likely to sound absurd, because it is a sentence. The concepts associated with the words form a complex concept, the parts of which are related in a pattern analogous to the word-pattern. Word-meaning and grammatical forms, or rules for word-using, may be freely assigned; but once they are accepted, propositions emerge automatically as the meanings of sentences. One may say that the elements of propositions are *named* by words, but propositions themselves are *articulated* by sentences.

A complex symbol such as a sentence, or a map (whose outlines correspond formally to the vastly greater outlines of a country), or a graph (analogous, perhaps, to invisible conditions, the rise and fall of prices, the progress of an epidemic) is an *articulate form*. Its characteristic symbolic function is what I call *logical expression*. It expresses relations; and it may "mean"—connote or denote—any complex of elements that is of the same articulate form as the symbol, the form which the symbol "expresses."

Music, like language, is an articulate form. Its parts not only fuse together to yield a greater entity, but in so doing they maintain some degree of separate existence, and the sensuous character of each element is affected by its function in the complex whole. This means that the greater entity we call a composition is not merely produced by mixture, like a new color made by mixing paints, but is *articulated*, i.e. its internal structure is given to our perception.

Why, then, is it not a *language* of feeling, as it has often been called? Because its elements are not words—independent associative symbols

with a reference fixed by convention. Only as an articulate form is it found to fit anything; and since there is no meaning assigned to any of its parts, it lacks one of the basic characteristics of language—fixed association, and therewith a single, unequivocal reference. We are always free to fill its subtle articulate forms with any meaning that fits them; that is, it may convey an idea of anything conceivable in its logical image. So, although we do receive it as a significant form, and comprehend the processes of life and sentience through its audible, dynamic pattern, it is not a language, because it has no vocabulary.

Perhaps, in the same spirit of strict nomenclature, one really should not refer to its content as "meaning," either. Just as music is only loosely and inexactly called a language, so its symbolic function is only loosely called meaning, because the factor of conventional reference is missing from it. In *Philosophy in a New Key* music was called an "unconsummated" symbol.[8] But meaning, in the usual sense recognized in semantics, includes the condition of conventional reference, or consummation of the symbolic relationship. Music has *import*, and this import is the pattern of sentience—the pattern of life itself, as it is felt and directly known. Let us therefore call the significance of music its "vital import" instead of "meaning," using "vital" not as a vague laudatory term, but as a qualifying adjective restricting the relevance of "import" to the dynamism of subjective experience.

So much, then, for the theory of music; music is "significant form," and its significance is that of a symbol, a highly articulated sensuous object, which by virtue of its dynamic structure can express the forms of vital experience which language is peculiarly unfit to convey. Feeling, life, motion and emotion constitute its import.

Here, in rough outline, is the special theory of music which may, I believe, be generalized to yield a theory of art as such. The basic concept is the articulate but non-discursive form having import without conventional reference, and therefore presenting itself not as a symbol in the ordinary sense, but as a "significant form," in which the factor of significance is not logically discriminated, but is felt as a quality rather than recognized as a function. If this basic concept be applicable to all products of what we call "the arts," i.e. if all works of art may be regarded as significant forms in exactly the same sense as musical works, then all the essential propositions in the theory of music may be extended to the other arts, for they all define or elucidate the nature of the symbol and its import.

[8] Harvard University Press edition, p. 240; New American Library (Mentor) edition, p. 195.

That crucial generalization is already given by sheer circumstance: for the very term "significant form" was originally introduced in connection with other arts than music, in the development of another special theory; all that has so far been written about it was supposed to apply primarily, if not solely, to visual arts. Clive Bell, who coined the phrase, is an art critic, and (by his own testimony) not a musician. His own introduction of the term is given in the following words:

Every one speaks of "art", making a mental classification by which he distinguishes the class "works of art" from all other classes. What is the justification of this classification? . . . There must be some one quality without which a work of art cannot exist; possessing which, in the least degree, no work is altogether worthless. What is this quality? What quality is shared by all objects that provoke our aesthetic emotions? What quality is common to Santa Sophia and the Windows at Chartres, Mexican sculpture, a Persian bowl, Chinese carpets, Giotto's frescoes at Padua, and the masterpieces of Poussin, Piero della Francesca, and Cézanne? Only one answer seems possible—significant form. In each, lines and colours combined in a particular way, certain forms and relations of forms, stir our aesthetic emotions. These relations and combinations of lines and colours, these aesthetically moving forms, I call "Significant Form"; and "Significant Form" is the one quality common to all works of visual art.[9]

Bell is convinced that the business of aesthetics is to contemplate the aesthetic emotion and its object, the work of art, and that the reason why certain objects move us as they do lies beyond the confines of aesthetics.[10] If that were so, there would be little of interest to contemplate. It seems to me that the *reason* for our immediate recognition of "significant form" is the heart of the aesthetical problem; and Bell himself has given several hints of a solution, although his perfectly justified dread of heuristic theories of art kept him from following out his own observations. But, in the light of the music theory that culminates in the concept of "significant form," perhaps the hints in his art theory are enough.

"Before we feel an aesthetic emotion for a combination of forms," he says (only to withdraw hastily, even before the end of the paragraph, from any philosophical commitment) "do we not perceive intellectually the rightness and necessity of the combination? If we do, it would explain the fact that passing rapidly through a room we recognize a picture to be good, although we cannot say that it has provoked much emotion. We seem to have recognized intellectually the rightness of its forms without staying to fix our attention, and collect, as it were, their emotional significance. If this were so, it would be permissible to inquire

[9] Ibid., p. 8. [10] Ibid., p. 10.

whether it was the forms themselves or our perception of their rightness and necessity that caused aesthetic emotion.[11]

Certainly "rightness and necessity" are properties with philosophical implications, and the perception of them a more telling incident than an inexplicable emotion. To recognize that something is right and necessary is a rational act, no matter how spontaneous and immediate the recognition may be; it points to an intellectual principle in artistic judgment, and a rational basis for the feeling Bell calls "the aesthetic emotion." This emotion is, I think, a result of artistic perception, as he suggested in the passage quoted above; it is a personal reaction to the discovery of "rightness and necessity" in the sensuous forms that evoke it. Whenever we experience it we are in the presence of Art, i.e. of "significant form." He himself has identified it as the same experience in art appreciation and in pure musical hearing, although he says he has rarely achieved it musically. But if it is common to visual and tonal arts, and if indeed it bespeaks the artistic value of its object, it offers another point of support for the theory that significant form is the essence of all art.

That, however, is about all that it offers. Bell's assertion that every theory of art must begin with the contemplation of "the aesthetic emotion," and that, indeed, nothing else is really the business of aesthetics, seems to me entirely wrong. To dwell on one's state of mind in the presence of a work does not further one's understanding of the work and its value. The question of what gives one the emotion is exactly the question of what makes the object artistic; and that, to my mind, is where philosophical art theory begins.

. . .

The concept of significant form as an articulate expression of feeling, reflecting the verbally ineffable and therefore unknown forms of sentience, offers at least a starting point for such inquiries. All articulation is difficult, exacting and ingenious; the making of a symbol requires craftsmanship as truly as the making of a convenient bowl or an efficient paddle, and the techniques of expression are even more important social traditions than the skills of self-preservation, which an intelligent being can evolve by himself, at least in rudimentary ways, to meet a given situation. The fundamental technique of expression— language—is something we all have to learn by example and practice, i.e. by conscious or unconscious training.[12] People whose speech

[11] Ibid., p. 26. [12] Cf. *New Key*, Chap. v, "Language."

training has been very casual are less sensitive to what is exact and fitting for the expression of an idea than those of cultivated habit; not only with regard to arbitrary rules of usage, but in respect of logical *rightness and necessity* of expression, i.e. saying what they mean and not something else. Similarly, I believe, all making of expressive form is a craft. Therefore the normal evolution of art is in close association with practical skills—building, ceramics, weaving, carving, and magical practices of which the average civilized person no longer knows the importance;[13] and therefore, also, sensitivity to the rightness and necessity of visual or musical forms is apt to be more pronounced and sure in persons of some artistic training than in those who have only a bowing acquaintance with the arts. Technique is the means to the creation of expressive form, the symbol of sentience; the art process is the application of some human skill to this essential purpose.

At this point I will make bold to offer a definition of art, which serves to distinguish a "work of art" from anything else in the world, and at the same time to show why, and how, a utilitarian object may be *also* a work of art; and how a work of so-called "pure" art may fail of its purpose and be simply bad, just as a shoe that cannot be worn is simply bad by failing of its purpose. It serves, moreover, to establish the relation of art to physical skill, or making, on the one hand, and to feeling and expression on the other. Here is the tentative definition, on which the following chapters are built: Art is the creation of forms symbolic of human feeling.

The word "creation" is introduced here with full awareness of its problematical character. There is a definite reason to say a craftsman *produces* goods, but *creates* a thing of beauty; a builder *erects* a house, but *creates* an edifice if the house is a real work of architecture, however modest. An artifact as such is merely a combination of material parts, or a modification of a natural object to suit human purposes. It is not a creation, but an arrangement of given factors. A work of art, on the other hand, is more than an "arrangement" of given things—even qualitative things. Something emerges from the arrangement of tones or colors, which was not there before, and this, rather than the arranged material, is the symbol of sentience.

The making of this expressive form is the creative process that enlists a man's utmost technical skill in the service of his utmost conceptual power, imagination. Not the invention of new original turns, nor the

[13] Yet a pervasive magical interest has probably been the natural tie between practical fitness and expressiveness in primitive artifacts. See *New Key*, chap. ix, "The Genesis of Artistic Import."

adoption of novel themes, merits the word "creative," but the making of any work symbolic of feeling, even in the most canonical context and manner. A thousand people may have used every device and convention of it before. A Greek vase was almost always a creation, although its form was traditional and its decoration deviated but little from that of its numberless forerunners. The creative principle, nonetheless, was probably active in it from the first throw of the clay.

12. SYMBOLISM IN THE NONREPRESENTATIONAL ARTS

CHARLES L. STEVENSON

I

There are four important ways in which those interested in the arts might hope to profit by studying the nature of symbolism. Only the fourth will be developed in this chapter, but a brief mention of the first three is needed to indicate the neighbourhood, so to speak, in which the fourth is located.

In the first place, an interest in symbolism may spring from an effort to clarify and supplement the vocabulary of criticism. A critic who uses the term "spatial rhythm," for instance, may or may not communicate to us exactly what he means. If he attempts to define the term he takes a first step toward an interest in symbolism; and if he finds that an acceptable definition is not easily given (as he is likely to) he may be led to discuss terminological issues of a more general character. Thus, he may ask such questions as these: "Can a term like 'spatial rhythm' be helpfully defined by means of other terms, or must one point out its meaning by the use of examples?"; or "To what extent does 'spatial rhythm' become intelligible from the use of the word 'rhythm' in other contexts, such as those dealing with the rhythms of music and poetry?" This sort of interest is evident (to take only one of many possible examples) in Bernard Heyl's *New Bearings in Aesthetics and Art Criticism,*[1] where the author, a historian and critic of the spatial arts, feels hampered by the terms that are at his disposal. In trying to remedy the situation he is led to study signs more generally, with attention to the nature and function of definitions.

In the second place, the interest may spring from an effort to

[1] New Haven, 1943.

REPRINTED FROM *Language, Thought, and Culture,* ED. PAUL HENLE, BY PERMISSION OF THE UNIVERSITY OF MICHIGAN PRESS. COPYRIGHT © BY THE UNIVERSITY OF MICHIGAN 1958. REPRINTED ALSO BY KIND PERMISSION OF THE AUTHOR.

understand an artist's personality or his times by making a careful study
of his works. Here the sign in question is not this or that term that a
critic uses in discussing the arts, but is rather a work of art itself—the
term "sign," of course, being used in an extremely broad sense. Thus
Freud attempts to disclose certain of Leonardo's unconscious desires,
finding signs of them in the *Mona Lisa* and other paintings—the
symbolic meaning of these paintings being interpreted by much the
same techniques that Freud uses in interpreting dreams.[2] We have
much the same thing, on a less complex level, outside psychoanalysis.
When Robert Graves, in a novel,[3] portrayed Milton as an insensitive,
harsh, and altogether petty man, his critics insisted that Milton's
poetry was in itself a sufficient sign (in the very broad sense of that
term that we are now considering) that Graves's characterization was
unjust. Or for that matter, we have a simple case when we take our
radio and television programs as a sign of the prevailing level of our
culture. One can make off-hand observations about these matters, of
course, without any general and explicit *theory* of signs; but a theory
might help to make our observations more trustworthy. Note that it
would be a broad and many-sided theory, suited to this broad sense of
"sign."

Although the work of art is considered as a sign in these cases, its
sign function is not necessarily of a sort that must be grasped by those
who are appreciating the work. If it should happen that the work is
better appreciated after this aspect of its sign function is attended to,
that would be somewhat accidental; for aesthetic interest here gives
place to an interest in biography, history, and psychology.

The third sort of interest in symbolism takes us closer to peculiarly
aesthetic problems. It is concerned with the arts normally classified as
representational (such as literature, portrait painting, etc.) and not
with the arts normally classified as nonrepresentational (such as pure
music, nonobjective painting, architecture, etc.) Here the work of art
has a sign function that we must presumably take into account if we are
to have a full appreciation of the work. A critic helps us in our inter-
pretation of signs, for instance, when he analyzes an obscure passage in a
poem, or when he comments on the subject matter of a picture. A
general theory of signs can obviously be important as a background for
interpreting these particular signs—as is the case with Richards,
Empson, Burke, Murry, Brooks, etc.,[4] though these writers frequently
have the first sort of interest we have mentioned as well.

[2] Sigmund Freud, *Leonardo Da Vinci*, trans. by A. A. Brill (New York, 1916).
[3] *Wife to Mr. Milton* (London, 1943).
[4] W. Empson, *The Structure of Complex Words* (London: Chatto & Windus, 1951). I. A.

The fourth sort of interest in symbolism is simply a generalization of the third. It is based on the hope that the arts normally classified as nonrepresentational, no less than those normally classified as representational, have an important sign-function—and one that is not merely of biographical, historical, or psychological interest, like that mentioned in our second heading, but one that is of genuine aesthetic interest. Thus Schopenhauer wrote of music: "The composer reveals the inner nature of the world, and expresses the deepest wisdom in a language which his reason does not understand; as a person under the influence of mesmerism tells things of which he has no conception when he awakes."[5] And Croce speaks of all the arts, representational and nonrepresentational alike, as being a "language."[6] Views of this sort differ markedly from one another, and by many writers are rejected altogether. But whatever one may think about them, they frequently reappear in aesthetic theories of the present day—theories that appeal to the study of signs in an effort to reveal unsuspected relationships between the several arts, or to enhance our appreciation of them, or even to explain the importance of the arts in social and individual life.

These four headings do not *exhaust* the ways in which a study of symbolism is related to aesthetics. To take a passing example, none of them includes the interest in symbolism that one would have if he were trying to simplify the notation of music, or improve or standardize the notation that is used in choreography. But they will be sufficient to orient the fourth heading. which, as has been said, is the only one that the present chapter will attempt to discuss.

II

In a very broad sense of "sign," and one constantly used by Charles Morris,[7] the arts commonly called nonrepresentational have *quite obviously* the status of signs. But the very obviousness of the point should warn us against taking it to be more than of passing interest. To understand this let us examine Morris's work somewhat closely, with particular attention to what he wants the word "sign" to mean.

Richards, *Philosophy of Rhetoric* (London, 1936). J. M. Murry, *Countries of the Mind* (London, 1931). K. Burke, *A Grammar of Motives* (New York, 1945). C. Brooks, *The Well-wrought Urn* (New York: Harcourt Brace and Co., 1947).

[5] *World as Will and Idea*, trans. by R. B. Haldane and J. Kemp (London, 1883–86), I, 336.

[6] See Croce's *Aesthetic as Science of Expression and General Linguistic*, trans. by D. Ainslie (2d ed.; London, 1922).

[7] *Foundations of the Theory of Signs* (International Encyclopedia of Unified Science; Chicago, 1938), Vol. I, no. 2.

Morris speaks of a *sign situation* whenever any entity, S, leads us to take account of some entity, D. He goes on to say that S, when so used, is the *sign*, that the process-of-taking-account-of is the *interpretant* of the sign, and that D is the sign's *designatum* or *denotatum*. A sign has a denotatum only when the designatum actually exists (as Morris uses the terms); thus "unicorn" has a designatum but no denotatum.

Now when "sign" (along with its supplementary terms) is used in this way, its sense is extremely broad, since the phrase "take account of" is ubiquitous in its applications. We have a sign situation when a dog detecting the scent, chases a fox. We have another when, on seeing a friend, we reach out to shake his hand; for our visual experience obviously leads us to take account of something—namely, the friend himself, or if you like, merely his hand, or the experience of feeling his hand as we shake it. We have another sign situation when an astronomer takes the present state of the heavens as a sign of a coming eclipse—or for that matter, when an astrologer takes it as a calamity, for if the calamity doesn't come it will even so be the designation of a sign that has no denotatum. It is not easy, in fact, to find a complex psychological process that *doesn't* involve the interpretation of a sign. So for this broad sense it is only to be expected that we should find many sign situations in our appreciation of the arts—including even such arts as pure music and nonobjective painting.

Morris himself gives such examples as this: in any complex work of art one part may occasion expectations that are fulfilled in another part, and since the one leads us to take account of the other it becomes a sign of it.[8] There can be no doubt that this happens in ever so many cases of aesthetic appreciation; but it is of no more than passing interest, as suggested above, simply because the observation is so elementary, and because the situation is so little illuminated by being called "symbolic" rather than something else.

Morris gives this further and more strained example: in considering whether a nonobjective work of art, such as a Greek border, can have a denotatum, he points out that "every iconic sign has its own sign vehicle among its denotata," and that "there is sometimes no denotatum other than the aesthetic sign vehicle itself."[9] This can be made a little more concrete than Morris makes it by the following observation: A man who sees a Greek border only casually may immediately become more interested in it, and take a second look. So the border, *via* the first look, may lead the man to take account of it via the second look,

[8] C. W. Morris, "Aesthetics and the Theory of Signs," *Journal of Unified Science*, VIII (1939): 131–50.
[9] Ibid., pp. 136, 141.

and may thus become a sign of itself. Moreover, since a sign becomes iconic in virtue of a similarity between itself and its designatum, we need only the principle, "Everything resembles itself," to conclude that a Greek border can be an *iconic* sign of itself. Note that the same thing can be said of anything on earth, provided only that it is perceivable and of sufficient interest to get a second look.

Morris presses these considerations still further. If a work of art can be a sign of itself, it can also be a sign of its properties—for in leading us to take account of itself it leads us to take account of its properties as well. And if its value is one of its properties, it may lead us to take account of that, becoming a sign that "designates a value"— a conclusion that Morris welcomes.[10]

There can be no doubt that signs referring to themselves have sometimes interesting examples. Thus in Pope's familiar:

And ten low words oft creep in one dull line,[11]

his words immediately lead us to take account of themselves, and so (in Morris' very broad sense) are signs of themselves. But it is hard to believe that this simple observation has far-reaching implications.

In general, when Morris remarks, "Aesthetics thus becomes in its entirety a subdivision of semiotic"[12] ("semiotic" being his name for the study of signs), it is important to realize that no one would be likely to disagree with him. If his statement at first seems surprising, that is only because it suggests that he is finding more sign situations in the arts than others are accustomed to recognize. But he is not doing that at all. He is simply calling an unusual number of processes by the name "sign situation," using the name in such a broad sense that its application to nonobjective painting, pure music, architecture, etc., can be taken for granted.

If anything is to come from Morris' approach, it must come not merely from an attempt to classify aesthetics as a branch of the theory of signs but rather from a detailed study showing that the problems of aesthetics, when so classified, can be discussed in a more illuminating way. In particular, it must be shown that the skills developed elsewhere in the study of signs (in linguistics, for example, and in certain parts of logic) can be transferred to parallel situations that arise in the study of the arts. And Morris has scarcely made a beginning of this. He has suggested that all the arts have their syntactical, pragmatic, and semantic rules,[13] but it is hard to see how his suggestion will help us to improve our understanding of these rules. Presumably, the syn-

[10] Ibid., p. 141. [11] *An Essay in Criticism*, Pt. II, 1. 347.
[12] Op. cit., p. 145. [13] Ibid., p. 149.

tactical rules of music are no more than the rules of harmony and counterpoint, together with those broader rules of composition that concern the form of the sonata, the fugue, etc. And it is not clear that these familiar disciplines, once they are classified as "syntax," will have enough in common with the syntax of ordinary languages, or the syntax of logic, to make the classification useful.

It is possible that Morris' programmatic suggestions will some day be worked out in detail and that his innumerable sign situations will prove, in spite of their many differences, to have similarities such that they may be profitably studied together. His own more recent work,[14] however, is disappointingly silent about this. And until more detailed work has been done, his views can have only the importance that comes from a promise, and not the importance that comes from an achievement.

III

If we use "sign" in a somewhat narrower sense than Morris does, ruling out the more trivial of his examples, an application of the theory of signs to the arts in general (and not merely to those normally classified as representational) becomes much harder to defend. Such arts as pure music and nonobjective painting appear to have no aesthetically relevant symbolic function at all. Mrs. Susanne Langer, however, has argued that they do in fact have such a function, and a very important one. And whatever is to be thought of her view, it is not trivial; rightly or wrongly, it ascribes a symbolic function to the arts that other writers have often denied to them. So let us summarize a part of what she says and see if it is plausible. The account that follows will be based largely on her *Philosophy in a New Key*;[15] and it will deal with her views on music, since that is the part of her work that she has subsequently generalized in dealing with the other arts.[16]

The symbolic function of music, according to Mrs. Langer, serves primarily to relate it to the *emotions*. Her conception of this relationship is so complicated, however, that we can best come to understand it by contrasting it with a simpler one that she explicitly rejects.

It is often said that music *expresses* the emotions; but "expresses" is not necessarily a synonym of "symbolizes" or "designates." So if one of the older expressionists had stated his view in contemporary terminology, he might have been inclined to make very little of the topic

[14] *Signs, Language and Behavior* (New York, 1946).
[15] Cambridge, Mass.: Harvard University Press, 1942; New York: Mentor Books, 1948. References are to the Mentor edition.
[16] Susanne K. Langer, *Feeling and Form* (New York, 1953).

of symbolism, speaking in some such fashion as this: "Music is not a sign of an emotion but is rather a particularly intimate and direct cause or effect of it. If it signifies at all it signifies something that is quite distinct from an emotion. Program music may represent a storm, for instance; but although it may do this partly with the *help* of an emotion—the emotion being appropriate to the storm and thus reminding us of it—we must remember that it is the storm that it designates, and not the emotion. The emotion can at most be accessory to the *interpretant* of the musical sign; and if we should take it as the *designatum* as well we should divert 'designatum' into such a confused sense that it would be useless."

Now Mrs. Langer's way of connecting music with the emotions is definitely not this way. She sharply denies what the expressionists most wish to affirm—that music is an immediate cause or effect of an emotion. Roughly speaking, she thinks that we only suppose that we feel an emotion when we listen to music, but that we really do not. A fortiori, she denies that a felt emotion, in program music, is an accessory to the interpretant of a musical sign. Indeed, she mentions program music only in order to repudiate it.[17] And this leads her to give the emotions a place in a symbolic situation that the expressionists (or at least, those of them who subscribe to a view like the one just mentioned) do not give to it. She holds that music quite literally *designates* an emotion. It doesn't give release to the composer's emotions, and (normally) it doesn't cause emotions in the listener. Rather, it *stands for* an emotion, or *represents* it.

To those who are accustomed to the expressionist theory Mrs. Langer's repudiation of it may seem arbitrary; so let us examine this negative part of her view a little more closely.

She acknowledges, to be sure, that people *sometimes* feel emotions when they listen to music, even to the point of weeping. But this comes as an acknowledgment rather than an affirmation; and she thinks that the cases in which people feel emotions are atypical, involving a lack of psychic distance (in Bullough's sense) that most musicians are accustomed to preserve.[18] Typically, then, music is attended by no emotion: and her reasons for saying so are essentially these:

Sheer self-expression requires no artistic form. A lynching-party howling round the gallows-tree, a woman wringing her hands over a sick child, a lover who has just rescued his sweetheart in an accident and stands trembling, sweating, and perhaps laughing or crying with emotion, is giving vent to intense feelings; but such scenes are not occasions for music, least of all for composing.[19]

[17] *Philosophy in a New Key*, p. 197. [18] Ibid., p. 181. [19] Ibid., p. 175.

In the second place, she thinks that the presence of strongly felt emotions would leave us puzzled to explain how music can be performed:

> If the primary purpose of music were to enable us to work off our subjective experiences it would be utterly impossible for an artist to announce a program in advance . . . or even . . . to *express himself* successively in *allegro, adagio, presto*, and *allegretto*, as the changing moods of a single sonata are apt to dictate. Such mercurial passions would be abnormal even in the notoriously capricious race of musicians![20]

And in the third place, she feels that if we take music as providing only substitutes, as it were, for the emotions of real life, we shall be led to underestimate its importance:

> Let us now explicitly abandon the problems of music as stimulus and music as emotive symptom, since neither of these functions . . . would suffice to account for the importance that we attach to it.[21]

We must consider later on whether or not these are very strong reasons for abandoning the expression theory of music. For the moment we need only note that Mrs. Langer abandons it without the slightest regret.

Like every other writer on music, however, Mrs. Langer wants to recognize some sense, and some very fundamental sense, in which we can distinguish between music that is emotionally impoverished and music that is emotionally rich. A Czerny exercise is not a Beethoven sonata, and no one could play or hear the one with the emotional insight that is appropriate to the other. So Mrs. Langer immediately proceeds to reinstate the emotions in her theory of music, though in her own way. That is the constructive part of her work to which we must now turn. Her central thesis is evident from such a remark as this:

> If music has any significance, it is semantic, not symptomatic. . . . If it has any emotional content, it "has" it in the same sense that language "has" its conceptual content—symbolically.[22]

It will be observed that she here makes an implicit reference to the three elements that enter into any sign situation. The sign itself is the music; the designatum of the sign is the emotion; and the interpretant of the sign, whatever else it may be, is something generically comparable to the interpretant of a linguistic sign, being of a "conceptual" nature.

She then goes on to discuss the *particular way* in which music becomes a sign of an emotion. And here her view, though not altogether

[20] Ibid., p. 176. [21] Ibid., p. 177. [22] Ibid., p. 176.

clear, is clear at least to this extent: she takes music to be what Peirce and Morris would call an *iconic* sign of the emotion that it designates. It is not strictly comparable to the iconic signs that we find in portraits, etc., since the point of resemblance between sign and designatum, in music, is more abstract. But it is nevertheless an iconic sign of a certain kind; and to understand what it is (as she conceives it) we must see what sort of resemblance it involves.

In good measure Mrs. Langer adopts a principle that has been much emphasized in contemporary psychology: that the felt resemblances between experiences extend beyond the range of any one sense-field. She holds that certain musical patterns *sound like* emotions. This is central to the view of Carroll Pratt, from whom she quotes, with approval, the following passage:

[The auditory characteristics] of music intrinsically contain certain properties which, because of their close resemblance to certain characteristics in the subjective realm, are frequently confused with emotions proper. . . . [But] these auditory characters are not emotions at all. They merely sound the way moods feel.[23]

And perhaps the point can be made in this alternative way: just as a diapason stop, on an organ, sounds more like a smooth *touch* than does a reed stop, so a soft, consonant musical phrase sounds more like a tranquil *mood* than does a loud, dissonant one.

But it is evident, throughout, that Mrs. Langer is thinking of some more complicated point of resemblance between music and emotions— some further sort of iconicity—than the above view will serve to suggest. And the clue to what she means lies in her description of music as being a "logical"[24] picture of the emotions it designates, and as having a "morphology"[25] that is similar to them. Although it is difficult to interpret these remarks, it is probable that they refer to what in logic and mathematics is referred to as an "isomorphism," . . . Let us first examine this term, and then attempt to show its specific connection with Mrs. Langer's problem in aesthetics.

Any map is said to be isomorphic with the region it maps. For each point on the map uniquely corresponds to a point on the region mapped, and some relations between points on the map (e.g., to the left of) have corresponding relations in the region mapped (e.g., west of). More generally, when any two entities have such a correspondence between their elements, and such a correspondence between certain

[23] Ibid., p. 198. The quotation is from Carroll Pratt, *The Meaning of Music* (New York, 1931), pp. 191, 203.
[24] Ibid., p. 180. [25] Ibid., p. 193.

relations holding between these elements, then the entities are isomorphic with respect to these elements and relations.

Suppose, then (to take another, and altogether trivial example, but one that may help to illustrate the point in question) that we correlate the squares on a chess board with various musical sounds. And suppose that the sounds correlated with any given rank of squares are all of the same pitch, but grow louder and louder corresponding to a movement from left to right along the rank. And suppose that the sounds correlated with any given file of squares are all of the same loudness, but grow higher and higher in pitch, by steps of the diatonic scale, corresponding to a motion up the file. In that case the sounds in question will be isomorphic with the chessboard, since there will be a correspondence in both elements and relations. The sounds, metaphorically speaking, will be a nonspatial "map" of the chess-board. (Note that the squares covered by a bishop's move from the near left corner to the far right corner would be "mapped" by a one-octave, diatonic scale, played with a steady crescendo.)

Now the most characteristic part of Mrs. Langer's view of music (if the present interpretation of her remarks is in any way near to being correct) is that the forms of music are isomorphic with the *emotions* that the music symbolizes. So we must go on to examine the particular respects in which she thinks the isomorphism holds. One cannot easily avoid the impression, in reading this part of Mrs. Langer's work, that she has in mind a much more elaborate isomorphism than she has been able to mention in detail; but a beginning of her view is this:

In music there are passages that have a certain "tension," and others that have a certain "resolution."[26] ("Resolution" by the way, is to be understood in a rather broader sense than is current in traditional harmony.) Mrs. Langer takes these terms from von Hoeslin, but it may be mentioned, in passing, that she might equally well have taken the first of them from Hindemith, who represents the increasing and decreasing "tensions" of music by diagrams.[27] These tensions and resolutions are presumably Gestalt qualities and not reducible without remainder to this or that combination of notes; but roughly speaking, tension tends to go with dissonances, quick modulations, large melodic skips, etc., and resolutions with the opposite to these. Now in a musical composition we may consider passages with varying degrees of tension and resolution as being the *elements* which, when correlated with the elements in an emotion, begin to establish the isomorphism in question.

[26] Ibid., p. 184.
[27] Paul Hindemith, *Craft of Musical Composition*, transl. by Arthur Mendel (New York, 1942), Book I, p. 117 and passim.

And to see what might be considered elements in the emotion we need only remember that the emotion is not an undifferentiated feeling, but is rather a changing state of mind, some phases of it involving complex feelings and attitudes, and others relatively tranquil, simple ones. As might be expected, the intense, complex elements of the emotion are taken as correlates of the musical tensions, and the others with the musical resolutions.

This correlation of *elements* goes only part way toward establishing an isomorphism; for there must also be a correlation of certain *relations* holding between the elements. And what will these relations be? One of them, clearly, will be of a temporal nature. Whenever a musical tension occurs *before* a musical resolution, then a tense phase of the correlated emotion will occur *before* a relatively tranquil one. But the exact duration of the temporal intervals need not, presumably, be the same; for the music may "map" the emotion on either a large or a small scale. A more important relation, however, will be a *requiredness* of the sort emphasized by Wertheimer and Köhler. Whenever there is a requiredness between a musical tension and a musical resolution, there will be *some* relation between the corresponding elements in the emotion. The latter relation may also be a requiredness; but it may, alternatively, be simply a causal relation, the intense phase of the emotion bringing about physiological changes, for instance, that in turn bring about the relatively tranquil phase.

It must be understood that this is a somewhat conjectural interpretation of Mrs. Langer's view. As previously remarked, she seems to have in mind a much richer isomorphism than she is prepared to exemplify. An elaboration of her view might profitably make more of her references to Köhler, who points out that when we use musical terms to refer to the emotions of everyday life, as in expressions like "increased inner tempo," we seem to be emphasizing, by metaphor, an important analogy.[28] She finds these metaphors wholly congenial to her thesis about "morphology." But for the moment the above remarks will be sufficient to serve as a simplified model, at least, for the view that she seems to be expressing.

Mrs. Langer does not expect music, in view of the isomorphism in question, to designate highly specific emotions. It cannot, she thinks, designate some one, peculiar sorrow, like the sorrow of the Wotan, as distinct from some other noble sorrow. In fact music may designate emotions "ambiguously," as is evident from this quotation:

It is a peculiar fact that some musical forms seem to bear a sad and a happy interpretation equally well. At first sight that looks paradoxical; but it really

[28] *Philosophy in a New Key*, p. 183.

has perfectly good reasons, which do not invalidate the notion of emotive significance, but do bear out the rightmindedness of thinkers who recoil from the admission of specific meanings. For *what music can actually reflect is only the morphology of feeling*; and it is quite plausible that some sad and some happy conditions may have a very similar morphology.[29]

But in spite of recognizing this ambiguity, she holds that the isomorphism between music and the emotions is what gives music its importance; it enables music to act as a sign that gives us "insight" into the emotions.

It should be noted that Mrs. Langer often calls music a "presentational" symbol of the emotions. The essential part of what she means by this is evident from her remark that the parts of such a symbol can be understood "only through the meaning of the whole, through their relations within the total structure."[30] This bears out the present interpretation, which compares her conception of music to a map of the emotions. A circle on a map is not destined by its shape to be a sign, say, of Ann Arbor, but becomes a sign of it mainly because of its relations to other parts of the map; and similarly, a chord in music is not destined to have tension, and to designate an intense phase of an emotion merely because of its own nature, but acquires this function because of its relation to the whole context of notes in which it occurs. It is on this ground that Mrs. Langer finds it misleading to call music the "language" of the emotions. Language, whose symbolic function is "discursive," as opposed to "presentational," has a fixed vocabulary, the significance of its words depending only a little on their context; but music has no analogue of a word, almost everything depending on the longer message of which a note, chord, or short phrase forms a part.[31]

A criticism of Mrs. Langer's theory will be developed in the next section; but it may be well to indicate in advance some points that she has left incomplete:

Her view about the "morphological similarity" between music and the emotions, which we have taken to refer to an isomorphism, needs to be formulated much more specifically. If music can be isomorphic with something so remote from it as chess (and we have seen that it can), we do not learn much on being told that it is isomorphic with the emotions as well. We must be told *just how* it is isomorphic with the emotions, and why this particular isomorphism is so important to music. But to whatever extent Mrs. Langer goes beyond the "tensions and resolutions" mentioned here, she becomes altogether general and indefinite.

[29] Ibid., p. 193. Italics in text. [30] Ibid., p. 78. [31] Ibid., p. 76 ff., 185.

She also needs more evidence for saying that music is really a sign of the emotions. For a morphological similarity need not involve any sign function at all. Thus if a child, drawing lines on a piece of paper, should happen by accident to map a remote region in Siberia, its drawing would not be a sign of that region unless someone interpreted it as such, as perhaps nobody would. The same is true of a musical map of an emotion; it cannot be a sign unless it is connected with its designatum by some interpretant. Yet Mrs. Langer gives us no evidence for believing that her "conceptual" interpretant is present in music; she simply takes it for granted. In Morris' work, as we have seen, the interpretant of a sign, is conceived so broadly that it tends to trivialize his conclusions; and although Mrs. Langer is clearly striving for something that isn't trivial, it is interesting to see that for her, too, the interpretant presents a difficult issue.

IV

A profitable way of criticizing any theory—and a particularly profitable way when the theory is incompletely developed—is to present an alternative theory that is equally tenable. And that, it will now be argued, can easily be done for Mrs. Langer's view. The alternative theory to be developed is not new. It can take several different forms, one of which was suggested by Hanslick[32] some one hundred years ago; and perhaps Hanslick's form of it differs less sharply from the others than it initially seems to—as has been argued, and most plausibly, by John Hospers.[33] But it will be of interest to expound the theory once more, with the emphasis that the present chapter requires. It may or may not be a correct theory, regardless of the form that it takes; but it will at least show that Mrs. Langer's view, with its emphasis on the symbolic function of music, has no special theoretical advantage. And perhaps it will show, more generally, that the importance of the theory of signs to all the arts, rather than merely to those commonly classified as representational, is seriously open to question.

Let us begin by noting that our efforts to describe a work of art are frequently attended by the realization that we haven't a vocabulary to say just what we want to say. We must accordingly *borrow* words, extending their normal senses. Thus, many of the melodies of Handel are "square," whereas there is rarely anything "square" in the music of Debussy. Or there is a certain "heaviness" in Browning that is not

[32] Eduard Hanslick, *The Beautiful in Music*, transl. by Gustav Cohen (New York, 1891), pp. 37, 38, 75. (The German edition first appeared in 1854.)
[33] *Meaning and Truth in the Arts* (Chapel Hill, N.C., 1946), Chapter IV, Sec. 3.

found in Tennyson. Or there is a certain "soaring" quality in Tintoretto
that is not found in Cézanne. And so on. This borrowing of terms is
likely to be the first thing one notices in examining the terminology
of criticism (which is the first of the four studies as mentioned at the
beginning of this chapter, that relates symbolism to aesthetics); and
although it may at first seem remote from our present topic, perhaps it
will later prove to be very close to it.

It is more than an accident that we choose just these terms rather
than others—that we say "square" rather than "jagged," for instance,
in describing Handel's music. Psychological tests have been made that
help to confirm this. In an experiment conducted by Willman,[34] various
composers were shown four figures, one of them square and the others
of irregular shapes, and were asked to write music to go with each of
them. The music they wrote for the square was then examined by
trained critics, who agreed that it was of much the same character in
each case, in spite of the different personalities of the composers, and
that it differed markedly from the music that the composers wrote for
the other figures.

We extend the word "square" from a shape to a melody because we
feel that the two resemble one another. But the resemblance is not an
ordinary one. Note that it is generically the same sort of resemblance
that we have dealt with earlier, in connection with Pratt's view that
music sounds the way moods feel. And it is the same sort of resemblance
that Professor Heinz Werner[35] has discussed in his chapter on "Physio-
gnomic Perception," where, in a manner reminiscent of Hornbostel and
other Gestalt writers, he emphasizes similarities that cut across the
familiar sense fields. Among other examples, he mentions an experi-
ment (which for convenience can here be simplified) in which various
observers are shown the following diagrams:

and are then required to name one of them "iron" and the other
"gold" without being permitted to use any other name. There is a
great deal of agreement in naming the left one "iron" and the right
one "gold"; and Werner finds reason to suppose that this is not due to
association of ideas—as if the left figure were called "iron" because it

[34] Rudolph R. Willman, "An Experimental Investigation of the Creative Process in
Music," *Psychological Monographs*, ed. by John F. Dashiell (Evanston, Ill., 1944), 57, No. 1.
[35] *Comparative Psychology of Mental Development* (New York, 1946), pp. 70–71. This is a
translation of *Einführung in die Entwicklungs-Psychologie* (Leipzig, 1933).

reminded the observers of a crosspiece in an ironwork gate—but that it comes as a much more immediate reaction to the figures.

Let us now see how this bears on the relation of music to the emotions, and in particular, how it helps to suggest that Mrs. Langer's evidence can be explained in an alternative way. It will be obvious that a part of Mrs. Langer's evidence (though only a part, of course) is concerned with the appropriateness of describing music as "sad," "gay," and so on. She accounts for this by saying that music is a symbol of an emotion—implying, in effect, that an *emotion* is in music only in the sense that a man is in a picture. So she herself tacitly acknowledges that the emotional terms have extended senses when they apply to music. But we have now to ask, in view of the fact that such a word as "square" can also be applied to music, whether the principle exemplified by the latter term will not apply to the emotional terms as well. When we say that music is sad, are we not, perhaps, extending the sense of "sad" *only* in the way that we extend the sense of "square"—and thus extending it quite differently from the way that she emphasizes? And if so, will it not be possible to dispense altogether with the notion that music *symbolizes* the emotions?

More specifically: We are not tempted to say that a square melody, heard in any usual way, leads us to take account of the geometrical square; for we there realize that we are calling the melody "square" in the lack of any other appropriate adjective. And perhaps we should not be tempted, with Mrs. Langer, to say that a sad melody leads us to take account of sadness. Instead of supposing that the melody symbolizes an emotion, we have the alternative of saying that it merely resembles an emotion—and resembles it, perhaps, in a rather imperfect way. In that case there will be only one symbolic relation that requires attention: that between the *word* "sad" and the music, where the word is used in an extended sense. And this symbolic relation will not be an unusual one. It will be just another of the many instances in which the poverty of our language forces us to borrow a term.

Perhaps this further analogy will be of interest. Suppose that pastel colors occur only in paintings, the colors of nature being always darker or more highly saturated. And suppose that in a certain community the vocabulary for colors has grown up entirely in connection with the colors in nature. If the members of this community are asked to name a certain color in a painting—one that *we* should unhesitatingly call "lavender"—they will probably call it "purple". But that will not require us, in theorizing about their aesthetic sensibilities, to say that they take lavender to be a symbol of purple, or to say that they have a conceptual insight into purple every time they enjoy the lavender of

the painting. It permits us to say that they normally have an experience of lavender that is nonsymbolic, and that they become concerned with symbolism only when their efforts to keep from being inarticulate lead them to borrow "purple" as a name for this experience. We have only to compare lavender to the properties of music, and the term "purple" to the term "sad," to obtain a model for the view that is now in question —one that accounts for our calling music "sad" without having to acknowledge that music is a symbol of sadness.

V

Let us now see whether this alternative to Mrs. Langer's view can be developed in ways that will make it seem less arbitrary. There are four ways of developing it, differing with regard to the degree of complexity that they recognize in our experience of music. Each of them has its place in traditional aesthetic theory, the last three being variants of the expression theory.

In the first place, there is a view that emphasizes very much the same similarities between music and the emotions that Mrs. Langer wishes to emphasize. (The preceding section deliberately made more of this view than of the others that will be mentioned, but only in the interest of simplifying exposition.) The view is normally limited to the recognition of intersense field or "physiognomic" similarities, as Pratt's version of it is: but there is nothing that prevents it from taking into account isomorphic similarities as well, to whatever extent these can be found. Indeed, Hanslick's view anticipates Mrs. Langer's in this respect. The theoretical use that it makes of these similarities, however, has nothing to do with a symbolic function of music. It has entirely to do with an explanation of our habit of describing music by borrowing such terms as "sad" and "gay."

In the second place, there is a view which holds that the sounds of music are actually accompanied by (and *not* merely signified by) a certain feeling or mood—one that is *something* like an everyday-life emotion but not *exactly* like it. For instance, the feeling or mood that attends sad music may have a generic resemblance to that attending a bereavement, but need not resemble it in provoking tears, or in being uncontrollable, etc. Our application of the term "sad" to music is then explained, as before, by our tendency to extend the term to this otherwise unnamed feeling or mood; and here the meaning is taken to be extended much less severely than it was by the previous view.

In the third place, there is a view that combines the two just mentioned—one that accounts for our calling music sad by saying

that we extend the term in a way that makes it apply *both* to a musical pattern *and* to a mood or feeling. To make a somewhat eccentric but helpful comparison, "sad" in its extended sense is then taken to behave rather like the term "feeling of dizziness." If we are asked what the latter term designates, we may be inclined to mention a feeling vaguely located in the stomach (say), and then go on to mention a certain swimming in the visual field as well. So we take "feeling of dizziness" to designate both a feeling and a variety of five-sensory experiences that accompany it; and in the same way, "sad" is taken by the present view to designate both a feeling and a sound-pattern.

The view just mentioned, like the preceding two, makes no provision for saying that *music designates* an emotion. It could do so, however, provided that only unusual cases were in question. Thus when a piece is performed with exaggerated sentimentality a sophisticated hearer is likely to inhibit any mood that first tends to arise and proceed to laugh *at* the music rather than to feel *with* it. But the pattern of sounds permits him to know, on the basis of past experience, what sort of mood the performer is indulging in; so in an appropriate sense we can say that he takes the music as a sign of the sentimentality. Or again, a listener may be so fatigued that he can't, as he says, "properly react" to a certain composition; but he may take the notes as a sign of the mood that he would have if he were not so fatigued. But these symbolic situations, for the view now in question (and, more indirectly, for the preceding view), hold only in atypical cases. In the typical cases there is no musical signification of the emotions at all—no "taking account" of them (as distinct from *feeling* counterparts of them) by those who are appreciating the music. According to Mrs. Langer, on the other hand, the symbolic situations hold in the typical cases, any suspension of them being atypical.

In the fourth place, there is a view to the effect that certain moods or feelings "fuse" with musical patterns. (The main contemporary writer who emphasizes fusion is Stephen Pepper.[36]) There is a sense of "fusion" that is appropriate to the mental chemistry of John Stuart Mill—a view holding that two elements can be so related in an experience that neither is introspectable, each being disguised, so to speak, by the relationship. This view is now abandoned by most psychologists as empirically useless. But the term lends itself to other definitions, one of which would take "is a fusion of Y and Z" as a way of saying, merely, that X resembles Y in a certain way, and resembles Z too in this way, but does not have either of them as a component. In this sense the color orange is a fusion of red and yellow. In the same

[36] *Esthetic Quality* (New York, 1938).

sense our experience of expressive music is said to involve a unique experience which is a fusion of a sound pattern and a feeling. We need not here be concerned with what *kind* of resemblance is involved in fusion (though that is otherwise a pertinent question) because *any* sort of resemblance between sound patterns and emotions will be sufficient to establish the point we are making. The resemblance need not be taken to show that music has a symbolic function; it can equally well be taken to show that music is sad or gay only in extended senses of the terms.

Let us now, somewhat arbitrarily, take the second of these views (which is a kind of expression theory) and see what else, beyond our habits of applying terms like "sad" and "gay" to music, it permits us to explain.

It freely allows us to say, with Mrs. Langer, that a member of a lynching party howling round the gallows tree is not, in spite of his emotion, in a fit mood for composing. For if the mood of music *imperfectly resembles* its everyday-life counterpart, it will *differ* from it as well; and nothing obliges us to hold that the mood attending the lynching party is ever expressed in music.

There is, again, no difficulty in accounting for the way a virtuoso adapts himself successively to the varying moods of a sonata. It would indeed be odd if the emotions of everyday life changed in this "mercurial" way; but if the moods attending music differ from those of ordinary life (though not completely, of course) then the change is not so odd. The dependence of the moods on the musical sounds is scarcely a psychological accident, however difficult it is for psychology to explain the relationship; so the very fact that the performer is playing different notes will help to bring about his change from sadness to gaiety (in the extended senses of those terms).

Finally, the view here presented can take account of the importance we attach to music. If music simply reduplicated the feelings of everyday life, it could have only a modest importance, just as Mrs. Langer implies. It would be a substitute for living, much as a travel book is a substitute for traveling; and although there is nothing wrong about such a substitute, there is also nothing very exciting about it. But if music gives us new moods—moods partly the same and partly different—and if this is simply concealed by the way in which our limited vocabulary forces us to call them by the old names, then the moods can become important for enriching our experience. Perhaps they will be new sources of intrinsic value. It is not so evident that they will be new sources of extrinsic value, since that will depend on the consequences of the moods. But any uncertainty on that point arises for Mrs. Langer's

theory no less than for the present one. No matter whether music symbolizes moods or produces them, its extrinsic value must (by definition) be estimated in the light of its consequences, which still await a careful study.

What has here been said of the second of the four views can presumably be said, *mutatis mutandis*, of the other three; so it will be convenient to think of them as the several forms of *one* view that provides an alternative to the view held by Mrs. Langer. It is an alternative that can accept any analogies between our reaction to music and the emotions of everyday life that she wishes to emphasize, though it is not committed to precisely those; it can take into account all the evidence that she presents for her view; and finally, it can do this without granting to music *any* symbolic function. It locates the problem not in a study of the symbolic function of music but only in a study of the vocabulary of criticism.

VI

Our considerations have shown that Mrs. Langer's view is *no more* tenable than its alternative, but have not shown that it is *less* tenable. And indeed, the difficulties of the issue are too great to permit us to decide, categorically, which of the two views is correct. It may be useful, however, to consider just what the difficulties are, and to see what sort of study could hope to surmount them.

Some of the difficulties are of a psychological character. They attend the general question, "What happens when we listen to music, and how are our reactions related to the emotions of everyday life?" Here the evidence, though in some respects abundant, is not decisive. One must normally use questionnaires, etc., and it is not easy to make them at once intelligible, reliable, and relevant to the sort of information that is wanted.[37]

Perhaps some further light on the topic will eventually come from the work being done in psychology on the felt similarities that extend beyond any one sensory field—work like that previously mentioned with reference to Werner and others. Within a given sense field, such as vision, the various qualities and their similarities are well studied, as the color-solid manner of representing them will indicate. But much more work will be needed before we have a precise "dimensional" study of the physiognomic, intersense-field similarities; and this work will be particularly difficult when it concerns similarities between

[37] See *Music and Its Lovers* by Vernon Lee (London, 1932), and *The Psychology of Music* by Max Schoen (New York, 1940).

sounds and emotions, which are emphasized both by Mrs. Langer's view and by some forms of the alternative here presented to it.

It would be interesting, for instance, to see whether there is any intervening mood between people's reaction to music and their reaction to the emotional situations of daily life—an intervening mood in the sense that blue is an intervening hue between violet and green. If that could be shown it would do something to support the view advanced here, or rather, the second form of this view; and if it were shown impossible it would take us a step, perhaps, in the direction of Mrs. Langer's view. That there are such intervening states is suggested by the fact that handkerchiefs are often visible at plays, though more psychic distance is preserved there than in real-life situations, and by the fact that handkerchiefs are rarely visible at concerts. But such offhand observations are by no means an adequate substitute for a detailed study.

But although it is difficult to get psychological evidence that will help to decide between Mrs. Langer's view and its alternative, the main problem actually lies elsewhere. It lies not in psychology but in analytical philosophy. In essentials it is a problem of making clear just what we are asking when we ask about the symbolic character of music. And it is difficult because it requires us to deal with such terms as "thought," "concept," and "cognition," which have long been troublesome in philosophy.

More specifically, the problem lies in clarifying what is meant by the "interpretant" of a sign. If we try to do this without making use of the traditional terms, "thought," "concept," and "cognition," we shall probably be led to use terms that are even more untrustworthy than these. We have seen at the beginning of this chapter that Morris has difficulties in this connection; and we have seen subsequently that Mrs. Langer does. In fairness to them both we must remember that the difficulties are not peculiar to their views; similar difficulties arise in *any* theory of signs, and it would be rash to expect any immediate success in surmounting them. For the moment, however, we need not discuss the difficulties in their full generality, but can be content to see how they are involved in an attempt to decide between Mrs. Langer's view and the present one.

Suppose, entirely for the sake of argument, that there is such a thing as a pure thought-experience—an experience that reveals its full nature to introspection, and in the same way reveals what the thought is *about*. And suppose that this pure thought-experience is always the interpretant in any sign process, being uniquely caused by the sign. In that case we could readily test Mrs. Langer's view by getting people

to listen to music and by asking them whether the music caused them to have a pure thought-experience that was about emotions. If the people answered affirmatively, music would presumably be a genuine sign of the emotions, its resemblance to the emotions being attended by an interpretant. If they answered negatively, some form of the alternative view, developed here, would be required. It will be evident, however, that we find no pure thought-experience that reveals its nature to introspection in anything like so obliging a way; nor is it certain, even, that the phrase "pure thought-experience" makes sense. And so long as we are still seeking a more adequate conception of the interpretant in a sign-process (for a *promise* of a behavioral definition, or of a definition in terms of this or that disposition, is not the same as an actual definition) the adequacy of Mrs. Langer's view, *or of the present one,* is scarcely clear enough to be tested.

So it seems advisable to reserve judgment, adopting one or the other of the views tentatively, to be sure, but without considering it the only possible view.

VII

Our discussion of symbolism in the arts commonly classified as nonrepresentational will not be complete unless it mentions theories of program music—and in particular, theories maintaining that programs are present even in music for which the composer himself has provided no program in words. In Mrs. Langer we have emotions as the designata, but in these views we have other events as the designata —a sunrise, for example, or the death of a hero. The view is not, to be sure, necessarily confined to music. Just as an orchestral composition may be alleged to represent the death of a hero, so too a nonobjective painting (i.e., one that doesn't resemble the *shapes* of objects that are familiar in real life) may be alleged to represent the death of a hero. But critics of painting are less likely to recognize such "programs" than are critics of music; and critics of architecture, ceramics, etc., are likely to defend "programs" still more rarely. So it will be convenient, as before, to draw our examples from music.

In discussing this topic we shall encounter the same difficulties that were mentioned in the preceding section—difficulties about the nature of the resemblance between an iconic sign and its designatum, and difficulties about the nature of the interpretant.

The central questions have been partly anticipated in section III, but can be made clearer by developing this quotation from Sapir:

Aside from the emotional substratum which we feel to be inseparable from a truly great and sincere work of musical art, are there not in the earlier supposedly absolutistic art plenty of instances of direct realistic suggestion, sometimes intentional, no doubt, at other times a spontaneous product of association on the part of the listener? . . . I do not think it would be going too far to say that all musical art worthy of the name has implicitly, if not avowedly, some of the fundamental qualities of so-called "programme" music; from a musical standpoint it should make little difference whether the emotional appeal is left to declare itself [of its realistic suggestions] in the mind of the sympathetic listener or is trumpeted at him by means of a formidable printed analysis.[38]

It will be noted here that Sapir emphasizes the "emotional substratum" or "emotional appeal" of music, though it is not evident whether he takes the emotions as being closely like those of ordinary life or, as in the view suggested in section IV, only a little like them. In any case, these emotions "declare themselves." So Sapir recognizes a *similarity* between our immediate reaction to music and our reaction to the sort of thing that he takes it to represent: the music "declares itself" to be about the death of a hero, for instance, because the emotion it presents is like the emotion we would feel at the death of an actual hero. To that extent he makes a comparison between music and an *iconic* sign.

In an important respect the comparison is not a close one. No one would ever take a representational picture of a hero's death to be a picture of the fall of an empire; yet in the musical case the emotional similarity to a hero's death is not any more striking, perhaps, than is its similarity to the fall of an empire, and some listeners might feel that the composition in question "really" represented the latter. It is possible, however, to take this into account by saying that music is an ambiguous sign of its program; or alternating we may say that it is merely a very general sign—a sign that represents neither the death of a hero, specifically, nor the fall of an empire, but rather the termination of *anything* that is of great human interest.

If we were to pursue this matter, we should have to consider essentially the same question that we mentioned in the preceding sections. Just *what* is our emotional reaction to music, and just how much does it resemble our emotional reaction to real-life situations? And even if that were settled we should still have our old question about the interpretant; for the interpretant must be present before the similarity becomes a sign-situation.

[38] "Representative Music," *Selected Writings of Edward Sapir*, ed. by David G. Mandelbaum (Berkeley and Los Angeles: University of California Press, 1951), p. 492.

It will be useful to show that the question about the interpertant has here no simple, straight-forward solution. One can argue (as Morris[39] and others actually have) that the presence of an interpretant, in music that at first seems to have no program, is evidenced by the strong preference we have for one verbally formulated program over another—this being evident when, for purposes of experiment, we are *forced* to choose between programs. If we were asked, for instance, whether Schubert's "Moment Musical" in F minor is better suited to depicting a little girl dancing than it is to depicting a wounded elephant, we should almost all (including some tone-deaf people, even) answer in the affirmative. And this preference between the alternatives, even though we may never before have formulated them to ourselves in words, might be taken to show that we are "unconsciously" in the habit of using Schubert's composition as a sign—if not a sign of a little girl dancing, then of something generically like that. A moment's thought, however, will show that this proves nothing at all about a sign or an interpretant, so long as we let "interpretant" mean anything that will really interest us. For consider this counter-example:

Suppose that Mr. A is admiring the new Ford sedan that he has bought; and suppose he has previously noted that Mr. B has one just like it, and that Mr. C has an aged Chevrolet coupe. Now if we interrupt Mr. A, in his aesthetic admiration, and ask him whether he thinks his car better suited to be a sign of Mr. B's car than it is of Mr. C's, requesting him, for purposes of our experiment, not to reject both alternatives, he will answer in favor of Mr. B's car, pretty certainly. But in this case we shall scarcely wish to argue that Mr. A, in the course of admiring his car under any ordinary set of conditions, actually takes his car as a sign of Mr. B's, or as a sign of anyone else's car. In spite of the great similarity between A's car and B's, we shall be inclined to recognize no sign situation at all, feeling that there is nothing here that we want to call an interpretant—nothing that is sufficient to make the similarity into an iconic sign-situation. And if in this case Mr. A's strong preference, given a forced choice, does not establish the presence of such an interpretant under normal circumstances, there is no reason to suppose that it does in the case mentioned above about Schubert's "Moment Musical." One can insist that the musical case is "different"; but the point is that an appeal to forced choices does not in itself show this. And our perplexity in showing it by some other means testifies to our uncertainty about what we want "interpretant" to mean. (Note that we should like, as before, to have some pure thought-experience that we could appeal to in deciding whether an interpretant is present.)

[39] *Signs, Language, and Behavior*, p. 193.

We must not forget that program music can depend on other sorts of similarity than those that involve the emotions. Music may be taken to have a program because its sounds are similar to sounds that occur elsewhere. Crude and humorous examples of this may take the form, say, of a musical imitation of the cackling of a hen (as in Rameau); and more subtle examples may take the form of musical imitations of *verbal* inflections (as in Schumann's *Warum?* or Ravel's *Beauty and the Beast.*) But more interesting examples are found when music resembles the *visual* appearance of certain objects. Here we find once more a similarity that cuts across the sensory modalities. Thus Debussy's *Reflections on the Water* has little to do with the sound of the mood of water; but it has a certain similarity to the way quietly shimmering water *looks*. Often this resemblance between sound and sight is attended by a resemblance of mood as well. Thus Schumann's *Prophet Bird* and MacDowell's *The Eagle* both imitate the visually perceivable flight of a bird, but the mood of Schumann's music is appropriately mysterious, while that of MacDowell's is one of dignity. Some may feel, in such cases, that there are other sorts of similarity involved, depending, say, on a kind of empathy, yielding something similar to a kinaesthetic sense of flying.

These points of resemblance are worth further study; but they do not show that music is always of a symbolical character, or even that it typically is. In the above examples, a title to the music provides a key to the program; and if we take the title as a part of the whole work, as seems appropriate, we have the effect of music reinforced by the obviously symbolic function of language. In works without a title the music sometimes invites us, as it were, to supply a program; but it does so only because of similarities that are highly generic—similarities that are variously perceived, and may suggest a program to one listener that is sharply different from the one that it suggests to another. So before saying that music is an iconic sign of something else we must pause to ask ourselves whether "iconic" can profitably refer to a situation in which the similarities are quite so generic, and whether "sign" can profitably refer to a situation in which the interpretant, or alleged interpretant, is quite so inconstant. We are left, in short, with our recurrent questions.

Nothing has been said here that helps to answer these questions; but in the present current of opinion in aesthetics it is of the utmost importance to realize that they demand an answer, and an answer that can be given only after many difficult issues have been carefully examined. Meanwhile, it is necessary to protect aesthetics from an understandable but misguided enthusiasm—an enthusiasm that induces

people to hope that the theory of signs will soon disclose the "true nature" of the arts. The theory of signs is not a well-developed discipline that can be applied to the arts in the way that mathematics can be applied to physics. On the contrary, a study of the (allegedly) symbolic aspects of the arts is largely of interest for disclosing the problems that lie in the theory of signs itself—problems that must be solved before the theory can be of much use in contributing to the solution of other problems.

VIII

In this chapter, which is concerned with the aesthetically relevant signification, or alleged signification, of the arts commonly classified as nonrepresentational, these points have been stressed:

In a highly generic sense of "sign," as used by Morris, there can be no doubt that sign situations arise in all the arts; but it remains to be seen whether anything illuminating to aesthetics will come of this observation.

In a more specific sense, such an art as music can be taken to signify emotions, in the manner suggested by Mrs. Langer. But such a view is no more plausible than an alternative one, which takes music to resemble emotions without signifying them, or which takes it to be attended by something rather like the emotions. The fact that we use "sad," "gay," etc., to describe the music can then be accounted for by recognizing extended senses of those terms.

Music (or, *mutatis mutandis*, any other art commonly classified as nonrepresentational) can also be taken to signify something other than emotion. We then have the traditional issue about program music. And there, although people will often acknowledge that a composition is better fitted to represent one thing than it is to represent another, it may be doubted whether the composition is *in fact used* to represent anything.

In each case there is a problem of establishing the nature of the *interpretant* in a sign situation; and since the alleged sign is usually taken to be iconic, and iconic in some extremely subtle way, there is the further problem of indicating the precise respects in which it resembles what it signifies. Until these difficult problems are settled, the theory of signs is likely to make only a modest contribution to aesthetics.

Selected Readings on Part V: Art as Symbol

Beardsley, Monroe. *Aesthetics*. New York: Harcourt, 1958. Chapter 7.

Bernheimer, Richard (ed.). *Art: A Bryn Mawr Symposium*. Bryn Mawr, Pa.: Bryn Mawr College, 1940.

Bevan, Edwyn. *Symbolism and Belief*. London: Allen & Unwin, 1938.

Ferguson, George W. *Signs and Symbols in Christian Art*. New York: Oxford U.P., 1954.

Goodman, Nelson. *Languages of Art*. Indianapolis, Ind.: Bobbs, 1968.

Kaplan, Abraham. "Referential Meaning in the Arts." *Journal of Aesthetics and Art Criticism*, XII (June 1954), 457–74.

Langer, Susanne K. *Philosophy in a New Key*. Cambridge, Mass.: Harvard, 1942. Chapter 8.

———. *Feeling and Form*. New York: Scribner, 1952.

———. *Problems of Art*. New York: Scribner, 1957.

Morris, Charles. "Aesthetics and the Theory of Signs." *Journal of Unified Science (Erkenntnis)*, VIII (1939–1940), 131–50.

Nagel, Ernest. Review of Susanne Langer's *Philosophy in a New Key*. *Journal of Philosophy*, XL (1943), 323–29.

Pratt, Carroll C. *The Meaning of Music*. New York: McGraw, 1931.

Price, Kingsley B. "Is the Work of Art a Symbol?" *Journal of Philosophy*, L (1953), 485–503.

Rudner, Richard. "On Semiotic Aesthetics." *Journal of Aesthetics and Art Criticism*, X (1951), 67–77.

Urban, Wilbur M. *Language and Reality*. New York: Macmillan, 1939.

Weitz, Morris. "Symbolism and Art." *Review of Metaphysics*, VII (1954), 466–81.

Welch, Paul. "Discursive and Presentational Symbols." *Mind*, LXIV (1955), 181–99.

VI

ART AND TRUTH

13. TRUTH IN LITERATURE

MORRIS WEITZ

I want to begin by asking whether works of art contain truth claims. But because this is such a large problem, with many different facets in music, painting, and architecture, I intend to specify and reduce it to what I take to be the crucial question: Are there any empirical claims about the world in literature, i.e., in plays, poems, and novels?

Since Croce there have been a number of views which deny that art, including literature, does contain such claims. As attractive as this contention may be, especially to those who like their art neat, unmixed with the murky waters of life, it does not, even when formulated most convincingly, seem to square with certain important features of some art, namely, with some passages in literature. Consequently, as I shall try to show, there are certain empirical claims—some true, some false—in some works of literature, especially novels, where these claims are as artistically relevant as anything else in the works. The importance of this to the so-called autonomy of art and to our critical evaluations I shall also discuss.

It does not initially strike us as fantastic to construe the printed sentences of novels as true or false statements. If we were so inclined we could always ask of anything said about the various characters, situations, places, and things in a novel whether it was true or not. Is Jane Austen, for example, writing about real people, events or places, say, in *Pride and Prejudice*?

We rarely raise questions of this sort, at least while we are reading what the author wrote as a novel. In some fundamental sense, we feel that such questioning is inappropriate, and more akin to scientific than to aesthetic inquiry. Of course, we can and no doubt some scholars do, investigate the veracity of the characters, events and places of certain novels; but always, I daresay, with the clear understanding

FROM *Revue Internationale de Philosophie*, IX (1955), PP. 116–29. REPRINTED BY KIND
PERMISSION OF THE AUTHOR AND THE PUBLISHER.

213

that theirs is no aesthetic enterprise; i.e., that what they are doing is not necessary to the reading of these novels as works of art.

This recognition of the basically *fictional* aspects of the novel is fundamental because it determines our attitude toward the printed sentences about persons, places, events, and things: that we shall not take them either to be claims or not to be claims about anything. To say these sentences are fictional is, of course, not to say that they are false; rather it is to waive the whole question of their truth or falsity.

Recognition, acceptance, attitude point, I think, to something philosophically important. One begins by asking what looks like a straight-forward factual question, "Are there empirical claims in literature?", and soon realizes, because of the role of the reader's attitude, that one's answer to this question derives primarily from an entirely different, indeed a normative question: "From an aesthetic point of view, *ought* one to interpret the printed sentences of literature as statements at all?"

In each of the major discussions of the problem of truth in art, since Croce anyhow, the denial of truth in literature rests primarily, it seems to me, upon a consideration of how best to read literature and not upon any direct appeal to the actual sentences in it. Here is a radical confusion of problems and yet I cannot myself see how to avoid doing consciously what these writers have been doing unwittingly.

The fact with which we must start is this, that the printed sentences of novels do not of themselves proclaim any statement-making role. Now, of course, this is the case with all printed sentences. They do not of themselves come labelled physical or psychological or philosophical statements. It is we, the readers, who, guided by certain conventions for interpreting the sentences at hand, impose the appropriate label. Abstract any sentence from any text, offer no guiding label, and the reader simply does not know whether it is to be construed as statement, mere illustration, an exercise in mere printing techniques, or what. It is only because most of the sentences we encounter come enveloped in their settings, with their labels of names of books or journals, that this problem of how to interpret them rarely arises. But it does arise with the sentences of novels, and precisely because here there is no one or well-established convention to guide our interpretation. It may seem as natural to construe all as to regard none of the sentences of a novel as statements until we are reminded that we oughtn't to take them as statements in order not to violate the convention of treating the novel as art and not as history, biography, or science. If we decide that there are no statements in literature is it not because we have already decided that it would not be proper for there to be?

I. A. Richards, who has done more than anyone else to clarify our problem, is a perfect illustration of this confusion of factual and normative. He asked, "Can literature contain empirical truths?", and argued negatively on the grounds that literature was primarily emotive language, hence incapable of truth or falsity. But Richards saw and was constrained to deny that, if it were emotive, it was so in some extended, recommended sense since, on the face of it, it is fantastic to reduce literature to a long series of "ouches!" and "hells!" What Richards really did was to ask how best to read literature and, in his terms, how to read it without becoming a physicist, psychologist, moralist, or metaphysician while reading it. The best, the positive aesthetic way, he *decided*, was to read it as collections of items intimately associated with our conative-affective life. It was this decision as to what was most valuable which prompted his semantics of literature. Consequently, his assertion that literature is emotive is based not upon the sentences he found there but primarily upon his conviction that we would get the most from literature if we read it his way. The alternative, he thought, was classical moralism or literalism, the prolongation of the "revelation" theories.

One may share Richards' conviction that the normative question is prior and yet not swallow his semantics. Indeed, this is precisely what recent discussions have done, albeit again in an unconscious manner. Mrs. Langer's treatment in her *Feeling and Form* is a case in point.

To my mind the best attempt to formulate a view which recommends that we deny truth and falsity in literature has been suggested by recent writers on the more general problem of assertion and language. Strawson, Hart, and others, in a number of writings, have forced the distinction between falsity and fiction in a way that may well be the starting-point of a new approach to the problem of truth in literature. At any rate, I shall now try to sketch such an approach.

Sentences, they begin, are neither true nor false. They can be used to make statements, i.e., true or false assertions about the world. Among statements are those which involve references to people, places, things, and events in the world. We talk *about* these when we refer to them in order to say something about them. This whole referring *cum* descriptive use of language can be genuine and give rise to true or false claims only if one existential condition is fulfilled, namely that what we are talking about actually exists. If it does not exist and we use sentences containing referring expressions then, it is argued, what we say is spurious and not a genuine use. One cannot say, e.g., of the present King of France that he is or isn't wise unless there is a present King of France.

However, they continue, there are recognized uses of sentences containing referring *cum* descriptive words which are not true or false or spurious. One of these is the fictional use. Here we do not fail to refer or even think we refer when we do not. We simply *pretend* to refer or to talk about something. We know that the things that are being talked about do not exist or that their existence or non-existence is not relevant in this context of pretending; and, consequently, we shift our orientation from belief and disbelief to make-believe, wherein the whole question of truth or falsity does not arise.

Getting to understand the difference between the fictional and the assertive uses of language is one of the feats of childhood. When, as children, we listen to fairy-tales, one of the essentials that we are taught is not to raise the question of the truth or falsity of the things said about any of the persons, places, events, and things of the tale. In a sense, to learn this essential is to get the point of the fairy-tale use of language; this is why children eventually stop asking, e.g., "Are ogres really wicked?". They have learned to drop the question for the sake of the story. In effect, isn't this what we mean by being introduced, as children, into the life of the imagination? That children are to interpret what is said as neither being about nor not being about anything in the world is a guiding principle which is offered them so that they can get the most out of this kind of literature. Of course, there are children who refuse to pretend, who remain literal-minded in their demand for truth or falsity for anything in print. What can we say of these except that they have not grown into a proper response to the things of the imagination?

What is central in the view I am sketching is the insistence upon a variety of employments of language, each irreducible to others, each with its own characteristic point; and, as its aesthetic corollary, that we ought to construe the whole of literature as the fictional use of language, according to which the entire question of its being about anything, or its being true or false statement, cannot properly arise. Story-telling, it follows, from fairy-tales to novels, is not to be assimilated to history-telling or science-telling, if we get the point of and wish to get the most from this story-telling activity. Do not, we are admonished, construe the sentences of a story as being about anything in the world. Instead conceive them as uses of language to create certain imaginary characters, events, places and things. Do this and you will have artistic intention, cultural tradition, and the ideal of maximum appreciation on your side. Such an approach, with its emphasis upon the imaginary instead of the assertive, it could be said, preserves the all-important creative as against the reportive or informative character of the novel.

This is all I wish to say now about this new approach to truth in literature. Let us next see how it squares with an actual example. Suppose we consider something as typical of the novel as Proust's *Remembrance of Things Past*. To most of us, "common readers", in Virginia Woolf's apt phrase, the novel is a long story involving characters, places, events, and things. To be sure, we are never concerned with the veracity of what is said about these in the novel; the existence of Paris, for example, occupies for us the same artistic footing as the non-existence of Combray, i.e., as a place in the novel. Further, we never ask, unless we leave off being common reader to become uncommon scholar, whether Swann, Odette, de Charlus or any of the other magnificent characters created in the novel are replicas of any one in the world. Fundamentally, we understand that Proust has created or invented a story about imagined characters, places, events, and things, all of which is self-contained, i.e., has no reference to the world. He has written no bit of history about anything. His novel may *seem* to be about the world, but we will not read it as such because we are guided by the convention of pretending, basic in all story-telling, according to which none of the sentences of the novel can properly be interpreted as statements, and hence true or false, at all.

I grant all this. It seems to me that there is every aesthetic reason for waiving the question of the existence or non-existence of the persons, places, events, and things talked of in novels, and, consequently, the truth or falsity of this talk. But does this settle the issue of truth in literature? I think not, for it does not explain at all the role of other kinds of sentences in novels. Consider again Proust's *Remembrance*. One of its distinctive features, in volume after volume, is its combination of narration and commentary upon it. Certain fictional characters are created, inter-related. Then, in the midst of this, large chunks of reflections upon them occur. These are not bits of dialogue either but sentences which, because of their phrasing and their resemblance to other sentences in non-artistic contexts, immediately invite interpretation as claims, i.e., statements about certain traits of experience.

Space will allow only one example of this Proustian feature. It is from *Swann's Way* and its setting is Swann's first invitation to Odette to visit his home.

And when he allowed her to come she had said to him as she left how sorry she was to have stayed so short a time in a house into which she was so glad to have found her way at last, speaking of him as though he had meant something more to her than the rest of the people she knew, and appearing to unite their two selves with a kind of romantic bond which had made him smile. But at the time of life, tinged already with disenchantment, which

Swann was approaching, when a man can content himself with being in love for the pleasure of loving without expecting too much in return, this linking of hearts, if it is no longer, as in early youth, the goal towards which love, of necessity, tends, still is bound to love by so strong an association of ideas that it may well become the cause of love if it presents itself first. In his younger days a man dreams of possessing the heart of the woman whom he loves; later, the feeling that he possesses the heart of a woman may be enough to make him fall in love with her. And so, at an age when it would appear—since one seeks in love before everything else a subjective pleasure— that the taste for feminine beauty must play the larger part in its procreation, love may come into being, love of the most physical order, without any foundation in desire. At this time of life a man has already been wounded more than once by the darts of love; it no longer evolves by itself, obeying its own incomprehensible and fatal laws, before his passive and astonished heart. We come to its aid; we falsify it by memory and suggestion; recognising one of its symptoms we recall and recreate the rest.

Of course there is a fictional element here; but what needs explaining is the shift from narration to what seem to function as generalizations about the world. Put in paraphrase, one can count up at least five big claims about people in the world. (1) Disenchanted men content themselves with the pleasure of loving rather than with any expectations from the beloved. (2) In youth, the goal of love is the linking of hearts; whereas when we are older this goal may become the cause of love. (3) In youth a man dreams of possessing his beloved; later, he may fall in love with her if he feels he possesses her. (4) In love one seeks primarily one's own pleasure. (5) Love begins in men in their taste for feminine beauty; but since this does not last, the falsification of memory and suggestion help us to love again.

Here are a few more bits, from other parts of the novel. None of these is from dialogue either, but they all are interspersed reflections on the created experiences of the invented characters. In our love for a woman, "What we are really doing is to project on her a state of *ourselves*". "In love we cannot but choose badly". "For in order to suffer at the hands of a woman one must have believed in her completely".

Shall we say now, according to the theory we have sketched, that these sentences are like the others, simply part of the story? That even though they may invite statement interpretation, we oughtn't to accept the invitation, any more than we ought to construe mentions of invented persons, places, things, and events as referential claims?

Now, it seems to me that there is real point and no aesthetic violence in waiving the truth or falsity of the referential parts of novels; but that there is violence—real truncation of the work of art—and no good

point in refusing to construe these seeming general claims as state-
ments. These sentences, coming as they do, as reflections upon created,
imaginary episodes, are too similar to certain sorts of sentences outside
of art that function as natural claims about the world. The whole
context of these reflections or commentaries or observations on the
human scene, the use of the universal "one" or "a", plus our own
cultural tradition of reading some novels with these commentaries in
mind, legitimize our statement interpretation of these sentences.
Indeed, the demand that we waive their being read as statements has a
strange resemblance to certain recent formalist doctrines in painting
that we disregard the non-plastic elements in favor of line, color,
harmony, etc., on the ground that the former elements take us out of
the picture to life and the non-artistic. Here, too, the simple answer
is that some of the representational features ("Does Sainte Victoire
really look like that?") are aesthetically irrelevant; but that some
("Has Cézanne captured something of the serenity, massiveness, or
ordered character of the world in this painting?") are as important as
any of the elements of the painting. We give up nothing of the novel by
not inquiring into the veracity of the persons, places, things, and events
depicted in it in the way that we do give up something essential if we
refuse to take these general claims as statements.

I do not mean to suggest, however, that the presence of these
claims in novels is always meritorious. On the contrary, we all recognize
the difference between a novel like Proust's and, say, one like Samuel
Butler's *The Way of All Flesh*. In the latter there is the same mixture
of narration and essay but the essay parts are simply thrown in every
so often and rarely flow from the narrative. Here one feels real aesthetic
deficiency since the story is not integrated with the commentary: it is
almost as if there were two books. Now, this is never the case with
Proust. Indeed, in his novel the commentaries actually enhance the
narrative in its enrichment of character and plot.

I turn next to the logical status of these claims about experience.
Those which we have garnered from Proust are, I think, of the order
of universal generalizations; therefore, they are true or false. As they
stand, some of them would no doubt be taken by many to be true, some
false. And always the test of acceptance or rejection is our own backlog
or inventory of experiences. Yet we do not consider these to be generali-
zations of the scientifically arrived at sort. Rather they are like those
general observations on the different aspects of the world which are
encompassed by that larger family of claims whose members include
epigrams, *aperçus*, and the like.

These claims are also unlike ordinary scientific generalizations in

that the denial of them seldom involves total rejection of them. As scientists we reject generalizations upon presentation of negative instances. But in our reading of novels, as in our reading of epigrams, we tend to convert many of these generalizations into limited or partial claims about certain phenomena. For example, because there are in the world plenty of people like Swann, at least in some respects, we tend to interpret some of the things that Proust says about the nature of love as being about people like him. It is in this way that we learn from novels certain things about the world, about the behaviour of disenchanted men, for example; and it may become a lesson that we begin eventually to apply to ourselves.

Of course, with some of these claims, we may reject or accept them as they stand. When this happens, then they are functioning on the level of ordinary scientific generalization to us.

In many novels, including Proust's, there is another level of truth claim that may operate upon readers. This occurs when the reader—now turned exegetical critic—collects together the entirety of the interspersed comments of a novelist in a particular work and integrates these with the other parts of the novel and especially with the symbolic dimension of some of the created characters. When we read about Swann and Odette, for example, we soon realize that they are very much like us when we are in love.

Given the presence of symbolism plus the general claims about experience, we soon pick out a larger pattern of claim about the world, and perhaps, in some cases, a whole theory of behaviour in regard to some phenomenon. Never printed as such, the theory is yet suggested or implied by the total combination of invented characters, places, things, events, their symbolic associations, and the reflections of the author.

Proust's *Remembrance* is a perfect example of what I am discussing. In a recent excellent critique of Proust, *The Quest for Proust*, André Maurois elicits a whole empirical philosophy of love from his long novel. Love, Maurois contends, in Proust's *Remembrance*, is basically characterized by its morphology. It begins in unattached desire and anguish which spur us on to make choices. But every attachment springs from the subjective temperament, not from any objective evaluation. "What we are really doing [in loving a woman] is to project in her a state of *ourselves*." The lover and the beloved are consequently involved in a double misconception in that each expects of the other what each has only imagined exists in the other but does not really. And this is why "in love we cannot but choose badly." The discrepancy between the person we have imagined and the person we

have gotten becomes more and more obvious, giving rise to a basic disillusionment even in the state of actual possession. It is here that love is aided by another element in the cycle—doubt. "Love can survive possession, can even grow, so long as it contains an element of doubt." But even with the help of doubt, love cannot give us what we want. We seek happiness, inevitably we get suffering. Thus, our nature drives us to love with all its illusions, for which the only rewards are continuing misery. Proust, Maurois sums up, is therefore an utter pessimist on love; through his dissection of it, he destroys it altogether except in its subjective dimension where "the beloved has no real existence outside the imagination of the lover".

Proust is no exception to the general rule that novels have something to say about human traits. It seems to me that most literary works contain these printed or suggested truth claims which we are called upon to take as serious commentaries on life. Most novelists see the world from a certain point of view and try to express their vision and understanding in the characters, dialogue, and plot that they invent as well as in their interspersed reflections. Of course in plays and poems it is more difficult than in novels for the artist to make these claims since he has not the technique of essay-interpretation at hand. But he can still make them through his plots or images, or even statements, provided the suggestion that "this is the way life is" is present in his created materials. Consider these lines, e.g., from Eliot's *Four Quartets*:

> Men's curiosity searches past and future
> And clings to that dimension. But to apprehend
> The point of intersection of the timeless
> With time, is an occupation for the saint—
> No occupation either, but something given
> And taken, in a lifetime's death in love,
> Ardour and selflessness and self-surrender.
> For most of us, there is only the unattended
> Moment, the moment in and out of time,
> The distraction fit, lost in a shaft of sunlight.

Here Eliot epitomizes part of his philosophy of life and the world. His previous piling up of images and symbols in the poem allows of at least one interpretation which reaches its climax in these lines. There are, he seems to say, two kinds of lives, two different conceptions of the world. One is the religious, the other the secular. The religious, with all that it connotes in regard to beliefs about man, his destiny, his God, and his world, Eliot says, is true; and the secular is false. That there is a God (the "timeless") who endows the world and all that is in it ("time") with a purpose or significance is a fundamental truth claim

in the *Quartets*, a claim which, quite independently of its actual truth or falsity, works its way through many of the other elements of the poem.

Besides literary works that proceed from printed to suggested or "depth" claims about the world, there are certain novels which have no significant printed claims and yet do contain important statements about the world. I am thinking especially of *Anna Karenina* and *The Brothers Karamazov*, the latter in spite of Ivan's famous "Grand Inquisitor" speech, which is after all only a claim in character, so to speak, and not to be taken as true or false as much as a part of Ivan's created character. In neither of these novels is there any significant commentary interwoven with the narrative by the author. And yet, by means of the total delineation of character, dialogue, and plot, they seem to suggest one truth claim which, incidentally, I at least find the most engaging of all, and true in a way that Proust or Eliot is not. What is being proclaimed, and it is one aspect of them as novels, through the enormous expanse of character, situation, and lack of commentary really, is the truth that human life is too complex, too inexhaustibly variegated, ever to be reduced to a single formula. I note with satisfaction that in some quarters philosophers themselves are beginning to learn this truth in regard to knowledge, perception, morality, etc. Much of the world's great literary art, it seems to me, embodies this claim of the irreducibility of experience to a single pattern. Even love is too many-sided to be squeezed into the Proustian formula. I have a feeling, although I am not at all sure about this, that it is this suggested claim about the irreducible complexity of the world which is at the bottom of the attribution of profundity to some works of art, that contain no printed truth claims, which we sometimes make.

If, then, as I have tried to show, there are truth claims in some art, what, finally, is the reader's attitude to be toward these?

Let us return to Eliot. Many contemporary readers reject completely his cosmology and his assessment of the human scene. They may not find much in the secular but they find what they take to be all there is. How much does this rejection matter if they are reading properly? After all, there are all the false bits about Fate in Sophocles and all the incredible (at least to these secular readers) claims of Dante's *Comedy*. The well-wrought reader, if he happens to be a secularist, rejects these false claims but he does not allow his rejection to enter into his response to the work of art. This is the way, e.g., Eliot sees the world, he reasons; I disagree with him, but because I am reading him not as science, philosophy, or theology, but rather as art, my disagreement isn't relevant here. My focus is on what Eliot does with his convictions in relation to

the rest of his poetic materials. I am interested in his images, metaphors, versification, language, and if his claims about the world relate to these, I conceive the claims primarily as part of the poem. Ultimately, this reasoning is secured by a fundamental principle of the well-wrought reader, that his theory of appropriate response to art shall not entail anything which will needlessly cut him off from a part of the body of the world's art. Of course one can always persist in maintaining that one's rejection of a claim in a work of art is an essential part of one's response and determines one's total evaluation of it. But such a person must be made to see how much this will cost him in his inability to comprehend a good deal of the world's literature since his area of positive response and evaluation will be confined only to those works which have no claim or claims which he happens to accept.

Consider Proust again. Love is an illusion and cannot bring us happiness: such is one of his basic truth claims in his novel. True or false? Obviously, Proust thought it true. Perhaps it is, but anyhow it is a point of view, a doctrine that helps to unify an artist's vision of experience. From the reader's point of view, this should suffice, even if he disagrees with Proust on the best of empirical grounds and proclaims the exceptions to his pessimism. For the reader, Proust says something which, as Maurois declares, is "new and tragic", and this is enough. What Proust says is true or false and cannot easily be denied to be so. But the actual falsity of what he says, it seems to me, does not enter into our reading if we are doing it well. For the sake of what awaits us we let him have his way; we don't accept his world, we only see it as he does.

But, now, what about those claims which we accept as true? Here I am really puzzled. One would like to say—for the sake of a uniform theory—that acceptance of claims ought to play the same role as rejection, that both should be aesthetically irrelevant. But, once more, such a view does not seem to account for certain features of our response to art which detract from or ruin nothing in art. There are many readers who never confuse non-referential inventions in literature for true or false references to the world, nor who repudiate the presence of the claims in the literature that contains them, nor who even allow false claims to influence their responses, and yet whose appreciation is greater than it would otherwise be when they feel that a specific work does contain an important or novel truth. Maurois is a case in point, and there are plenty of readers of Proust who agree with Maurois that the greatness of *Remembrance* is based in part upon some of the truths that it contains. I cannot see that there is anything in this that is aesthetically at fault; the novel has not been converted into science or

history. It remains a work of art which is to be responded to, as it is sometimes said, "in and through itself", i.e., as a totality of elements in relation to each other. Those of us who do not accept the claims of Proust can recognize the quality of this assessment. For these readers, Proust is simply their kind of art; and for us, that ends the matter. Of course, in return, we demand a similar tolerance for our choices. And, at least in my own case, I cannot but think that there is that added moment of greatness in *The Brothers Karamazov* or *Anna Karenina* precisely because Dostoyevsky and Tolstoy, in those novels, see something which is true about our world that neither Eliot nor Proust nor many others ever do.

14. MUST ART TELL THE TRUTH?

DOUGLAS N. MORGAN

"The fright of the mind before the unknown," said Wilhelm Worringer, "created not only the first gods, but also the first art." He might have added that this same fright later created the first science as well.

Were it not far too pretentious, my title might be "the fright of the mind before the known," for I believe that in worshipping science, we have come to fear it. Out of our fear, we are consigning other precious realms of human expression, like religion and the fine arts, to science's shadow, by imposing an irrelevant demand that they produce cognitive credentials.

Our first formulation of the cognitive problem in art is far too easy to be interesting: we might mean by our question simply, Can any truths be inferred from any works of art? The answer, in a word, is yes. Of course we can learn from a seventeenth-century Dutch still life that men then loved to eat and drink, and from portraits of the day we can learn what clothes they wore. We can learn from the music Mozart wrote what instruments he had at hand. We learn from Japanese *haiku* something of the purity of the contemplative life. And so on and delightfully on. Learning is delicious, precious, human. By almost any means, let us develop new information, and enrich our understanding of our history, our fellow men, ourselves. Let no barriers save those of time and taste inhibit our hungry pursuit of knowledge. Nearly every monument in every art can be useful or even necessary to this pursuit.

Yet in proclaiming that truths can be inferred from works of art we we have really proclaimed very little, and nothing at all uniquely characteristic of art. For truths can be inferred from literally anything in the world. The truth we have always with us; our concern is rather

ORIGINALLY PUBLISHED IN THE *Journal of Aesthetics & Art Criticism*, VOL. 26 (FALL 1967), PP. 17–27, AND REPRINTED BY KIND PERMISSION OF THE AUTHOR AND THE EDITOR.

with sorting, relating, and evaluating truths. The worst of art, as well as the best, can serve as evidence for truth. Therefore this aspect of art's cognitive significance, because it is very general, is also totally boring and unrevealing.

Let us try a second formulation. Suppose we read our topic to ask, Are any truths ever expressed or affirmed by artists in or through works of art? Again the answer is easy: Of course they are, most obviously in literature. Words are used to refer to concepts, which serve as vehicles for ideas. Words are combined to make sentences which, in turn (some-how; I deliberately evade the semantic problem), exhibit statements or propositions, true or false. In these ways, words in poems and stories can be and sometimes are unmysteriously used to say things, to utter truths.

The theoretical interest arises when we inquire just what it is that this humble discovery is supposed to reveal. That some artists do sometimes assert truths in some works of art does not really tell us very much; and if we interpret this claim broadly enough to make it interesting, it becomes dangerously misleading. For it can tempt us to equate the value of the work of art with the value of the truths expressed in or through it, and this surely is a blunder: turgid poems have been written on the profoundest of subject matters, and masterpieces have been composed on trivia. Or we can be tempted by the discovery that some artists sometimes express truths in art to suppose that the more literal truth there is in a work the better art it is; this bit of foolishness hardly needs scouting. Finally, no one can well deny that in any clear sense in which some poems can be claimed to exhibit truths, other poems, no whit less poetic, can be claimed to exhibit falsehoods. I conclude that our second formulation has left us with a conclusion too trivial to be rewarding.

Far more intriguing is the claim that there are some truths uniquely affirmable in art: that paintings, poems, and pieces of music can express truths inexpressible through any other medium. This position is serious and deserves far more extensive study than I can here bestow upon it. Eminent critics have argued it, and even urged that the communication of these truths is the peculiar essence of art.

Nonetheless, it seems plain to me that whenever and wherever any truth can be asserted, its contradictory falsehood can also be asserted. Unless I understand how to contradict a statement or a proposition, I cannot clearly understand what it means to assert it at all, and until I can understand what it means to assert a proposition, I cannot even begin to determine whether the proposition is true or false. It seems further clear that of two contradictory propositions, one (though we

may not know which) is to be rejected. And finally it seems clear that the words used to express concepts and the true-or-false propositions they form are translatable in various natural languages. All of this holds, I submit, at least of the straightforward, everyday senses in which we normally use the word *truth*.

But notice that none of it holds of art. The truths supposed to be uniquely affirmable in a word of art are not relevantly contradicted by the truths affirmed in some other work of art. And we feel no compulsion to reject one of a pair of contradictory works of art, whatever in the world *contradictory* might mean here. Nor can any work of art be in any strict sense, translated. Synonymy has no evident use, when we are speaking of distinct works of art.

Yet these considerations do not daunt the truth-addicted critic. He disdainfully replies that we have here been using a narrow, pedantic sense of truth. The truth he intends is some nobler thing, an occult poetic or pictorial or aesthetic sort of truth: a truth that is non-propositional, non-deniable, non-translatable. But if we are to allow the word *truth* to be thus redefined in order to blur its blessing from science over into art, we shall find our eventual victory paltry and pyrrhic. There are, I shall propose, persuasive reasons for resisting this temptation.

Our fourth and final preliminary formulation of the cognitive significance of the arts is perhaps the most widespread and most dangerous of all. It begs the entire question heroically and asks: What kinds of knowledge are found in and through works of art? The question is begged simply by assuming without argument that there are any typical, interesting, and relevant kinds of knowledge at all to be found in art. Even more seriously and misleadingly, it assumes without argument that unless some kinds of knowledge are to be found in art, art simply is not worth our time. It is precisely here that I shall focus my attack.

This attitude is one of desperation. It grows out of the discovery that some great works of art appear, when considered as knowledge-bearers, to be false, or to exhibit falsehoods, to present unrealities. How dare we, our truth-righteous critics protest, take art seriously if it diverts us from the strait path of technologically useful or theoretically interesting truth? Art (they propose) must give us knowledge of some queer sort, lest it be dismissed as sugar candy, to be served only for dessert after a well-balanced meal of staple, scientific formulas, and only on promise that we shall promptly wield a truth-brush to prevent aesthetic decay. Truth (being scientific, which means Goodly if not downright Godly—ours being probably the first age in which God, if

we believed in Him, would be pictured in a white laboratory coat)—
is here conceived as cognitive, antiseptic, even sterile. Art, by contrast,
is felt to be emotional and therefore somehow suspiciously germy,
irrational and dangerously disbalanced by comparison with the sane
safety of truth. Can art, some men want to know, be domesticated into
respectability and awarded a *cordon vrai*? The lady is so irresistibly
attractive to us, yet for some odd reason we are reluctant to take her
home and introduce her to mother; perhaps if we scrub her up a bit
and cloak her with some invisible, unspeakable, counterfeit truth-
virtue, we will be able to clear our embarrassed consciences. We are
uneasy about taking even a single step down the garden path of art,
however beautiful the flowers there—unless, of course, we go down the
path as a botanist does, to classify, to categorize, and to kill the living
beauty. This is the addiction.

The addiction is no less corrosive for being pervasive. We are drunk
with truth. Self-consciously prideful of our few poor discoveries about
nature and our still fewer, poorer discoveries about ourselves and each
other, we are unconsciously warping our talents, blinding our senses,
and too narrowly channeling our hearts.

The root-cause of this truth addiction in our understanding of art
is a healthy refusal to rest content with the notion that art is a trivial
plaything, to be set resolutely aside as soon as Life's going gets rough,
together with the unhealthy superstition that the only alternative to
sugar-icing frivolity is speciously scientific truth. The theorist's problem
is to ground the being of art neither in mere informational truth, nor
simply in decoration. I find that ground in human sense, in human
feeling, and in human imagination.

I begin where art begins: in organic, human sensation, in seeing and
hearing. These, our best-developed and most characteristically human
sense organs, we use along with touch and taste as our primitive
avenues for contact with the world about us. Through them, the world
around us becomes a world within us. As I see you and hear you and
perhaps touch your hand, I know you in a basic human sense of "know."
Every healthy baby revels as an animal in the sensory exploration of
the mysteries that surround him; as he hears, sees, touches, tastes, he
grows and adapts creatively, and gradually learns to become human.

It is by no mere chance that our fine arts are made for and given to
our eyes and ears. These, of all our senses, are those that give us objects
beyond our skins and can structure experience subtly anew. In audition
and vision, we discriminate delicately, and our discriminations fall into
natural orders of color and tone, shape, texture, volume, and harmony.
The very quality of almost any simple sensation can be enjoyed by

eye or ear, on a naive and unaffected level of human response. Simple qualities seen or heard can cohere into complexes of delightful sensation, even before we make any conceptual or informational demands upon our worlds.

Soon enough, of course, these demands do bear in upon us. We need to till our fields and move our goods across the oceans because we want to eat well and master each other. Seeing and hearing work here, too, in our pragmatic intercourse, our pushing and pulling about of stuff and things. But the way they work is different; strangely, we do not typically need fully to see and hear what we need merely to push and pull. We need instead only the quickest, slightest cue or clue. A glance or fleeting sound is enough; we hurry along into the hurly-burly world of manipulation. Any fleeting sideways look will do, so long as we notice the car approaching from our left; we correct our course without a thought, and career slap-happily along the highway, seeing with only half of our eyes and minds, or less. Any toot of any horn will do to alert us to danger; we need not—must not—pause to savor its sound. Of all the greens and reds in the color spectrum, any green signal will do to tell us to go, any red to warn us to stop.

Here, in this semantic use of our sensations, is our first critical turning away from felt quality, the first substitution of doing something and going somewhere, for being somebody and feeling somehow. It is also our first desertion of direct, organic humanity. For once a man moves wholly through sensation to mere reference, he has begun to fit himself for a computer-suit, tailormade for programmed participation in establishment society.

The second step is effectively derived from the first. It involves learning, usually unconsciously, how not to feel, how to substitute token symbol—or sign—responses for spontaneously felt responses. Here, as with the uses of sensations, there are crucial advantages in learning society's lessons, as well as desperate disadvantages. Part of the price we pay for the agony and privilege of efficiency is stereotyping the expression of our idiosyncratic feelings, just as, to score as efficient citizens, we must long since have forfeited the delights of tasting sensations for their unique flavors.

The third and final step involves not the barren evaporation, but the radical narrowing of that most precious of human faculties we know as living imagination. Men willingly and unwittingly cash in the breadth of their imaginative visions in exchange for efficacious manipulation of their environments.

I underscore the importance of the word *breadth*. A wholly semantic imagination, moving entirely from one conceptually specifiable

meaning to another, can be powerful. Such an imagination is valuable in business success, as our curious proto-civilization measures these weird things. To picture businessmen as unimaginative, routinely ploughing the same dull but profitable furrow year after year, is to mistake their creative personalities and to misconstrue the dynamism of our papermythical economy. Businessmen cannot accumulate power and privilege (and it is power and privilege, not material goods, that they seek) except by imaginative manipulation of people and pieces of paper, and high-order intelligence is often exercised in this manipulation. But the height of the intelligence-order and the depth of the imagination delimit narrow gorges.

Even our scientific-theoretical life is narrowed in its exercise of human imagination. Data do not display themselves; they must be ferreted out. Nor do data automatically array themselves in imaginatively revealing patterns, nor can they by any innate fertility principle fecundate new theoretical directions to excite our wonder and invigorate further discovery. All this is the creative work of the scientific-insightful mind. But rich and revealing though this imagination may be, it remains chained to concepts and wholly directed through concepts toward truth, toward the ideal exploration of What Is. Bronowski speaks of the "paradox of imagination in science" that leads to its own impoverishment because in its highest flights it progressively excludes the proliferation of new ideas, by producing theoretical universes rich enough in concepts to need few or no hypotheses.

When I speak of "What Is," I mean of course to designate not any state of being, but an ideal: What Is is far more than a banal report of what may at any one moment in time and from any one point of view appear to be the case. What Is is what (to adopt a traditional device at once epistemological and ontological) God would know if there were a God; or what God does know and believe if there is one. To construe believing and knowing as trying to read God's mind is one limited way of conceiving the imaginative duty and privilege of the research scientist.

We are not being irreligious, rebellious, or heterodox to any theology or science I know if we respectfully insist that God's is not the only mind in the world; that we as finite human minds have other things to be and do, to sense and feel and imagine, besides trying to second-guess some divinity or other. We do not disserve God and truth if we see and hear as sensitive beings, without forever demanding that every sight and every sound must truth-cue some practical action; if we dare to feel honestly, without self-consciously justifying every emotive response by reference to some scientifically confirmable truth; if we

sometimes dream with discipline and live lives in which scientific-truth orientations play a part, even an important part, but in which there remain other avenues invitingly open for other adventures of the human spirit.

The fine arts are adventures that deserve to be taken seriously. To subordinate them to the sciences, by reducing each work of art to the status of a truth-vehicle, is to take each art less than seriously. This maneuver evidences the addiction in question: It would never occur to anyone to ask whether art essentially conveys truth, unless he had already taken it for granted that life's important business lay only in listing and relating truths. I believe that life can contain more important business than this. Not all of science's discoveries appear to me to be equally, pre-eminently, and supremely valuable in human terms. We are learning in our present mad thrust toward research for research's sake, at least as many insipid truths as we are learning vivid and important ones. Truth is not a stigma, indisputably indicating holy origin. Headpieces can be filled with straw-truths as well as with wise ones. I ask a moment's critical hesitation before we become inundated by a flood of trivial truths: Which of these, we should wonder, are really worth pursuing with all our minds and time and dollars? And do we still have patience to attend the man who dares stop short of truth and falsehood or go beyond it, and make with sound or color or words a thing that neither asks nor welcomes any ambitious techniques of "verification" but is modestly content with enriching some lonely human soul?

To the question of the "cognitive significance of art" I say directly that although many words in many arts can and do give us knowledge of many kinds, nonetheless if this knowledge were the key and limit to the love of art, the world of art would be even sorrier than it now is, and that so long as we continue to accept the absurd alternative which offers us only a specious choice between art as a diversion or decoration, on the one hand, or as a peculiar second-rate substitute for true-blue empirical knowledge, on the other, we shall block every hope of understanding ourselves and our culture.

Remember, if you can, that breathless final moment when you have moved intensively with heart and mind through a quartet of Brahms or Bartok. You have hoped, expected, feared, been lifted, lowered, fulfilled, and disappointed, and now, inevitably, the voices together sing one rich, climactic chord. You as a person vibrate, suspended, with the vibrating sound.

Now imagine your neighbor leaning toward you anxiously and expectantly to ask, "Quickly, tell me what you learned from that music.

What information did it communicate to you? What knowledge do you now have that you didn't have before?" Such a neighbor deserves only an icy glare of disdain. He is projecting learning, knowledge, and truth into an arena of human experience where it has no natural or necessary place. Learning, knowledge, and truth are no less valuable because their value is not exclusive. There really are other goods in the world than these, and there really is no need to confect such bogus kinds of truth as poetic or pictorial or even musical truth for works of art to wear as certificates of legitimacy.

Consider, as an experimental exercise of imagination, a world in which men and women were as beauty-addicted as men and women are truth-addicted in our own. Suppose, if you can for a moment, that we were extravagantly to exaggerate the value of beauty, and to assign to it a status as exclusive and demanding as that occupied by truth in our contemporary world. Then, when someone proposed a new scientific hypothesis to us, we should look not primarily to its evidence, nor to its conceptual place in some larger theory, nor to its implications in verificatory procedures; instead, we should first ask whether the hypothesis enriches our vision, excites and enlivens the perceptions of our souls; whether it presents a vivid world in which we can imaginatively participate; whether, in old-fashioned language, the hypothesis is a thing of beauty. Let us further suppose that the scientist who proposed the hypothesis had not had these criteria in mind at all; he was merely trying to say something true. He thought that his confidence in his hypothesis was healthy and well-grounded, and felt that it was sound as science, even though it could claim no aesthetic warrant. Should we then expect him to reply on behalf of his hypothesis that even though it may not appear to be beautiful in the everyday direct sense in which paintings and pieces of music are beautiful, nonetheless his hypothesis was chemically beautiful, or microbiologically beautiful, or geomorphologically beautiful?

There is, of course, an important sense of beauty in science but it is irrelevant here. Should we not all laugh or cry at the attempt to excuse the introduction of a scientific hypothesis by any such spavined, quasi-aesthetic means? Ought we not rather to reply comfortingly that science needs no apology, and to say that a belief that can claim evidential justification, that can warrant predictions and grow as knowledge, needs no aesthetic alibi?

Why then, are we reluctant to affirm the counterclaim? Why should we feel impelled to grope for obscure cognitive excuses to justify our loves of art? Is it not, after all, enough that a painter can build a world in which we can see intensely, feel vividly, dream constructively, live

with imaginative humanity? Why must we also impose upon him the scholar's burden of finding and reporting and interpreting mere facts? Would Franz Schubert really have done more for the world if he had given us a few scraps of truth instead of the B flat trio? Who among us would exchange the Sistine Ceiling for one more monograph, however learned, on Pauline theology? Then why should the B flat trio and the Sistine Chapel need to be reduced to any ersatz cognitive status, as if art were but a stepchild to science?

Music draws its life as art from our profound organic rhythms of breathing and loving, from our muscular contraction and expansion in speaking and singing, walking and dancing, from the heart-deep pulse of life itself. Sounds move as we move, and we move as we live: in joy and sadness, in worship and lust and repentance. Music *is* moving sounds, not only in that musical sounds themselves move but also as they move us. These sounds we may make with no other instrument than our bodies, when we sing or clap; or we may bring sounds forth through a thin reed pipe, a monstrous organ, or even a set of electronic tapes, amplifiers, and speakers: in all, we are singing as human beings.

Sometimes, to be sure, we sing words, as in our hymns and operas. Whenever we use words we may be uttering truths: a sentence never becomes false simply because it is sung rather than spoken, and truth has at least this distant claim upon music: that some men sometimes sing truths. Yet surely we must resist the temptation to bring the informational truth of what is sung into the singing itself, at pain of invoking irrelevant criteria, and playing on an irrelevant ambiguity. A voice may well sing true, even as it is singing falsehoods, and a false note is corrected, not contradicted, by a true one.

This temptation is not always easy to resist. So many interesting and important truths about music can be discovered—like the truth that music is natural to man, one of his very few basic and universal expressions; and the truth that music can move man profoundly—that it appears only too easy to identify music with the truth it may occasionally embody. Yet when we yield to this temptation, we default our privilege and our responsibility. We confound the expressive sound with the cognitive message we suppose the music somehow to convey.

There are rare and special occasions on which musical sounds are systematically used for the purpose of communicating information and motivating extra-aesthetic action. The soldier who hears the bugle gains knowledge and responds to it as information and motivation. But note that he has had, in a conventional language-learning situation, to learn a code: these tones in this sequence have been artificially imbued with a meaning. But reveille's tones no more naturally contain getting-

up-ness than do mess call's tones contain beans, and either call could without strain have been plugged into the other's meaning.

It must be confessed that there are important limits, still imperfectly understood, to the freedom of such interchange, and that the connections between music and meanings are not wholly arbitrary. Taps, for example, would be as unlikely to arouse men in the morning as would reveille to make them sleepy in the evening, again because of our biological natures.

What, after all, could we literally mean by characterizing a sonata as true? If we say that it is true music, we presumably mean merely that it is true that it is music: a true sonata truly is a sonata. Or, perhaps, we mean to call it a good sonata, or good music. If we mean this, why not say so directly? And how could we seriously impute truth to some music, unless we were ready to impute falsity to some other—presumably contradictory—music? Yet surely no piece of music can, expect in some wildly metaphorical manner, be said to contradict any other piece of music. Moreover, we already have rich vocabularies for saying what we want to say about music, and we are free to extend these vocabularies whenever we feel the need; but to extend them into the range of informational truth is implicitly to subsume them under extraneous validational criteria for understanding and evaluation.

I conclude that although knowledge and truth *about* music are to be had in plenty, and may be a useful and even necessary requirement *for* music, there is no persuasive reason for supposing that music cannot be sung and loved directly, without pretending that we must scratch up some queer kind of knowledge and truth *in* music, in order to justify our love. Why should love—whether for music, or for a human being—need any justification, anyway?

The theoretical situation in the visual arts is more complex, because there is here an evident kind of reference that cannot be found at all, or can be found only obscurely, in music. Many of the pictures men make do look more or less like things men see outside pictures and in the visual arts this iconicity goes much farther than the introduction of thunderclaps, cannon booms, birdsongs, and taxihorns into symphonies. Partly because most of us use our eyes almost entirely semantically, forever turning our visual cues to practical account, almost any visual presentation is likely to be "seen as" standing for some thing or other. It is extremely difficult to set down completely non-referential, nonsuggestive lines on a piece of paper; images, however unwelcome, are forever intruding. Most of us are so semantic-habituated that we impose object-shapes upon grease spots and ink blots and vagrant clouds as well as upon Leonardo's famous plaster cracks.

So, when we look at almost any picture, we want too soon to look through it, to move beyond the given vision to some realm of action. What is the painter trying to tell me? we want to ask. What can I learn from this looking? What am I to do with what I see? The most important move in any course in art appreciation is to arrest this tendency, to bring seeing up short with a resolute Behold! Behold! will almost never do, if all we are to behold is a peeled-off surface of autonomous colors and shapes, despite the Bell-like echo of many modern critics. There just plain are pictorial objects in most pictures—apples and mountains, cows and castles and naked women—and to dissolve these objects into sensations is as absurd in art as it is absurd in science to dissolve steady, solid tables into congeries of floating sense-data. But pictorial objects, unlike merely space-time ones, are wholly to be attended to. In art, if not in physics, to be really is to be perceived. Painted women are to be seen and not loved—as women, that is.

A second reason for the greater complexity of the problem of knowledge in the visual arts is the simple fact that drawings are often useful and sometimes indispensable in communicating information. A verbal description of a cabinet, a machine, or a house would be intolerably prolix; a blueprint or simple sketch can describe its structure and prescribe its making. An illustration in a medical text can clarify and instruct; in a magazine it can persuade; and so on. The powers of pictures are all but endless, and many of these powers are indisputably cognitive in their uses, in almost every straightforward sense of that term. But these cognitive functions of pictures can never be identified with their roles as works of art.

Of course, paintings are sources of knowledge; who could ever have doubted it, and what richer source could we have, for some sorts of knowledge? Of course, knowledge of many kinds is essential to the making and enjoying of paintings, as it is to the making and enjoying of works in every art. Of course, paintings are scientific-cognitive in all these senses.

Nonetheless, we must once again hold back, lest in acceding to the cognitivist's claims we allow him surreptitiously to smuggle in a vicious *only*, as in "Paintings are only cognitive"; or a betraying *essentially*, as in "Paintings are essentially cognitive." The fact that paintings are sources of knowledge does not make of paintings mere storehouses of knowledge any more than the fact that we can learn by looking at paintings makes our looking merely a form of learning. A man can learn about a woman as he kisses her, too, but any man who kissed a woman in order to learn about her, or who described his kiss as a learning experience, would be a boob.

Literature in general and poetry in particular are by far the most complex arts for any theorist to characterize, and the network of problems arising around the issue of poetic truth is far too dense to unravel here.

A fundamental reason why cognition seems to press upon us even more urgently in poetry than in music and the visual arts is precisely that poetry is essentially linguistic, and that scientific information is essentially expressible in language. Statements, expressed in sentences of a language are true or false; and poetry is typically written in sentences of a language. So deeply conditioned are we by informational ways of using language that it seems almost odd to attend to the sound or rhythm of a sentence or to savor its reverberating images, even for a moment of suspended contemplation, without steamrolling through it to contrive some way of testing whether it be matter-of-factly true or false.

Even more difficult is the fact that the words *true* and *false* can themselves occur in poetry, as they cannot do in music or in painting. A string quartet cannot by itself claim to be true, nor can a still life, but a poem can appear to make any affirmation in the world, including the (often duplicitous) affirmation of its own truth.

Now, every poem is a world formed in words, a world with its own mode of being, a little world (as John Donne put it) "made cunningly." But the making of every poetic world is all too human, and no such world can claim total transcendence; if it could, no man could read the poem, just as, if there were any music of the spheres, no human ear could hear it. Poetry, like every art, begins and breathes in this our world, and speaks from and to and often of this world.

Yet the conditions of poetic speech must never be inferred unchanged from table talk. They can never be easily generalized from any old poem and imputed to any new one, let alone from the dull speech of most of us mortals. The poet, in contriving the being of his poetic world, contrives at the same time the conditions for that being. He invariably begins with a language men speak and sing, but this language is transformed in the transformation of the world in which men merely live into one in which they can imaginatively be. And *everything* in his created world is transformed: every object, every person, every passion, every thought. Even logic. Even sense and rationality. Even truth itself.

The wonder-world of Alice is of course derived from and related to our world; were it not so, we could never enter it. Alice's world leads us back to our world, too, and we see our world anew, with intensified awareness of its absurdities. But her world, happily, is not our own; I say *happily* not because we live more wisely than she, or more comfortably, or more efficiently. *Happily* rather because the very movement

between her wonderland and our no man's land can release our dreams, fulfill us, and help us to become much more than we merely are.

Into that wonderful wonderland of Lewis Carroll we—not some rarefied, imaginary, aesthetic-attitude counterparts of men, but we ourselves with our own piecemeal personalities, our private agonies and hopes, we really, queerly real people—enter. We live there. What was true outside Wonderland still conditions our seeing, of course; Wonderland would not seem wondrous, but simply silly, if it did not. But our attention is wholly engaged by the internal truths of the new world; they are as necessary in their way as are progressions of chords in music. We move to the world of art as a lover does to his beloved, openly and gladly. In the current arthritic jargon of lay philosophy, we engage, commit, and relate. More simply, we live a while, live along with Alice, grow and shrink with her, take tea with the Mad Hatter, play croquet with the Queen of Hearts, dance and sing with the Mock Turtle. In all this living, the central conditions of the truth of what we do are internal to the poem.

Fundamentally, the world of almost every work of art is internally defined, determined, complete, as life outside it can never be. Within the drama and during it, all sorts of issues may be debated and free decisions made; but the consequences of every decision, once the play is written, are forever inevitable. Irresolute though he has been for so long, Macbeth must murder Duncan, else he be not Macbeth, and Birnam Wood to Dunsinane must come. Shakespeare created this world that way. We who would live in the world must accept its conditions wholeheartedly and wholemindedly, else we be not participants in it. Naturally, we do not cease thinking, reasoning, debating, even verifying and confirming, though only internally; we do not simply emote or feel. Within the play intense and complex cognitions may be demanded of us, but the play is still the thing, and we who participate in it are players.

We must expect that our participations will be castigated by the vulgar as frivolous or escapist until we can isolate, identify, and correlate such husks of chaffish external knowledge as we may have gleaned from our experience. I reply that these very participations themselves are a human standard against which we may measure, if we must, the picayune assemblage of trivial information. I give the lie to the banaustic mechanics of our pseudo-culture; it is rather for them to show us why a man of taste and judgment should distract and concern himself by fussing with grubby data that purport merely to be externally true.

I overstate here, of course, and by design. For there are sound reasons why we should concern ourselves with external data; but I do

not overstate in insisting that these data do not define every world worth living in, and that there are other gods in the pantheon beside that of truth.

By now, it may appear as if I were trying to make a case for the untrammelled exercise of the imagination, proposing in place of the rigor of scientific dreams the jungle of unrestricted nightmares. But "Imagination Unlimited!" is a slogan and a rallying-cry, not an insight. It is also a psychological and social impossibility. We are all habituated organisms, and limits have been conditioned into every one of us since before our birth. Every dream we have ever dreamt has been dreamt within a context of personal hungers and terrors. Whatever reservations we may entertain concerning the scientific status of his psychology, Freud was surely correct in his unremitting insistence that *every* aspect of human behavior, however wild, wanton, and irrational it may at first appear, must in principle submit to some scheme of meanings, if we can but discern it. I believe he was also correct in his demand that we deepen and broaden our interpretations of our selves, because no simple, straight-line chain of generalizable implications or causal entailments will ever suffice to explain the inward-turnings, overlappings, and tortured twistings that make up our minds. We are paradoxical beasts. But we are natural beasts, too, and natural beasts are animals bred, born, and destined to die within the limits of nature. Freud showed us something of how intricate those limits are, and of how deviously static rationality can be transformed into the dynamic mysteries of multiple consciousness.

In one ancient area of human concern, the uncritical adulation of truth has almost totally succeeded in its innocent corruption of the human spirit. A three-centuries-long attrition has ended in almost abject surrender. I refer to the religious tradition, now in intellectual straits approaching desperation. I need not detail the painful death-agonies of our ancestral churches. The roar of the lion of Judah has become a tame, faint whisper, all but inaudible in our clamorous secularization. Why has this happened to us?

Because, I suggest, we have confused faith and duty and beauty with belief and action and truth. Because, finding no serious scientific excuse for our traditional devotions, we have supposed that these devotions must be worthless, instead of recognizing that there are other human richnesses and rewards besides truth and beyond it. Our sophisticated neo-theologians, candid enough to confess the wobbliness of their historical space-time claims, are giving them up and now compete in pronouncing existential epitaphs over the corpse of God. And yet, somehow, the corpse keeps on kicking. The Holy Ghost of the God they

say is dead continues to float among men, and to quicken their souls. Like the ghost of Banquo, he keeps on showing up for supper.

But I wonder why religion, any more than poetry or painting, should have to be demythologized? Why should religion require any mock-scientific, shamefaced alibi? Why, to put the point incisively if painfully, should we demand a birth certificate of Jesus of Nazareth any more than of Oedipus or Buddha or Hamlet? Why can we not live and grow in these beings imaginatively, without feeling any nagging guilt because we cannot recite their social security numbers? Are they not, in human terms, much more important than they would be if they were merely literal and historical?

Naturally, I do not intend simple-mindedly to identify Jesus with any deliberately created fictional character, or to pretend that entering into a truly religious relation is like attending a Broadway play. It is not, and to transmute Holy Communion into an entertaining ritual is to commit a vulgar aestheticism. I mean rather that the relation between Jesus and those who believe in Him is internal, like that between Hamlet and Ophelia, rather than external, like that between Shakespeare and a literary historian. What counts religiously—and artistically—is intimate, personal, and non-verificational; what counts in terms of historic truth is external, evidential, and impersonal. Religion, far from being demoted to the status of mere art, should be promoted above the status of mere science. By recognizing and releasing its mythic-imaginative-expressive powers we can rescue religion from its present truth-competitive plight. Our Hebrew-Christian religious tradition, for example, is much more humanly important than it would be if it were merely true. And this, I think, is why, even if God is dead, He will not lie down.

Of course, I do not pretend here to enunciate any great new truth about either religion or art. My aim is more modest: I seek rather to alter our attitudes toward both, because an attitude which sees in them only a sickly substitute for science is itself sick. My philosophy, insofar as it deserves the name at all, is simply a proposal to consider alternative and healthier attitudes.

Philosophy is itself to be conceived as an invitational, dialectical activity rather than as any system of dicta. A philosopher can be thought of as a man who, far from commanding assent with any thunderous barrage of argumentative artillery, invites you to think the world or some aspect of it in a somewhat different way. "Come in," he says cordially, "and welcome. Sit down. Let me mix you an idea. Sip this thought, and tell me how your own experience looks. If you should find my way of construing our world unappetizing or un-

promising, pray show me your way. Let us once again in the good old Greek way, *dia-lego*, talk it through together."

So here, at the very end of our inquiry, we come at last to our second meaning for knowledge, and one which, unlike the scientific-informational sense, bears central, direct, and healthy relevance to the making and loving of works of art. This is, as many of you will have surmised, the now archaic sense in which knowledge is identical with intimacy and possession.

"But I know no man," Mary is said to have replied when the tiny bird glided in on a ray of sunshine toward her right ear, bearing the momentous news that she was pregnant with the Son of God. "And Adam knew Eve," the Mosaic author of Genesis tells us in the story of the Fall. The quaint phrase *carnal knowledge* is found in our criminal law. As Paul Tillich reminded us, *Know* bears this meaning-legacy of intimate, especially sexual, belonging.

In our religious heritage, as in our art, all sorts of external "truths-about" may be affirmed and denied. If we were to consider "And Adam knew Eve" externally, and read it as merely one more gossipy historic report, describing what happened once upon a place and time, we should have to take it as either informational-true or informational-false, to be verified or disverified, confirmed or disconfirmed, by the admittedly scanty evidence. Such a reading seems to me to be a trivialization; the moral meaning of man's fall from grace can never be encompassed in any recitation of historic fact. I warrant that Adam did not consider the act and fact thus remotely, any more than David, when he smote Goliath, considered himself to be making one more entry in some future history textbook.

So, too, with the seeing and hearing of art. We who participate in art—and I use the word *participate* advisedly, to carry along its sense of sharing—may indeed need to know-about a great deal, and to know-how to do many things, in order to enter into a work of art. But once we are in it, as when we listen with all our might to the movement of the music, we can be said to know only in the Biblical way: to know by sympathetic union with what is known.

While knowledge and truth of every kind are precious, it is a pedantic, philistine mistake to suppose that everything precious must be translated into bits and pieces of scientific knowledge and truth in order to be honestly enjoyed. We must indeed learn and know in order to become ready to participate in art, but our participation alone can turn all our learning and knowing into human being. This intimate, participative sense of being is a far truer guide to God and art than any cognition can ever be.

Selected Readings on Part VI: Art and Truth

Aiken, Henry D. "The Aesthetic Relevance of Belief." *Journal of Aesthetics and Art Criticism*, IX (1955), 301–15.

Aristotle. *Poetics*. Many editions.

Beardsley, Monroe. *Aesthetics*. New York: Harcourt, 1958. Chapter 8.

Collingwood, Robin G. *The Principles of Art*. London: Oxford U.P., 1938.

Hospers, John. "Literature and Human Nature." *Journal of Aesthetics and Art Criticism*, XVII (1958), 45–57.

——. "Art and Reality." In Sidney Hook (ed.), *Art and Philosophy*. New York: New York U.P., 1966.

——. *Meaning and Truth in the Arts*. Chapel Hill: U. of N.C., 1946.

——. "Implied Truths in Literature." *Journal of Aesthetics and Art Criticism*, 1960.

Isenberg, Arnold. "The Problem of Belief." *Journal of Aesthetics and Art Criticism*, XIII (March 1955).

Lewis, H. D. "Revelation and Art." *Proceedings of the Aristotelian Society*, Supplementary Vol. XXIII (1949), 1–29.

Price, Kingsley B. "Is There Artistic Truth?" *Journal of Philosophy*, XLVI (1949), 285–91.

Richards, Ivor A. *Science and Poetry*. London: Routledge & Kegan Paul, 1926.

Sesonske, Alexander. "Truth in Art." *Journal of Philosophy*, LIII (1956), 345–53.

Weitz, Morris. *Philosophy of the Arts*. Cambridge, Mass.: Harvard, 1950. Chapter 8.

VII

CRITERIA OF CRITICISM

15. REASONS IN AESTHETIC JUDGMENTS

MONROE C. BEARDSLEY

I call a reason Objective if it refers to some characteristic—that is, some quality or internal relation, or set of qualities and relations—within the work itself, or to some meaning-relation between the work and the world. In short, where either descriptive statements or interpretive statements appear as reasons in critical arguments, they are to be considered as Objective reasons. The distinction may seem a little artificial here, for according to some theories certain types of interpretive statements, for example, "*X* represents *Y*," could be reformulated in such a way as to refer to effects of the work upon its percipients. But I put interpretations in with the Objective Reasons, though I do not assume that all the Objective Reasons that critics have ever given are good reasons.

Even if we confine ourselves now to Objective Reasons, we still have a very large variety, so it might naturally occur to us to wonder whether any further subdivisions can be made. I think when we take a wide survey of critical reasons, we can find room for most of them, with very little trouble, in three main groups. First, there are reasons that seem to bear upon the degree of *unity* or disunity of the work:

It is well-organized (or disorganized).
It is formally perfect (or imperfect).
It has (or lacks) an inner logic of structure and style.

Second, there are those reasons that seem to bear upon the degree of *complexity* or simplicity of the work:

It is developed on a large scale.
It is rich in contrasts (or lacks variety and is repetitious).
It is subtle and imaginative (or crude).

FROM *Aesthetics* BY MONROE C. BEARDSLEY, © 1958, BY HARCOURT, BRACE & WORLD, INC., AND REPRINTED WITH THEIR PERMISSION. REPRINTED ALSO WITH KIND PERMISSION OF THE AUTHOR.

245

Third, there are those reasons that seem to bear upon the *intensity* or lack of intensity of human regional qualities in the work:

> It is full of vitality (or insipid).
> It is forceful and vivid (or weak and pale).
> It is beautiful (or ugly).
> It is tender, ironic, tragic, graceful, delicate, richly comic.

The first two groups of reasons do not seem to raise any difficulties that we have not already noticed in discussing the terms "unified" and "complex." It is obvious that critics very often explicitly advance the unity of a work as a reason for praising it, or assume that unity is a good thing; and I have never encountered the argument that a work was good because it was disorganized. I have read the following in *The New York Times* about the *Rhapsody in Blue*.

The humor, gusto and sentiment are all there. The work is not tightly organized by symphonic standards, but its very looseness of design adds to its charm.

I think this has to mean, not that it is better precisely because it is loosely organized, but that its peculiar qualities, its "humor, gusto and sentiment," would perhaps be weakened by a more highly organized form. If a critic said that a work is poor just because it is too unified, I think his context would show he meant that it is too simple (that is, too lacking in interesting complexities) or too cold (that is, too lacking in intense regional qualities).

It is perhaps less obvious that critics very often explicitly advance the complexity of a work as a reason for praising it, or assume that complexity is a good thing. Sometimes critical theorists talk as though complexity was invented by modern critics and was unknown to Homer, Virgil, and Horace. But when it is said that a simple lyric may be a fine poem, I think this is because it may yet have a high degree of unity and an intense quality. And, indeed, certain regional qualities can only be had in aesthetic objects that are relatively simple . . . but in this case we do not praise them for their simplicity, but for their intensity.

The reasons in the third group are the most puzzling. There seems to be no doubt that there is such a class of actual reasons:

> *A:* This painting is good.
> *B:* Why?
> *A:* Oh, it has such a sense of eternal calm and stillness about it.

I take "eternal calm and stillness" to refer to a pervasive regional quality here, as in the other examples, and I (tentatively) understand "beautiful" in the same way, though this very special term will have to

be discussed at greater length in the following chapter. But there is one difficulty that presents itself at once.

You could say—with what justification we shall later consider— that a good aesthetic object must have *some* marked quality, and not be a sheer nonentity or a zero. The quality does not matter—it can be sad or cheerful, graceful or rugged, soft or stern, provided it be *something*. But this may be too broad. We can think of works with uncontrolled horror or disgustingness—realistically painted corpses, Henry Miller's *Tropic of Cancer*, or the razor slicing the eye at the beginning of the surrealistic film, *The Andalousian Dog*. In these works we have intensity of quality, all right, but that does not make them good. It may be that certain qualities are simply not contemplatable for any time with normal human endurance, and that we must except these, if we can draw the line. Or it may be that it is not human regional qualities as such, but those we already value in human beings, that we accept as standards in critical evaluation. More likely, I think, it is that in certain works the intensity of the quality is achieved at too great a sacrifice of unity. This is perhaps what the critics meant by saying that in *Les Demoiselles d'Avignon* there is "too much concern for effect."

But again it might be argued that it is not just any human regional quality that is given as a ground of praise, for some qualities are cited as grounds of dispraise: pompousness, pretentiousness, ostentatious vulgarity; a work is bad *because* it is flashy, or labored, or sentimental. Now these terms are predicates, of course, but not all predicates refer to positive perceptual qualities. Where such characteristics as these are cited as grounds for dispraise, they can, I think, be analyzed as negative. Pompousness is the outward form of grandeur and greatness —it is a long symphony with enormous crescendos—combined with an emptiness, lack of vitality and richness. Sentimentality in a poem is not a sentiment, but a claim on the speaker's part to a feeling that he does not dramatize and present in the texture and objects of the poem. No doubt all these words are far too subtle to be disposed of so briefly, and no doubt their meaning varies; I leave many questions hanging in the air. But I suggest that so far as these characteristics are standards of (negative) critical evaluation, they refer not to intensity of quality, but to its absence, or to lack of unity or complexity: to slackness, faintness, flabbiness, the work's inability to live up to its own promises, declining power after a good start.

Merits and Defects

Now, suppose a critic supports a value judgment by pointing out some feature of the particular work in question: "Wordsworth's 'Ode:

Intimations of Immortality' is less good than it would be if its theme were not so vague." The form of the declaration claims that this vagueness is a defect in this poem, just as one might say that the grandeur of its imagery is a merit in it. By "defect" and "merit" I mean features that detract from its value or contribute to it: they are defective, or "bad-making," and meritorious, or "good-making," features respectively. Similarly we might say that firmness without hardness is a good-making feature, and worminess a bad-making feature, of apples.

But this terminology of merits and defects raises an important question. Can a feature be a merit in one poem and a defect (or neither) in another? Or does calling the feature a merit in one poem entail, or pre-suppose, a general principle according to which it is meritorious wherever it occurs? Is grandeur of imagery always a merit and vagueness of theme always a defect? Now, notice in the first place that we are not asking for universal conditions of goodness and badness. A wormy apple may still be a good apple, if the worm's operations have been confined to a small sector, provided the apple has other qualities that are desirable in apples. The worm is a defect, but not a fatal one. So a poem, indeed the "Ode" itself, may be a great poem because of its good-making features even though it has some bad-making features. Thus if there is a general principle—stated as, "Vague themes are always defects in poetry," or, "Grand imagery is always a merit in poetry"—this principle does not mean that these features are either *necessary* or *sufficient* conditions of goodness in poetry, but only that, other things being equal, their presence makes it better or worse.

It does not seem that the contribution of each feature of an aesthetic object can be considered in an atomistic fashion. This is true of many things in life; mustard depends on frankfurters, as a baseball bat depends on a baseball, for its maximum value; it is not, so to speak, a good-making feature of a picnic unless both are present. But then there *is* a general principle connecting baseball bats and picnics, though it is not simple: In the presence of baseballs, baseball bats are fun-making features of picnics—assuming certain sorts of picnickers. And similarly we might hold that to claim brilliant imagery as a merit in one poem is to commit yourself to some general principle about the capacity of grand imagery to help along poems, at least poems in which certain other features are present. But to commit yourself to the existence of such a principle is, of course, not to be able to state it. The critic may have a hunch that in the "Ode" the grandeur of imagery is a good-making feature, but then it would become a critical question whether it is always such or whether its being such depends upon being associated with other features. If we know what we mean by "good,"

as I hope we shall later, then this question becomes an empirical one.

Similar remarks hold for the merits and defects that fine arts and music critics single out for attention. For example, deep space is a good thing in some paintings, while flat space is a good thing in others, different qualities depend for their intensity upon each other. Exactness in perspective and in the size-distance relations of figures is needed in a Piero della Francesca or in a Rembrandt etching, where the violation of it in one part of the work would introduce a disturbing disunity: but its violation in a Cézanne still life or in some works by Tintoretto and Toulouse-Lautrec is a merit because of the qualities that are obtained in this way. Sometimes the critic can see these things at once, and with a confident perceptiveness. Yet an adequate justification for saying that any feature is a defect or a merit in any work would include an explanation in terms of some general principle about the value-contribution of that feature, alone or in combination with others.

A principle about defects and merits in one art we may call a *Specific Canon*. The next question is whether such Specific Canons can always be subsumed under *General Canons* that apply, not to poetry in particular, but to all the arts. Suppose, for example, a drama critic claims that it is a defect in a certain play that the action takes place over thirty years, and the story thus becomes diffuse. Now, again, he does not have to claim that the shorter the action of a play, the better it necessarily is; nor does he have to fall back on one of the neoclassic rules, such as that the action of a play should take no more than twenty-four hours; nor does he have to say that the best plays are always those whose action is the shortest possible, that is, exactly the same as the time of the play itself, such as Ben Jonson's *The Silent Woman*, Ibsen's *John Gabriel Borkman*, Tennessee Williams' *Cat on a Hot Tin Roof*. But he could perhaps claim, if his reason were questioned, that, other things being equal, the shorter the time of action, the more unified the play will tend to be; and the longer the time, the more it will tend to fall apart. This tendency may be, in some plays, counteracted by other unifying features, unfortunately lacking in the play in question. Now, this argument would subsume the long action-time as a defect under a Specific Canon—"A long action-time is a bad-making feature in a play that has a large number of characters, striking changes of scenery, and no symbolic carry-over from act to act." But the argument does more than this, for it subsumes this Specific Canon for the drama under a more General Canon, by claiming that the long action-time is a perceptual condition of disunity. The General Canon is, then, something like "Disunity is always a defect in aesthetic objects," or, in other words, "Disunity is a bad-making feature of aesthetic objects."

And this is the same Canon that was appealed to when *Les Demoiselles d'Avignon* was said to have a "confused" composition.

The classification of Objective Reasons that we have made so far, then, shows that at least a very large variety of them can be subsumed under three General Canons: the Canon of Unity, the Canon of Complexity, the Canon of Intensity. In other words, the objective features of plays, poems, paintings, and musical compositions referred to in the Special Canons can, at least most of them, be conditionally justified as standards because they are, so to speak, unifying, complexifying, or intensifying features of the works in which they occur, either alone or in combination with other features.

Applying the General Canons

The next question is whether in fact *all* Objective Reasons can be subsumed under these three Canons. This is, no doubt, a very bold question, for considering the subtlety and flexibility of critical language and the waywardness of some critical thinking, it would be almost incredible if it turned out that all the Objective Reasons given by critics were subsumable under three headings—unless the headings were so vague or so general that they could cover every logical possibility. But let us see what we discover if we examine some cases of critical reasoning with our three-fold classification in mind.

Cleanth Brooks, in his well-known essay on Tennyson's "Tears, Idle Tears," compares this poem with "Break, Break, Break," and explains why he judges it to be a much better poem.[1] The former, he says, is "very tightly organized," whereas the latter brings in an "irrelevant" reference to the "stately ships," and is "more confused." Here he is clearly appealing to the Canon of Unity. He says that the latter "is also a much thinner poem," and is "coarser"; it avoids "the psychological exploration of the experience," whereas the former has "richness and depth" because of its "imaginative grasp of diverse materials." Here he is appealing to the Canon of Complexity; the first poem has more *to* it, both in range and in subtlety. He speaks of the "dramatic force" and of the "dramatic power" of "Tears, Idle Tears," and particularly praises the intensity of its final stanza, in contrast to "Break, Break, Break." And here he is appealing to the Canon of Intensity. Brooks raises the question whether the opening paradox of "idle tears" is a merit or a defect, but in the light of his discussion he concludes that

[1] "The Motivation of Tennyson's Weeper," *The Well Wrought Urn*, 1947, New York: Reynal and Hitchock, pp. 153–62.

it contributes valuably to the complexity of the poem rather than detracting from its unity.

Or, consider a comparison of Picasso's two versions of *The Three Musicians*, one in the Museum of Modern Art, New York (1921), the other in the Philadelphia Museum of Art (also 1921):

The first . . . is the most moving of these, as well as the most solid and the most soberly coloured. The figures of the three characters are laid out in broad rectangular planes, while their faces give the impression of primitive masks. Only the harlequin, in the centre, with his yellow-and-red-checked dress and the curves of his guitar, serves to add a touch of cheerfulness to this sombre, eerie, hieratic work, whose structure bears witness to profound thought and incomparable craftsmanship. The other version . . . is painted in a different spirit altogether. . . . But though the composition is more varied and the colouring pleasanter, while more emphasis is given to depth and the decorative intention is more obvious, this variant lacks the dignified grandeur of the New York picture. . . . More complex, and fresher in colour, this final version has neither the severity nor the stark economy of the other, which impresses by its dignified generosity of conception.[2]

The traces of intentionalism here can probably be converted into an Objective terminology: "economy," can mean variety of significance in line and shape, hence a kind of complexity; the "profound thought and incomparable craftsmanship" do not enter as Objective Reasons, but are (deserved) praise for Picasso. What do we have left? The two paintings are not compared with respect to unity at all; it is taken for granted that the composition in both is unified, and that this is one of the factors relevant to the high value attributed to both paintings. The paintings are compared with respect to complexity; it is a merit in the Philadelphia one that it is more complex, more varied, and richer in decorative detail, and that it has a depth lacking in the New York one. But this aspect is said to be over-balanced by the third comparison: the New York one has a certain difficult-to-describe regional quality, its "hieratic" sombreness, its "severity," its "dignified grandeur" which is far more intense than any regional quality present in the Philadelphia one; and this is claimed to be a considerable merit.

It would be instructive to compare a number of passages dealing with music, say in the writings of Donald F. Tovey, though I have not found a single passage that combines such a variety of reasons as those just considered. We might examine his analysis of Mozart's *Linz Symphony in C Major* (K. 425), or of Mendelssohn's *"Italian" Symphony*. But perhaps this comparative passage will serve:

Thus, Schubert is apt to weaken and lengthen his expositions by processes

[2] Elgar and Maillard [*Picasso*, New York: Praeger, 1956], pp. 104–06, 126–29.

of discursive development where Beethoven would have had a crowd of terse new themes; while, on the other hand, Schubert's developments are apt indeed to develop some feature of one of his themes, but by turning it into a long lyric process which is repeated symmetrically. Dvořák is apt to be dangerously discursive at any point of his exposition, and frequently loses his way before he has begun his second group, while his developments often merely harp upon a single figure with a persistence not much more energetic or cumulative than that of the Dormouse that continued to say "twinkle, twinkle" in his sleep. But none of these matters can be settled by rule of thumb.[3]

Here phrases like "discursive development" and "loses his way" seem to bear upon the unity of the work; "a crowd of terse new themes" and "merely harp upon a single figure" seem to bear upon its complexity; "weaken," "lyric," "energetic or cumulative" seem to bear upon the intensity of its qualities. Tovey assumes that it is relevant to take these into account in considering the value of music, though of course he is not trying to make any final disposition of these masters.

The three Canons, then, support a large number of critical reasons. This is not due, I think, to their being vague, for they are not too vague to be testable and usable, as I have argued in Chapters IV and V. Nor is it due to some concealed ambiguity that makes the set really tautological, like saying every aesthetic object is either complex or not. For it is easy to invent reasons that fall outside these three Canons, such as the Genetic ones, or these:

NoT
OBJECTIVE
{ It was printed in a syndicated newspaper column.
It deals with Japanese pearl-diving.
It was written by a Communist.

Only these don't happen to be good reasons. We can find other critical formulae that do not at first glance seem to be subsumable under the three Canons, for example:

It is sincere.
It has spontaneity.
It violates (or is faithful to) its medium.
It fully exploits (or fails to exploit) its medium.

With such formulas there may be a preliminary question concerning their intelligibility; indeed, we have glanced at some of these terms already. But I believe that on analysis they will be found either to fall outside the group of Objective Reasons into intentionalism or affectivism, or else to connect indirectly with the Canons.

Nor is the plausibility of the conclusion due to the fact that the Canons permit free-wheeling rationalizations. It might seem that you

[3] Donald F. Tovey, *Essays in Musical Analysis*, London: Oxford U., 1935, Vol. I, 13–14.

could justify practically anything as a good aesthetic object: surely it
must have *something* in its favor that can be connected with one of the
Canons. Now, there is truth in this objection, but I do not think it is de-
plorable. We have not yet raised the question whether it would be
possible to *grade* aesthetic objects in terms of some scale; at this point we
are only asking what a critic could sensibly talk about if he were asked
to name the good things or the weaknesses in an aesthetic object, and
we ought to encourage the critic, as well as ourselves, to be as open as
possible to the variety of good things that can be found in art. The
Canonic scheme is generous in this sense, even if its principles are few.
But at the same time it remains true that in some aesthetic objects one
can point out numerous defects, and serious, that is, pervasive, ones,
whereas in others one can find only a few; and similarly with merits.

For example, a certain college library has a plaque that contains
the following lines, by W. D. Foulke:

> How canst thou give thy life to sordid things
> While Milton's strains in rhythmic numbers roll,
> Or Shakespeare probes thy heart, or Homer sings,
> Or rapt Isaiah wakes thy slumbering soul?

You could spend quite a while pointing out how bad this is, and you
would have a hard time finding things good about it. From the point of
view of unity, it breaks down on an elementary level; the addressee is
giving his life to sordid things while Shakespeare is probing his heart and
Isaiah is waking him up. This mixture would be tolerable, if the diverse
images did not, on reflection, show a profound looseness in conception,
the various poets being thrown together by the word "while." From the
point of view of complexity, the poem is utterly lacking in subtlety; it
contains dead spaces like "Homer sings"; and none of the possible
connotations of "sordid" or "probes" get taken up and developed, but
they are canceled out by the other words. From the point of view of its
human regional qualities, it is feeble and half-hearted, even as moral
advice. And it has no rhythmic, syntactical, or verbal life. These things
cannot be truly said of Wordsworth's "Ode."

To sum up, the three general critical standards, unity, complexity,
and intensity, can be meaningfully appealed to in the judgment of aes-
thetic objects, whether auditory, visual, or verbal. Moreover, they are
appealed to constantly by reputable critics. It seems to me that we can
even go so far as to say that all their Objective reasons that have any
logical relevance at all depend upon a direct or an indirect appeal to
these three basic standards. This may be too sweeping a claim; at any
rate, it is stated explicitly enough so that it can be attacked or defended.

16. CRITICAL COMMUNICATION

ARNOLD ISENBERG

That questions about meaning are provisionally separable, even if
finally inseparable, from questions about validity and truth, is shown
by the fact that meanings can be exchanged without the corresponding
cognitive decisions. What is imparted by one person to another in an
act of communication is (typically) a certain idea, thought, content,
meaning, or claim—not a belief, expectation, surmise, or doubt; for
the last are dependent on factors, such as the checking process, whice
go beyond the mere understanding of the message conveyed. And there
is a host of questions which have to do with this message: its simplicity
or complexity, its clarity or obscurity, its tense, its mood, its modality,
and so on. Now, the theory of art criticism has, I think, been seriously
hampered by a kind of headlong assault on the question of validity.
We have many doctrines about the objectivity of a critical judgment
but few concerning its import, or claim to objectivity, though the
settlement of the first of these questions probably depends on the
clarification of the second. The following remarks are for the most part
restricted to meeting such questions as: What is the content of the
critic's argument? What claim does he transmit to us? How does he
expect us to deal with this claim?

A good point to start from is a theory of criticism, widely held in
spite of its deficiencies, which divides the critical process into three
parts. There is the value judgment or *verdict* (V): "This picture or
poem is good—." There is a particular statement or *reason* (R): "—
because it has such-and-such a quality—." And there is a general

FROM *The Philosophical Review*, VOLUME 58 (JULY, 1949), 330–44. REPRINTED WITH
THE PERMISSION OF *The Philosophical Review*.

statement or *norm* (N): "—and any work which has that quality is *pro tanto* good."[1]

V has been construed, and will be construed here, as an expression of feeling—an utterance manifesting praise or blame. But among utterances of that class it is distinguished by being in some sense conditional upon R. This is only another phrasing of the commonly noted peculiarity of aesthetic feeling: that it is "embodied" in or "attached" to an aesthetic content.

R is a statement describing the content of an art work; but not every such descriptive statement will be a case of R. The proposition, "There are just twelve flowers in that picture" (and with it nine out of ten descriptions in Crowe and Cavalcaselle), is without critical relevance, that is, without any bearing upon V. The description of a work of art is seldom attempted for its own sake. It is controlled by some purpose, some interest; and there are many interests by which it might be controlled other than that of reaching or defending a critical judgment. The qualities which are significant in relation to one purpose—dating, attribution, archaeological reconstruction, clinical diagnosis, proving or illustrating some thesis in sociology—might be quite immaterial in relation to another. At the same time, we cannot be sure that there is any *kind* of statement about art, serving no matter what main interest, which cannot also act as R; or, in other words, that there is any *kind* of knowledge about art which cannot influence aesthetic appreciation.

V and R, it should be said, are often combined in sentences which are at once normative and descriptive. If we have been told that the colors of a certain painting are garish, it would be astonishing to find that they were all very pale and unsaturated; and to this extent the critical comment conveys information. On the other hand, we might find the colors bright and intense, as expected, without being thereby forced to admit that they are garish; and this reveals the component of valuation (that is, distaste) in the critic's remark. This feature of critical usage has attracted much notice and some study; but we do not discuss it here at all. We shall be concerned solely with the descriptive function of R.

Now if we ask what makes a description critically useful and relevant, the first suggestion which occurs is that it is *supported by N*. N is based upon an inductive generalization which describes a relationship

[1] Cf., for instance, C. J. Ducasse, *Art, the Critics, and You* [New York, 1944] (p. 116): "The statement that a given work possesses a certain objective characteristic expresses at the same time a judgment of value if the characteristic is one that the judging person approves or, as the case may be, disapproves; and is thus one that he regards as conferring, respectively, positive or negative value on any object of the given kind that happens to possess it." See, further, pp. 117–20.

between some aesthetic quality and someone's or everyone's system of aesthetic response. Notice: I do not say that N *is* inductive generalization; for in critical evaluation N is being used not to predict or to explain anybody's reaction to a work of art but to vindicate that reaction, perhaps to someone who does not yet share it; and in this capacity N is a precept, a rule, a *generalized value statement*. But the *choice* of one norm, rather than another, when that choice is challenged, will usually be given some sort of inductive justification. We return to this question in a moment. I think we shall find that a careful analysis of N is unnecessary, because there are considerations which permit us to dismiss it altogether.

At this point it is well to remind ourselves that there is a difference between *explaining* and *justifying* a critical response. A psychologist who should be asked "why X lies the object y" would take X's enjoyment as a datum, a fact to be explained. And if he offers as explanation the presence in y of the quality Q, there is, explicit or latent in this causal argument, an appeal to some generalization which he has reason to think is true, such as "X likes any work which has that quality." But when we ask X as a critic "why he likes the object y," we want him to give us some reason to like it too and are not concerned with the causes of what we may so far regard as his bad taste. This distinction between genetic and normative inquiry, though it is familiar to all and acceptable to most of us, is commonly ignored in the practice of aesthetic speculation; and the chief reason for this—other than the ambiguity of the question "Why do you like this work?"—is the fact that some statements about the object will necessarily figure both in the explanation and in the critical defence of any reaction to it. Thus, if I tried to explain my feeling for the line

<p style="text-align:center">But musical as is Apollo's lute,</p>

I should certainly mention "the pattern of *u*'s and *l*'s which reinforces the meaning with its own musical quality"; for this quality of my sensations is doubtless among the conditions of my feeling response. And the same point would be made in any effort to convince another person of the beauty of the line. The remark which gives a reason also, in this case, states a cause. But notice that, though as criticism this comment might be very effective, it is practically worthless as explanation; for we have no phonetic or psychological laws (nor any plausible "common-sense" generalizations) from which we might derive the prediction that such a pattern of *u*'s and *l*'s should be pleasing to me. In fact, the formulation ("pattern of *u*'s and *l*'s," etc.) is so vague that one could not tell just what general hypothesis it is that is being invoked or assumed; yet it is quite sharp enough for critical purposes.

On the other hand, suppose that someone should fail to be "convinced" by my argument in favor of Milton's line. He might still readily admit that the quality of which I have spoken might have something to do with *my* pleasurable reaction, given my peculiar mentality. Thus the statement which is serving both to explain and to justify is not equally effective in the two capacities; and this brings out the difference between the two lines of argument. Coincident at the start, they diverge in the later stages. A *complete* explanation of any of my responses would have to include certain propositions about my nervous system, which would be irrelevant in any critical argument. And a critically relevant observation about some configuration in the art object might be useless for explaining a given experience, if only because the experience did not yet contain that configuration.[2]

Now it would not be strange if, among the dangers of ambiguity to which the description of art, like the rest of human speech, is exposed, there should be some which derive from the double purpose—critical and psychological—to which such description is often being put. And this is, as we shall see, the case.

The necessity for sound inductive generalizations in any attempt at aesthetic explanation is granted. We may now consider, very briefly, the parallel role in normative criticism which has been assigned to N. Let us limit our attention to those metacritical theories which *deny* a function in criticism to N. I divide these two kinds, those which attack existing standards and those which attack the very notion of a critical standard.

(1) It is said that we know of no law which governs human tastes and preferences, no quality shared by any two works of art that makes those works attractive or repellent. The point might be debated; but it is more important to notice what it assumes. It assumes that if N *were* based on a sound induction, it would be (together with R) a real ground for the acceptance of V. In other words, it would be reasonable to accept V on the strength of the quality Q if it could be shown that works which possess Q tend to be pleasing. It follows that criticism is being held back by the miserable state of aesthetic science. This raises an issue too large to be canvassed here. Most of us believe that the idea of progress applies to science, does not apply to art, applies, in some unusual and not very clear sense, to philosophy. What about criticism? Are there

[2] I should like to add that when we speak of "justifying" or "giving reasons" for our critical judgments, we refer to something which patently does go on in the world and which is patently different from the causal explanation of tastes and preferences. We are not begging any question as to whether the critical judgment can "really" be justified; that is, established on an objective basis. Even if there were no truth or falsity in criticism, there would still be agreement and disagreement; and there would be argument which arises out of disagreement and attempts to resolve it. Hence, at the least there exists the purely "phenomenological" task of elucidating the import and intention of words like "insight," "acumen," "obtuseness," "bad taste," all of which have a real currency in criticism.

"discoveries" and "contributions" in this branch of thought? Is it reasonable to expect better evaluations of art after a thousand years of criticism than before? The question is not a simple one: it admits of different answers on different interpretations. But I do think that some critical judgments have been and are every day being "proved" as well as in the nature of the case they ever can be proved. I think we have already numerous passages which are not to be corrected or improved upon. And if this opinion is right, then it could not be the case that the validation of critical judgments waits upon the discovery of aesthetic laws. Let us suppose even that we had some law which stated that a certain color combination, a certain melodic sequence, a certain type of dramatic hero has everywhere and always a positive emotional effect. To the extent to which this law holds, there is of course that much less disagreement in criticism; but there is no better method for resolving disagreement. We are not more fully convinced in our own judgment because we know its explanation; and we cannot hope to convince an imaginary opponent by appeal to this explanation, which by hypothesis does not hold for him.

(2) The more radical arguments against critical standards are spread out in the pages of Croce, Dewey, Richards, Prall, and the great romantic critics before them. They need not be repeated here. In one way or another they all attempt to expose the absurdity of presuming to judge a work of art, the very excuse for whose existence lies in its *difference* from everything that has gone before, by its degree of *resemblance* to something that has gone before; and on close inspection they create at least a very strong doubt as to whether a standard of success or failure in art is either necessary or possible. But it seems to me that they fail to provide a positive interpretation of criticism. Consider the following remarks by William James on the criticism of Herbert Spencer: "In all his dealings with the art products of mankind he manifests the same curious dryness and mechanical literality of judgment. . . . Turner's painting he finds untrue in that the earth-region is habitually as bright in tone as the air-region. Moreover, Turner scatters his detail too evenly. In Greek statues the hair is falsely treated. Renaissance painting is spoiled by unreal illumination. Venetian Gothic sins by meaningless ornamentation." And so on. We should most of us agree with James that this is bad criticism. But *all* criticism is similar to this in that it cites, as reasons for praising or condemning a work, one or more of its qualities. If Spencer's reasons are descriptively true, how can we frame our objection to them except in some such terms as that "unreal illumination does not make a picture bad"; that is, by attacking his standards? What constitutes the relevance of a reason but its correlation with a norm? It is astonishing to notice how many writers,

formally committed to an opposition to legal procedure in criticism, *seem* to relapse into a reliance upon standards whenever they give reasons for their critical judgments. The appearance is inevitable; for as long as we have no alternative interpretation of the import and function of R, we must assume *either* that R is perfectly arbitrary *or* that it presupposes and depends on some general claim.

With these preliminaries, we can examine a passage of criticism. This is Ludwig Goldscheider on *The Burial of Count Orgaz*:

Like the contour of a violently rising and falling wave is the outline of the four illuminated figures in the foreground: steeply upwards and downwards about the grey monk on the left, in mutually inclined curves about the yellow of the two saints, and again upwards and downwards about . . . the priest on the right. The depth of the wave indicates the optical centre; the double curve of the saints' yellow garments is carried by the greyish white of the shroud down still farther; in this lowest depth rests the bluish-grey armor of the knight.

This passage—which, we may suppose, was written to justify a favorable judgment on the painting—conveys to us the idea of a certain quality which, if we believe the critic, we should expect to find in a certain painting by El Greco. And we do find it: we can verify its presence by perception. In other words, there is a quality in the picture which agrees with the quality which we "have in mind"—which we have been led to think of by the critic's language. But the same quality ("a steeply rising and falling curve," etc.) would be found in any of a hundred lines one could draw on the board in three minutes. It could not be the critic's purpose to inform us of the presence of a quality as obvious as this. It seems reasonable to suppose that the critic is thinking of another quality, no idea of which is transmitted to us by his language, which he *sees* and which by his use of language he *gets us to see*. This quality is, of course, a wavelike contour; but it is not the quality designated by the *expression* "wavelike contour." Any object which has this quality will have a wavelike contour; but is not true that any object which has a wavelike contour will have this quality. At the same time, the expression "wavelike contour" *excludes* a great many things: if anything is a wavelike contour, it is not a color, it is not a mass, it is not a straight line. Now the critic, besides imparting to us the idea of a wavelike contour, gives us directions for perceiving, and does this *by means* of the idea he imparts to us, which narrows down the field of possible visual orientations and guides us in the discrimination of details, the organization of parts, the grouping of discrete objects into patterns. It is as if we found both an oyster and a pearl when we had been looking for a seashell because we had been told it was valuable. It *is* valuable, but not because it is a seashell.

I may be stretching usage by the senses I am about to assign to certain words, but it seems that the critic's *meaning* is "filled in," "rounded out," or "completed" by the act of perception, which is performed not to judge the truth of his description but in a certain sense to *understand* it. And if communication is a process by which a mental content is transmitted by symbols from one person to another, then we can say that is a function of criticism to bring about communication at the level of the senses; that is, to induce a sameness of vision, of experienced content. If this is accomplished, it may or may not be followed by agreement, or what is called "communion"—a community of feeling which expresses itself in identical value judgments.

There is a contrast, therefore, between critical communication and what I may call normal or ordinary communication. In ordinary communication, symbols tend to acquire a footing relatively independent of sense-perception. It is, of course, doubtful whether the interpretation of symbols is at any time completely unaffected by the environmental context. But there is a difference of degree between, say, an exchange of glances which, though it means "Shall we go home?" at one time and place, would mean something very different at another —between this and formal science, whose vocabulary and syntax have relatively fixed connotations. With a passage of scientific prose before us, we may be dependent on experience for the definition of certain simple terms, as also for the confirmation of assertions; but we are not dependent on experience for the interpretation of compound expressions. If we are, this exposes semantical defects in the passage— obscurity, vagueness, ambiguity, or incompleteness. (Thus: "Paranoia is marked by a profound egocentricity and deep-seated feelings of insecurity"—the kind of remark which makes every student think he has the disease—is suitable for easy comparison of notes among clinicians, who know how to recognize the difference between paranoia and other conditions; but it does not explicitly set forth the criteria which they employ.) Statements about immediate experience, made in ordinary communication, are no exception. If a theory requires that a certain flame should be blue, then we have to report whether it is or is not blue—regardless of shades or variations which may be of enormous importance aesthetically. We are bound to the letters of our words. Compare with this something like the following:

> "The expression on her face was delightful."
> "What was delightful about it?"
> "Didn't you see that smile?"

The speaker does not mean that there is something delightful about

smiles as such; but he cannot be accused of not stating his meaning clearly, because the clarity of his language must be judged in relation to his purpose, which in this case is the *evaluation* of the immediate experience; and for that purpose the reference to the smile will be sufficient if it gets people to feel that they are "talking about the same thing." There is understanding and misunderstanding at this level; there are marks by which the existence of one or the other can be known; and there are means by which misunderstanding can be eliminated. But these phenomena are not identical with those that take the same names in the study of ordinary communication.

Reading criticism, otherwise than in the presence, or with direct recollection, of the objects discussed is a blank and senseless employment—a fact which is concealed from us by the cooperation, in our reading, of many non-critical purposes for which the information offered by the critic is material and useful. There is not in all the world's criticism a singly purely descriptive statement concerning which one is prepared to say beforehand, "If it is true, I shall like that work so much the better"—and *this* fact is concealed by the play of memory, which gives the critic's language a quite different, more specific, meaning than it has as ordinary communication. The point is not at all similar to that made by writers who maintain that value judgments have no objective basis because the reasons given to support them are logically derivable from the value judgments themselves. I do not ask that R be related *logically* to V. In ethical argument you have someone say, "Yes, I would condemn that policy if it really did cause a wave of suicides, as you maintain." Suppose that the two clauses are here only psychologically related—still, this is what you never have in criticism. *The truth of R never adds the slightest weight to V*, because R does not designate any quality the perception of which might induce us to assent to V. But if it is not R, or what it designates that makes V acceptable, then R cannot possibly require the support of N. The critic is not committed to the general claim that the quality named Q is valuable because he never makes the particular claim that a work is good in virtue of the presence of Q.

But he, or his readers, can easily be misled into *thinking* that he has made such a claim. You have, perhaps, a conflict of opinion about the merits of a poem; and one writer defends his judgment by mentioning vowel sounds, metrical variations, consistent or inconsistent imagery. Another critic, taking this language at its face value in ordinary communication, points out that "by those standards" one would have to condemn famous passages in *Hamlet* or *Lear* and raise some admittedly bad poems to a high place. He may even attempt what he calls an

"experiment" and, to show that his opponents' grounds are irrelevant, construct a travesty of the original poem in which its plot or its meter or its vowels and consonants, or whatever other qualities have been cited with approval, are held constant while the rest of the work is changed. This procedure, which takes up hundreds of the pages of our best modern critics, is a waste of time and space; for it is the critic abandoning his own function to pose as a scientist —to assume, in other words, that criticism explains experiences instead of clarifying and altering them. If he saw that the *meaning* of a word like "assonance"— the quality which it leads our perception to discriminate in one poem or another—is in critical usage never twice the same, he would see no point in "testing" any generalization about the relationship between assonance and poetic value.

Some of the foregoing remarks will have reminded you of certain doctrines with which they were not intended to agree. The fact that criticism does not actually designate the qualities to which it somehow directs our attention has been a ground of complaint by some writers, who tell us that our present critical vocabulary is woefully inadequate.[3] This proposition clearly looks to an eventual improvement in the language of criticism. The same point, in a stronger form and with a different moral, is familiar to readers of Bergson and Croce, who say that it is impossible tby means of concepts to "grasp the essence" of the artistic fact; and this position has seemed to many people to display the ultimate futility of critical analysis. I think that by returning to the passage I quoted from Goldscheider about the painting by El Greco we can differentiate the present point of view from both of these. Imagine, then, that the painting should be projected on to a graph with intersecting co-ordinates. It would then be possible to write complicated mathematical expressions which would enable another person who knew the system to construct for himself as close an approximation to the exact outlines of the El Greco as we might desire. Would this be an advance towards precision in criticism? Could we say that we had devised a more specific terminology for drawing and painting? I think not, for the most refined concept remains a concept; there is no vanishing point at which it becomes a percept. It is the idea *of* a quality, it is not the quality itself. To render a critical verdict we should still have to perceive the quality; but Goldscheider's passage already shows it to us as clearly as language can. The idea of a new and better means of communication presupposes the absence of the sensory contents we are talking about; but criticism always assumes the presence of these contents to both parties; and it is upon this assumption that the vague-

[3] See D. W. Prall, *Aesthetic Analysis* [New York: Thomas Y. Crowell Co., 1929], p. 201.

ness or precision of a critical statement must be judged. Any further illustration of this point will have to be rough and hasty. For the last twenty or thirty years the "correct" thing to say about the metaphysical poets has been this: They think with their senses and feel with their brains. One hardly knows how to verify such a dictum: as a psychological observation it is exceedingly obscure. But it does not follow that it is not acute criticism; for it increases our awareness of the difference between Tennyson and Donne. Many words—like "subtlety," "variety," "complexity," "intensity"—which in ordinary communication are among the vaguest in the language have been used to convey sharp critical perceptions. And many expressions which have a clear independent meaning are vague and fuzzy when taken in relation to the content of a work of art. An examination of the ways in which the language of concepts mediates between perception and perception is clearly called for, though it is far too difficult to be attempted here.

We have also just seen reason to doubt that any aesthetic quality is ultimately ineffable. "What can be said" and "what cannot be said" are phrases which take their meaning from the purpose for which we are speaking. The aesthetics of obscurantism, in its insistence upon the incommunicability of the art object, has never made it clear what purpose or demand is to be served by communication. If we devised a system of concepts by which a work of art could be virtually reproduced at a distance by the use of language alone, what human intention would be furthered? We saw that *criticism* would not be improved: in the way in which criticism strives to "grasp" the work of art, we could grasp it no better then than now. The scientific *explanation* of aesthetic experiences would not be accomplished by a mere change of descriptive terminology. There remains only the *aesthetic* motive in talking about art. Now if we set it up as a condition of communicability that our language should *afford* the experience which it purports to describe, we shall of course reach the conclusion that art is incommunicable. But by that criterion all reality is unintelligible and ineffable, just as Bergson maintains. Such a demand upon thought and language is not only preposterous in that its fulfilment is logically impossible; it is also baneful, because it obscures the actual and very large influence of concepts upon the process of perception (by which, I must repeat, I mean something more than the ordinary *reference* of language to qualities of experience). Every part of the psychology of perception and attention provides us with examples of how unverbalized apperceptive reactions are engrained in the content and structure of the perceptual field. We can also learn from psychology how perception is affected by verbal cues and instructions. What remains unstudied is the play of critical

comment in society at large; but we have, each of us in his own ex-
perience, instances of differential emphasis and selective grouping
which have been brought about through the concepts imparted to us
by the writings of critics.

I have perhaps overstressed the role of the critic as teacher, i.e., as
one who affords *new* perceptions and with them new values. There is
such a thing as discovering a community of perception and feeling
which already exists; and this can be a very pleasant experience. But
it often happens that there are qualities in a work of art which are, so to
speak, neither perceived nor ignored but felt or endured in a manner
of which Leibniz has given the classic description. Suppose it is only a
feeling of monotony, a slight oppressiveness, which comes to us from
the style of some writer. A critic then refers to his "piled-up clauses,
endless sentences, repetitious diction." This remark shifts the focus of
our attention and brings certain qualities which had been blurred and
marginal into distinct consciousness. When, with a sense of illumination,
we say "Yes, that's it exactly," we are really giving expression to the
change which has taken place in our aesthetic apprehension. The post-
critical experience is the true commentary on the pre-critical one. The
same thing happens when, after listening to Debussy, we study the
chords that can be formed on the basis of the whole-tone scale and then
return to Debussy. New feelings are given which bear some resemblance
to the old. There is no objection in these cases to our saying that we
have been made to "understand" why we liked (or disliked) the work.
But such understanding, which is the legitimate fruit of criticism, is
nothing but a second moment of aesthetic experience, a retrial of
experienced values. It should not be confused with the psychological
study which seeks to know the causes of our feelings.

Note

In this article I have tried only to mark out the direction in which, as I believe,
the exact nature of criticism should be sought. The task has been largely negative:
it is necessary to correct preconceptions, obliterate false trials. There remain questions
of two main kinds. Just to establish the adequacy of my analysis, there would have to
be a detailed examination of critical phenomena, which present in the gross a fearful
complexity. For example, I have paid almost no attention to large-scale or summary
judgments—evaluations of artists, schools, or periods. One could quote brief state-
ments about Shakespeare's qualities as a poet or Wagner's as a composer which
seem to be full of insight; yet it would be hard to explain what these statements do to
our "perception"—if that word can be used as a synonym for our appreciation of an
artist's work as a whole.

But if the analysis is so far correct, it raises a hundred new questions. Two of these—rather, two sides of one large question—are especially important. What is the semantical relationship between the language of criticism and the qualities of the critic's or the reader's experience? I have argued that this relationship is not designation (though I do not deny that there *is* a relationship of designation between the critic's language and *some* qualities of a work of art). But neither is it denotation: the critic does not *point* to the qualities he has in mind. The ostensive function of language will explain the exhibition of *parts* or *details* of an art object but not the exhibition of abstract *qualities;* and it is the latter which is predominant in criticism. The only positive suggestion made in this paper can be restated as follows. To say that the critic "picks out" a quality in the work of art is to say that if there did exist a designation for that quality, then the designation which the critic employs would be what Morris calls an analytic implicate of that designation. (Thus, 'blue' is an analytic implicate of an expression 'H3B5S2' which designates a certain point on the colour solid.) This definition is clearly not sufficient to characterize the critic's method; but, more, the antecedent of the *definiens* is doubtful in meaning. A study of terms like "Rembrandt's chiaroscuro," "the blank verse of *The Tempest*," etc., etc., would probably result in the introduction of an idea analogous to that of the proper name (or of Russell's "definite description") but with this difference, that the entity uniquely named or labelled by this type of expression is not an object but a quality.

If we put the question on the psychological plane, it reads as follows: How is it that (*a*) we can "know what we like" in a work of art without (*b*) knowing what "causes" our enjoyment? I presume that criticism enlightens us as to (*a*) and that (*b*) would be provided by a psychological explanation; also that (*a*) is often true when (*b*) is not.

Contrary to Ducasse[4] and some other writers I cannot see that the critic has any competence as a self-psychologist, a specialist in the explanation of his own responses. There is no other field in which we admit the existence of such scientific insight, unbridled by experimental controls and unsupported by valid general theory; and I do not think we can admit it here. (For that reason I held that critical insight, which does exist, cannot be identified with scientific understanding.) The truth is that, in the present stone age of aesthetic inquiry, we have not even the vaguest idea of the form that a "law of art appreciation" would take. Consider, "It is as a *colorist* that Titian excells"; interpret this as causal hypothesis—for example, "Titian colors give pleasure"; and overlook incidental difficulties, such as whether 'color' means tone or the hue (as opposed to the brightness and the saturation) of a tone. Superficially, this is similar to many low-grade hypotheses in psychology: "We owe the *color* of the object to the retinal rods and cones," "It is the *brightness* and not the color that infuriates a bull," "Highly *saturated* colors give pleasure to American schoolboys." But the difference is that we do not know what test conditions are marked out by our chosen proposition. Would it be relevant, as a test of its truth, to display the colors of a painting by Titian, in a series of small rectangular areas, to a group of subjects in the laboratory? I cannot believe this to be part of what is meant by a person who affirms this hypothesis. He is committed to no such test.

[4] Op cit., p. 117.

Anyone with a smattering of Gestalt psychology now interposes that the colors are, of course, pleasing *in* their context, not out of it. One has some trouble in understanding how in that case one could know that it is the *colors* that are pleasing. We may believe in studying the properties of wholes; but it is hard to see what scientific formulation can be given to the idea that a quality should have a certain function (that is, a causal relationship to the responses of an observer) in one and only one whole. Yet that appears to be the case with the color scheme in any painting by Titian.

We can be relieved of these difficulties simply by admitting our ignorance and confusion; but there is no such escape when we turn to criticism. For it *is* as a colorist that Titian excels—this is a fairly unanimous value judgment, and we should be able to analyze its meaning. (I should not, however, want the issue to turn on this particular example. Simpler and clearer judgments could be cited.) Now when our attention is called, by a critic, to a certain quality, we respond to that quality *in its context*. The context is never specified, as it would have to be in any scientific theory, but always assumed. Every descriptive statement affects our perception of—and our feeling for—the work as a whole. One might say, then, that we agree with the critic if and when he gets us to like the work about as well or as badly as he does. But this is clearly not enough. For he exerts his influence always through a specific discrimination. Art criticism is analytic, discriminating. It concerns itself less with over-all values than with merits and faults in specified respects. It is the quality and not the work that is good or bad; or, if you like, the work is good or bad "on account of its qualities." Thus, we may agree with his judgment but reject the critic's grounds (I have shown that the "grounds," to which he is really appealing are not the same as those which he explicitly states or designates); and when we do this, we are saying that the qualities which he admires are not those which we admire. But then we must know what we admire: we are somehow aware of the special attachment of our feelings to certain abstract qualities rather than to others. Without this, we could never reject a reason given for a value judgment with which we agree—we could never be dissatisfied with descriptive evaluation. There must therefore exist an analyzing, sifting, shredding process within preception which corresponds to the conceptual distinctness of our references to "strong form but weak color," "powerful images but slovenly meter," and so on.

This process is mysterious; but we can get useful hints from two quarters. Artists and art teachers are constantly "experimenting," in their own way. "Such a bright green at this point is jarring." "Shouldn't you add more detail to the large space on the right?" We can compare two wholes in a single respect and mark the difference in the registration upon our feelings. Implicit comparisons of this kind, with shifting tone of feeling, are what are involved in the isolation of qualities from the work, at least, in *some* critical judgments. I am afraid that as psychology, as an attempt to discover the causes of our feelings, this is primitive procedure; but as a mere analysis of what is meant by the praise and blame accorded to special qualities, it is not without value.

If, in the second place, we could discover what we mean by the difference

between the "object" and the "cause" of an emotion, *outside* the field of aesthetics; if we could see both the distinction and the connection between two such judgments as "I hate his cheek" and "It is his cheek that inspires hatred in men"; if we knew what happens when a man says, "Now I know why I have always disliked him— it is his pretence of humility," there would be a valuable application to the analysis of critical judgments.

Selected Readings on Part VII: Criteria of Criticism

Beardsley, Monroe. *Aesthetics*. New York: Harcourt, 1958. Chapter 10.

Boas, George. *A Primer for Critics*. Baltimore: Johns Hopkins, 1937.

Coleman, Francis J. *Aesthetics: Contemporary Studies in Aesthetics*. New York: McGraw, 1968. Part Two.

Ducasse, Curt J. *Art, the Critics, and You*. New York: Liberal Arts Press, 1944.

Eastman, Max. *The Literary Mind: Its Place in an Age of Science*. New York: Scribner, 1931.

Gotshalk, D. W. *Art and the Social Order*. Chicago: U. of Chicago, 1947.

Greene, Theodore M. *The Arts and the Art of Criticism*. Princeton: Princeton, 1940.

Hazlitt, Henry. *The Anatomy of Criticism*. New York: S. and S., 1933.

Heyl, Bernard C. *New Bearings in Aesthetics and Art Criticism*. New Haven: Yale, 1943.

Kellett, E. E. *Fashion in Literature*. London: Routledge & Kegan Paul, 1931.

Macdonald, Margaret, A. H. Hannay, and John Holloway. "What Are the Distinctive Features of Arguments Used in Criticism of the Arts?" *Proceedings of the Aristotelian Society*, Supplementary Vol. XXIII (1949), 165–94.

Osborne, Harold. *Aesthetics and Criticism*. London: Routledge & Kegan Paul, 1955.

Pepper, Stephen C. *The Basis of Criticism in the Arts*. Cambridge, Mass.: Harvard, 1945.

Richards, Ivor A. *Principles of Literary Criticism*. New York: Harcourt, 1926.

Wellek, Rene, and Austin Warren. *The Theory of Literature*. New York: Harcourt, 1949.

Wimsatt, W. K. *The Verbal Icon*. Lexington, Ky.: U. of Ky., 1954.

VIII
AESTHETIC VALUE

17. THE OBJECTIVITY OF AESTHETIC VALUE

T. E. JESSOP

It is the way of a newly quickened science to claim that it supplies a philosophical viewpoint. Physics did this in the seventeenth century and biology did the same in the last few decades of the nineteenth. Nowadays, it is psychology that claims to prove the all-seeing eye. Aesthetic theory and art-criticism alike are accepting and elaborating this claim. The study of beautiful objects has become the study of their origination in a mind and of their effect on a mind. I want first to argue that such contraction of interest to subjective considerations is a mistake, and then to discuss certain difficulties which seem to lie in the way of the objective definition of beauty.

It is certainly a relief to turn away from those older aesthetic theories that were mere deductions from general metaphysical principles which drew neither content nor inspiration from aesthetic experience, deductions drawn simply to complete the circuit of a system. Besides being in this sense oblique they were so general as to have no close and clear relation to the realm of actual aesthetic objects, and supplied little help for a principled discrimination of these. But if metaphysical aesthetics was harmless because it simply remained aloof from the peculiar difficulties of the concrete field, psychologically biased aesthetics is harmful because it leads us away from those difficulties. Where, at any rate, a work of art is in question, the inquiry is deflected to an examination of either creation or application.

In the emphasis on creation the product is lost in the producer. We are made to jump from the poem to the poet. When we ask for an analysis of a statue we are given a piece of conjecture about the sculptor. The inseparability of the work of art from the artist is the justifying

"THE DEFINITION OF BEAUTY" BY T. E. JESSOP. REPRINTED FROM *Proceedings of the Aristotelian Society*, VOL. 33 (1932–33) WITH THE KIND PERMISSION OF THE AUTHOR AND THE EDITOR OF THE ARISTOTELIAN SOCIETY.

principle. It is, of course, a true one, but the respect in which it is true is the respect in which it is a commonplace for all that its truth involves is that the work of art is an element in a system of causes and effects. Aesthetics begins only when this point has been transcended. Its relevance for the critic is to the preliminary business of understanding a work of art—more particularly an elaborate, obscure or eccentric work—not to the task of judging this aesthetically; and for the theorist it is a principle of purely psychological interest. However hard it may sound, both for the immediate aesthetic judgment and for the philosophical analysis of such judgment, the nature of the artist need not be considered. A judgment about an artist cannot always be transferred to the thing he has made, the reason being that most of what happens in him does not happen afresh, or have any direct correspondence, in his work. He may, for example, be insincere, and yet we may find no trace of this in his work. Insincerity, moreover, is a moral quality. Motive, too, is irrelevant: in art, as in conduct, there is often a disparity between aim and achievement, and often a pure difference. The judgment of motive is a moral affair; the judgment of the relation of motive to achievement requires only predicates such as success and failure; an achievement alone can accept an aesthetic predicate, and, in fact, it is to achievements—to poems, pictures, statues, buildings—that aesthetic predicates are applied. A work of art may realise a motive, but this is not its defining characteristic. Even when causally considered, its deeper relation is to sensibility, which is not a motive, nor even an emotion, but just a sense which very commonly runs through to the finger-tips of the painter without any conscious or describable intermediary, leaving on the canvas a passage of so-called accidental beauty of which the painter himself becomes aware not as creator but simply as beholder. Beauty arises in a thousand ways, even with a bread-and-butter motive; to trace these out is an interesting essay in conjecture; but the story of the mental genesis of beauty is not aesthetics. Those who think it is are thrown into the curious position of making natural beauty a special and specially difficult problem. However produced, a beautiful object is what it is, and its beauty, whencesoever derived, is a part of what it is. If in order to judge a work of art or to vindicate the aesthetic predicate in my judgment I had to know anything of the creative experience of the artist a palsy would fall upon my sensibility. In fact, however, I roundly call the line-work of a prehistoric bone-graving beautiful, although I neither know nor ever will know what sort of experience originated it. My judgment, being about the engraving, is based on the engraving. It cannot decently have any other ground. By "beautiful" I mean, not that the thing has been produced in a certain

way, but that it is in a certain state. I have in mind only what is in it, not what lay behind it. The causal explanation of beauty is not a definition of its nature, which is the only peculiar problem I can find for aesthetics as a philosophical science.

Perhaps the bias against which I am here arguing is not entirely psychological, but springs in part from that emphasis on origins which arose with the rebirth of the theory of evolution, an emphasis which has brought with it the odd principle, implied in a great deal of current quasi-philosophical thinking, that a thing is not really what it is but only what it sprang from: man is an animal, religion is fear, this vast frame of things is but an assemblage of star-dust. Even where this egregious principle is not insinuated, we have a diversion of interest from what a thing is to how it came to be what it is. The neglect of essence, the cult of causality, is one of the chief distinguishing marks of modern as compared with Greek and medieval philosophy; and its being later does not make it better. Phenomenology is a timely recall to the Platonic ideal of knowledge.

The other pole of subjectivism—interest in appreciation—is more enticing. It has the considerable scientific advantage that the connection between appreciation and the object appreciated is more open to inspection than is the connection between creation and the object created. Appreciation is a more conscious process, also a more common one, for while few of us are artists we are all appreciators. But if, in this commerce of object and appreciation, we concentrate on the appreciative side, we do no more than prepare the approaches to aesthetics. To differentiate aesthetic experience from other forms of experience by comparing its subjective aspect with theirs, seeking its peculiarity in a characteristic attitude or emotion, is to conduct an entirely psychological inquiry. So far, it is legitimate, but all too commonly the boundary is passed with a bias which leads to the further step of defining the aesthetic object in terms of that attitude or emotion.

When this step is taken we are left in the air with a purely formal definition. The aesthetic object is reduced to a mere correlate: it is simply whatever we respond to in the supposed aesthetic manner. We are even discouraged from trying to fill the empty form with any content of its own. Objects *quâ* aesthetic are said to be simply objects related to aesthetic feeling. Anything can be made aesthetic by adopting the aesthetic attitude towards it; some object is needful to provide a focus, but otherwise it is indifferent. This seems to me to be an error of fact. It amounts to saying that an entire section or function of experiencing consistently lies under no restraint whatever from the objective side. I believe in the spirit's freedom as firmly, though not so

ardently, as those aestheticians to whom it is the most dear of all things, but I cannot find in myself a freedom of the kind asserted. When I attribute beauty to an object the tribute seems to be wrung from me by the object, and if on reflection I conclude that I have misapprehended the object, I am unable to retain the attribution, at any rate in the form of a judgment (I may retain it in the form of emotion, but emotion is the most conservative part of our nature, much more quick than judgment to slip into a habit). I cannot at pleasure give it, withhold it, or change it. Under the influence of a mood beauty may lose its savour, but not its beauty; in a reflective person the judgment remains the same so long as the object does.

The practical consequence of defining beauty as just what we greet with the supposed aesthetic attitude is that every aesthetic response would be right, or rather neither right nor wrong, but merely natural. Even the most discerning piece of art-criticism would be no more than a personal confession, to be read, if read at all, only in order to know what the critic feels about his object, not whether he has detected in this some aspect or relation which I may have overlooked. I must accept his judgment as final for himself and irrelevant to me. On this view the aesthetic judgment disappears, becomes a synonym for a judgment of introspection, being reducible without any loss of meaning to "I feel in such and such a way towards this object." To say conversely, "This object makes me feel in such and such a way"—which, though not an aesthetic judgment, is on the way towards one—would be to destroy the subjectivism I have in view, for by imputing a potency to the object it prescribes an investigation into the general nature and particular forms of that potency.

The reasoned way of escape from all this subjectivism which is due to onesided concern with appreciation seems to me to consist in reminding ourselves of two very elementary distinctions. The first is the distinction between object and thing. It is sufficient for our present purpose to say that the thing is what is really there, whereas the object is so much of it, or of anything else, as comes effectively before the mind. Now what may be indifferent to the aesthetic feeling is the thing. In the presence of any thing I may under subjective causation adopt an aesthetic attitude, but only because I apprehend the thing either in one of its intrinsic aspects or in a certain context of images and ideas. Subjective conditions may determine the perceptual discrimination (as they do, indeed, even in perception with a scientific interest) or the movement of imagination, but it is the perceived or imagined object that determines the appreciation. When in certain conditions of light I see a foul slum-alley as beautiful, I am not asserting an unrestricted liberty of

judgment and feeling. The only freedom I am asserting is from my olfactory sensations and from my knowledge of the ghastliness of slum-life. For the rest I am submitting to my mind's immediate object—to the patterned incidence of light, the mercury of concealing shadow, the balance of the two, the continuity and contrast of lines, and the coherent arrangement of masses. When the object is constituted by imagination instead of by perception, the situation is the same: however the object is produced, it is the object that produces the appreciation. Presumably, then, it has specific properties, of which the appreciation is a recognition.

But the term "appreciation" is ambiguous, and the second elementary distinction to be stressed is between appreciation as emotion and appreciation as judgment. The one is simply an event, and the other an event bearing a claim. The first savours beauty, the second asserts it. The one calls for causal study, the second for definition and testing. The distinction is not a merely analytical one. Unreluctantly and unaffectedly I can admit an object to be beautiful without liking it (even without having liked it, so that the judgment is not explicable by memory or habit). This may be shocking to those subjectivists whose ruling desire is to enjoin that the aesthetic objective shall be greeted with an emotion at once vibrant and authentic. The requirement is in place in a *Lebensanschauung*, but not in aesthetics. Anyhow, I do meet objects with the judgment that they are beautiful, and all that is theoretically required of judgment is that it shall be true; the emotion that accompanies it is logically irrelevant, irrelevant because it is bound up with an individual set of mental and bodily conditions. Reverting now to our previous point, I would say that what enjoys a considerable degree of independence of the aesthetic object is the emotion, or the attitude of which the emotion is part. I cannot neatly balance this statement by saying that contrariwise every judgment is wholly determined by the object. Nevertheless, the ideal is that they should be. Determination in this sense, however, is not the right word to use. What matters about a judgment is not what causally determines it, but what it logically determines. Its judgmental character consists in a claim to be *relevant* to an object, and it is by reference to the object that the claim has to be understood and tested. I see no reason for exempting aesthetic judgments from this requirement.

From the foregoing considerations I venture to draw the following conclusions: (1) That the constant form of aesthetic experience is the aesthetic judgment. It is, moreover, the perfect form, the entelechy, the experience gathered up, articulated, and brought to the clear level of cognitive awareness and intention. If, then, I may be allowed to follow Plato, Aristotle and Hegel in holding that philosophy is distinguished

by its studying everything in its most organised form, I must hold that aesthetics as a philosophical science is primarily concerned with the aesthetic judgment, not with its subjective accompaniments and conditions. (2) That the aesthetic judgment cannot be reduced without remainder to an introspective one. It is not about me but about the object. Nor is it a blank assertion of the object's potency over me, but about some feature in it that wields that potency. And the potency it primarily wields is not over my feelings, but over my powers of judgment. The minimum and distinctive quality of beauty is that it wins for itself admission; whatever else it wins is largely a matter of accident, the accident of association, of mood and of taste. (3) That aesthetic experience needs to be studied normatively (i.e. leaving room for a right and a wrong), and that the only feature of it that allows of an aesthetic norm is the aesthetic judgment interpreted objectively. If "This is beautiful" meant *simply* "I like it," it would be impossible to pass to "All people ought to like it"; a purely subjective judgment cannot be generalized and elevated into a norm. Even if it could be, a canon that enjoins us to adopt a certain attitude to beauty loses all its canonical character if beauty be defined as that to which this attitude *is* adopted, and all sense except that of tautology if beauty be defined as that to which this attitude *ought to be* adopted. And in either of these two senses the canon dogmatically brushes aside as meaningless the perfectly sensible question: What kind of object am I to respond to aesthetically? But in any case a norm or canon of feeling belongs to ethics, not to aesthetics. The right attitude to beauty is no more the affair of aesthetics than is the right attitude to truth the affair of epistemology. What we require, in aesthetics as in practice, is a canon of judgment; the only canon of the aesthetic judgment is a definition of its predicate, beauty; and the only definition of beauty that preserves the aesthetic judgment in its integrity (that is, from being a synonym for an altogether different kind of judgment, an introspective or lyrical one) is a statement of certain properties of objects.

As Plato pointed out, the paradox of all search for definition is that we already know what we are seeking to define. The paradox is not resolved by simply restating it in the form that we already perceive what we want to conceive, for the conception is prior. The paradox is that while psychologically the denotation comes first, providing the material over which the defining activity analytically and synthetically plays, logically the connotation is prior because it prescribes the denotation. We only escape from the paradox by admitting that conception has an embryonic stage in the perception. It is just because the concept is already involved in our immediate apprehensions that it can be evolved

from these by reflection. Our spontaneous application of the same term to many things rests on a basis of unconscious recognition of that common quality which is to be abstractly expressed in the definition. In defining we do but raise to clarity, purity and organization a precedent knowledge that was obscure, confused and inarticulate.

Where, then, there is consistency in our perceptions the business of defining is in principle easy. An accepted denotation seems to be the condition of reaching an acceptable connotation. Now the absence of this condition is the practical difficulty in the way of defining beauty. We haven't the agreed instances from which to generalize, nor by which to check our tentative generalizations. Where there is no homogeneous group there can be no common quality.

It may be urged that beauty, being an ideal, is insusceptible of inductive definition, and that the difficulty here is that we have not yet devised a logic for the definition of ideals. But I am by no means certain that beauty is an ideal in the sense in which good is; the most striking respect in which they are alike is that we differ heartily about their meaning, and this does not make beauty an ideal. Whether it is or not we meet it as a fact. But an ideal is a *summum*, and the expression *summum pulchrum* is nothing more than a grammatically correct collocation of words. It is meaningful to speak of a more beautiful and a less beautiful, but there is a heavy limitation to this quasi-quantitative comparison. One painting may be more beautiful than another, and yet two others may be incomparable in respect of degree, being, like a daffodil and a rose, like a statue and a piece of music, just different. Beauty, unlike goodness, has various orders—visual, auditory and so on—and in no one of these orders, still less in all of them taken together, is there one perfect degree or form, a *summum pulchrum*. It is not a hierarchy of subordinate and superordinate degrees, but a galaxy of brilliant individuals. Of each of these we ask only if it is beautiful: to ask how beautiful it is is trivial even where it is possible. Beauty as value is equally unintelligible to me. It *has* value; what it *is* is my present concern.

To return to the difficulty of the inductive definition of beauty. The wide disagreement about the denotation of the term is one of the grounds of subjectivism. I now want to protest that the disagreement has been exaggerated. We must at once discount the large number of second-hand judgments which, being determined neither by the judger's own sensibility nor by the character of his object but by modesty, laziness, desire to be counted perspicacious, up-to-date, or well-informed, are not properly aesthetic judgments but only verbally identical with these. Turning from the diffusion and persistence of

disagreements to their origination, we have to note that many people are unskilled or careless in discerning which of the stimuli is effective, exactly which aspect of the total object occupies the focus of attention. This ineptitude shows itself in many ways. Before a picture an onlooker is frequently excited by the painter's name, by the special reputation of the picture, by its rarity as a specimen, its market value, its history, its title, its mere subject-matter; and because a picture is admittedly an aesthetic thing he mistakes his excitement for aesthetic response and applies to a non-aesthetic aspect an aesthetic predicate. When "How beautiful!" really means "How rare!", "At last!", "Lucky owner!" and so on, it is not, of course, an aesthetic judgment. Disagreements here have no bearing on the question of the objectivity of beauty. Nor have the disagreements that arise through the efficacy of purely casual associates which are linked with the aesthetic object by nothing more than the accidents of individual experience, and which displace from the foreground of awareness the aesthetic stimulus that introduced them. (See *Note*, p. 281.)

The amount of disagreement, then, is considerably reduced if it be granted that not all judgments about a beautiful thing are really about its beauty, even though they verbally purport to be so. A single thing can strike at many a chord of our nature, touch many a need, show many an aspect of itself to cognition, and not every person is skilled enough to frame either spontaneously or reflectively a judgment which accurately expresses his dominant reaction or his dominant object. And the disagreement is even further reduced if we do in aesthetics what we do in all other spheres of study, namely, refuse to put everybody's judgment on one plane of equal worth. There is more concord among experts than among lay minds, one reason being that they are able to state their judgments in objective terms.

To these complaints about the ways in which the problem of the definition of beauty is treated I have to add two more. The first concerns the assumption that beauty is one. Doubtless there is a sense in which it is, but if the concept is reached quickly it is likely to be too narrow, empty enough not to gainsay a single kind of beauty instead of rich enough to comprehend them all. The concept of harmony is of this kind, the *abstractum* left when all differences have been left out. We may avoid this abstract form of unification by identifying all beauty with one of its concrete forms. This is very commonly done, and the form taken as standard is literary beauty. I feel increasingly sure that this exaltation of the literary type has an ultimate justification and yet not an aesthetic one. Keeping to beauty I find one difference which I cannot overcome, the difference between sensory and what, through

inability to find a better term, I will call ideo-sensory beauty. The first has an obvious exemplification in painting, the other in literature.

In literature the medium is not, and cannot be, regarded as purely sensory. Words, phrases, sentences are not mere sounds, but sounds appointed to be and operative as vehicles of determinate images and meanings and of the emotional evocations of these. The auditory aspect offers many possibilities of design, but all this various form and texture of sound-pattern has to be contributory to or concordant with the ideal burden which is the inalienable essence of the words. The so-called pure poetry desiderated by some of the moderns is not poetry, not literature, because its medium is not words but simply sounds; nor is it even music, for music is minimally a pattern of musical sounds, different both sensorily and physically from spoken sounds. Important, then, as sound-beauty may be in verbal art, it is subordinate; its whole office is not to present itself, but to introduce and reinforce a system of images and meanings and emotions; and since images and meanings and emotions are the distinctive stuff and life of human experience, verbal beauty is indefeasibly humanistic; not only properly but inescapably ideal, representative, expressive and evocative—which is another way of saying that it is inescapably related to that system of needs, interests and evaluations which make us practical and moral beings.

This is not the case in painting. Here the medium can be apprehended in its purely sensory aspect without mutilation. It can stand alone entire. It is not a necessary part of colour, line, and space to represent, express, or evoke. The sensory medium itself has a beauty all its own. Certain colours sit quietly side by side, others enhance each other; certain lines are graceful, directive, and organizing; certain masses are mutually supporting, coherent. These are the specific excellences of colour in its spatial setting, its own aesthetic aspect. With nothing more than these, a picture is beautiful, and so, too, is an evening sky, for I can detect no difference of kind between a natural scene and a painted one: both consist of congruent visual elements. In no case is it necessary to know what a colour-object stands for in order to appreciate its own beauty; as beautiful it is non-significant. I could still apprehend beauty in a sunset even if I did not know it to be a sunset, and without contemplating it imaginatively as the death-moment of day, as an emblem or monition of our mortality, or as an intimation that a passing so gorgeously attended is not extinction but translation. Paint may be used to represent, but the mere representing of things will not make beauty unless the things are beautiful. When what is represented is not centrally a visual thing, but some fragment of life's joy or pathos, itself perhaps beautiful, we have a supervenient

beauty, that of the subject of the painting, not of the medium, of the painting as paint. If, then, painting and the other visual arts, and probably music, too, may be beautiful quite apart from what they represent or express, there is a beauty distinct from that of which alone literature is capable. To approach painting, sculpture, architecture and music from the side of literature and require there what is always to be found here is to overlook the nature of the difference between the two kinds of media, one of which may, the other of which may not, forgo all representative or expressive character. A word ceases to be a word and therefore loses the beauty of a word when its signification and significance are not apprehended; a colour is most a colour when apprehended apart from what it may happen to represent, and then most reveals its own beauty. Between the homogeneous beauty of a colour-pattern and the ideo-sensory beauty of a poem I can find no likeness, for the latter is not a pattern of mere images, still less of visual images, but an organic concretion of every kind of experienceable element. This "Persian carpet" account of painting may be a poor theory of art, but it is the only just theory of visual beauty.

This leads me to my final grumble, one against the tendency to define beauty as whatever can be achieved in the arts. This gives us the absurdity of calling the comic beautiful. Aesthetics and the philosophy of art are made to coincide instead of to overlap. Art is capable of, and achieves, more than beauty—this is the secret of its thrall. The minimal task of each art is a manipulative emphasis on the peculiar virtues of its medium, but if, when this first duty has been cared for, the medium can be further exploited without prejudice to its basic excellence, the result is a richer and therefore more acceptable gift. I see no reason why a painter should not represent things, express his attitude towards them, preach, teach and move, provided he does so from a rostrum of beautiful paint. Nor do I see any reason why a painter should be required to do these additional tasks, since the discipline and craft of painting have no magic to give its practitioners insight into human character, moral values, and non-phenomenal truth. The school that would limit art to the creation of its proper beauty is trying to reduce it to its minimal task; the school that would force an art with a material medium to expression and the like, is requiring of the artist what his special skill does not of itself enable him to give. In the sphere of aesthetics this conflict has its correspondence in the controversy between formalism and, in the widest sense of the term, expressionism. For the first, all beauty is sensory, for the second ideo-sensory. For me there are both these kinds, irreducible to each other. But if, under a verbal scruple, under the desire to define beauty univocally, I have a

leaning, it is towards formalism, for sound and sight that self-effacingly present a world of significant and emotive ideas appeal not to a part of man but to the whole of him; he meets them as a practical, moral and religious personality. Beauty is too poor a predicate to apply to anything expressive. From which I deduce that an expressive work of art, not being exhaustively describable as beautiful, falls under the approval and law of our moral judgments. Only senses are non-moral. But the sphere of moral judgments is to be circumscribed in ethics; aesthetics can only mark out its own realm.

Note

Sometimes, of course, the associate, or the complex now formed of it and its introducing object is a new aesthetic object. When Keats contemplated his Grecian urn, he apprehended neither the beauty of its shape nor the specific beauty of the painting on it. What he noticed was the subject of the painting and the silence and immobility of the representation, and then, with a sweep of imagination, he idealized and eternalized it. The unheard melodies of the painted piper are sweeter than those that strike the sensual ear; the painted tree has happy boughs that cannot shed their leaves; the painted damsel will never age nor her painted lover ever cease his wooing. The visual beauty of the vase is curtained over with a new object, also beautiful, but in a different way. Here we have the distinction between sensory and ideo-sensory beauty.—Cf. above.

18. THE SUBJECTIVITY OF
AESTHETIC VALUE

CURT J. DUCASSE

1. Criticism Is (a) Judgment, (b) of Worth, (c) Mediate or Immediate, and (d), Respectively Fallible or Infallible

Criticism is judgment concerning questions of worth, value. All criticism involves reference to some character, the possession of which by the object criticized is regarded by the critic as being in some way good, or the lack of it, bad. The object is then examined with respect to that character, and pronounced good or bad in the degree in which it possesses it or lacks it. Such a character so used constitutes a standard of criticism. The character used may be one the possession of which makes an object *mediately* good; or on the other hand it may be one that makes the object *immediately* good. The object is said to be mediately or instrumentally good, when the character used as standard of goodness, and possessed by the object, is that of being an adequate instrument to or a necessary condition of the production or preservation in certain other objects, of characters which confer upon those objects immediate goodness of some sort. An object, on the other hand, is said to be immediately good when the character used as standard of goodness, and possessed by the object, is that of being directly and immediately a source of active or passive pleasure to some conscious being. That is to say, the object is called immediately good when it is, to the sentient being in terms of whose point of view it is asserted to be good, a source of pleasure *directly through its relation to him,* and apart from any pleasure which it may also procure him indirectly through its actual or potential effects upon other objects. The conscious being in terms of whose point of view the assertion of immediate goodness is made may be one person

or a class of persons; it may be oneself or someone else; it may be a self considered in some one only of its aspects, which may be an active or a passive one; or it may be a self, such only as it is at a given time or in given circumstances. But any doubt as to which such sort of self is referred to when goodness is predicated of anything, will leave the import of the predication hopelessly ambiguous.

The instrumental goodness of an object can be proved or disproved, if there is agreement as to the end, being a means to or condition of which constitutes the object's goodness; for it is then only a matter of showing whether or not the object does under the sort of conditions in view, cause or make possible in other objects effects of the sort desired. Thus it is possible to prove to someone who doubts or disbelieves it, that a given chisel is a good, or as the case may be, a bad chisel. As to instrumental goodness, mistakes can be made.

But the immediate goodness of an object cannot be proved or disproved to the self in terms of whose point of view immediate good-ness is asserted to be possessed by the object. Such immediate goodness being a matter of the pleasure which *that* self experiences through his direct relation to the object, he himself is the final and infallible judge of it; for, as to pleasure, appearance and reality are identical. His actual pleasure or displeasure when in direct relation to the object, constitutes the proof or disproof *to others*, of any assertions or predictions that *they* may have made as to what, in terms of his point of view, is, or will turn out to be, immediately good. Such an other, to whom the prediction may have been made, may of course be, or have been, living under the same skin as the self who verifies the prediction; but it cannot be strictly the same self.

2. Possible Standards of Criticism of Aesthetic Objects

The foregoing remarks embody the essential propositions of a general theory of criticism, which cannot itself be argued here in greater detail, but of which an outline was necessary since it constitutes the foundation of the opinions on the criticism of works of art and aes-thetic objects, to be set forth in this chapter.

The principal standards of criticism that may be used in connection with works of art and aesthetic objects are as follows:

(a) A work of art may be considered as such, i.e., as the product of an endeavor on the artist's part to express objectively something he felt, and the question be raised whether or not it is good, in the sense of expressing that feeling adequately.

(b) The question may on the other hand be asked whether the work

adequately expresses not so much the feeling that the artist originally attempted to express through it, but rather a feeling which on consideration he is willing to acknowledge as truly an aspect or part of himself.

(c) A work of art may, however, be considered also in the light of its capacity to communicate to others the feeling that the artist objectified in it, and be judged good or bad according to the measure of that capacity.

(d) Again, any aesthetic object, whether it be a work of art or a natural thing, may be criticized simply in respect to its beauty or ugliness.

(e) Any aesthetic object, whether natural or a product of art, may also be criticized in the light of the worth of the sort of action through which the particular feeling obtained in the contemplation of the object will tend to discharge itself, if, when that feeling has been obtained, the *practical* attitude is then allowed to replace the contemplative.

These various standards of criticism will now be examined in turn.

3. Success of the Attempt at Self-expression as Standard

The most common form of criticism of works of art is criticism in terms of beauty and ugliness. The terms beautiful and ugly, however, have no meaning whatever in terms of the creating artist's point of view, but only in terms of the spectator or "consumer," whether he be the artist himself later contemplating and evaluating his creation, or someone else. That which is evaluated in terms of beauty and ugliness is therefore not at all the work of art as such, viz., as product of the artist's endeavor to give his feeling embodiment in an object, but only the object itself that the spectator contemplates, and wholly without reference to the question whether that object is a product of art or of nature.

On the other hand, criticism of a work of art considered as such, would be concerned solely with the measure of success or failure of the art, i.e., of the artist's attempt consciously to objectify his feeling. It is obvious, however, that no one but the artist himself is in a position to say whether, or how far, he has succeeded in creating an object adequately embodying his feeling. The test of the success of his attempt at objectification, as we have seen, is whether the object created does, in contemplation, mirror back the feeling which he attempted to express. What that feeling was, however, is something which is known to no one but himself; and therefore he alone is in a position to perform the test. If the artist is able to say: "Yes, this exactly reflects back to me the feeling I had," then the last word has been said *as to that*, i.e., as to the

success of his attempt at objective expression of his feeling. It may quite properly be insisted, however, that success of that sort is something which is of interest to no one but himself, or, possibly, his mother or his wife. Conscious objectification of feeling, as defined by that test, may therefore be termed *private or individual objectification*, as distinguished from *social objectification*, the test of which would be the object's capacity to impart in contemplation the artist's feeling not merely back to himself, but on to others also. Criticism in terms of this test will be considered presently.

4. Signability of the Work of Art by Its Creator

As already noted, however, the artist's *final* criticism at least, of his own work, is likely to be based not so much on the question whether the feeling which he finds he has objectified is exactly that which he attempted to objectify, as on the question whether, after thoroughly "tasting" (through contemplation of his work) the feeling he has actually objectified, he finds it to be one that he is *willing to own*, i.e., to acknowledge as being really a part or aspect of his emotional self at the time. In other words, the question is whether the work he has created is one which he honestly feels he can sign.

It is obvious that, again, no one but the artist himself is in a position to criticize his own work on that basis. Criticism of this sort would normally accompany criticism of the kind first mentioned, which passes on the question of the sameness of the feeling actually objectified, and of the feeling which was to be objectified.

As pointed out earlier, this sameness obviously cannot be sameness in every respect, but only *qualitative* sameness. Such qualitative identity of the two feelings, however, leaves room for gain in clearness and vividness of the given quality of feeling, as a result of the process of objectification. Such a gain in clearness and vividness beyond question occurs, but it is the only respect in which the feeling need become different through the process of objectification. Indeed, the qualitative identity of the feeling before and after objectification is an absolute prerequisite, if one is to be able to say that it is *that* feeling which has been clarified. That the feeling should be clear, however (in the sense in which it is possible for a feeling to become so), is in turn a prerequisite of criticism of one's work in terms of the second question mentioned above, namely, the question whether it constitutes objectification of an emotional self *truly one's own*.

It is perhaps unnecessary to point out in this connection that approving on this basis the object that one has created is quite a differ-

ent thing from finding it beautiful. The pleasure which such approval does express is pleasure found, *not in the feeling* objectified by the work (which would be what would constitute the work of art beautiful), but *in the success* of one's attempt to objectify an aspect of one's emotional self; and this latter pleasure remains, whether the feeling objectified be a pleasurable or a painful one, i.e., whether the object created be beautiful or ugly. The difference is analogous to that between the pleasure of having succeeded in stating accurately some thought that one had, and the pleasure (or displeasure) of finding true (or false), on reflection, the statement that one has made.

5. Signability of the Work of Art by the Beholder

Criticism of a work of art (and equally of a natural object) on the basis of the question whether one is willing to *own* the feeling which it objectifies, is possible to others than the artist himself. The only difference is this. When the artist answers that question in the negative, he then proceeds to alter the object he has created until he finds himself able to say: "Yes, the feeling which this now objectifies is truly a part of myself." But when the critic on this basis, is someone else than the artist, that critic is then not trying to objectify his feeling himself, nor therefore is he called upon to make alterations in the object before him. His problem is simply to decide whether or not the thing before him objectifies a feeling that was his, or one that perhaps he had not yet experienced but that he is able and willing to call his. And once more, this decision is one quite distinct from the question whether or not the feeling objectified is pleasant and the object therefore beautiful. Most of us are quite able to obtain pleasure from various sources of which we are ashamed; so that the self that experiences pleasure from such sources is not one which we acknowledge as truly our own, but only a self with which we find ourselves saddled, and of which we cannot get rid.

6. Capacity to Transmit the Artist's Feeling to Others

To say that a given aesthetic object (whether natural or a work of art), objectifies a certain feeling means, we have agreed, simply that that feeling is obtainable from it in contemplation, and we have just seen that, with regard to such a feeling, the question can be raised, by others as well as by the maker of the object (if it be man-made), whether the feeling objectified in it is a feeling that they are *willing to own*.

We saw too that another question distinct from this can be asked, namely, the question whether the feeling actually objectified, i.e., obtained from the object in contemplation, is qualitatively *the same as* that which the artist originally endeavored to objectify. We may now go on and point out that this question, like the preceding one, can be asked (if not, perhaps, answered) by others than the artist himself. When others than the artist ask it, what they do is to consider the work of art as a possible *means for the conveying to them* of the feeling which the artist endeavored to express.

Expression of a feeling in a manner adequate to impart it in contemplation not merely back to the artist himself, but also on to others, may be called *socially objective*, as distinguished from expression which is only *privately* or *individually objective*.

Whether an artist's expression of a feeling which he had, achieves private objectivity, is something which, as we have noted, cannot be decided by others; but *can* be decided by the artist since both of the feelings the qualitative sameness of which is in question are facts of his own experience. Social objectivity of the expression of a feeling, on the contrary, is not something the achieving of which can ever be strictly proved or disproved either by the artist or by others, since God alone would be in a position to compare *directly* the two feelings experienced by two persons in contemplation of the same object. All that can be said is that the two feelings will be qualitatively the same (i.e., social objectification of the feeling will be a fact), if the two (or more) persons concerned are alike in their psycho-physical constitutions. Of this, however, we can make no direct observation either, or at least none that will be adequate. Any conclusion that we reach as to the sameness of the feeling that the two persons each have on the given occasion, has therefore no other status than that of an inference from their observable behavior, which here would be mainly verbal behavior, viz., their words. And any such conclusion, therefore, is reliable only so far as the two persons use their words in the same sense. But whether two people use their words in the same sense is something which, in *ultimate* analysis, can be checked up only through the act of pointing. This means that it can be checked up only in case a word signifies something that can be pointed to, and even in such cases, the sameness that is insured is sameness only so far as purposes of coöperation are concerned. For instance, if I say that by "green" I mean something which I actually point to, and another person accepts my use of the word, all that we then know is that we call by the same name whatever color we each perceive in the place pointed to. We do not in the least know that the *quality* of sensation which the one experiences when he looks

there, is the same quality as that experienced by the other. It is quite conceivable, for instance, that all my sound sensations in response to given stimuli should be pitched one octave above those which another man has in response to the same stimuli. If this were so, all *relations* between sounds would be left unaltered by this difference, and the answers of each of us concerning questions of intervals, pitches, tone-color, etc., would agree perfectly although we never in fact would be hearing literally the same thing. The *literal* qualitative sameness of the subjective experiences of two persons such as their sensations and feelings, could be ascertained only if we, or some third party, were in a position to compare the experience of the two in the same direct manner in which anyone of us can compare, for instance, two of his own sound sensations, or two of his own emotions.

Such literal qualitative sameness, of course, has no *practical* importance whatever. For all practical purposes the only thing important is the sameness of the relations, which can be checked up by pointing. But where the transmission of feeling for purely aesthetic purposes is concerned, the *literal qualitative sameness of the feeling* is on the contrary the only sort of sameness then relevant. Oratory, in probably the majority of cases, is primarily skilled work. That is, the orator is usually not primarily intent upon transmitting integrally his own feelings to his auditors, but rather upon inspiring them with any feeling that will express itself practically in the sort of behavior he desires of them,— voting, fighting, subscribing to a fund, or what not. But with the artist it is otherwise. The poet, for instance, if he reads his verses to others at all, is not concerned to make them do anything but only to have them reproduce in themselves the very feeling which he sought to objectify. Only literal sameness of the feeling will do here. The most enthusiastic praise of an artist's work by someone else is disappointing to the artist and makes him feel more alone than adverse but discriminating criticism would, if he believes the praise to be based upon a misperception of what he sought to express. Pragmatic sameness of feeling, i.e., sameness *of behavior* after contemplation of the object, has no relevance here except in so far as it may constitute evidence of literal qualitative sameness of feeling. And that it constitutes any evidence of it at all is ultimately nothing but a postulate, a fond hope of the gregarious heart, the fulfilment of which is never actually to be verified. But it is nevertheless a hope that the gregarious heart does entertain, and does stake upon.

Just this, viz., staking upon a hope, is what constitutes *making* a postulate, as distinguished from merely *stating* one. But when one is made the general postulate that sameness of behavior constitutes

evidence of sameness of feeling, then under that postulate *the strength* of the evidence becomes a matter of the *degree* of sameness of the behavior, and of the *variety of respects* in which that sameness obtains. This theoretically precarious criterion of literal sameness of feeling being the only one available, it is the one we actually use to decide whether another person gets or (with more confidence) does not get from the contemplation of a given object the same feeling that we do. The same thing may be put in other words by saying that the criterion is the one we use to decide whether or not a given work of art is good, considered as a means of conveying some certain feeling from one person (who may or may not be the artist) to another.

7. Judgments Passed on Aesthetic Objects Constitute Information Concerning the Judge

It is interesting to note, however, that that criterion may, under the same postulate, equally be used to judge, not the worth of the work of art as instrument of transmission of feeling, but the range and nature of the feeling-capacity of the person to whom we exhibit it. For *what* a person's reaction to a given aesthetic object is or is not signifies fully as much concerning him as concerning the object. He may thereby be revealed, for instance, as learned, or intelligent, but aesthetically insensitive; or as aesthetically sensitive, but without knowledge *about* works of art, or without much aesthetic past experience and aesthetic perspective; or as possessed of a highly specialized sort of aesthetic sensitivity; or of an aesthetic sensitivity which we ourselves should call perverted, or exaggerated; and so forth.

8. Connoisseurship

This directly leads to the question what exactly constitutes a person a "connoisseur," and what do a connoisseur's pronouncements signify.

A clue to the answer may be found in what we find ourselves spontaneously saying on the concrete occasions where we discover that a given person is *not* a connoisseur of something or other. The discovery is likely to be expressed by us in the remark that *he cannot tell the difference*. This clue, however, must not be followed blindly. We cannot define a connoisseur as a person who can "tell the difference," for the important matter here is not capacity to *tell* it, but capacity to *know* it. Moreover, among those who "know the difference," we must distinguish between those who know it as it were by proxy, i.e., by inferring from memorized signs a difference which they have learned that *others*

would perceive; and those who "know the difference" in the sense of *concretely experiencing it themselves*. It is to these, I should say, that the name of connoisseurs most properly belongs, although when confronted by the distinctions to which I have just called attention, linguistic usage in regard to the term "connoisseur" must I think acknowledge itself hazy. Let us suppose that we have before us two men, one of whom can experience the difference concretely himself but cannot tell it to others, (i.e., cannot conceptualize it); and the other, a man who cannot himself experience it concretely but is able to infer it from signs learned and to formulate it conceptually to others. We should I think say that it is the former rather than the latter who is truly a connoisseur. The second we should rather describe as an intelligent echo; or compare him, perhaps, to the trained reporter who, himself barren of deeds and blank of adventures, writes up those of automobile magnates and African pioneers. Such a person is not a connoisseur, but only the mouthpiece of a tongue-tied connoisseur. Or, the most that could be said of him is that he is a connoisseur at second-hand. However, although one may be tongue or pen-tied and yet truly a connoisseur, one may also be truly a connoisseur, and yet not be tongue or pen-tied. That is, one who knows the difference through his own direct experience may well also be able to state it in concepts. Although neither capacity involves the other, the two are quite compatible; and to the man who has both, the name of connoisseur would be disputed by no one.

We must next inquire, however, just what being able to experience the difference, means. Most people are amply aware of a difference between, for instance, "Home, Sweet Home," and "The last Rose of Summer"; that is, if one is played after the other, they are aware that the second melody is not the same as the first. Or again, if one of these melodies is played first in one key, and then in another, most people, I suppose, are aware that the second time their experience is somewhat different from the first. But a much smaller number of persons would be aware of any difference if the same melody were played first in perfect tune, and then with a note here and there slightly off pitch; and probably a still smaller number, if the difference were between the melody as played, let us say, first by Elman and then by Kreisler, each behind a screen. But, the number of those aware of any difference would dwindle down to relative insignificance if, instead of a simple melody played by two different violinists, the test were, let us say, a Beethoven symphony as interpreted by two different conductors. In each of these supposed cases, the sort of difference referred to is, let it be emphasized, *difference in feeling import* of what is heard, whether or not accompanied by awareness of a conceptually analyzed difference between the objects,

—such as awareness of difference in pitch, recognized as such, would constitute.

A person, we may then say in general, is a connoisseur in proportion as he is capable of experiencing directly differences of which others remain unaware. And in particular he is connoisseur *in aesthetic matters* when the differences he intuits are differences in the aesthetic feelings and the aesthetic pleasure obtained in the contemplation of closely similar objects; but *not* when the differences of which he is aware are *merely* differences between the objects themselves. In that case he is merely fitted to be an expert detective of such historical facts as authorships, periods, influences, fine points connected with the technique of the medium, etc.; or an augur, expert in reading the signs on the basis of which can be predicted the aesthetic experiences of certain persons or classes of persons. Connoisseurship in such things, however, is quite compatible with nearly complete emotional and algedonic anaesthesia. The art-critic's essential business is not to "consume" works of art, i.e., to contemplate them aesthetically, but to write or talk about them, i.e., *around* them; and the best art-critics are not infrequently persons of the type just described, who are connoisseurs of everything about works of art, except of the work's aesthetic import. Indeed, it has been said,— I believe by Müller-Freienfels,—that the best critic must be a man who has no taste. His essential interest being in matters which do not require the aesthetic experience, capacity for the latter and inclination to it, could only distract his attention.

But even in connection with the definition of the true aesthetic connoisseur given above, certain reservations must be made. The aesthetic connoisseurship of a given person may be confined not merely, as usual, to some particular aesthetic field such as that of music, poetry, painting, etc., but to some very limited aspect of one of those fields. For instance, in the field of painting, a person may possess high aesthetic sensitivity to color differences, and yet be aesthetically very insensitive to line or shape differences; or he may be sensitive to line differences but not to differences of "values," i.e., of lights and darks; or again he may be sensitive to the feeling-import of the design aspect as a whole, but virtually anaesthetic as regards the feeling-import of the dramatic aspect, or vice versa; and so on. Aesthetic connoisseurs of such specialized sensitivity may be good guides but are bad leaders. They are useful if one allows them to lead one's attention for a time, but dangerous if one lets them capture it and permanently mold it to the warp of their own.

Again, it should be clearly realized that the nature of aesthetic connoisseurship is one thing, and the value of it another. The capacity to intuit differences to which others are insensitive constitutes con-

noisseurship, whatever it is worth. It has a worth, but it also has a cost, the nature of which is suggested by the saying that where ignorance is bliss, 'tis folly to be wise. The usual reason why a "fool's paradise" is not as good as any other is that it soon leads one into some sort of purgatory owing to its practical connections. Aesthetic "fool's paradises," however, are relatively free from such connections, and so far as this is the case, they are as good as any others. Indeed, if one should elect to measure worth purely in terms of aesthetic value (as one may well do where aesthetic objects are concerned), one would have to say that there are then no such things as aesthetic fool's paradises, but that all aesthetic paradises are genuine, and equally capable of filling with bliss the individual cup of such persons as find themselves at home there. Connoisseurship makes possible aesthetic pleasures, and also pains, which persons who are not connoisseurs cannot experience. But it also makes impossible the aesthetic pleasures which none but aesthetically less sensitive souls can taste,—and the corresponding pains, such as that of the aesthetic bafflement and bewilderment experienced by such a tune-hungry soul, in listening to a symphony.

Increase in aesthetic sensitivity may then with equally good reasons be described as progress or as perversion. Which of the two one calls it depends usually on whether one's own aesthetic sensitivity is changing (and in what direction), or on the contrary "standing pat" at a place where it finds itself happy.

The upshot of these remarks is then that to call upon the aesthetic connoisseur for an answer to one's own questions of *aesthetic worth*, is, when considered in broad daylight, as ludicrous a procedure as would be the letting some person whose taste in matters of cookery differs from ours, but who is a connoisseur of foods, while we are not, choose our dainties for us. What he may do for us is to *introduce* us to delicate dishes of which we knew nothing and which perhaps will disclose to us pleasures hitherto unknown. But if after tasting these connoisseur's dishes we do not like them, or do not find them more enjoyable than our own familiar foods, we should be fools indeed to pick our menu according to our gourmet's taste rather than our own. Coarse the latter may be called by him; but we too have a stock of poisoned, question-begging adjectives, out of which we may without fear of refutation call his taste perverse.

9. Beauty as Standard

The account of standards of criticism of works of art and other aesthetic objects given up to this point has remained throughout

essentially independent of the notion of beauty. But the endeavor persistently through the present work to leave that notion out wherever possible is not due to an underestimation of the importance of beauty. It is due only to a desire that the notion of beauty shall not, as usual in works on aesthetics, spread itself like a spot of fragrant conceptual oil, haphazard over the whole subject. In these pages, on the contrary, the endeavor has been to define in the sharpest possible manner both what is, and what is not, the true place of beauty in the philosophy of art.

But now, after all the eloquence with which I have so far *not* brought in beauty on every occasion, I may without fear of misunderstanding freely acknowledge, or rather vigorously assert, that beauty is a perfectly legitimate standard (among others) in terms of which to evaluate works of art; that it is the standard most commonly and spontaneously used; and that of all standards of evaluation, it is the one here most obviously and directly relevant. Indeed, if beauty should have anything like the commendable affinities and hidden relations that Plato, perhaps rightly, ascribed to it, one might well then claim that beauty is not only the most naturally and generally employed standard of criticism of works of art, but also the most significant from the point of view of human life considered as a whole. While such far-reaching worthy affinities and hidden relations are not implied by the definition of beauty which I have proposed, they could not, on the other hand, be regarded as precluded by that definition, except on the puritanical assumption that whatever is pleasant is somehow bad. I have myself more sympathy with the opposite assumption, that whatever is pleasant is somehow good, not only directly but also in the fundamental tendencies of its affinities. However, I shall not attempt to argue this matter here; nor do I claim it to be much more than an article of faith, to be held cautiously and practiced with discrimination.

10. Beauty Is Relative to the Individual Observer

Beauty, it will be recalled, was defined as the capacity of an object aesthetically contemplated to yield feelings that are pleasant. This definition cannot be characterized simply either as objective, or as subjective. According to it, "beautiful" is an adjective properly predicable only of objects, but what that adjective does predicate of an object is that the feelings of which it constitutes the aesthetic symbol for a contemplating observer, are pleasurable. Beauty being in this definite sense dependent upon the constitution of the individual observer, it will be as variable as that constitution. That is to say, an object which one person properly calls beautiful will, with equal pro-

priety be not so judged by another, or indeed by the same person at a different time.

There is, then, no such thing as authoritative opinion concerning the beauty of a given object. There is only the opinion of this person or that; or the opinion of persons of some specified sort. When one has stated the opinion and mentioned the person or class of persons who hold it, one has gone as far as it is possible to go in the direction of a scientifically objective statement relating to the beauty of the object. When some matter (as that of beauty) is not of the sort which "is so," or "not so," in an *absolute* sense, the nearest approach that one can make to the wished-for absoluteness lies in furnishing, as fully as possible, the data to which the matter in question is *relative*; and this is what one does in the case of beauty when one indicates just who it happens to be, that judges the given object beautiful or the reverse.

All that was said above concerning aesthetic connoisseurship, i.e., concerning superior capacity for experiencing difference in aesthetic feeling in the presence of slight differences in the aesthetic object, applies equally here, where differences in the pleasantness of the feelings are particularly in question. There are connoisseurs of beauty, or, more often, of particular sorts of beauty; but their judgments of beauty are "binding" on no one. Indeed it is hard to see what could possibly be meant by "binding" in such a connection, unless it were an obligation on others to lie or dissemble concerning the aesthetic feelings which in fact they have or do not have on a given occasion. There is, of course, such a thing as good taste, and bad taste. But good taste, I submit, means either my taste, or the taste of people who are to my taste, or the taste of people to whose taste I want to be. There is no objective test of the goodness or badness of taste, in the sense in which there is an objective test of the goodness or badness of a person's judgment concerning, let us say, the fitness of a given tool to a given task.

11. Why We Have a Natural Inclination to Think Otherwise

What makes it so difficult for us to acknowledge that judgments of aesthetic value, i.e., of beauty and ugliness, which are truly judgments about objects, are not universally and necessarily valid, but on the contrary valid, except by chance, only for the individuals who make them, is that we are so constantly occupied otherwise with judgments concerning instrumental values. These have to do with relations of the object judged, *to other objects*, and such relations are socially observable, and the judgments concerning them socially valid. That a given rail-

road bridge is a good bridge can be proved or disproved by running over it such trains as we wished it to carry, and observing whether or not it does carry them. But there is no similar test by which the beauty of a landscape could be proved or disproved. Judgments of beauty (which is an immediate value) have to do with the relation of the object judged to the individual's own pleasure experience of which he himself is the sole possible observer and judge. Judgments of beauty are therefore in this respect exactly on a par with judgments of the pleasantness of foods, wines, climates, amusements, companions, etc. Like these they are ultimately matters of the individual's own taste. It is of course quite possible that two persons, or two million, should have similar tastes, i.e., should happen alike to find pleasure in a given food or wine, or to obtain pleasurable feelings in contemplating aesthetically a given picture, melody, etc. But such community in the experience of pleasure, even then remains a bare matter of fact concerning just the persons who have it in common, and leaves wholly untouched the equally bare fact that other persons—whether many, few, or only one—find not pleasure but displeasure in the very same objects.

The fact that judgments of immediate value (such as judgments of aesthetic value) differ from judgments of mediate value in being incapable of proof, or disproof, and are therefore binding (except by accident) only on the individual who makes them, seems to be entirely overlooked by Professor Thomas Munro, in his recent interesting short book, *Scientific Method in Aesthetics*. Starting from the fact that the essence of science is verification,—"a constant checking up of results by various workers in the same subject,"—he goes on to say that, "carried over into aesthetics, this would suggest a systematic comparison of notes on the result of individual experiences in art. Its aim would be to discover more specifically how people agree and how they vary in aesthetic responses and critical appraisals" (p. 56). But supposing we should thus discover some widespread agreements and thereby be enabled to formulate some probable predictions, I then ask, what of it? What exactly will this prove concerning the aesthetic merits of the objects judged, and to whom will it prove it? And what is anybody going to do with information of that sort? Truly it is scientific, but it is information *not about laws of the objects studied* (as in chemistry, or mathematics), but *about the public* who looks at the objects. And art-creation is no manufacturing of spiritual candy, that the artist should need to inquire-and cater to, what the market happens to like. And supposing half-a-dozen people or a hundred, agree that a certain melody is "gay and sprightly" (p. 58), what of it? If this is mere description, it is indeed either true or false, but is then no more criticism,—no more involves

any "oughts" or "ought-nots,"—than, say, the assertion that a given animal is a dog. If on the other hand the assertion that the melody is "gay and sprightly" constitutes criticism,—implies praise or blame,—then the fact that a hundred people evaluate the melody alike has neither more nor less significance than the fact of a hundred people being similar in liking (or disliking), say, caviar, or tobacco. What Professor Munro regards as constituting scientific method in aesthetic criticism, seems to me, for these reasons, to be on the contrary the using of scientific method in the study of facts wholly irrelevant to aesthetic criticism, for the ultimate and sole foundation of aesthetic criticism is individual taste such as it happens to be, and whether shared or not.

Beside the fact that we are so constantly occupied with instrumental values, however, and tend unconsciously to carry the habits of thought acquired there into the realm of immediate values, there are other human traits which explain, or manifest themselves in, our persistent reaching for rules also in the domain of aesthetic values. Most of us, for instance, instinctively abhor anything that savors even remotely of anarchy, and refuse to consider the possibility that a realm of anomic values may exist where anarchy would be legitimate. We fear that if we should grant it the right to live even there, anarchy (or shall we say freedom?) would come forth a monster elsewhere and bite us. Again, whatever is individual is unpredictable and therefore likely to be upsetting; and we ourselves, hating and dreading the responsibility of being ourselves, cling for dear life,—or it may here be dear death—to any seeming ready rules that would promise to save us from the need. Were one to lean on modern slang for a contribution to the ancient game of differentiating the species *homo*, one could well say that man is the animal that loves to "pass the buck" to a rule! But, like the fact or dislike it, there is a realm where each individual is absolute monarch though of himself alone, and that is the realm of aesthetic values.

12. Beauty Cannot be Proved by Appeal to Consensus, or to the "Test of Time," or to the Type of Person Who Experiences It in a Given Case

In the light of what precedes, it is obvious that the familiar attempts to prove the beauty of certain works of art by appeal to the consensus of opinion, or to the test of continued approval through long periods of time in the life either of society or of the individual, are, like the appeal to the connoisseur's verdict, entirely futile. Such tests cannot possibly prove the object's beauty to those who do not perceive any in it; and to those who do, they are needless. They prove nothing whatever,

except that beauty is found in the object . . . by such as do find it there.

We might attempt to rank beauties on the basis of the particular aspect of human nature, or type of human being, that experiences aesthetic pleasure in given cases. This would lead to a classifying of beauties as, for instance, sentimental, intellectual, sexual, spiritual, utilitarian, sensuous, social, etc. We might well believe in some certain order of worth or dignity in the human faculties respectively concerned, but this would not lead to any aesthetically objective ranking of beauties. To suggest it would be as ludicrous as a proposal to rank the worth of various religions according to the average cost of the vestments of their priests. For a ranking of beauties, there are available only such principles as the relative intensity of the pleasure felt, its relative duration, relative volume, and relative freedom from admixture of pain. These principles, however, do not in the least release us from the need of relying upon the individual's judgment; on the contrary their application rests wholly upon it.

13. Beauty Cannot be Proved by Appeal to Technical Principles or Canons

It may yet be thought, however, that there are certain narrower and more technical requirements in the various fields of art, without the fulfilling of which no work can be beautiful. Among such alleged canons of beauty may be mentioned the rules of so-called "harmony" in music; various precepts concerning literary composition; unity; truth to nature; such requirements as consistency, relevance, and unambiguity; and so on. There are indeed "rules" or "principles" of that sort, some of which are, I will freely declare, valid for me; so that when I find myself confronted by flagrant violations of them, I am apt to feel rather strongly, and to be impatient or sarcastic about "that sort of stuff." And indeed, on occasions when I have found myself inadvertently guilty of having drawn some line or written some sentence in violation of my own aesthetic canons, I have at times felt as ashamed of the line or the sentence as I should of having picked somebody's pocket. I admit having pronounced opinions about the beauty or ugliness of various things, and what is more, in many cases I am able to *give reasons* for my opinions.

But of what nature are those reasons? They are, ultimately, of the same nature as would be that offered by a man arguing that my pen had to fall when I let go of it a moment ago, *because of gravitation.* Gravitation is but the name we give to the general fact that unsupported objects *do* fall, and at a certain rate; but it is not a reason, or cause, or

proof of that fact. To say that something always happens, is not to give any reason why it ever does. Therefore when I say that a certain design is ugly because it is against the "law of symmetry," I am not giving a reason why it *had* to give me aesthetic displeasure, but only mentioning the fact that it resembles in a stated respect certain others which as a bare matter of fact also do displease me. This character which displeases me and many persons, may, however, please others. And, what is more directly to the point, it not only may but it does,— jazzy or uncouth though I may call the taste of such persons. But what most obstinately drives me to the acquisition of a certain, at least abstract, sense of humor concerning the ravening intolerance and would-be-authoritativeness of my own pet canons of beauty, is the fact that they have changed in the past, and that I see no reason why they should not change again in the future. For all I can see to prevent it, I may well to-morrow, next year, or in some future incarnation, burn what I aesthetically adore to-day, and adore what I now would burn. If this happens, I have no doubt at all that I shall then smugly label the change a progress and a development of my taste; whereas to-day I should no less smugly describe the possibility of a change of that sort in me, as a possibility that my taste may go to the devil. And, let it be noted, the sole foundation upon which either of the two descriptions would rest, would be the fact that the describer *actually* possesses at the time the sort of taste which he does. Tastes can be neither proved nor refuted, but only "called names," i.e., praised or reviled.

Certain limited and empirical generalizations have been found possible concerning factors upon which the aesthetic pleasure of most people, or of some kinds of people, appears to depend. Precarious generalizations of this sort may be found for instance in manuals of design and of pictorial composition, where they are often dignified by the name of "principles." People familiar with them may then be heard to say that a given picture, perhaps, is well composed and why; or that the tones, the masses, or the values are, as the case may be, well or ill balanced, and so on. Other statements that we may hear and which also imply "principles," would be that the color is clean, or else muddy; that the drawing is, perhaps, distorted; that the surfaces are well modelled; that the lines are rhythmical; that the color combinations are impossible; that the masses lack volume or solidity, etc. The words beauty and ugliness may not occur once, but it is nevertheless obvious that all such statements are not merely descriptive, but *critical*. They are not direct assertions of aesthetic value or disvalue, viz., of beauty or ugliness, but, taking it as an obvious fact, they attempt to trace it to certain definite sorts of features in the work. The more intelligent and

better informed kind of art-criticism is of this analytical and diagnostic sort, and there is nothing beyond this that the art-critic could do.

All such comments, worded in the technical jargon of the particular craft, have the imposing sound of expert judgments based upon authoritative principles, and are likely to make the lay consumer of art feel very small and uninitiated. Therefore it cannot be too much emphasized here that a given picture is not ugly because the composition of it, or the color combinations in it, are against the rules; but that the rule against a given type of composition or of color combination is authoritative only because, or if, or for whom, or when, compositions or combinations of that type are *actually* found displeasing. All rules and canons and theories concerning what a painting or other work of art should or should not be, derive such authority as they have over you or me or anyone else, solely from the capacity of such canons *to predict to us* that we shall feel aesthetic pleasure here, and aesthetic pain there. If a given rule predicts this accurately for a given person, that person's *actual* feeling of aesthetic pleasure or displeasure then, proves that this rule *was* a valid one so far as *he is* concerned. That is, the feeling judges the rule, not the rule the feeling. The rule may not be valid for someone else, and it may at any time cease to be valid for the given person, since few things are so variable as pleasure. The *actual* experience of beauty or ugliness by somebody is the final test of the validity of all rules and theories of painting, music, etc., and that test absolutely determines how far, and when, and for whom any given rule or theory holds or does not hold.

The difference between the criticisms of the professionals, and those of the people who, having humbly premised that they "know nothing about art," find little more to say than that a given work is in their judgment beautiful, or as the case may be, ugly or indifferent;—the difference, I say, between the criticisms of professionals and of laymen is essentially that the former are able to trace the aesthetic pleasure or displeasure which they feel, to certain features of the object, while the latter are not able to do it. From this, however, it does not in the least follow that the evaluations of the professionals ultimately rest on any basis less subjective and less a matter of individual taste than do those of the layman. Indeed, so far as the non-professionals really judge at all, i.e., do not merely echo an opinion which they have somehow been bluffed into accepting as authoritative, their judgment is based on the fact that they actually feel something. The artists and professional critics, on the other hand, are exposed to a danger which does not threaten people who know nothing of the factors on which aesthetic pleasure or displeasure has in the past been found to depend for most

people, or for some particular class of people,—the danger, namely, of erecting such empirical findings into fixed and rigid rules, and of judging the work of art no longer by the aesthetic pleasure it actually gives them, but by that which they think it "ought" to give them according to such rules. This danger is really very great, especially for the artist, who, in the nature of the case, is constantly forced to give attention to the technical means by which the objective expression of his feeling is alone to be achieved. Having thus all the time to solve technical problems, it is fatally easy for him to become interested in them for their own sake, and, without knowing it, to be henceforth no longer an artist expressing what he feels, but a restless virtuoso searching for new stunts to perform. This may be the reason why so many of the pictures displayed in our exhibits, although well-enough painted, make one feel as though one were receiving a special-delivery, registered, extra-postage letter, . . . just to say, perhaps, that after Thursday comes Friday!

Listening to the comments of artists and of some critics on a picture will quickly convince one that, strange as it sounds, they are as often as not almost incapable of seeing the picture about which they speak. What they see instead is brush work, values, edges, dark against light, colored shadows, etc. They are thus often not more but less capable than the untrained public of giving the picture *aesthetic* attention, and of getting from it genuinely aesthetic enjoyment. The theory that *aesthetic* appreciation of the products of a given art is increased by cultivating an amateur's measure of proficiency in that art, is therefore true only so far as such cultivation results in more intimate and thoroughgoing *aesthetic* acquaintance with the products of that art. This is likely to be the case in an interpretative art like music (not music-composing). But in an art which, like painting, is not so largely interpretative, and is at the same time dependent on rather elaborate technical processes, the amateur practitioner's attention is from the very first emphatically directed to these processes; and, when it is directed to extant works of art it is directed to them as examples of a technique to be studied, not as aesthetic objects to be contemplated. The danger is then that such technical matters will come to monopolize his attention habitually, and that even in the face of nature he will forget to look at her, wondering instead whether the water or the sky be the brighter, or what color would have to be used to reproduce the appearance of a given shadow. Attention to technique is of course indispensable to the acquisition of it; and mastery of technique is in turn necessary to the production of art on any but the most humble scale. The risk is that the outcome of technical training will be not

mastery of technique, but slavery to it. This risk disappears only when the technical apparatus has become as intimately a part of the artist as the hand is of the body for ordinary purposes, and is used without requiring attention. The attention can then turn from the means to the ends of art, viz, to the objective expression of feeling. But the stage at which technique has so become second-nature as to be forgotten, is not often fully reached. With most artists, what we may call their technical *savoir-faire* creaks more or less, as does the social *savoire-faire* of people who have become emilyposted but lately. Like the nouveaux gentlemen, such artists are too conscious of their technical manners, and forget what they are for.

14. Beauty and Accuracy of Representation

Among the special criteria by which the merit of works of art—especially paintings—is judged by many, there is one about which something should be said here, namely, accuracy of representation. Accuracy of representation is important from the standpoint of aesthetic criticism only so far as beauty happens to be conditioned by it. Representation, in painting, is a relation between the perceptual varicolored canvas and the aesthetic object, when that aesthetic object is not simply a flat design as such, but contains imaginal and conceptual elements. Accuracy of representation of the intended aesthetic object, by the perceptual canvas is thus not in itself an aesthetic but a noematic merit. Nevertheless it is a merit which is indispensable since without it the intended aesthetic object (in the sort of cases considered), would be set up before the attention either not at all, or only in altered form.

Accuracy of representation of the aesthetic object is of course not at all the same thing as accuracy of representation of the model. An accurate representation of a model is, merely as such, not a work of art at all, but only a document,—a piece of reliable information about the appearance of an existing object. If it is accurate, the copy will indeed have more or less the same aesthetic import and value as the model itself, but that copy as such will none the less be only a work of imitative skill. It will not be a work of art unless it also constitutes the conscious objective expression of a feeling experienced by the painter. Accuracy of representation of the aesthetic object, on the other hand, means only the perceptual canvas sets up clearly before the ideational attention just the aesthetic object that embodies the feeling which it is intended should be obtained in contemplation.

Photographic accuracy of drawing, and faithfulness of representation of persons or things, provokes the pleasure of recognition, and

admiration of the painter's capacity to act as a color camera. But this does not mean that his work is a work of art; nor even that he has created something beautiful, if the object which he has "photographed" happens not to be so. On the other hand, the fact that various elements are out of drawing in some pictures in which the artist is expressing himself in terms of represented objects, does not mean that they are necessarily ugly. What is important for beauty is *not truth but plausibility*. A dramatic entity represented may in fact be distorted, but it is not on this account ugly if it does not *look* distorted. Contrariwise, if something which in fact is photographically accurate looks distorted or un- plausible, it will be disagreeable in aesthetic effect. The works of El Greco, who is famous for his distortions of drawing, illustrate this. Some people have thought that something was wrong with his eyes; but the true explanation of his distortions is much more probably his preoccupation with the design-aspect of his paintings. When his design needed a line or thing of a particular shape and size at a certain place, and the object represented at that place happened to be, say, a human leg incapable of the needed shape and size, then it was so much the worse for the leg. Either design or accuracy of representation had to be sacrificed, and in such cases El Greco did not hesitate to sacrifice the latter. Whether ugliness is produced thereby, however, depends on whether the sacrifice is obvious,—the inaccuracy flagrant. In many places it is not; and it does not there constitute an aesthetic fault. Where the distortion is not plausible, on the other hand, but thrusts itself upon our notice as distortion, it gives rise to ugliness and is therefore to that extent aesthetically bad, whatever aesthetic gains it may otherwise involve. Only the addicts of design, who are satisfied with but a half of what an aesthetically complete beholder demands, fail to see this. On the other hand, to the painter who justifies this or that bad part of his picture by insisting that "nature looked just like that," the answer is that even if she did, she ought not to have, so far as beauty was concerned. As often has been said, when truth is stranger than fiction, it does not make good fiction, but only news for the papers.

15. Criticism of Aesthetic Objects in Ethical Terms

Instead of asking whether a work of art or other aesthetic object is beautiful or ugly, i.e., whether the feeling obtained in aesthetic contemplation of it is pleasant or unpleasant, we may on the contrary disregard this and ask whether the feeling so obtained by a person is or may become connected with the rest of his life, and in what manner it may affect it for good or ill. The ethical or the religious worth of the feelings obtained in aesthetic contemplation of works of art, it will be

recalled, would have been made by Plato and by Tolstoi the ruling standard in terms of which to judge art as good or bad. It is worth noting, however, that standards of evaluation cannot themselves be evaluated, except in terms of some standard not itself in any way vindicated but only dogmatically laid down. And any standard evaluated in this manner may itself equally well be laid down in turn as absolute, and be used to evaluate the standard which before was evaluating it. Arguments about the relative worth of various standards of worth are therefore wholly futile, inasmuch as, in the very nature of the logical situation, every such argument must to begin with beg as its premise the point essentially at issue. Ultimately, then, a given standard can only be sympathized with and adopted, or the reverse; and logic can come in only *after* this has occurred. Plato's and Tolstoi's choice of the ethical or religious nature of the aesthetic feelings imparted, as ruling standard for the evaluation of art, is legitimate, but it constitutes only a manifestation of their own ruling interest, and a different choice of ruling standard is equally legitimate by anyone else whose ruling interest happens to be different. With these remarks concerning the permissibility, but the arbitrariness, of describing any one standard of worth as "supreme" or "ruling," we may leave the matter, and now simply consider the question raised, namely, whether the feelings obtained in aesthetic contemplation may affect the rest of one's life, and how.

The value other than aesthetic that aesthetic feelings may have depends upon the fact that if, when a feeling has been obtained through aesthetic contemplation, the aesthetic attitude is then given up and replaced by the practical, that which had up to that moment the status of aesthetic feeling now assumes that of impulse.

So long as our state is properly describable as aesthetic feeling, its value is immediate and intrinsic, and consists in the pleasantness or unpleasantness of the state. But when our state comes to be properly describable as impulse, then its value is as usual to be measured in terms of the eventual significance of the impulse. An impulse is a seed of conduct, and an aesthetic feeling is at least a potential seed of impulse; the terms in which we commonly appraise conduct are therefore potentially applicable to it.

The impulse or embryonic conduct resulting from the transmutation of an aesthetic feeling through a shift to the practical attitude, may be either a novel impulse in the life of the individual or not. If it is an impulse of a sort already experienced and more or less established with characteristic modes of manifestation in the life of the person concerned, then the reëxperiencing of it as aftermath of aesthetic

contemplation will not affect the individual's life qualitatively, but only quantitatively. It will be simply fuel to an engine already existing and functioning; it will add to the intensity of some aspect of life but will not alter it in kind, except perhaps indirectly if the changes of intensity involved are such as to upset an equilibrium previously existing, and thus force the recasting of life in a different qualitative pattern.

If however the impulse is a novel one in the life of the individual, then it constitutes directly the seed of a change in the kind of life that has been his. The evolution (whether towards good or evil) of the will-aspect of man's nature does not take place merely through increases in his knowledge of the facts and relations that constitute the field of action of his will, but also through the advent in him of qualitatively novel impulses. Indeed, it might well be argued that mere increase in the quantity as distinguished from the nature of one's knowledge and experience, only furnishes one with new means for the service of old ends, or makes one better aware of the ends to which one's hitherto blind impulses tended; but that, however such increase of knowledge may transform the manifestations of existing longings or impulses, it does not of itself alter their intrinsic nature. Transformation in the nature of the impulses themselves (apart from maturation) seems traceable to experiences of two sorts. One of them is awareness by the individual of the presence of a practically real situation novel in kind in his life. This may call forth in him an impulse hitherto foreign to him. The other is what we might call the surreptitious implantation of the impulse itself in him, through the transmutation which we are now considering of an aesthetic feeling into an impulse, by a shift to the practical attitude.

The aesthetic contemplation of nature and of various aspects of life is, through such a shift of attitude, a source of germs of new impulses and of food for old ones. Some persons are known to the writer, in whom the contemplation for the first time of the ocean, or of great mountains, seems to have produced feelings comparable in point of novelty and depth to those reported by the mystics, and the aftermath of impulse due to which gave to life a different pattern, somewhat as does a religious conversion. But art is capable of being as much more effective in the sowing of such seeds of novel impulse, as, for instance, the study of existing records is more effective than personal investigation in acquiring a knowledge of geography. For one thing, art is usually easier than nature to contemplate, being, we might almost say, made for that. Again, when nature was its model, art may be described as at least a drastic editing of nature, supplying what she forgot, omitting what was irrelevant, accenting her here or there into unambiguity.

The work of art, being created specifically to give objective expression to a given feeling, is likely to have a pointedness of feeling-import which nature matches only by accident. The work of art, moreover, can be contemplated at length and returned to again and again, whereas natural facts and the aspects they show us are mostly beyond our control. They come and go heedless of the conditions which alone would make it possible for us to contemplate them adequately. But lastly, art, although in some ways it falls short of nature, has in another way a range of resources far greater than nature's, for it has at its command the boundless resources of the imagination. What it cannot present it often can represent, and thus set up before our attention objects of contemplation never to be found in nature. It can lead us into new worlds, in the contemplation of which our feeling-selves spontaneously burgeon and bloom in all sorts of new ways. Some poems, some music, some statues and pictures, have had in an extraordinary degree this power to bring to birth in people qualities of feeling that had remained latent in them. One such work of art is Leonardo's *Mona Lisa*. Art theorists whose fundamental dogma is that the end of painting is the representation of plastic form, and who find that picture but indifferently successful in this respect, cannot understand why the theft of it a few years ago should have been deemed a world-calamity. Their only explanation is the aesthetic ineptitude of mankind at large. They cannot see that design and the representation of plastic form is not the whole of the art of painting, but is rather a means which may be used to the ends of art, *when it is important to those ends*. Not the aesthetic ineptitude of mankind, therefore, but the sophomoric character of the measuring-rod by which such theorists would judge Leonardo's picture, is the lesson of the effect produced by that famous theft. There are doubtless people who, in a similar way, would insist on characterizing Socrates essentially as a Greek who was not a "good provider."

16. Liberalism in Aesthetics

The principal standards in terms of which works of art and aesthetic objects may be criticized have been considered above, and the general nature of the conclusions reached concerning the significance and validity of such criticisms may now be summarily characterized.

Judgments of mediate or instrumental value are capable of being proved or disproved. Their truth or falsity is objective, in the sense that it is not conferred upon them by the individual's taste, but is a matter of connections in nature independent of the critic's taste. But the *relevance* or importance, if not the truth, of any judgment of mediate value, is a

matter of the individual critic's taste or constitution, since for any such critic that relevance depends on a judgment of immediate value by him.

As regards judgments of immediate value, and in particular of beauty and ugliness, it seems to me that here as in other fields, ultimate analysis leads unavoidably to *the particular constitution of the individual critic* (no matter how he may have come by it); as the necessary and sufficient ground for all such judgments. The constitutions of numbers of individual critics may, of course, happen to be alike in some respects; or they can be made more or less alike by subjecting them to the sort of psychological pressure appropriate to the causation of such a result. If a number of critics are constituted alike in some respects, then any one of them will be able to formulate value judgments with which will agree as many of the other critics as are constituted like him in the respects needed for such agreement! I cannot see that "objective validity" in the case of a judgment of immediate value, means anything whatever but this; namely, several people judge alike because they are constituted alike. But whether a given taste be possessed by one person only, or by a thousand alike, the maxim that *de gustibus non est disputandum* holds with regard to it.

Is there then no such thing as the refining and educating of taste? Certainly there is,—and there is also such a thing as perversion and depravation of taste. But the question in any given case is, which is which? No one so far as I know has yet pointed out any way of answering this question otherwise than arbitrarily and dogmatically, i.e., otherwise than in terms of the taste actually possessed by some person or other, usually oneself, *arbitrarily* taken as standard. That question, indeed, is hardly ever frankly faced. Those who have approached it at all seem always to have labored under the strange delusion that if only they succeeded in showing that the tastes of a large number or a majority of people were alike, the question was answered; whereas the truth is on the contrary, as just pointed out, that mere numbers have no bearing whatever on the question. Taking a vote is only a device for ascertaining in advance what would be the outcome of a fight between two groups of people, if every person were as strong as every other and strength alone counted. "Proof" by appeal to a vote is obviously but a civilized form of the *argumentum ad baculum*.

It may be asked, however, whether in the absence of any standard of immediate value objectively valid in any sense other than that described above, it is not possible at least to point to some respects in which the (immediate) value judgments of all people whatever, would agree. Nobody whatever, it may be urged, likes great hunger or

thirst or cold, or cuts and burns, etc. Now it may be granted that certainly not many do. But after all there are masochists and ascetics and martyrs. It may be true because tautologous that nobody likes pain; but we must keep in mind that pain and pleasure are the predicates, not the subjects, of immediate-value-judgments. Their subjects are things, situations, experiences. The question is thus not whether painfulness is ever pleasurable, but whether there are any *situations* or *experiences* which everybody without exception finds, for instance, painful. And this is very doubtful. We can probably say only that with regard to some situations or experiences, the dissentients are very few. And as we have just seen, numbers mean nothing at all in such a matter.

This brings us to what may be called a dogmatico-liberalistic position. Neither I nor anyone can refute anyone else's judgments of immediate value,—here, of beauty and ugliness; nor can anyone refute mine. This is the liberalistic aspect of the situation. The fullest insight into it, however, constitutes no reason whatever why any one should hold to his own immediate valuations any the less strongly. That our own opinion must in the nature of such matters be dogmatic is no reason why it should not be honest, vigorous, and unashamed.

19. THE INSTRUMENTALIST
THEORY OF AESTHETIC VALUE

MONROE C. BEARDSLEY

There is another way of approaching the problems of aesthetic value. General judgments of critical praise can be cast in the form: "This is a good aesthetic object." We can also, of course, make specific judgments like "This is a good sonata," or "This is a good landscape." Now, students of value theory have pointed out that we seem to use the word "good" in two very different ways, grammatically speaking. We say things like "Money is good" and "You are very good," and in these statements "good" appears by itself as a predicate. But we also speak of "a good character," "a good car," "a good job," "a good way of holding the tennis racquet," and in these phrases the word "good" is adjoined, or affixed, to a noun or noun-phrase. When "good" is used in a phrase of the form "a good *X*," this is frequently called the *adjunctive* use of the word. It may be that even the apparently nonadjunctive uses are really adjunctive; this does not affect my argument.

The phrase "a good aesthetic object" is, then, an example of the adjunctive use of "good." And our problem is to understand what it would mean to say that something is a good aesthetic object, and how this could be shown to be true.

To help make clear the correct analysis of "a good *X*," let us first consider an analysis that is certainly not correct, though it might be offered. Suppose someone said

"This is a good *X*" means "This is an *X*, and I like it."

Now it is possible to find a few idiomatic phrases in which "good" is used adjunctively, and in which it indicates little more than the speaker's likings: for example, "a good time." But when we say that

FROM *Aesthetics* BY MONROE C. BEARDSLEY, © 1958, BY HARCOURT, BRACE & WORLD, INC., AND REPRINTED WITH THEIR PERMISSION. REPRINTED ALSO WITH THE KIND PERMISSION OF THE AUTHOR.

something is a good wrench, or a good cow, or a good plumber, we are surely saying something more than that it belongs to a certain class and is liked. We are stating the grounds for such a liking, and these grounds consist in the capacity of the wrench, or the cow, or the plumber to perform in a certain way that is to be expected of things of its kind.

Function-Classes

Under what conditions, then, is it appropriate to apply the word "good" adjunctively? Only if the noun to which it is affixed is one that denotes what I shall call a *function-class*. This concept needs a little clarification. Suppose we have a number of objects that are considered as belonging to the same class because of some internal characteristic that they all share, for example, their shape or color or the material of which they are made—but not an external feature, such as being all in Australia or having been made by a blind weaver after 1900. The distinction between internal and external characteristics would take some careful analysis to make very exact, but let us suppose that it can be done. Now after we have marked out such a class, we may find that there is something that the members of this class can do that the members of other similarly defined classes cannot do, or cannot do as well. It may be that an occasional object outside this class can do the job better than a few of the objects in this class, but taking the class as a whole, or on the average, it is the best, or the only, class for the job. Then this class may be said to be a function-class, and its members may be said to have a function.

Function is not necessarily connected with intention; it is the capacity of the objects to serve in a certain (desirable) way, whether or not they were created for that purpose. Of course, wrenches, which are best for turning nuts, were intended to have a function. Cows were not; still there is something good you can do with, or get from, cows that other creatures will not provide, or provide so cheaply or plentifully or dependably. If another gadget, say a plench (a cross between pliers and wrenches), is invented that turns nuts more easily, or with greater force, or with less likelihood of slipping, then wrenches will lose their function, except in regions where the new invention has not penetrated.

Chair is a function-class, and *desk chair* is also a function-class, since there is a purpose that desk chairs serve better than other types. *Furniture* is not, I think, a function-class, though it includes a number of distinct function-classes; there is nothing you can do with furniture, considered solely as furniture, that you can't do as well with other things. "This is a good piece of furniture," then, would have to mean

"This is either a good chair, or a good table, or a good sofa, or . . ." It is, in fact hard to find any really good examples of familiar classes that are *not* function-classes, since if there is some difference between this class and other classes, there is always the possibility of some good use to which that difference might be put.

But it is not sufficient that the members of the class have a function; they must differ among themselves in the degree to which they perform that function. If all dimes were exactly similar, then "a good dime" wouldn't make sense; a counterfeit dime is not a dime at all, and you don't say that a nickel is a poor dime. But it is hard to find examples of really nonsensical adjunctive uses of "good," for no matter how odd the combination appears at first, we will almost always, if we dwell on it, succeed in finding some conceivable use to which the class could be put, and which the members might serve more or less well. Thus "a good star" is peculiar, but perhaps one star might be a little better than another for navigation; "a good idiot" might be one most instructive as a textbook example; "a good case of measles" might be the one to show the internes.

The discussion so far, then, might be summarized in the following formula:

"This is a good X" means "This is an X, and there is a function of X's that it successfully fulfills."

Or, to be both more specific and more explicit:

"This is a good wrench" means "This is a wrench, and it is efficient [handy, convenient] for the (good) purpose of turning nuts."

These are not very smooth definitions; they are in fact twisted slightly to bring out the next important point. The second definition does define "a good wrench," in terms of the assumed function of wrenches. But note that it does *not* define the word "good," for this word turns up in the defining term as well; it is not eliminated by the definition. To make the same point another way, in my definition of "function" I have inserted a reference to value: for an object to have a function, there must not only be something special that it can do, but that something must be worth doing.

In my view, the phrase "a good X" typically presupposes that the use of X is itself a good one. Now, no doubt "good" can be used, and is sometimes used, with what might be called value-neutrality. In this sense, it means nothing more than efficient. But I think that in general —and at least in "a good aesthetic object"—to use the word "good"

rather than the word "efficient" is tacitly to endorse the end to which it is put. It would be a little queer for one who believes that torture is never justified to say, "That is a good method of torture," or for a thoroughgoing advocate of nonviolence to say, "Hanging is a good way to execute criminals." To bar any misapprehension, he would do better to say "effective" or "successful," or something of the sort. Statements like "He is a pretty good burglar" and "That is a perfect murder" are likely to sound either ironic or callous.

If we treat "a good aesthetic object" on the same lines as "a good wrench," we come out with some interesting possibilities. First, of course, we should have to establish that *aesthetic object* is a function-class—that is, that there is something that aesthetic objects can do that other things cannot do, or do as completely or fully. Is there something that aesthetic objects are especially good at? Now, the sort of thing you can do with an aesthetic object is to perceive it in a certain way, and allow it to induce a certain kind of experience. So the question, "Is *aesthetic object* a function-class?" is only a somewhat pedantic way of asking an old and familiar question, which we have long postponed: "Is there such a thing as *aesthetic experience?*" We saw in the preceding section that the Psychological Definitions lead into this question, in distinguishing aesthetic likings from other likings. Many Beauty Theorists have discussed it, too. But it is in the present context that the question becomes most pressing.

Aesthetic Experience

The problem is whether we can isolate, and describe in general terms, certain features of experience that are peculiarly characteristic of our intercourse with aesthetic objects. Of course, listening to music is a very different experience in some ways from looking through a cathedral or watching a motion picture. Reading literature certainly does something to us, and probably *for* us, that listening to music cannot do, and vice versa. A full account of our experience of aesthetic objects would have to deal carefully with these matters. But is there something that all these experiences have in common—something that can be usefully distinguished? This is at least an empirical question, open to inquiry. And some inquiry has been made, though many mysteries remain. However, we can be reasonably confident of certain generalizations, which some writers have obtained by acute introspection, and which each of us can test in his own experience.

These are the points on which, I take it, nearly everyone will agree:

First, an aesthetic experience is one in which attention is firmly fixed upon heterogeneous but interrelated components of a phenomenally objective field—visual or auditory patterns, or the characters and events in literature. Some writers have suggested that in such an experience, as when we are deeply absorbed in the tension of a visual design or in the developing design of music, the distinction between phenomenal objectivity and phenomenal subjectivity itself tends to disappear. This may be overstated, but in any case the experience differs from the loose play of fancy in daydreaming by having a central focus; the eye is kept on the object, and the object controls the experience. It is all right, I think, to speak of the object as *causing* the experience, but of course the connection is more intimate, for the object, which is a perceptual object, also appears *in* the experience as its phenomenally objective field.

Second, it is an experience of some intensity. Some writers have said that it is an experience pervasively dominated by intense feeling or emotion, but these terms still occupy a dubious position in psychological theory; what we call the emotion in an aesthetic experience may be simply the intensity of the experience itself. In any case, the emotion is characteristically bound to its object, the phenomenal field itself— we feel sad *about* the characters, or uncertain *about* the results of an unexpected modulation. Aesthetic objects give us a concentration of experience. The drama presents only, so to speak, a segment of human life, that part of it that is noteworthy and significant, and fixes our minds on that part; the painting and the music invite us to do what we would seldom do in ordinary life—pay attention *only* to what we are seeing or hearing, and ignore everything else. They summon up our energies for an unusually narrow field of concern. Large-scale novels may do more; they are in fact always in danger of dissipating attention by spreading it out into our usual diffuse awareness of the environment.

This is why the expression "feeling no pain" is particularly apt to aesthetic experience. The pleasure is not often comparable in intensity to the pleasures of satisfying the ordinary appetites. But the concentration of the experience can shut out all the negative responses—the trivial distracting noises, organic disturbances, thoughts of unpaid bills and unwritten letters and unpurged embarrassments—that so often clutter up our pleasures. It does what whiskey does, only not by dulling sensitivity and clouding the awareness, but by marshalling the attention for a time into free and unobstructed channels of experience.

But this discussion already anticipates the two other features of aesthetic experience, which may both be subsumed under *unity*. For, third, it is an experience that hangs together, or is coherent, to an unusually high degree. One thing leads to another, continuity of develop-

ment, without gaps or dead spaces, a sense of an overall providential pattern of guidance, an orderly cumulation of energy toward a climax, are present to an unusual degree. Even when the experience is temporarily broken off, as when we lay down the novel to water the lawn or eat dinner, it can retain a remarkable degree of coherence. Pick up the novel and you are immediately back in the world of the work, almost as if there had been no interruption. Stop the music because of a mechanical problem, or the ringing of a phone, but when it is started again, two bars may be enough to establish the connection with what went before, and you are clearly in the *same* experience again.

Fourth, it is an experience that is unusually complete in itself. The impulses and expectations aroused by elements within the experience are felt to be counterbalanced or resolved by other elements within the experience, so that some degree of equilibrium of finality is achieved and enjoyed. The experience detaches itself, and even insulates itself, from the intrusion of alien elements. Of course, it cannot survive all emergencies. I have heard the last movement of Beethoven's "*Waldstein*" *Sonata* (*Op.* 53) interrupted by a fire chief who suddenly appeared on stage to clear the aisles of standees; and even though the pianist, Paul Badura-Skoda, started off again at the beginning of the movement, he could not, of course, recapture the peculiar quality of that beginning, which moves without pause from the slow section of the sonata. But because of the highly concentrated, or localized, attention characteristic of aesthetic experience, it tends to mark itself out from the general stream of experience, and stand in memory as a single experience.

Aesthetic objects have a peculiar, but I think important, aspect: they are all, so to speak, objects *manqués*. There is something lacking in them that keeps them from being quite real, from achieving the full status of things—or, better, that prevents the question of reality from arising. They are complexes of qualities, surfaces. The characters of the novel or lyric have truncated histories, they are no more than they show. The music is movement without anything solid that moves; the object in the painting is not a material object, but only the appearance of one. Even the lifelike statue, though it gives us the shape and gesture and life of a living thing, is clearly not one itself. And the dancer gives us the abstractions of human action—the gestures and movements of joy and sorrow, of love and fear—but not the actions (killing or dying) themselves. This is one sense of "make-believe" in which aesthetic objects are make-believe objects; and upon this depends their capacity to call forth from us the kind of admiring contemplation, without any necessary commitment to practical action, that is characteristic of aesthetic experience.

One aesthetic experience may differ from another in any or all of

three connected but independent respects: (1) it may be more *unified* that is, more coherent and/or complete, than the other; (2) its dominant quality, or pervasive feeling-tone, may be more *intense* than that of the other; (3) the range or diversity of distinct elements that it brings together into its unity, and under its dominant quality, may be more *complex* than that of the other. It will be convenient to have a general term to cover all three characteristics. I propose to say that one aesthetic experience has a greater *magnitude*—that is, it is more of an aesthetic experience—than another; and that its magnitude is a function of at least these three variables. For the more unified the experience, the more of a whole the experience is, and the more concentratedly the self is engaged; the more intense the experience, the more deeply the self is engaged; the more complex the experience, the more of the self is engaged, that is, the more wide-ranging are its responses, perhaps over a longer time.

I do not think of magnitude here as implying measurement—it is merely a collective term for how much is happening, intensively or extensively, in the experience. It may be too vague a concept to be useful. That remains to be seen, but there are two sources of legitimate uneasiness about it that should be frankly faced at once. First, note that I am now applying the terms "unity," "complexity," and "intensity" more broadly than before—not only to the phenomenally objective presentations in the experience, but to the whole experience, which includes affective and cognitive elements as well. The terms are still understandable, even in this extended use, I judge, but of course less capable of sure and exact application. Second, though I claim that these three characteristics all have a bearing upon magnitude, and that the magnitude of the experience is a resultant of them, I am not yet raising certain questions—which will shortly come to our attention— concerning the comparability of magnitudes. Evidently it will be possible to say that of two experiences approximately equal in unity and complexity, the one having a greater intensity will have the greater magnitude. But what if they are equal in one respect, and differ in opposite ways in the other two? This question is still open.

The traits of aesthetic experience are to be found individually in a great many other experiences, of course, but not in the same combination, I think. Play, in the sense in which we play games, involves the enjoyment of activity that has no practical purpose. But though the psychology of play has not yielded up all its secrets to psychological inquiry, it seems not necessarily to be an experience of a high degree of unity. Watching a baseball or football game is also generally lacking in a dominant pattern and consummation, though sometimes it has

these characteristics to a high degree and is an aesthetic experience. Carrying through a triumphant scientific investigation or the solution of a mathematical problem may have the clear dramatic pattern and consummatory conclusion of an aesthetic experience, but it is not itself aesthetic experience unless the movement of thought is tied closely to sensuous presentations, or at least a phenomenally objective field of perceptual objects.

Such distinctions are vague and tentative; they are some of the problems that most need to be studied at the present time. In any case, we can identify aesthetic experience as a kind of experience, though it is unique only in its combination of traits, rather than in any specific one. And we can say that aesthetic objects, generally speaking, have the function of producing such experiences, even though quite often aesthetic experiences of some degree of magnitude are obtained in the regular course of life from other things than aesthetic objects. This is their special use, what they are good for. On the whole, it is what they do best; they do it most dependably, and they alone do it in the highest magnitude.

Value as a Capacity

We can now define "good aesthetic object," in terms of the function of aesthetic objects—provided we can make another assumption. Suppose that what makes an aesthetic experience itself good, that on account of which it is a good aesthetic experience, is its magnitude, and, moreover, that one aesthetic experience is better than another, more worth having, if it has a greater magnitude. Then we can say,

"X is a good aesthetic object" means "X is capable of producing good aesthetic experiences (that is, aesthetic experiences of a fairly great magnitude)."

And,

"X is a better aesthetic object than Y" means "X is capable of producing better aesthetic experiences (that is, aesthetic experiences of a greater magnitude) than Y."

I shall call these *Functional* definitions of "good" in its adjunctive use as applied to aesthetic objects.

The transition to a definition of "aesthetic value" is now readily made. I propose to say, simply, that "being a good aesthetic object" and "having aesthetic value" mean the same thing. Or,

"X has aesthetic value" means "X has the capacity to produce an aesthetic experience of a fairly great magnitude (such an experience having value)."

And,

"*X* has greater aesthetic value than *Y*" means "*X* has the capacity to produce an aesthetic experience of greater magnitude (such an experience having more value) than that produced by *Y*."

Since this definition defines "aesthetic value" in terms of consequences, an object's utility or instrumentality to a certain sort of experience, I shall call it an *Instrumentalist* definition of "aesthetic value."

Two clarifying comments are called for at this point. The first concerns the phrase "has the capacity to produce," or "is capable of producing." The defining term does not stipulate that the effect will happen, but that it can happen. The definition is, of course, nonrelativistic; it even permits us to say that a painting never seen by anyone has aesthetic value, meaning that if it were seen, under suitable conditions, it would produce an aesthetic experience. "Capacity" is called a *dispositional term*, like the term "nutritious." To say that a substance is nutritious is not to predict that anyone will in fact be nourished by it, but only that it would be healthful to—it would have food value for— someone who ate a certain (unspecified) amount of it under certain (unspecified) conditions. Now no doubt we can sometimes make specific predictions about aesthetic objects, just as we do about foods— "This will make you healthier if you eat at least six ounces of it every day for three months." And we sometimes go to people who have read a book and ask questions like, "Did it move you? Do you think I would enjoy it?" But the kind of question a critical evaluator is attempting to answer, I believe, is not of this sort, but rather of the sort: "*Can it move people?*" In other words, the question of aesthetic value, like the question of nutritiousness, seems to be a question about what effects the object is capable of yielding, or, to put it another way, what can be done with it if we want to do it.

The "capacity" terminology, it must be conceded, is a deliberately indefinite one, but not too indefinite, I think, to be useful, so long as it is subject to certain controls. First, a statement about a capacity is required to specify some reference-class, if it is to be readily confirmable.[1] We want to know what class of things we are to try out the object on, in order to see whether it really does have the capacity. What nourishes a horse will not necessarily nourish a man. The narrower the reference-class, of course, the more informative the capacity-statement, but so long as there is some reference-class, the statement can be correct and useful. For statements about aesthetic value, the reference-class is the

[1] This point has been well made by Albert Hofstadter in a recent symposium on "The Evidence for Esthetic Judgment" [*Journal of Philosophy*, LIV (1957), 679–88].

class of human beings, to begin with, but we can easily narrow that down considerably by adding obvious requirements. To read Baudelaire you must understand French; to listen to music, not be tone-deaf; to see paintings, not be color-blind. No doubt we could go further. Note that this is not the same problem as that of defining "competent critic," for here we are not asking for the criteria of being an expert evaluator, but only ruling out certain classes of people whom it would be useless to expose to the aesthetic object. Even after we have eliminated the impossibles, we still use the "capacity" terminology, for we cannot predict that all who understand French will derive an aesthetic experience from Baudelaire, but only that, as far as this requirement goes, they are not prevented from doing so.

Second, although a capacity statement can be true even if the capacity is never actualized—natural resources are still resources even if they never happen to be exploited—the only direct confirmation of it is its actualization. The test of whether an object has aesthetic value is just that some of its presentations actually cause, and enter into, aesthetic experiences.

Third, "capacity" is a positive, rather than a negative term, and this distinction is important, if not pressed too far. We can speak of the capacity of an aesthetic object to produce an aesthetic experience, or we can speak of the capacity of a person to be affected by the object. But in both cases we assume—and, I believe, on adequate evidence— that there is a direction of development in aesthetic experience, a difference between greater and less capacity. It takes a greater capacity to respond to Shakespeare than to Graham Greene, to Beethoven than to Ferde Grofé, to Cézanne than to Norman Rockwell. People outgrow Graham Greene, but they do not outgrow Shakespeare. People sometimes give up Tchaikovsky's symphonies for Haydn's but they do not, I think, give up Haydn for Tchaikovsky. And if we lose our admiration for Brahms at one stage, and return to him later, it will be for different reasons. We do not say that a person has the capacity to remain unmoved by Shakespeare; this is not a capacity, but the lack of a capacity. Now the object with the greater capacity may not have its capacity actualized as often as the object with less—the heavier the sledge, the greater its force, but the fewer who can use it well. If, therefore, the aesthetic value of Tchaikovsky is more often had and enjoyed than that of Bach, it still may be true that the value of the latter is greater.

The Instrumentalist definition, as I have framed it, contains another unusual feature, that is, the parenthetical insertion. I am not sure that

the parentheses are the best notation for my meaning, but they are the best I can think of. The Instrumentalist definition is not a Psychological definition, in the sense of the preceding section, for it does not claim to reduce statements about value to purely psychological terms. Indeed, it does not define "value" at all, for this word appears in the defining term as well as in the term to be defined. It only defines the whole term, "aesthetic value," in terms of a certain kind of experience. But it concedes that this definition cannot be adopted except on the assumption, set forth in parentheses, that the experience is itself worth having.

If the Instrumentalist definition had been stated in purely psychological terms, for example,

"X has aesthetic value" means "X has the capacity to produce an aesthetic experience of some magnitude,"

it would have been open to the objections raised against all Psychological definitions—the "open question" argument and the complaint against Persuasive definitions. This last definition does not really define "aesthetic value" but only "aesthetic power," or something of the sort. To call that power a value is to presuppose that the effect itself has value, and this presupposition should be made clear. Yet the presupposition is not strictly part of the defining term; it is more like a stipulation about the conditions under which the definition applies, and that is why I have put it in parentheses. The definition might be expanded in this way:

If it be granted that aesthetic experience has value, then "aesthetic value" may be defined as "the capacity to produce an aesthetic experience of some magnitude."

To say that an object has aesthetic value is (a) to say that it has the capacity to produce an aesthetic effect, and (b) to say that the aesthetic effect itself has value. In exactly the same way, the statement, "Penicillin has medical value," means (a) that penicillin has the capacity to produce medical effects, that is, it can cure or alleviate certain diseases, and (b) that curing or alleviating diseases is worthwhile.

Selected Readings on Part VIII: Aesthetic Value

Aldrich, Virgil C. *The Philosophy of Art*. Englewood Cliffs, N. J.: Prentice-Hall, 1963. Part Four.

Alexander, Samuel. *Beauty and Other Forms of Value*. London: Macmillan, 1933.

Bartlett, Ethel M. *Types of Aesthetic Judgment*, London: Allen & Unwin, 1937.

Beardsley, Monroe C. *Aesthetics*. New York: Harcourt, 1958. Chapter 11.

Carritt, E. F. *The Theory of Beauty*. London: Methuen, 1928.

———. *What Is Beauty?* Oxford: The Clarendon Press, 1930.

Ducasse, Curt J. *The Philosophy of Art*. New York: Dial, 1929. Chapters 14 and 15.

Ekman, Rolf. *Problems and Theories in Modern Aesthetics*. Malmo, Sweden: Gleerups, 1960.

Jarrett, James L. *The Quest for Beauty*. Englewood Cliffs, N.J.: Prentice-Hall, 1957.

Joad, C. E. M. *Matter, Life and Value*. London: Oxford U.P., Humphrey Milford, 1929, 266–83.

Margolis, Joseph. *The Language of Art and Art Criticism*. Detroit: Wayne, 1965. Part Four.

Mead, Hunter. *Aesthetics*. New York: Ronald, 1952. Part Two.

Osborne, Harold. *The Theory of Beauty*. London: Routledge & Kegan Paul, 1952.

Stace, Walter T. *The Meaning of Beauty*. London: Richards & Toulmin, 1929.

Stolnitz, Jerome. *Aesthetics and Philosophy of Art Criticism*. Boston: Houghton, 1960. Part Five.

INDEX

INDEX